Paris
Bon Appetit

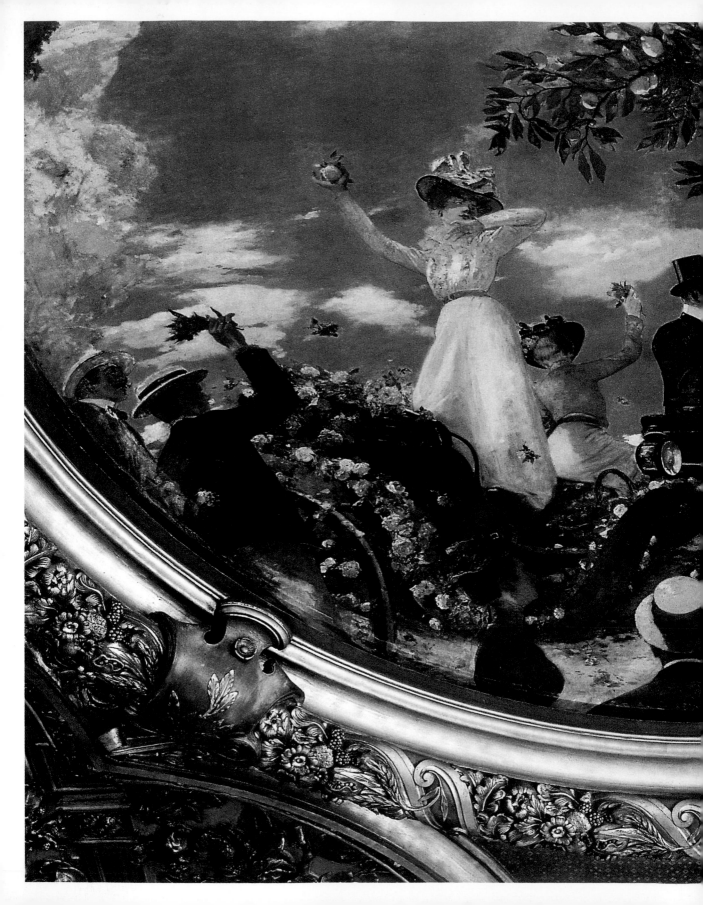

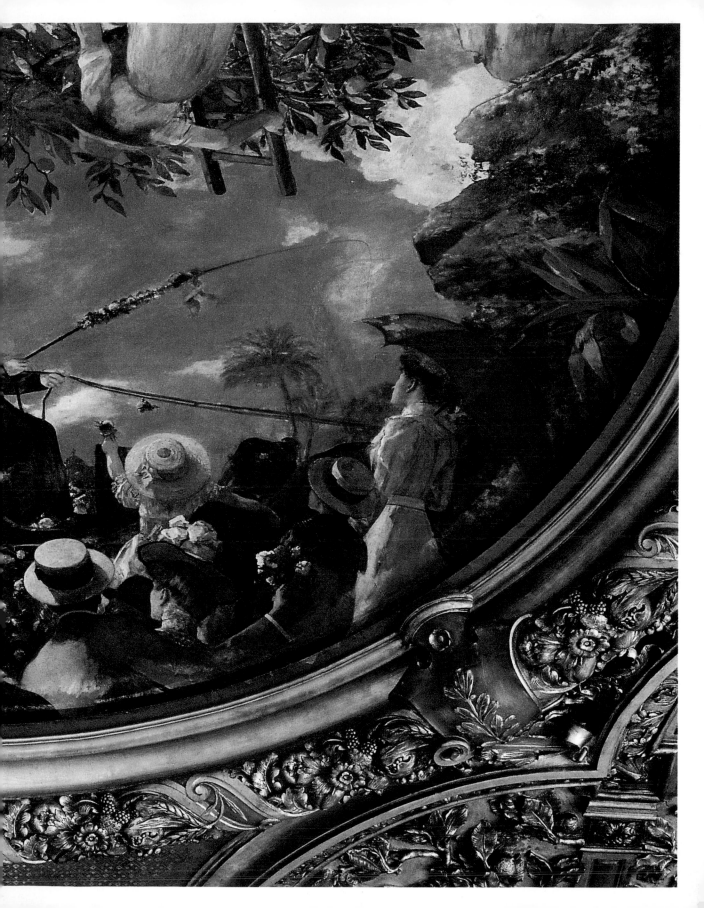

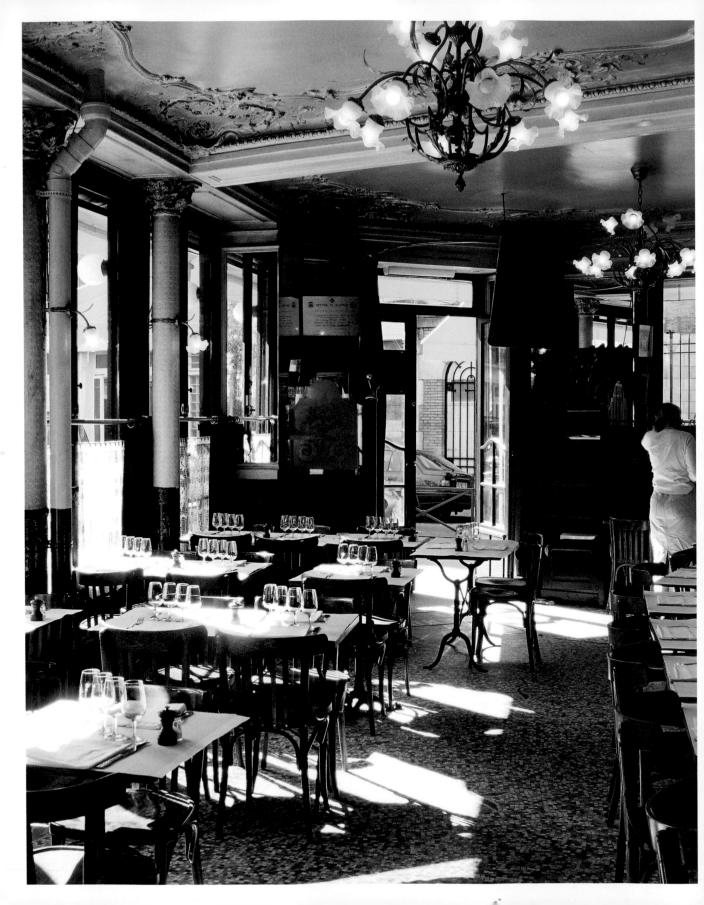

Pierre Rival

…graphy by Christian Sarramon

Paris
Bon Appetit

Shops, Bistros, Restaurants

Flammarion

Contents

*Pages 2–3: 1900 depiction
of the Nice Carnival on the ceiling
of Le Train Bleu, the palatial buffet
at the Gare de Lyon.*

*Page 4: Le Square Trousseau, a stone's
throw from Bastille, is the perfect
example of a nineteenth-century bistro
that has preserved its soul.*

*Page 8: The large main room
of the brasserie Bofinger, near place
de la Bastille.*

*Pages 12–13: Dark red raspberry
hearts by chocolate maker Marcolini,
and the deep red robe of a wine from
La Dernière Goutte.*

*Page 14: Window display
at the bakery Paul.*

Traditional **Paris**
Old-Fashioned Flavors and Atmospheres

Contemporary **Paris**
Design and Creativity

104
Bistros

Join the locals at their favorite bistros, where Parisians go to find the tastes and aromas of home cooking.

202
The future perfect

The greatest interior designers of the day have created settings for the food of the future.

132
French culinary essentials

Bread, cheese, wine, and soup have long formed the basis of popular Parisian, and indeed French, fare. Today, these staples are still going strong.

242
Tradition revisited

Many Parisian creators have chosen to seek innovation in traditional savoir-faire and classic products.

170
Gourmet food stores and coffee merchants

From boutiques overflowing with sophisticated products to coffee merchants whose carefully selected and roasted beans make the perfect espresso.

264
Exotic flavors

A crossroads of cultures, The City of Light has been enriched by cuisine, products, and savors originating from afar.

182
Childhood treats

Paris is a paradise for confectionery lovers. Stores with nothing but candy, chocolates, and homemade cakes— the stuff of childhood dreams.

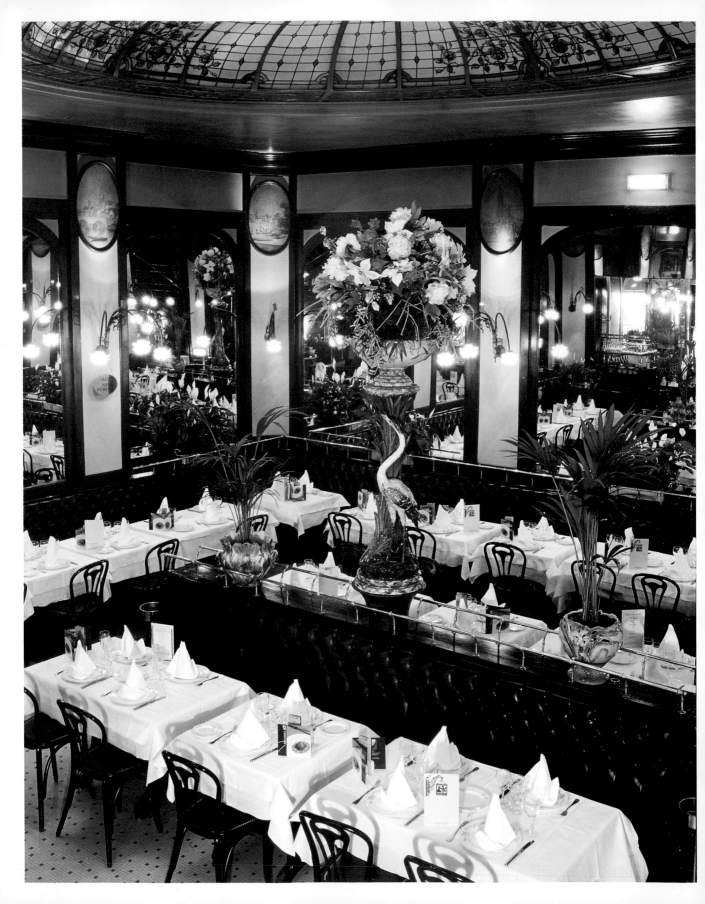

Paris—a gourmet's paradise. The capital of France may no longer be the center of the international art market, the French language may have ceased to be the language of diplomacy and cultured nobility the world over, and literature and theater may thrive elsewhere, but when it comes to food and restaurants, Paris is still the place that matters. The city's restaurants are institutions. The style of cooking that is internationally regarded as "classic" is essentially French: cooking schools from around the world have borrowed techniques and presentation styles from French cuisine for at least three hundred years. This privileged position is not to be attributed to some genius for creativity on the part of the French, nor even to the diversity of France's regional produce. Other countries rightly pride themselves on having similarly rich culinary resources, and there are other cultures with over a thousand years' experience in the art of transforming simple foodstuffs into morsels of delight. The abiding status of Paris as world capital of restaurants must be due, above all, to the special importance the French place on culinary passion. Gastronomy is no minor art, not simply a service intended to satisfy an inevitable need; it is a real artifact of civilization, a constituent part of the French identity as important as language or shared references to a common past.

This attitude can be seen in the position Parisian chefs hold in the cultural life of the city. They are considered true artists, whose recipes and techniques are discussed in learned tones by devotees, whether or not they have been to their restaurants. To a foreigner, it can seem paradoxical that gastronomy should be the subject of so much talking: in Paris it is certainly a subject of debate that is taken just as seriously as politics or sports. The reason for this resides partly in the fact that two styles of cooking, *cuisine savante*, which has graced the highest tables since before the Revolution, and the more popularly influenced *cuisine bourgeoise* one finds in a bistro, have never lost sight of each other. The refinements of the former tend to find their way to domestic stoves, while

with the latter, a regard for consistency and a respect for produce have held professionals back from baroque temptations. There is a dense network of catering schools in France, led by the famous École Ferrandi in Paris, which continuously transmit their extensive body of knowledge. Expertise is also passed on through the hierarchy of kitchen staff in grand hotels and luxury restaurants, and shared within the kitchens of family-owned establishments. For Parisians, the tradition of punctuating one's social life at fixed times during the day has also sharpened the desire to eat well, and to treat the occasion as an opportunity for everybody to meet and relax. That is why Paris decorates its restaurants as it used to its cathedrals. The Revolution has passed and cathedrals have been emptied of their treasures, but restaurants have bloomed in their place, designed by the best architects, decorated by the best artists, and ornamented by the best craftsmen.

This book is, in part, a promenade through the best restaurants in Paris, which also means the most beautiful ones, since great cooking thrives in a purpose-made setting, and nowhere are the settings finer than in Paris. As we shall see, since the eighteenth century, the best restaurants have prided themselves on their decor, whether harking back to a previous age or aiming squarely for the taste of the day. Some magnificent examples of art nouveau and art deco have survived in the restaurants of Paris. More recently, a new wave of establishments has turned to contemporary design and even a "post-historic" style that mixes references to the old with the conceptual boldness of the avant-garde— a very Parisian idea of harmony. Architects and designers like Jacques Garcia, Patrick Jouin, Philippe Starck, and Jean-Michel Wilmotte started off by decorating restaurants in Paris before working all over the world. From the dining rooms of the top hotels to corner bistros, the trend is now toward not only more spectacular decoration, but also the pursuit of a new level of conviviality around a table. There are now in-store

restaurants and restaurants where kitchens open directly onto the eating area. French table service, which was once considered overly formal, is lightening up without losing any of its quality. In Paris you can enjoy all the ceremony of your waiter carving at your table, or thrill in anticipation as you enjoy the spectacle of your meal being prepared at a counter-top kitchen. From every way you look at it, a trip to the gourmet Paris of today offers a complete experience. From one restaurant to the next, you can be plunged into history then immersed in a vision of the future. You can wander off the street into the nineteenth century or be catapulted into a kaleidoscopic vision of the bustle of the twenty-first and beyond. You can choose whether to savor the eternal dishes of classic French cooking, or give in to the giddiness of cutting-edge culinary creation. Paris has all it needs to appeal to both the nostalgic and the adventurous. And that, as always, is the source of its charm.

Paris—a gourmet's paradise. The number of first-class restaurants, bistros, and brasseries the capital holds is evidence of this incontestable fact. But it would be a pity to reduce the its gastronomic pleasures to this aspect alone, and in doing so to neglect many of the other very real pleasures to be had from a stroll through the city. A trip to any local patisserie or bakery, or a rummage through the bric-a-brac of a grocery store will give you an idea of the temptations Parisians are faced with every day, and such constant exposure has a tendency to turn every promenade into an aperitif. In this book we have also put together an itinerary for those interested in discovering the city's culinary curiosities. To facilitate that journey we have assembled a selection of the finest—and most beautiful—boutiques the city has to offer, the ones where all thoughts of diets and good resolutions are reduced to nothing.

The French capital is undergoing a number of culinary revolutions. The emergence of a "Paris School" of chocolate is one of them, a renaissance

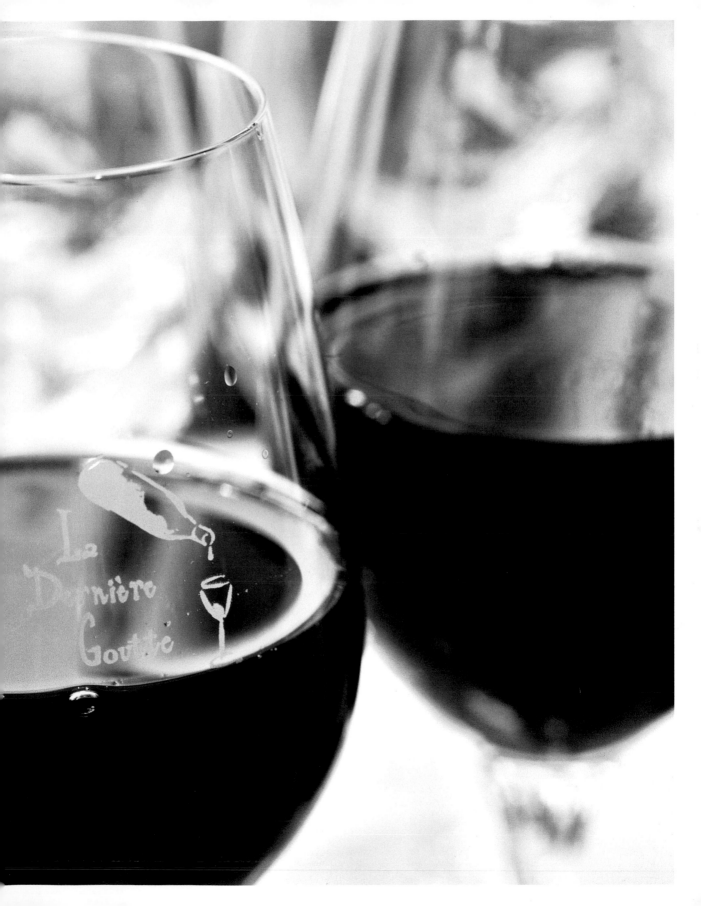

in patisserie is another. In all corners of the city one hears increasingly about the "French art of tea," as if this was something that had existed forever, and experts now come from the Orient to Paris in order to promote their finest teas. In the 1920s, Paris "invented" caviar from sturgeon roe. In the twenty-first century the city that soaks up culinary fashions like a sponge has gone crazy for Spanish cured ham and promotes it the world over as if it had been invented there. The same is true for olive oil, which Paris has helped to rejuvenate as a commodity and whose cardiovascular benefits it has trumpeted, far from its Mediterranean origins. Even in wine—a domain in which Paris's leading role has long since been ceded to London—a host of new wine merchants, keen to shake free of the dictates of the traditional labels of old, have shown their ingenuity and initiative by promoting organic wines, destined to become the *grands crus* of tomorrow. Parisians have also become adept consumers of snacks and sandwiches, thanks to a lightness and freshness that is new to these traditionally Anglo-Saxon specialties. And the choice of bread in the city, once limited to the humble baguette, has multiplied beyond belief.

Paris is now a gastronomic party open to all comers. Never has there been such attention to quality, originality, and unadulterated gastronomic pleasure in the city as at present. At a time when the future of small neighborhood shops looks increasingly perilous, this can only be a good thing. Because as new shops open around the city—whether in its chic arrondissements or bohemian quarters—those devoted to gastronomy seem to succeed and prosper best. Proof, if it were needed, that despite Paris's reputation for fickleness, when it comes to one of civilization's fundamental pillars—culinary pleasure—it knows how to steer a clear course.

Decadent Paris

Historic and Prestigious Settings

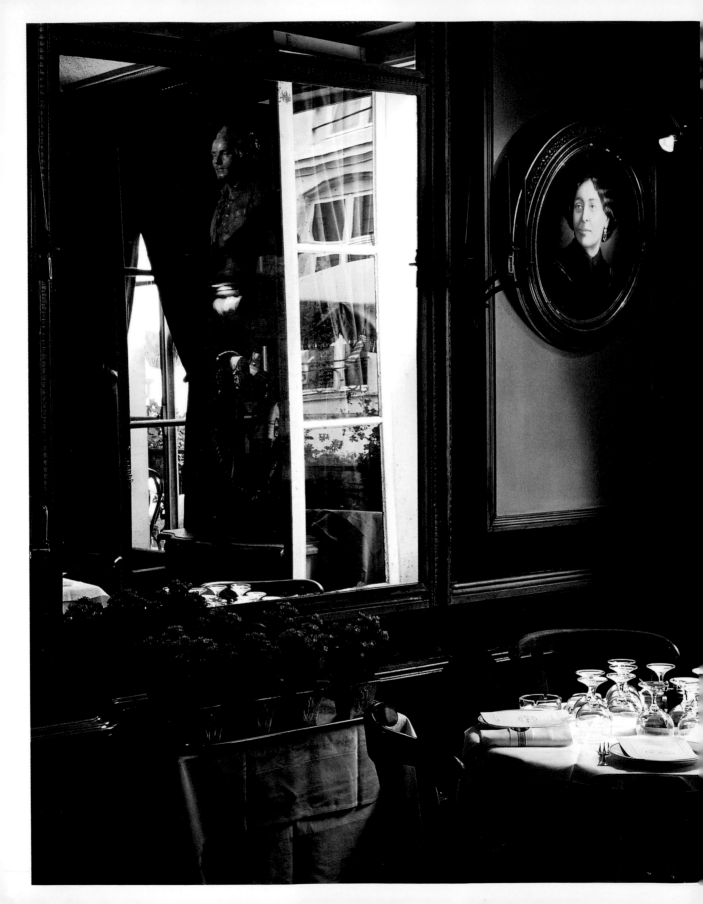

Museums
of gastronomy

PRUNIER
*Detail of the bar
at Prunier with its art
deco mosaics (page 17).*

LE PROCOPE
*With no great concern for
anachronism, Le Procope
juxtaposes the libertine
eighteenth century and the
romantic nineteenth
(facing page).*

A historical account of the finest restaurants in Paris could start with the story of one of the most resounding flops in the history of catering. The hero of this disaster is one Belloni, a great actor turned café-owner in the early eighteenth century, much admired by Parisians for his portrayal of Pierrot (Watteau's famous painting of a Pierrot in the Louvre, known as *Gilles*, may actually have been used as a sign for the café). Belloni decided to capitalize on his reputation and open an establishment to serve food to the public. A contemporary account by the Parfaict brothers, chroniclers of the French theater, contains this anecdote:

> Belloni being applauded by all publics, wanted still to enhance his reputation by joining with the ranks of Victualers. To this end, and having paid for such privileges as were necessary, he set up a shoppe on the rue de Petits-Champs, opposite the small passage leading to the Saint-Honoré cloister. The ceiling above the door bore the likenesses of divers Italian Actors, including his own, with the inscription "Au Caffé Comique." This title, along with Belloni's name, brought great popularity to the place, but its glory was destroyed in a moment by a candle end. One morning when many patrons were gathered there, one chanced to spy in his cup, in which some Coffee had just been poured for him, some thing, which he examined with care and recognized it to be a candle end. We shall curtail our account of the remainder of the scene, which was most mortifying for the Victualer-Actor. All shewed their disgust, and all unanimously promised him never more to set foot in his Caffé. He was talked to by nobody; and that very day, his shoppe was as deserted as it had been full theretofore.

This was in 1710 or 1712, at a time when coffee had become a fashionable drink, and Belloni should have been able to make a success of his venture. But by staking everything on his popularity as an actor, he forgot the quintessential importance of both setting and service. His establishment became indistinguishable from the "places of congregation and refuge for

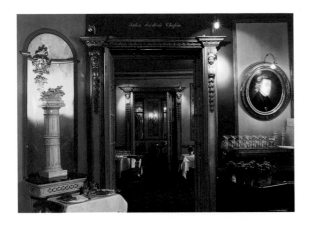

thieves, swindlers, and other wrongdoers and dissolute types" denounced in a contemporary police ruling. In other words, Belloni's Caffé Comique was no more than a smoky, ill-lit tavern where all manner of shady dealings were likely to take place.

What a contrast with Le Procope, which was opened in 1689 (although some sources say 1702) by an Italian from Palermo. Francesco Procopio dei Coltelli started at the bottom of the catering ladder—as so many restaurateurs would from then on—serving coffee at the Saint-Germain fair. Procopio's strong business sense led him to respect principles that, for the great Parisian food establishments that followed, were to prove vital ingredients for success: a place that serves drinks or food to the public must stand out thanks to its advantageous location, the beauty of the decoration, and the quality of its products. Le Procope had all three. As for the location, Procopio opened his café on rue des Fossés-Saint-Germain (today rue de l'Ancienne Comédie), opposite the Théâtre Français where Molière's successors regularly played. For the decor, he made the rooms large and covered the floor with black and white tiles (which are still there today), ensuring a high standard of cleanliness. He increased the impression of space still further by hanging mirrors on the walls, which at that time were usually seen only in private houses and aristocratic mansions. The ceilings were lit with crystal chandeliers, reflecting light from the candle flames. In short, opposite the Théâtre Français he created another stage, quite as elegant, where spectators could continue to suspend their disbelief, drinking not only coffee but syrupy liqueurs: *rossoli* and *populo* were made from eau-de-vie, cloves, black pepper, coriander seeds, green anise, and sugar, heated to a syrup. Sorbets and all sorts of lemonades were also available. Aristocratic ladies would stop their carriages just in front of Le Procope and be served without having to set foot in the establishment, while the gentlemen crowded inside.

The café became a fashionable place where one could buy *nouvelles à la main*, the forerunner of the modern newspaper. Authors, actors, foppish peers, and lay abbots from the court were regular customers. Throughout the eighteenth century, at one time or other, one might have bumped into the country's most celebrated philosophers and writers such as Alembert, Diderot, Piron, and Jean-Jacques Rousseau. Voltaire set his comedy *L'Écossaise*, also known as *Le Caffé*, at Le Procope, and Beaumarchais held the first-night party for *The Marriage of Figaro* there. During the Revolution, having undergone a change of ownership and name, as Café Zoppi, the coffee house become the unofficial headquarters of the Club des Cordeliers, the radical political group led successively by Danton, Marat, and Hébert.

With the Revolution also came an end to certain corporative restrictions, and the *cafés-limonadiers*, coffee houses such as Le Procope, were at last allowed to serve food.

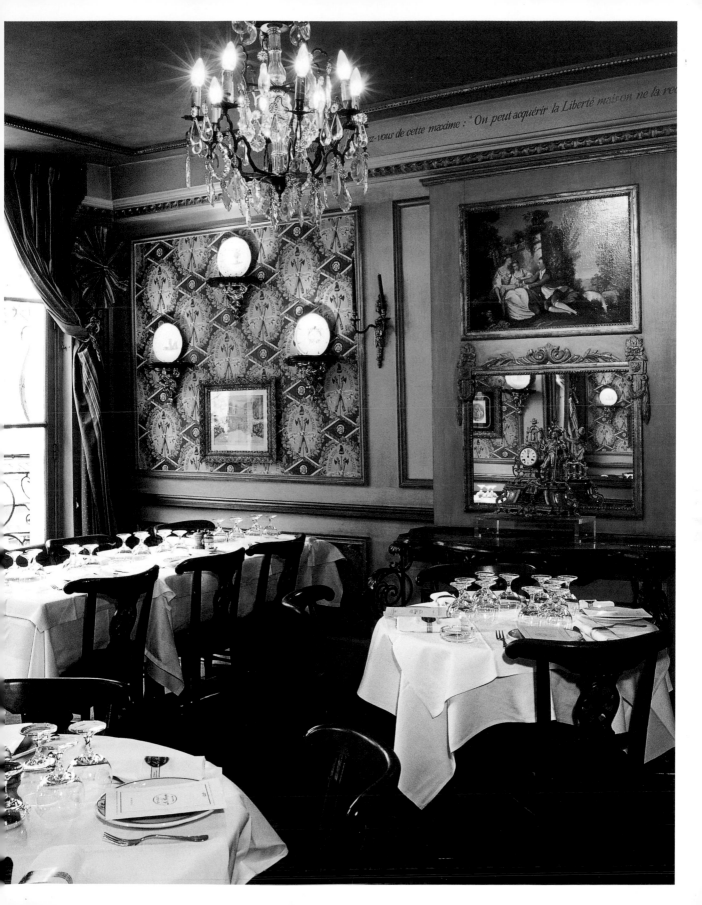

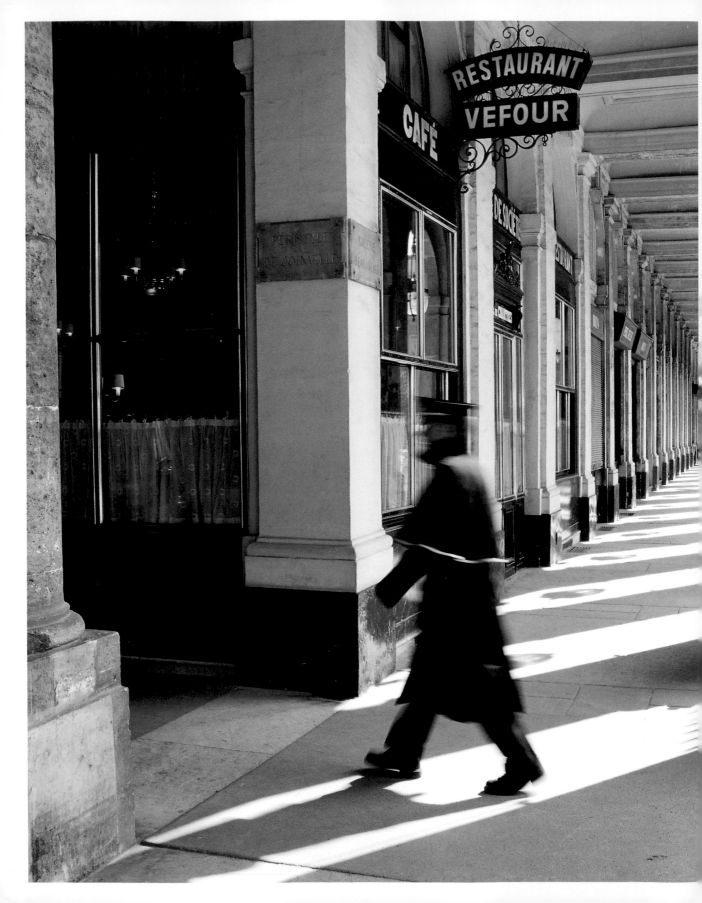

A contemporary account from 1807 notes that "nearly all today offer a light dinner, typically cutlets, kidneys in champagne wine, &c." The café had evolved into a restaurant, which would continue to attract artists and intellectuals throughout the nineteenth century. Enough of the original Procope still remains to give a good impression of this central point of Parisian social life: the black and white floor tiles, the fine mirrors on the ground floor, and the balcony from which authors and actors, fresh from their triumph at the Théâtre Français, would come and take one more curtain call from their public. As for the rest, having been freely refitted over the centuries, the restaurant today bears the traces of its successive occupants, from Voltaire's regular table, to the 1830 wallpapers depicting France's July Revolution power struggles, and portraits of a diverse family, from Benjamin Franklin to poet Paul Verlaine. The food is classic *cuisine bourgeoise*, and the signature dish, *coq au vin ivre de Juliénas*, is mentioned as early as 1746 in Menon's classic work of the same name (but without the tagliatelle). Today, a clientele of good-natured tourists has replaced the intellectual heavyweights of days gone by.

But the history of the restaurant as such really begins in Paris in 1782, with the opening of a luxurious establishment called La Grande Taverne de Londres in the Galerie de Valois next to the Palais-Royal. Antoine Beauvilliers, the proprietor, was the former *chef de bouche* (master of the household) to the Count of Provence, who was the king's brother and later became Louis XVIII. The birth of the restaurant was not, then, as persistent legend would have it, triggered by the Revolution, when chefs to the nobility were turned out onto the streets. The restaurant is an invention of the pre-revolutionary ancien régime, even if the social upheaval of the Revolution gave it a fundamental impetus. Brillat-Savarin's *La Physiologie du goût* tells us that Beauvilliers "was one of the first to have an elegant dining room, well-turned-out boys, a well-kept cellar and kitchen"; in a word, what would later be called a restaurant. Significantly, he placed great importance on the quality of service and surroundings. And Beauvilliers himself was no greasy-aproned cook: as an officer of the crown—a fact for which he was imprisoned in 1791—he greeted his customers wearing his sword.

The word restaurant itself refers back to another tradition: that of the *bouillon restaurant*, a "restorative soup," in which the word *restaurant* denotes the revitalizing virtues of consommé. In 1765, a certain Boulanger set up a few tables in his shop in rue des Poulies near the Louvre, serving predominantly working-class customers, judging by the individual portions of lambsfeet with chicken sauce. It was a precursor of the bistros of today. Yet restaurants did not really take off in Paris until the nineteenth century: in 1824, Brillat-Savarin still felt it necessary to furnish a job description of the restaurateur: "he whose business consists in offering to the public a feast which is always ready, and whose dishes are made into portions at a fixed

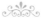

LE GRAND VÉFOUR

Underneath the arches of the Palais-Royal (facing page), Le Grand Véfour is the last survivor of the many establishments that animated these public gardens at the center of Parisian life between 1786 and 1829. A period sideboard, and tableware to harmonize with the historic setting (below). The main room of the restaurant with the red banquettes where Colette and Cocteau used to sit (following pages).

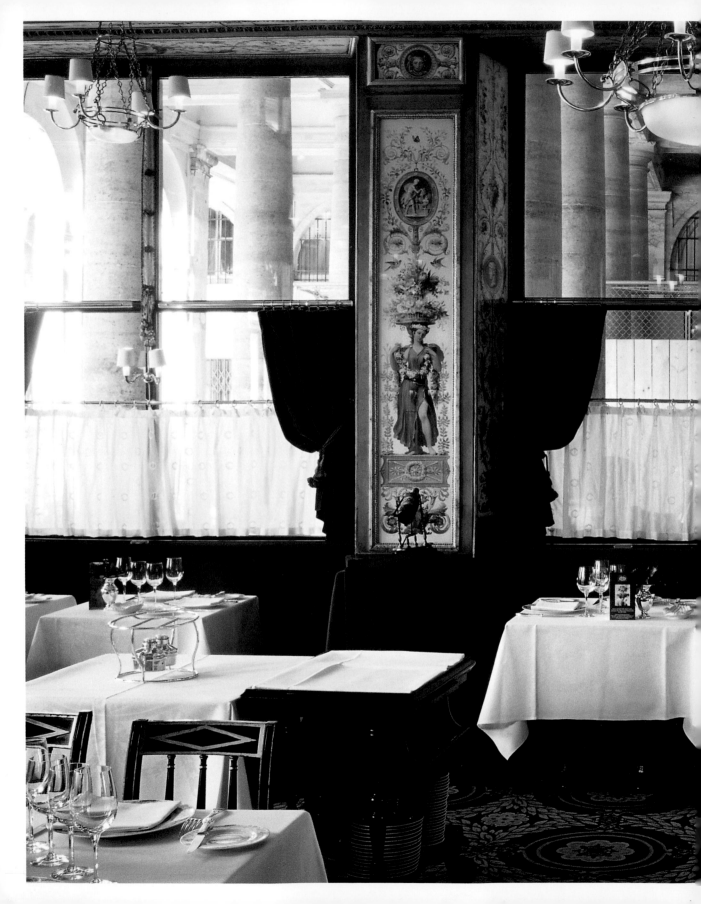

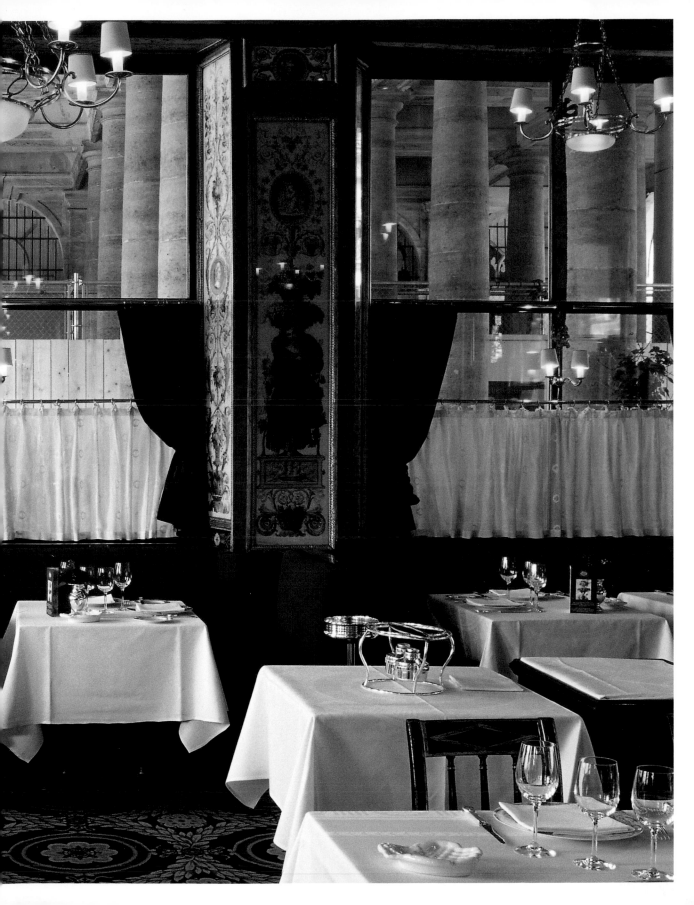

price at the request of the customers.... What they call *carte*: an itemized list of the dishes, indicating their price, and *carte à payer*: the bill of the quantity of dishes provided and their prices."

But let us return to Beauvilliers. In the wake of his success, other establishments opened in the vicinity of the Palais-Royal, which was at that time one of the busiest parts of the capital. Instead of the rather inert gardens of today, during the eighteenth century the site was densely packed with wooden stalls selling all manner of Parisian merchandise, from fabric and clothes to jewelry and books. The alleyways between bustled with men and women looking for bargains, or perhaps a romantic adventure (Bonaparte made his first conquest there). And the site was

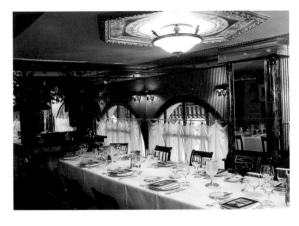

effectively immune to the forces of law and order: the Palais-Royal belonged to Louis-Philippe d'Orléans, grandson of the prince regent and therefore close enough to the king to be off limits to the local watch and the police. Under this extraterritorial arrangement, there was an upsurge in the circulation of satirical pamphlets and more or less clandestine gazettes, and the gardens were transformed into a hub for prostitution.

By 1789, the Palais-Royal was also one of the political hotbeds of the burgeoning Revolution. In the galleries surrounding the gardens, cafés, casinos, and taverns were opened, including the Café de Foy in the Galerie de Montpensier, the Café du Caveau and the Café de Chartres (to which we shall return in due course) in the Galerie de Beaujolais, and the Café Favier and the Café Méchanique in the Galerie de Valois. Beauvilliers' creation sounded the starting pistol for the restaurant race. Le Véry and Les Trois Frères Provençaux opened in the Galerie de Beaujolais, Le Petit Véfour in the Galerie de Valois, and the cafés were not slow to catch onto the new fashion and start serving food, too.

The Café de Chartres is one such example. Under the name of one of its first proprietors, Jean Véfour, the establishment attracted a refined foreign clientele after the royal Bourbon family returned to Paris in 1814. Count Rostopchin, the Moscow firebrand, was seen there dining with his French teacher, the beautiful Flore from the Théâtre des Variétés; the explorer Humboldt also dined there, invariably on "a vermicello, a breast of mutton and a bean." Since then, Le Grand Véfour (the "Grand" was added around 1825 to make the distinction from Le Petit Véfour) has always shone out in the gastronomic firmament, despite the decision of the future King Louis-Philippe in 1829 to clear the gardens of the stalls and drive out the prostitutes, after which the Palais-Royal was deserted. Le Grand Véfour withstood wind and tide, prompting a benevolent critic to say in 1842: "We go to Véfour and we keep going back; the place will be there for as long as there are large appetites: you see that it is eternal." And this does appear to be true: no other Parisian establishment can claim to trace the genealogy of its chefs back over more than two hundred years.

LE GRAND VÉFOUR

The fine Pompeian-style reverse-painted glass panels are difficult to date, but they indicate the sumptuousness of this restaurant, which has always been a luxury establishment (facing page). The small dining room on the second floor is ideal for more intimate meetings (above).

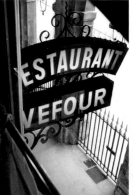
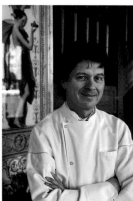

LE GRAND VÉFOUR

*Guy Martin is the latest
in an uninterrupted line
of great Parisian chefs
spanning two centuries
(above). An allegory
of Autumn in a sensuous
and calm setting
(facing page).*

After a brief eclipse due to the decline of the Palais-Royal, the gastronomic torch was taken up again after World War II. Louis Vaudable, then head of Maxim's, worked with Raymond Oliver, the greatest French chef of the 1950s, to bring the restaurant back up to scratch. The renaissance was rewarded in 1953 with three Michelin stars, and is continued today by Guy Martin, who has successfully maintained the standing of Le Grand Véfour, the ultimate witness of the eighteenth-century origins of the Parisian restaurant.

Inside this historic monument, the date of the interior decoration is still a matter of debate. Is this, as the profusion of Romanesque details might suggest, and as has long been believed, an example of Empire style? Or do we side with the authors of a report that led to Le Grand Véfour being listed as a historic monument in 1964, who held that only the ceiling, with its decorative grotesques, dates from the end of the eighteenth century? According to the report, the glazed canvases on the walls of the two dining rooms are in fact from the 1850s, when the Pompeian style came back into fashion. Were these panels imported from Italy, as some connoisseurs think, given their resemblance to those in the Café Florian in Venice, or are they to be attributed to Charles Prud'hon, a painter who was active under the Empire? None of this can be quite certain in the absence of documents formally establishing the provenance of the decor— but it doesn't really matter. We can all agree on the charm of these somewhat erotic figures, allegories of diverse activities more or less closely related to the "art of the table," which create a unique atmosphere, both magical and timeless. Le Grand Véfour is clearly a place devoted to pleasure. Luckily, the quality of the food still matches the beauty of the setting, allowing guests to unhitch themselves from the contemporary world for an evening and have a truly poetic experience. Guy Martin's preparations are perfect for this: his menus are modern without being unsettling. He has managed to preserve some of the great classics that made the reputation of Raymond Oliver (notably Pigeon Rainier III), but also proposes seductive culinary innovations with all the allure of a timeless classic—for example, his flavorsome oxtail with truffles.

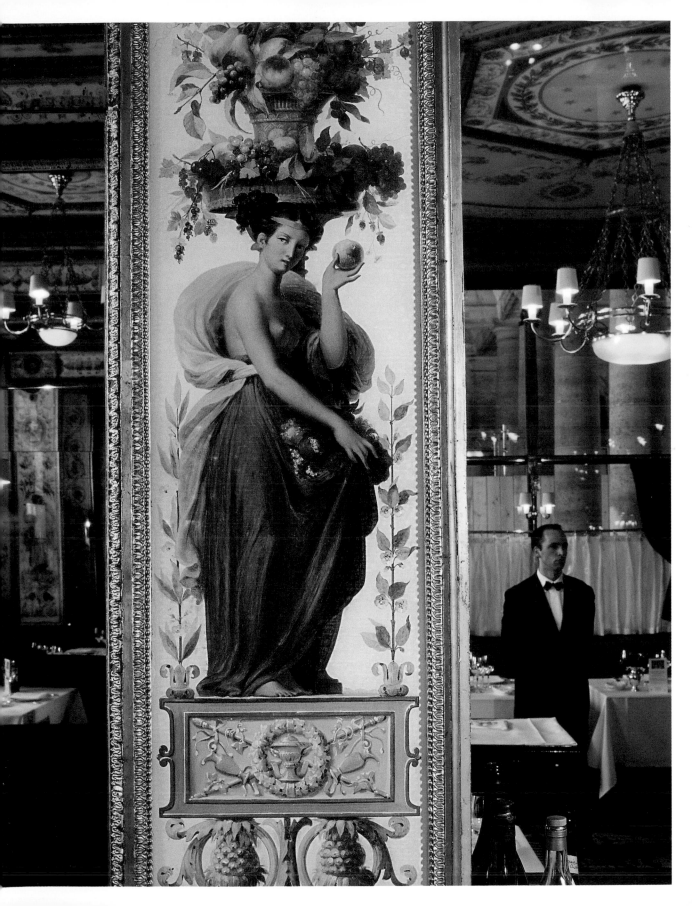

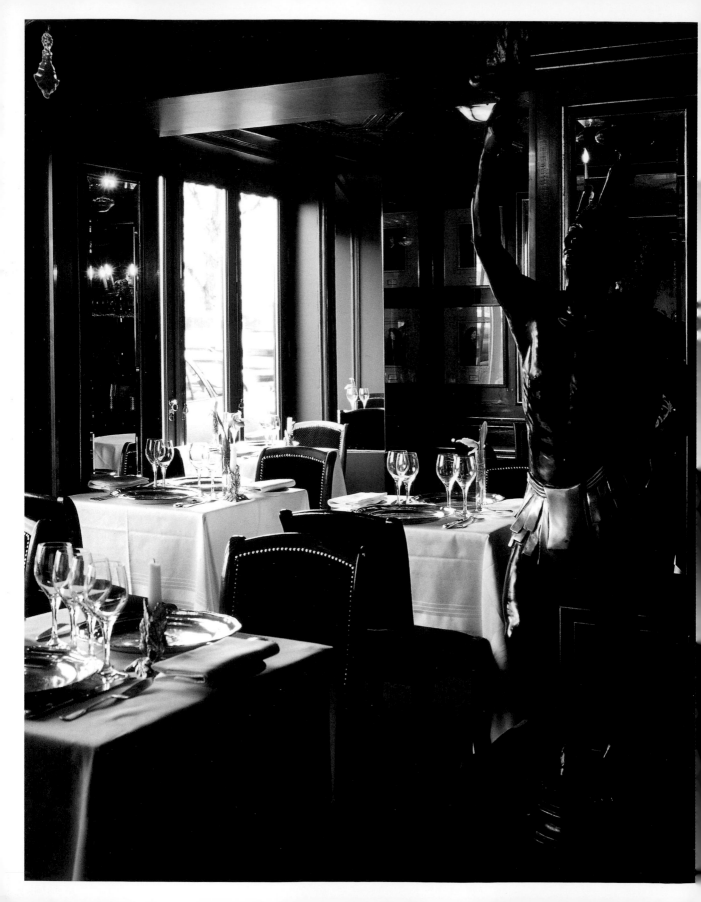

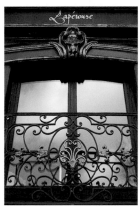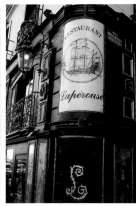

The German philosopher Walter Benjamin wrote that Paris was "the capital of the nineteenth century," meaning the leading cultural city. This superiority was particularly marked in the area of gastronomy. Just flicking through the novels that make up Honoré de Balzac's *The Human Comedy*, or plunging into Gustave Flaubert's great Parisian novel *A Sentimental Education*, one can see the importance of restaurants at the time in the social life of the capital. The names of the Café Anglais, Frascati, Tortoni, and Le Rocher de Cancale, the facade of which can still be seen on rue Montorgueil, turn up with significant frequency.

The Café Anglais—also visited by Emile Zola's heroine Nana—seems to have occupied the same position on the Parisian world map that would later be taken up by the Brasserie Lipp or Maxim's. It was here, on the corner of boulevard des Italiens and rue Marivaux, next to the Opéra Comique, that Adolphe Dugléré, the inventor of the eponymous sole dish, made his reputation. The gourmet spirit of the place lives on today at La Tour d'Argent, whose founder, André Terrail, married the daughter of the last proprietor of the Café Anglais, Claudius Burdel, and inherited the contents of its prestigious cellars. Before the café itself closed in 1913, Marcel Proust was a regular customer. *In Search of Lost Time* can be read as a synthesis of the French nineteenth-century novel, and indeed a recasting of the mold—and it includes a detailed directory of the restaurants of the time. Thus in *Swann's Way*, the lovelorn hero finds refuge at one of most prestigious gastronomic addresses in Paris:

> On some days, instead of staying at home, he would go for luncheon to a restaurant not far off to which he had once been attracted by the excellence of its cookery, but to which he now went only for one of those reasons, at once mystical and absurd, which people call "romantic"; because this restaurant (which, by the way, still exists) bore the same name as the street in which Odette lived: La Pérouse.

LAPÉROUSE

Overlooking quai des Grands-Augustins, Lapérouse presents an authentically eighteenth-century facade as seen, chiefly, in the elegant balcony ironwork (above). The room on the ground floor opens onto the banks of the Seine (facing page).

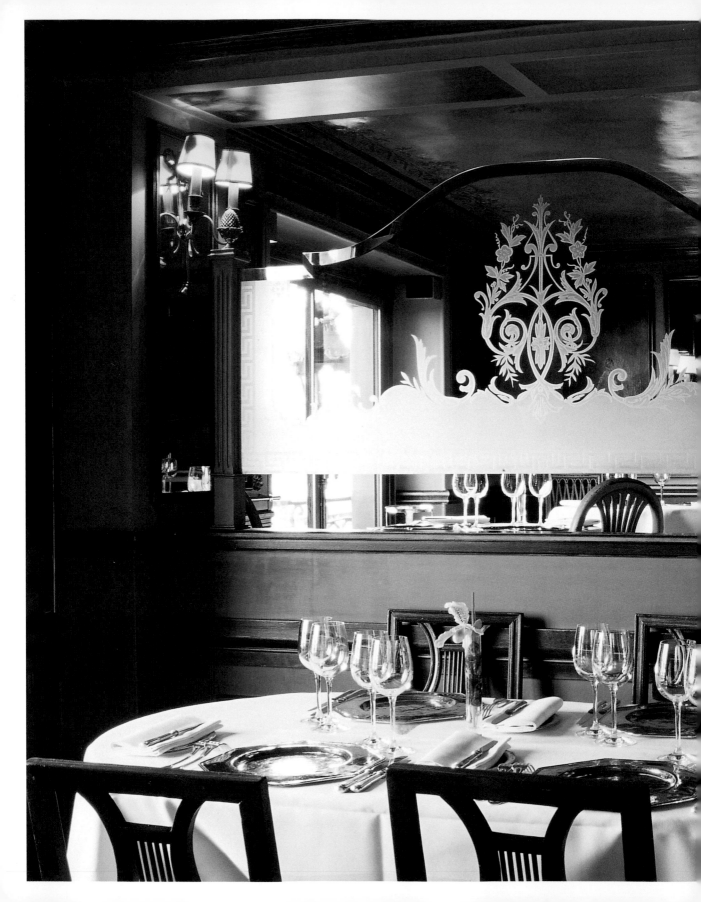

LAPÉROUSE

*The Third Republic
(1870–1940) lives on in
this room on the second floor,
particularly in the glass
dividers engraved with
stylized leaves and flowers.*

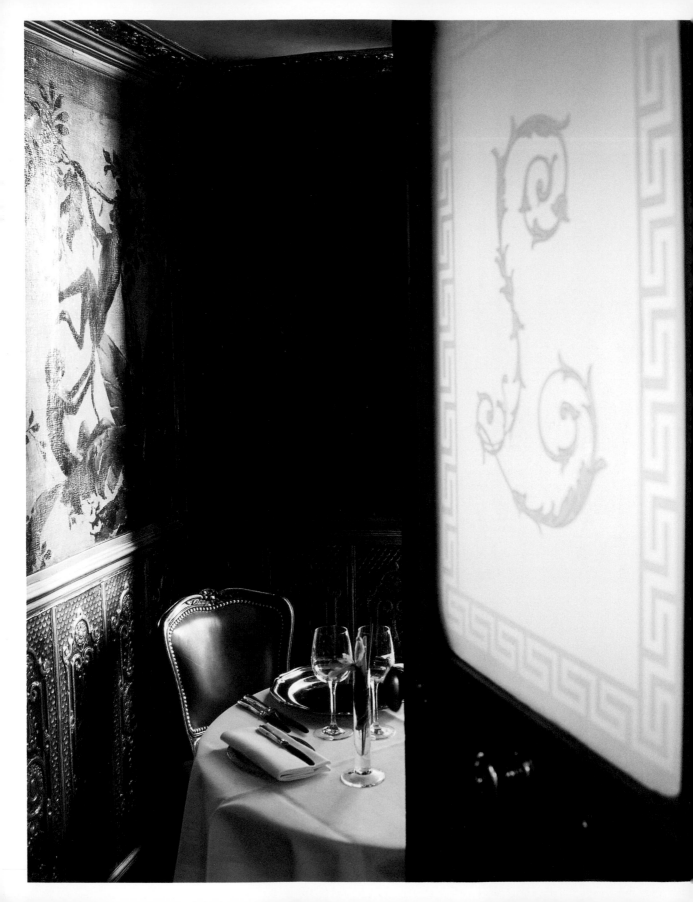

 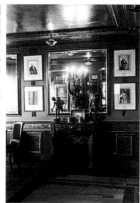

Lapérouse, which does indeed still exist, provides a pretty good idea of what a grand nineteenth-century restaurant was like. You wouldn't go there just to eat. Business meetings and romantic trysts would be made there, and while some went with the intention of showing themselves off, for others the attraction was the possibility of not being seen. Lapérouse had private offices and rooms that could be locked from the inside, and a hidden exit leading out to rue des Grands-Augustins. Guests were warned of imminent interruption by a bell placed directly on the steps of the service staircase, and could indulge in their favorite vices with complete peace of mind. What was more, since a clause in the French Civil Code classed restaurants as public places, illicit couples were protected from laws against adultery, and in particular the procedures pertaining to *in flagrante delicto*. When Lapérouse appeared on the Parisian landscape at the turn of the 1840s, its minimally decorated rooms were not yet accommodating prostitutes, merely their pimps whose girls were close on hand at the nearby Marché de la Vallée. Hidden from prying eyes, they would come and shake on deals, exchange rolls of gold coin, and drink to future business.

Jules Lapérouse bought the establishment in 1878, just as the Third Republic was being formed. It is to this astute proprietor that we owe the mounted canvases in the dining rooms, bearing idealized views of the preceding century. Throughout the restaurant, the walls were covered with leather embossed with Renaissance flower motifs, vaguely reminiscent of an inn in Dumas' *The Three Musketeers*. This pastiche style pleased the rich and influential of the time. Lapérouse became the place where members of the Senate would take their beautiful mistresses, who (as legend has it) would test the authenticity of the diamonds given them by their lovers by checking their sparkle in the mirrors.

The gastronomical standard was raised with the arrival in 1907 of a great chef, Marius Topolinski, at just the period when Proust sets the tortured affair between Swann and Odette

LAPÉROUSE

The small private rooms that made the fortune of Lapérouse: here guests could meet secretly for clandestine romantic affairs (above and facing page).

LE RELAIS PLAZA
*Authentic 1930s decor at
this brasserie in the fashion
district. Above the bar,
a fresco by F. Saqui depicts
Diana the huntress in
typically art deco style
(below).*

LE PLAZA ATHÉNÉE
*Alain Ducasse has turned
the restaurant at the Plaza
Athénée into one of the most
prestigious tables in Paris.
The interior designer Patrick
Jouin recently lightened the
feel of this slightly solemn
room by hanging a
chandelier with several
hundred glass drops
(facing page).*

de Crécy. Creations of his, such as Prince Orloff veal chops and *gratin de langoustines Georgette*, have immortalized their creator just as they have the customers that inspired them. When Topolinski's son Roger bought the establishment in 1923, the first Michelin Guides lavished it with praise. Topo, as he was called, was a gentle, bearded giant, a courteous host, and of course the soul of discretion. He was the personification of the idea that the setting should be as important as what goes onto the table. The Aga Khan, the Begum, and the Duke and Duchess of Windsor would come and slum it in this stronghold of Parisian society highlife. Lapérouse only lost its stars in 1969, when the fashion for nouvelle cuisine put more innovative chefs into the limelight. When its gentleman proprietor died, the restaurant sank slowly into a state of torpor from which it has not yet roused itself. Now the only regulars are staunch nostalgics and those to whom the notion of secrecy is still important, in a world dedicated to the celebration of media openness. One of the last clients of distinction was the late President François Mitterrand, who found shelter there when dining tête-à-tête with his illegitimate daughter Mazarine. The experience of luxury dining in Paris was, for a long time, characterized by pretentious service and a "catch-all" approach to the food. For several years now, however, this restaurant has been endeavoring to earn a new star by offering refined and elaborate cuisine, in the hope of repositioning itself in the leading pack of cult gastronomic establishments. Perhaps a renaissance is afoot.

Turning our attention to hotel dining, in the 1930s, the Hôtel Plaza Athénée made a popular departure into the realms of the luxury brasserie, with the Relais Plaza. This was a grill—a steakhouse—decorated in the most elegant style of the period, a sort of terrestrial luxury ocean liner. It was adopted by both the fashion and music worlds of Paris, being located on avenue Montaigne, and not far from the Théâtre des Champs-Élysées. On the other hand, Parisians never warmed to the large, cold kitchens of the city's top hotels like the George V that continued to pride themselves on a readiness to satisfy their clients' every whim, even the most eccentric (an American guest at the George V once ordered, and was served, lobster in chocolate sauce).

Two great chefs reversed this terrible state of affairs, and their influence persuaded the grand hotels in Paris to equip themselves with chefs and a supporting brigade of staff that were worthy of the name. Christian Constant, originally from southwestern France, introduced more stimulating tastes at the Ritz and then at the Crillon in the 1980s, bringing rough-and-ready dishes to tables that hitherto had seen little more than upgraded room service. This affected a whole generation of young chefs—including Yves Camdeborde at the Régalade and Thierry Breton at

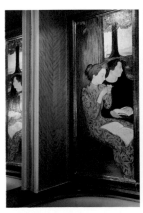
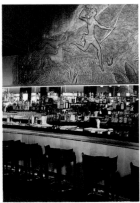

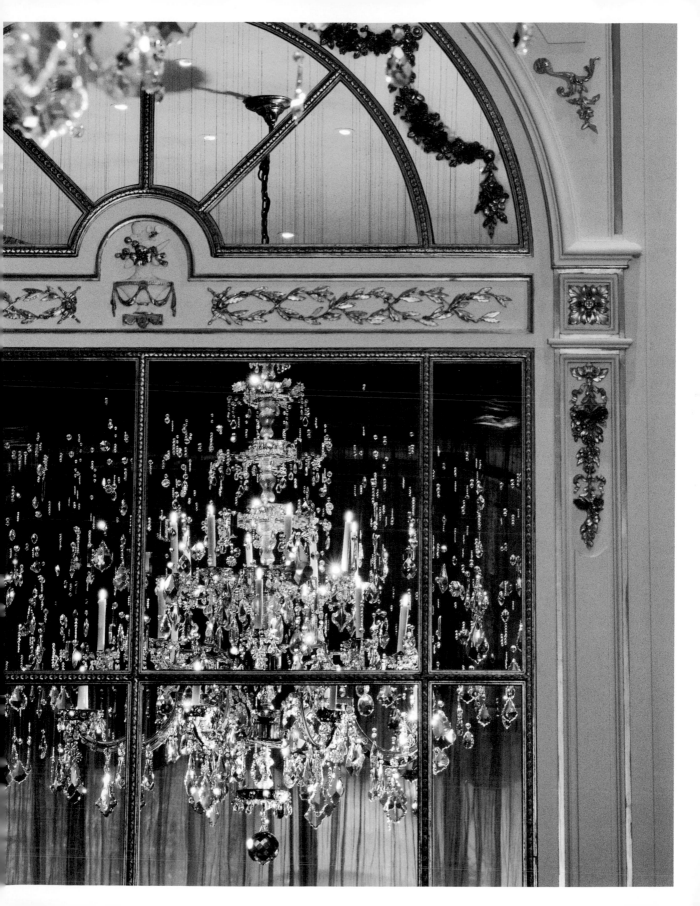

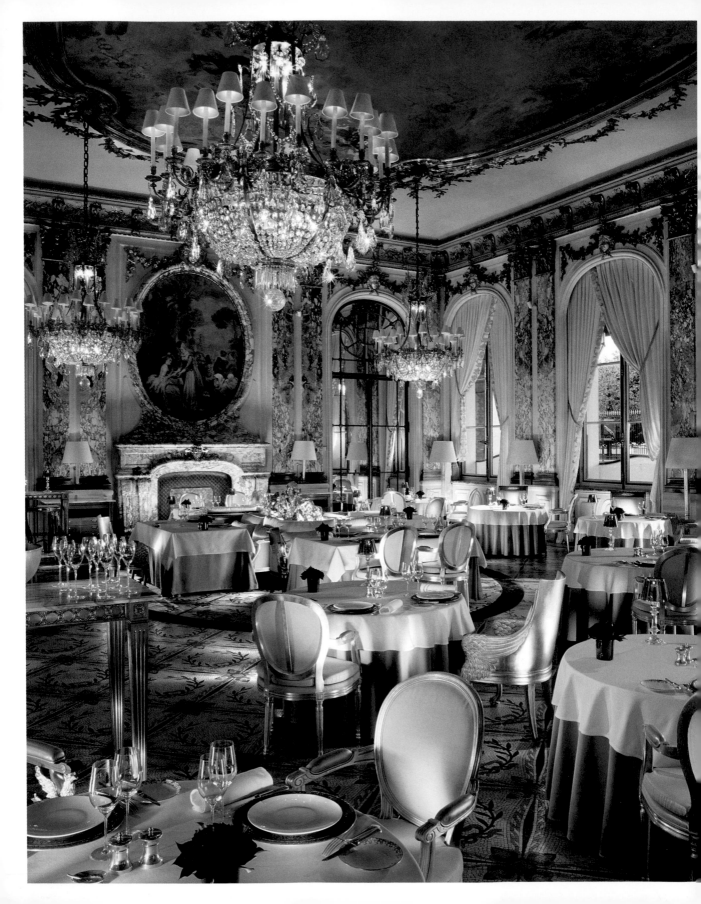

Chez Michel—who swarmed into Paris, finding positions in other luxury hotels and neo-bistros during the checkered-tablecloth boom of the 1990s. The second chef to restore nobility to the grand hotels was, of course, Alain Ducasse. Following in Escoffier's footsteps, in 1987 he took over the Louis XV at the Hôtel de Paris in Monaco. He was a disciple of Alain Chapel and Roger Vergé, and came to be regarded as the top chef of his generation, thanks to his inspired reinvention of Mediterranean cuisine. Then he headed up to Paris and started collecting Michelin stars. He made the restaurant of the Plaza Athénée one of the finest in the capital. The other luxury hotels were not long in following his lead.

The Meurice was once a regular meeting place for the English in Paris. This establishment, created in 1835 by Augustin Meurice, a postmaster from Calais whose stagecoach line terminated near rue de Rivoli, is the earliest of the grand hotels in Paris. At the turn of the last century, a thorough renovation gave it a patina of the ancien régime that it still has today. The restaurant is more evocative of a ballroom than a dining room, with its medallion-backed armchairs, crystal chandeliers, two fine marble chimneys facing each other, its ceiling painted with a very Tiepolo-like fresco, its romantic and vaguely mythological paintings, and the walls adorned with stucco, gilded wood, and mock-marble columns. Until the 1940s, one could also be served on the roof garden terrace on the top floor, which was reached by an elevator decorated as a reproduction of Marie-Antoinette's sedan chair. Marcel Proust, Salvador Dalí, and Florence Gould and her circle of writer friends—Marcel Jouhandeau, Paul Léautaud, and Paul Morand—often came to this sumptuous and slightly kitsch place. A certain whiff of decadence hung around the Meurice for a long time, partly because of the presence of German staff headquarters here during the Occupation in World War II. Its rebirth was all the more spectacular for that.

In 2003, the young Yannick Alléno, who had distinguished himself at the Hôtel Scribe, took over the running of the kitchens and straightaway earned two Michelin stars for the Meurice; the restaurant was awarded a third Michelin star in 2007. His multifaceted cuisine, simultaneously inventive and respectful of tradition, dazzled the Parisian food critics. This is a chef capable of masterfully reinterpreting a classic dish like *lièvre à la royale* by combining the two competing recipes, that of Sénateur Couteaux and the version preferred by Antonin Carême. And at the same time he can play in the contemporary register with disconcerting ease: take his Balik salmon with potato crust, leek custard, and caviar, which manages to be both light and hearty at the same time. Alléno's talent and virtuosity have brought a regular Parisian clientele to the Meurice, and their allegiance to the place is itself a sign of quality for visitors.

LE MEURICE
Hurried or uninformed customers might take the Louis XV decor for genuine work from the mid-eighteenth century, but its marble columns and chandeliers (facing page), paneled mirrors, and Sedan chair at the entrance (below) are pure early twentieth-century creations.

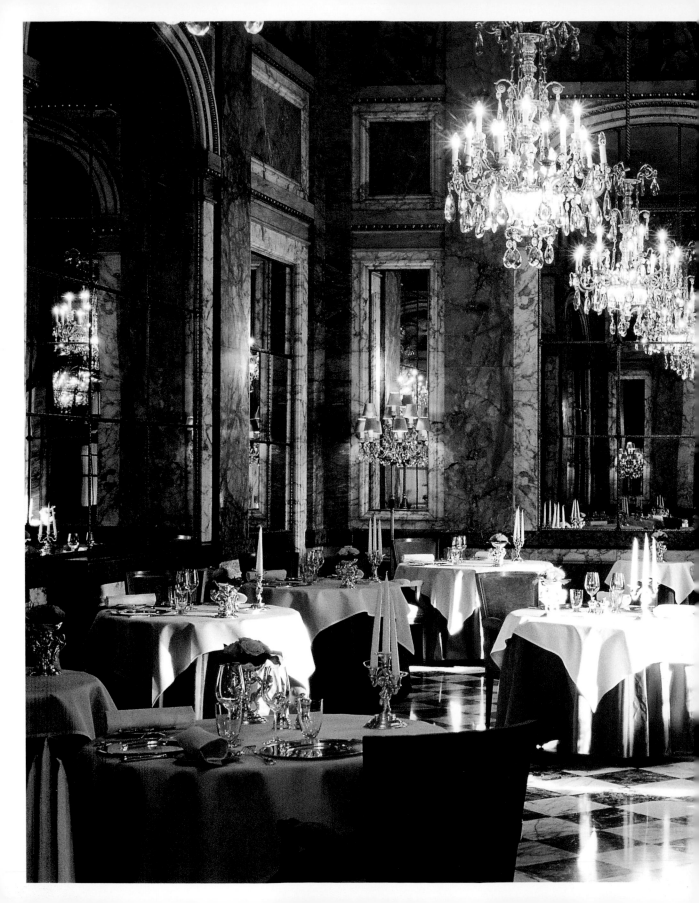

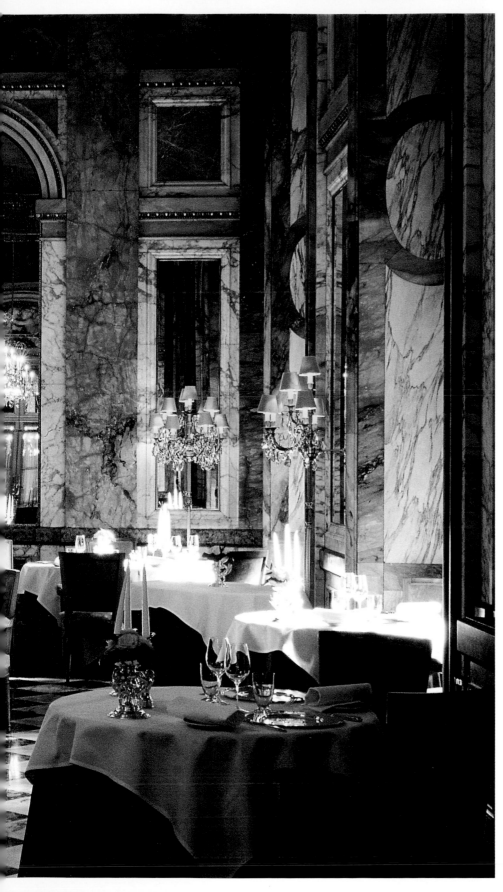

LES AMBASSADEURS

Les Ambassadeurs has inherited all the splendor of the Hôtel de Crillon's former ballroom, where it is situated: marble floor, marble walls, and large Venetian mirrors.

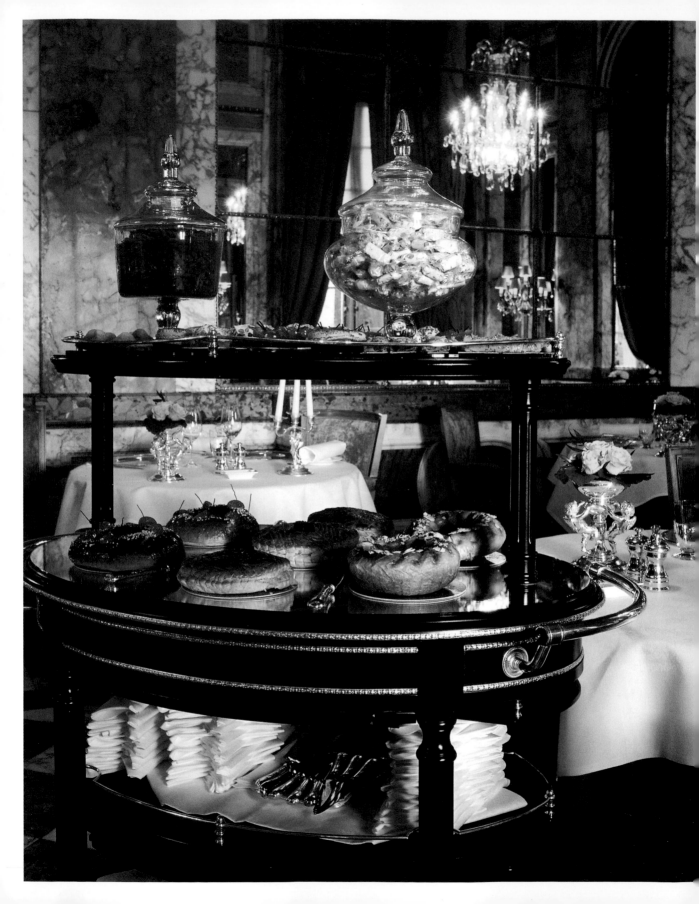

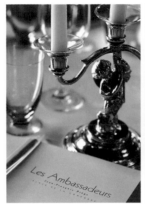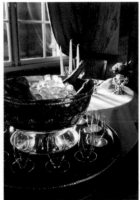

Unlike the Meurice, the Hôtel de Crillon is a true period piece, built behind the colonnade erected in 1758 by the architect Ange-Jacques Gabriel on place de la Concorde. In the beginning, this magnificent private mansion was intended to accommodate ambassadors from foreign countries, which explains the name of its restaurant, Les Ambassadeurs. The sumptuous eighteenth-century residence came into the hands of the Crillon family, descendants of one of Henry IV's favorites, after the Revolution, and they lived there until they sold it to the Société des Hôtels du Louvre in 1907. It was thus not until last century that the Crillon became the grand, luxurious hotel we know today, appropriately enough fulfilling the function it was originally intended for: the accommodation of distinguished guests.

Because of its proximity to the Élysée Palace where the French president has his office, the Crillon is still a regular port of call for the minister of foreign affairs, who has visiting heads of state stay there. The crystal chandeliers, marble statues, and wall mirrors give a timeless feel, but there are subtle touches to bring the setting up to date: champagne-colored curtains play with the light from place de la Concorde; armchairs and tables have been given a new lease of life by lighter colors, harmonizing well with shades in the marble. In the evening, the monumental chandeliers shine with all their might, while the wall lights give a more diffuse glow. Jean-François Piège, who came to the Crillon with a large part of the staff from the Plaza Athénée, was inspired by this eighteenth-century atmosphere to offer cuisine with pomp and ceremony, but cleverly modernized. Two Michelin stars rewarded the skill of this chef, still young, but already a master. In 2010, Jean-François Piège left the Crillon, carrying away his stars with him. He was, however, succeeded by a young chef to be reckoned with, Christopher Hache, who speedily brought back a new Michelin star to this luxury restaurant.

LES AMBASSADEURS

All the accoutrements of traditional service: dessert trolley, champagne bowl, and valuable crystal glasses and silverware (facing page and above).

The stained-glass ceiling reflected in art nouveau mirrors. The glass wall lamps add to the atmosphere of a Paris icon (facing page and below).

A stone's throw from the Crillon, in rue Royale, stands Maxim's, a one-stop incarnation of a certain idea of Paris. The singer Serge Gainsbourg, in a somewhat forgotten song, summed up the atmosphere like this: "Ah! baiser la main d'une femme du monde, et m'écorcher les lèvres à ses diamants, et puis dans la Jaguar, brûler son léopard avec une cigarette anglaise et s'envoyer des dry au Gordon et des Pimm's Number One avant que de filer chez Maxim's, grand seigneur dix sacs au chasseur!" (Ah, to kiss the hand of a fine lady, and scratch my lips on her diamonds, then in the Jaguar, burn her leopard-skin coat with an English cigarette and down some Gordon's and vermouth and Pimm's Number One before zooming off to Maxim's, feeling generous, a hundred francs to the doorman!) All the elements of the myth are there: the Maxim's doorman with his smart red uniform, the diamond-digging dame, and the anglophile snobbery which is so typically Parisian—which we also see in the restaurant's name, anglicized by the first proprietor, Maxime Gaillard, supposedly to add polish. There is an element of timelessness, too: instead of rolling up in a horse-drawn carriage like his illustrious predecessors, Gainsbourg screeches up to the door in an E-type Jaguar, showing how in the 1960s, Maxim's still embodied the temptation to live life at its fastest.

The place has settled somewhat as it has grown in international fame. With all the flexibility allowed by that name's mythical association with Paris as a constantly fizzing City of Light, Maxim's is now used by Pierre Cardin almost as a brand name. In a sense, the name has come to be separated from the place. There are now Maxim's plates, champagne, chocolates, cigars, and even Maxim's scent, not to mention the establishments opened under the name in other cities including Monte-Carlo, New York, Beijing, and Shanghai. The great fashion designer is no ordinary restaurateur; perhaps a figure of this caliber was just what was needed to help Maxim's weather the years.

The facade, the series of three rooms inside linked by the famous Omnibus bar (today on the second floor), the mezzanine, and the small saloons are art nouveau, dating exactly from the

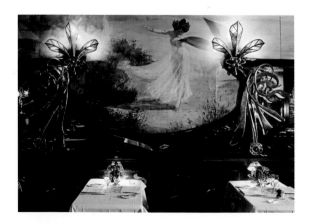

turn of the century. But this is a "flamboyant" art nouveau: the architect Louis Marnez favored eccentric scrollwork, exuberant organic motifs, mahogany woodwork picked out with copper, and wall seats and armchairs covered with red leather. The sumptuous display is given further complexity by mirrors that catch reflections of nymphs (frescoes by Martens and Soulié), translucent stained-glass windows, built up in overlapping layers in the style of Émile Gallé, and the glass roof of the large dining room where lemon-tree branches intertwine.

The patrons themselves were no less flamboyant, and helped secure Maxim's international reputation. For it was no genteel clientele, even if crowned heads, writers, and artists were regularly present. The patrons one came to

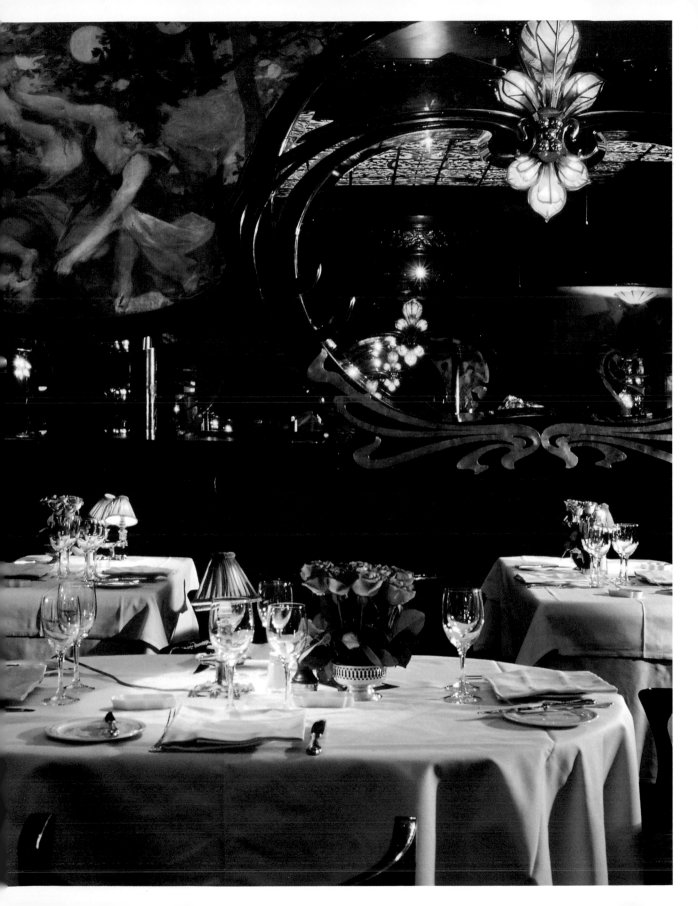

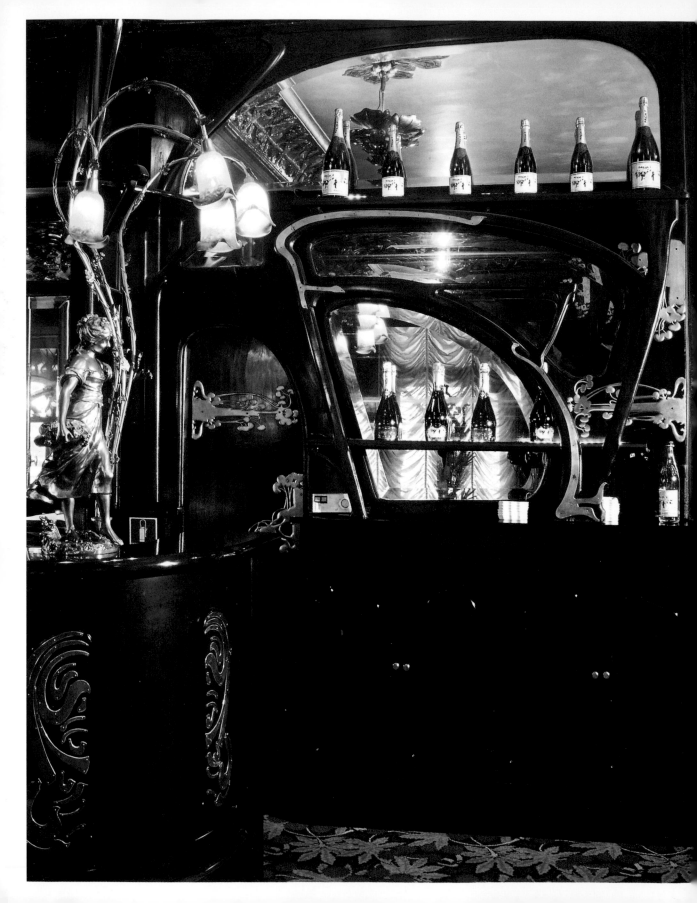

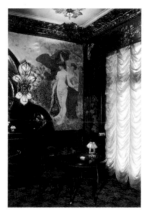
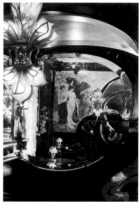
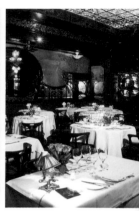

see—or to be seen with—at Maxim's in the 1900s were the *belles horizontales*, professional beauties with the names of princesses: Émilienne d'Alençon, Liane de Pougy, Caroline Otero. They reigned supreme over the Paris demimonde and their scandalous goings-on added spice to many a dinner at rue Royale. In this sense, Maxim's is more of a theater than a restaurant, and its founder, Eugène Cornuché, more of a theater director than a restaurateur. The rivalry between the beautiful Otero and Liane de Pougy has entered into legend. The former appeared one evening at Maxim's festooned with jewels that she had finessed out of the Grand Duke Nicholas, like so many flags brought back from a victorious Russian campaign. She paraded at length in the Omnibus bar to establish her superiority. But the brilliance of her trophies paled when her rival made an even more spectacular entrance. Liane de Pougy, in a light, simple, white dress that set off her beauty, was followed by none other than her maid, walking three paces behind her, clad in her precious stones and looking like a lavish shop window at Christmas time. The upstart triumphed, and the columns of *Le Figaro*, which carried an account of this civil war, were in tumult.

Several figures contributed to the metamorphosis of Maxim's into a mythological temple. First there was Albert, or *Monsieur* Albert, the "maître d' to princes, and prince of maître d's." From 1931–59, this stickler for custom maintained a list of clients that ran like a *Who's Who* of high society. He sat guests according to strict notions of precedence, from the best tables at the front, to the back of the back room, as if organizing ambassadors for an audience with the king.

Then came the Vaudable dynasty, the father Octave, the son Louis, and his wife, who transformed this restaurant little by little into a business of many parts, on which Pierre Cardin only had to affix his mark. Has this caused Maxim's to lose its soul? Certainly, what was at the hub of Parisian society has become one of the places most frequently visited by busloads of tourists. At the same time, the fashion world continues to flock to private parties held on the same premises. At the heart of the capital, despite the franchise, Maxim's still continues to exert its fascination.

MAXIM'S

The restaurant on rue Royale is reminiscent of a boudoir in its spectacular, muted intimacy. The theory of unity of decoration, so important to the supporters of art nouveau, is expressed here in all its coherence (above). The second-floor bar where sumptuous Parisian parties are still held once a month (facing page).

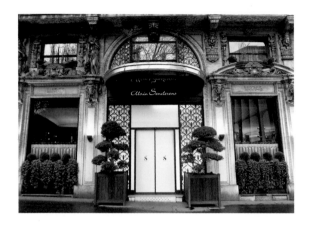

**ALAIN SENDERENS-
LUCAS CARTON**

*Le Senderens was renovated
in 2005 by Noé
Duchaufour-Lawrance,
the designer of Sketch in
London. One might prefer
the discreet coherence
of the 1900 decor to
the post-historic audacity
of the twenty-first century.
Yet the bulk of the protected
historic interior remains,
and is visible to the guests
(above and facing page).*

A little further up rue Royale, on the corner of place de la Madeleine and boulevard Malesherbes, is a much more discreet façade than Maxim's. It conceals another art nouveau jewel, which contrasts in its sobriety and elegance with the exaggerated profusion of its famous neighbor. Lucas Carton is today one of the most sought-after tables in Paris. The reason lies in the presence in the kitchen of Alain Senderens, one of the three musketeers of nouvelle cuisine, with Michel Guérard and Jean and Pierre Troisgros (who count as one). Senderens conquered Paris at the Archestrate in the 1970s, before finding a setting at Lucas Carton to match his cuisine. This wonderful chef has an acute sense of harmony, and has always had an ability to marry the richness of his ingredients with a lightness of preparation, and to complement the finesse of great wines with the complexity of his dishes' flavors.

Harmony is exactly the impression you get when you enter this restaurant. Before passing through the double doors, admire the art nouveau facade by the architect Étienne de Gounevitch. Once over the threshold, prepare to be charmed by the decor, which is bare without being austere, sensuous without being ostentatious. It was probably designed under the direction of the cabinetmaker Louis Majorelle, one of the leading lights of the École de Nancy, which was at the height of its popularity at that time. Between 1904 and 1905, craftsmen such as the sculptor Planel, cabinetmakers from the firm of Lucas & Co., and the bronzesmith Galli set their hands to this concerto in sycamore and maple. The blond tones of the organic motifs produce a soothing effect, as do the bronze wall lights representing female heads emerging from flower stems, framed by three luminous irises. Furnishings of an equally high quality— a clock, a sideboard, a credence table, and a chest—blend with the setting. The original paintings have been replaced by large mirrors, reflecting this gentleness harmoniously.

Lucas Carton has always been a temple of good form, ever since 1732, when a certain Robert Lucas from Great Britain founded the Taverne de Londres in rue Boissy-d'Anglas. In the nineteenth century it became the Taverne Lucas, then the Taverne de France, then from 1925 was transformed into the reputable establishment it has been ever since, by the dedication (and the name) of Francis Carton. Carton had worked at the Café Anglais and the Maison Dorée, and was president of both the Company of Paris Cooks and the World Federation of Cooks, the two concerns apparently being all but identical in that day. The Goncourt brothers were regulars, and Richard Wagner ate there every evening when he was in Paris composing *Die Meistersinger*. The upper echelons of the business world liked to meet in the private rooms on the second floor, which assured the most complete confidentiality thanks to a private entrance from passage de la Madeleine.

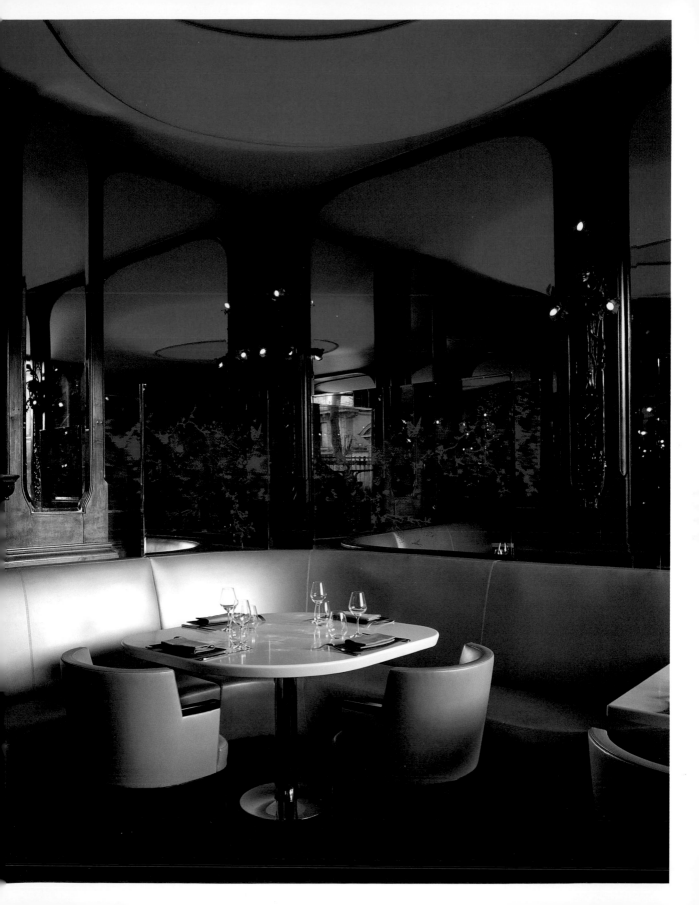

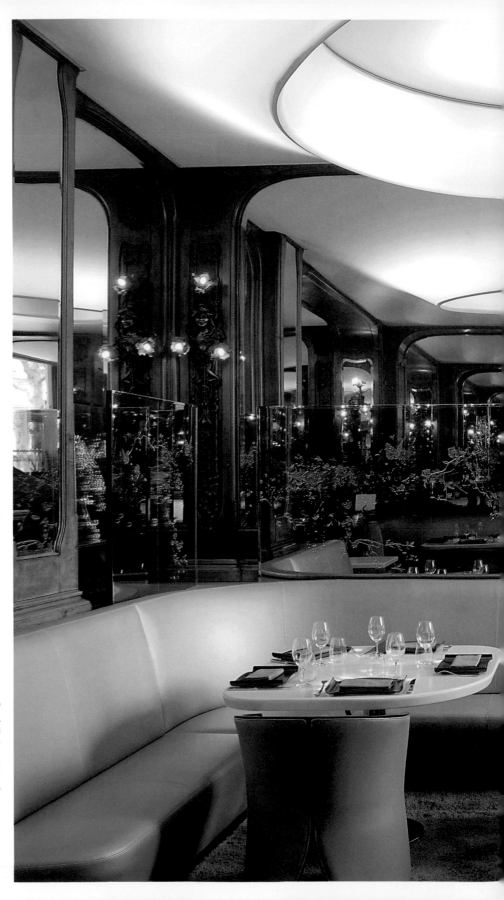

**ALAIN SENDERENS-
LUCAS CARTON**

*The woodwork is listed
as a historic monument,
and has thankfully been
left untouched in the
"new" Lucas Carton.*

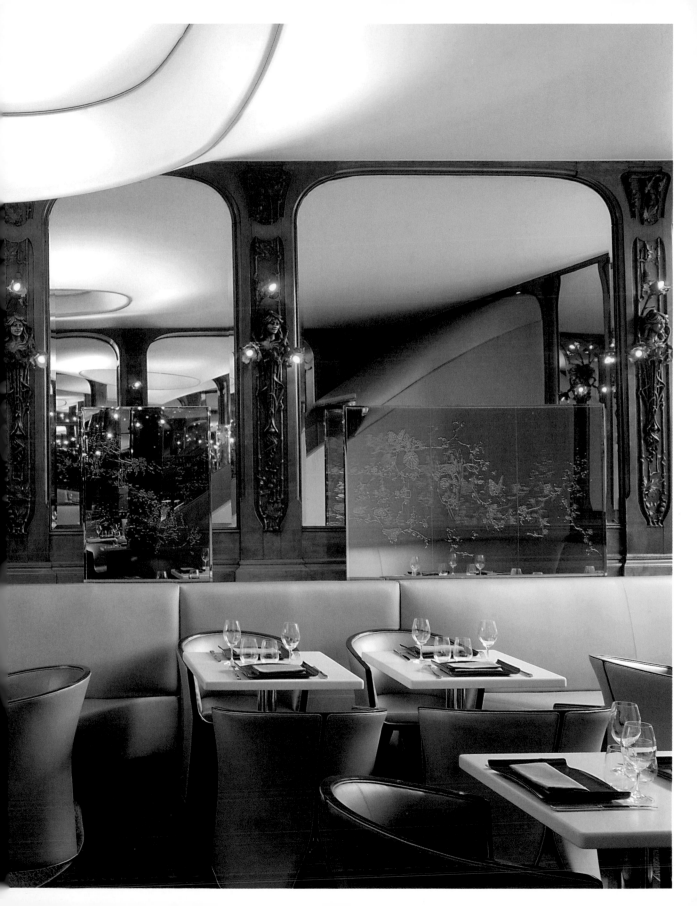

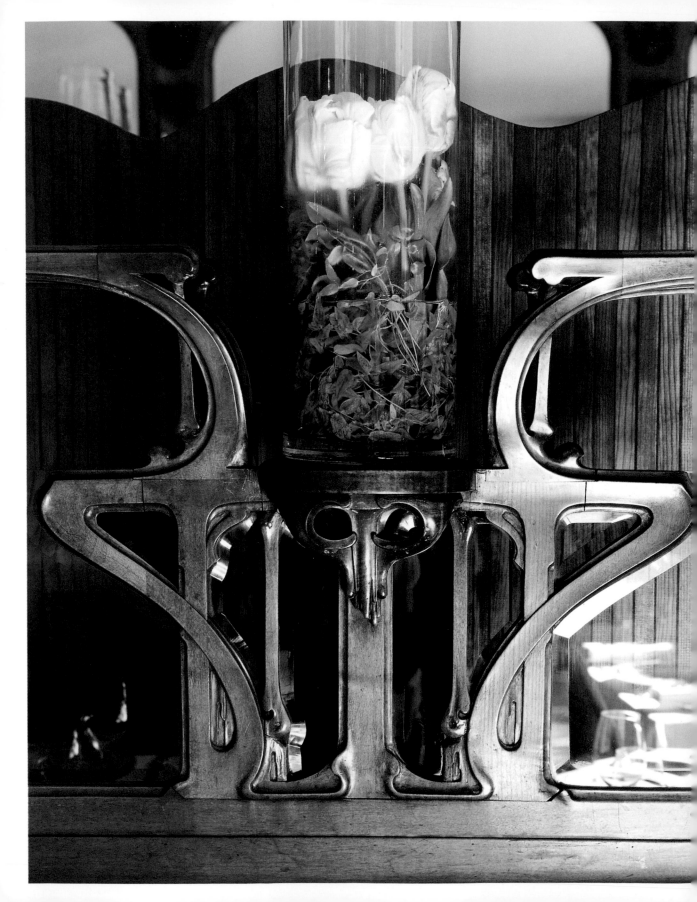

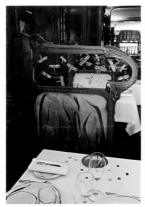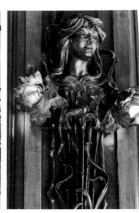

Francis Carton belonged to that class of chefs who have perpetuated the tradition of great French cuisine. His *sole de la Tante Marie*, his lobster gratin, and his woodcock flambé earned him the highest honors from the *Michelin Guide*, on the insistence of customers who were members of the 1912 Club des Cent, which included industrialists, politicians, and publishers with a mission to promote "good old French Cooking." Carton was also honored as *chef attitré*—chef by appointment—to the Third Republic. After the war, Carton's son-in-law and daughter took over the business, but were unable to maintain its standards. It was only in 1985, when Alain Senderens got behind the stove, that the establishment again reached the gastronomic splendor without which the upper echelons of Parisian society cannot imagine doing business. With this clientele from the smartest neighborhoods, and with this setting, Senderens, the quiet revolutionary of nouvelle cuisine, had to find a new angle. This he did, with gusto, by reviving an ancient recipe, *canard Apicius*, named after the great Roman compiler of *De re coquinaria*. But his hallmark is to provide the ideal glass of wine to complement each dish on the menu. In 2005 he decided to "give back" his three Michelin stars and offer simpler fare at more accessible prices. This radical move signaling a break with tradition was topped off the same year by the unveiling of a rejuvenated decor.

Other restaurants have their hallmarks, too. Take Prunier, for example. "Oh, oysters! I've been simply longing for some!" exclaims Albertine, the narrator's beloved in *In Search of Lost Time*, on hearing the cry of a passing oyster seller. Proust's rejoinder to his character's remark is as unexpected as it is significant: "she would find better oysters at Prunier's." It could be an advertising slogan of the time. Prunier's restaurant was started in 1872 from the meeting of two late nineteenth-century archetypes: a cellarman in charge of choosing and bottling wine, and the governess of a mansion. Alfred Prunier was from Normandy. He worked in a bistro on rue Montholon and knew just as much about seafood as he did about wine. Catherine Virion

**ALAIN SENDERENS-
LUCAS CARTON**
*The organic forms of art
nouveau express a discreet
sensuality: flower-women
and fragile dragonflies
engraved on the glass screens
inhabit the mysterious
arabesques of the woodwork
(facing page and above).*

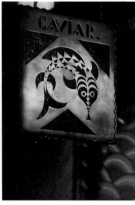

PRUNIER

From within a Russian isba
*theme, Jacques Grange's
panels on the second floor
(above, left) echo the gold
and copper tones of the metal
panels downstairs, which
mark out the different stages
of an evening at Prunier
(above and facing page).*

was from Lorraine, and had worked for the chief rabbi in Paris, then for Princess Dolgorouki. She was a good manager and a cordon-bleu cook. Together, they opened a restaurant—a first step on the social ladder for these two from the provinces—first on rue d'Antin, then on rue Duphot, near the Madeleine, which is the one Proust refers to in his novel. This restaurant still exists today under the name of Goumard, but its art nouveau interior designed by Louis Majorelle has been pretty badly damaged (although the toilets are still much admired, their proportions, apparently, prompting Charles de Gaulle to say that they were "equal to my standing").

Prunier quickly became the supplier of seafood to the smartest buyers in Paris, who included at the time aristocrats from the Faubourg Saint-Germain, English lords, American millionaires, and Russian grand dukes, in more or less equal measure. The Franco–Russian alliance of 1892 launched the Parisian fashion for caviar. Émile Prunier, heir to the restaurant's founders, introduced tanks, in imitation of the Norwegian fish markets, from which live fish could be sold. The typhoid epidemic of 1906 was rumored to have been caused by the consumption of raw oysters; Émile Prunier, as founder of the Oyster Culture Trade Union, helped to get new sanitary procedures adopted to guarantee the quality and harmlessness of the French produce. When the Bolshevik Revolution cut Russia off from the rest of the world, Prunier took steps to ensure an independent supply of caviar, and invested in sturgeon fishing in the Gironde. In 1924 this enterprising man also designed new premises on avenue Victor Hugo in the sixteenth arrondissement, which he intended to be ultra-modern. This was the Prunier-Traktir, *traktir* being an old Russian word for bistro. He died shortly after the restaurant was completed but his work lives on: for all Parisians, the name of Prunier remains unfailingly linked to all that comes from the sea.

The interior at Prunier was the work of Louis-Hippolyte Boileau, often confused with his father Louis-Charles, who designed the department store Bon Marché with Gustave Eiffel. Boileau, an eclectic architect if ever there was one, was also responsible for the wooden-framed pavilions for Togo and Cameroon in the Colonial Exhibition of 1931 in the Bois de Vincennes, which have since been transformed into a Buddhist temple. He also designed the monumental Palais de Chaillot, with Léon Azema and Jacques Carlu. Louis-Hippolyte Boileau was highly regarded by contemporaries for his interiors of bars and restaurants, which marked the beginning of the explosion of art deco into public spaces. The restaurants at the Hôtel Lutétia, the Grand Café de Madrid, and Bon Marché are examples of his work. His masterpiece, however, remains Prunier's restaurant, where he headed a team of leading artists and craftsmen: the artist Léon Carrière, the glass engraver Paul Binet, the sculptor Pierre Le Bourgeois, the leather engraver Alexeï Brodowitz, and the mosaicist Auguste Labouret.

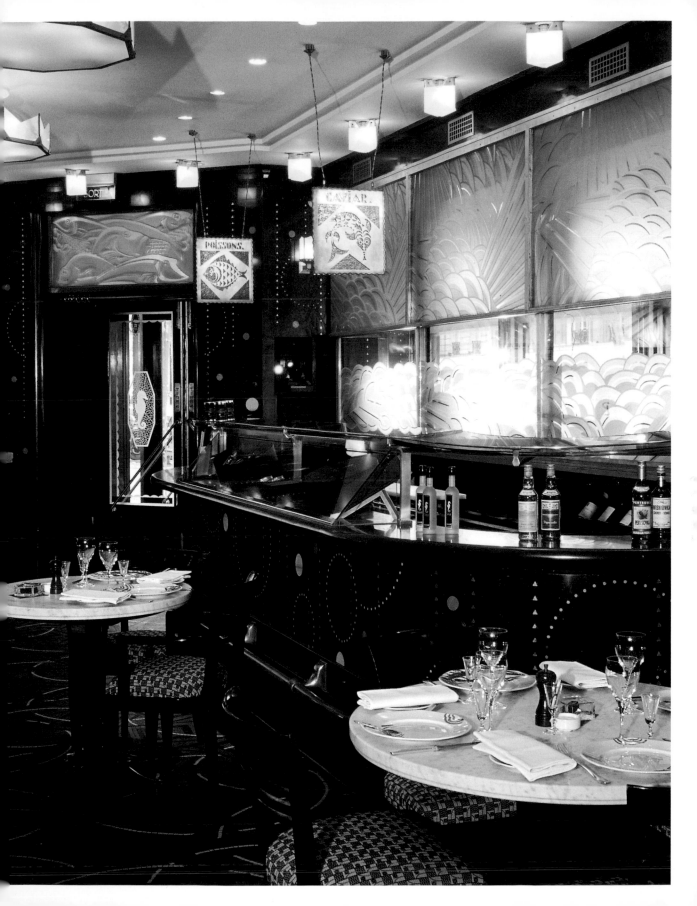

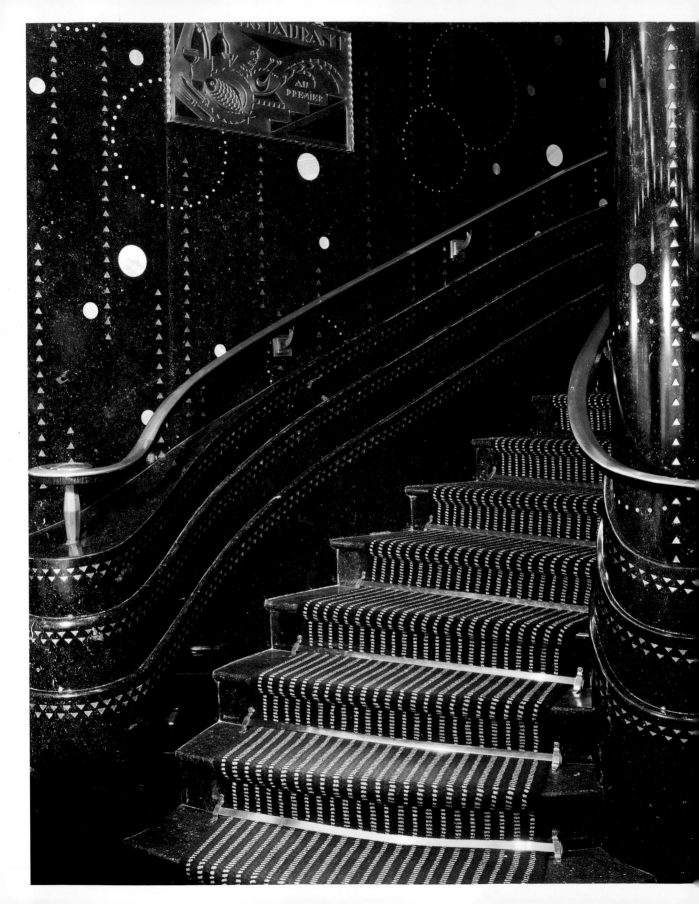

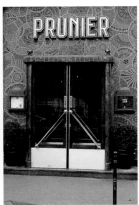

The latter's facade is enticing: a precursor of block stained-glass work set in cement, seen more often in religious settings. Here it illustrates the theme of the sea in blue-green tones, picked out with very art deco geometrical hoops. Inside, the marine atmosphere is to be found in the floor, punctuated with white lozenges encrusted in black marble, and in gold circle motifs on the walls, which evoke the play of champagne bubbles. Inlaid onyx and glass give the mosaics an oriental feel. Pleasingly oversimplified panels by Pierre Le Bourgeois— golden metal openwork on wood—mark out the different stages leading from the bar to your table, like so many stations. Glass engravings with geometric motifs reminiscent of waves give an ethereal character to the whole interior. On the tables, the octagonal plates, designed with controlled abstraction by the painter Mathurin Méheut in 1932, evoke fantastical views of Brittany. Some of the original fittings in a period that was already concerned about functional comfort are worthy of note: the heated handrail on the staircase, the natural cooling system for the seafood displayed in the window, and the gallant detail of hooks on the bar for ladies' handbags.

Pierre Bergé, who bought the premises in 2001 (he now has shared ownership with Caviar House), added a room on the first floor decorated by Jacques Grange in the style of a Russian *isba*, the walls and panels covered with gold leaf and bearing sea themes, inspired by Ivan Bilibine's illustrations of Russian folk tales. As an establishment dedicated to the celebration of seafood and caviar, Prunier is a luxury version of another type of restaurant that Paris was first to lay claim to: the brasserie.

PRUNIER

The entrance of Prunier, with its mosaic facade and art deco sign, invites one on a journey where champagne and seafood have their part to play (above). The elegant staircase, with a detail that sums up a whole era: discreet lighting under the handrail (facing page).

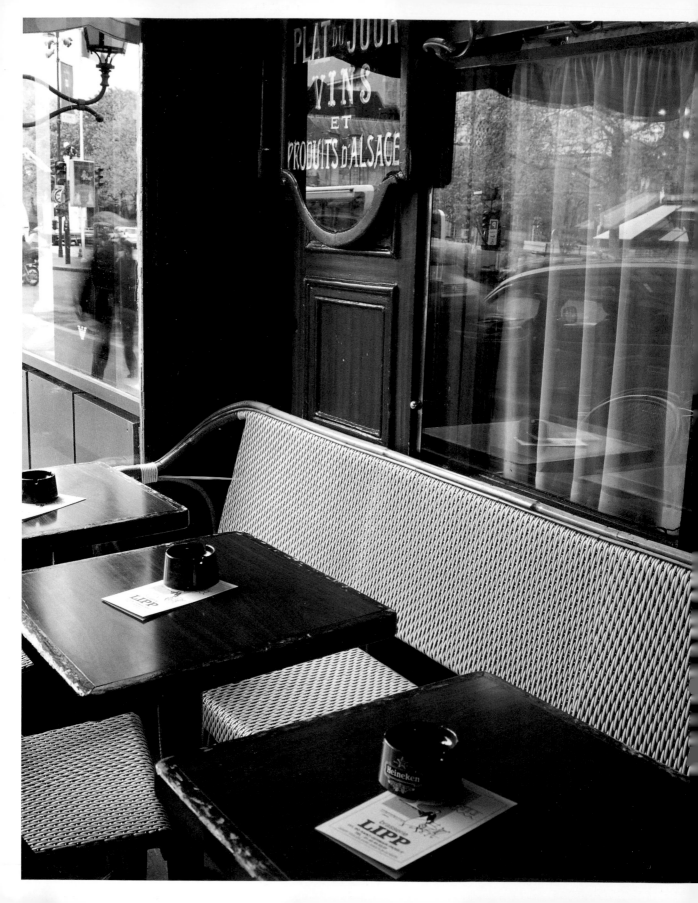

Legendary brasseries

LIPP

The wicker bench on the terrace of the most literary restaurant in Paris (facing page).

BOFINGER

Near Bastille, the buzz in the large main room echoes that of the lively neighborhood (following pages).

The definition of brasserie given by Paul-Émile Littré in his 1877 *Dictionnaire de la langue française*, is a "place where beer is sold by the measure and where there are only benches and wooden tables." Yet at precisely the period when the great lexicographer was compiling his work, refugees were coming to Paris from Alsace, after that province had been annexed by Prussia, and opening establishments called brasseries that exhibited quite a different standard of comfort from that suggested by Littré's definition. The newfound predilection for beer in the capital dates from slightly earlier on, however, before the terrible defeat of the French in the Franco–Prussian war. It was the Paris–Strasbourg railway, inaugurated by Napoleon III on July 17, 1851, which first brought Alsatian businessmen into the capital in number, and with them came the firm intention of offering the Parisian public a type of rapid refreshment hitherto unseen: sauerkraut and a glass of beer. Writers and artists such as Baudelaire, Corot, and Courbet practically lived in these popular and noisy places, where the city came as never before to show itself off.

The first beer pump was an Alsatian idea, and was installed in Paris in 1864 by Frédéric Bofinger in his brand new brasserie at the Bastille. The invention revolutionized the selling of beer and established it as a regular beverage amongst the working classes. The prospect of being served by young and pretty barmaids did no harm either: the *brasseries à femmes*— some of which tipped over into prostitution—were places where one could smoke, read the paper, and relax in a permissive atmosphere (which the temperance leagues were quick to condemn). Édouard Manet conveyed the joyous and sensual atmosphere of these places in a series of paintings and drawings begun in 1875.

Yet beer-drinking was still slow to gain popularity in Paris. Back in 1718, the German traveler Joachim Christoph Nemeitz had complained that the beer in Paris was unhealthy. "Hops," he wrote, "are often replaced by bitter herbs or by ox gall." But by the late nineteenth century, beer was definitely conquering the capital. The phylloxera epidemic had damaged the country's vineyards and made wine scarce and expensive. Also, the mere act of buying beer allowed Parisians to express a patriotic solidarity with the annexed province of Alsace. The authorities even looked on this low-alcohol drink benignly, as being much less harmful than the devastating absinthe. In a country of heavy drinkers, it was better that people become drunk on beer than on eau-de-vie or on its aniseed-flavored substitute. Everything conspired to give the brasseries a firm footing in the Parisian landscape, and they have never lost it.

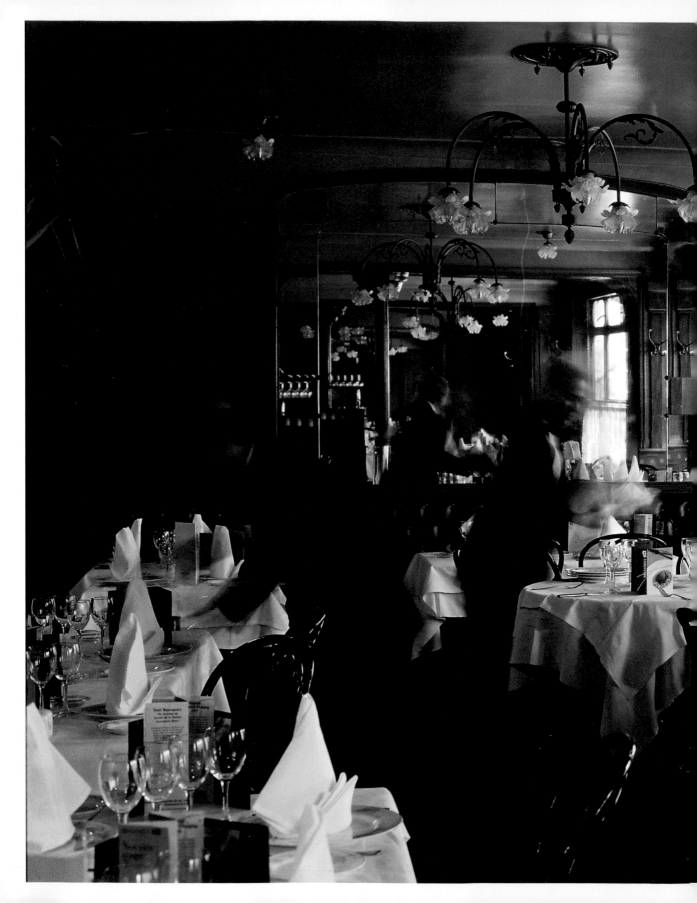

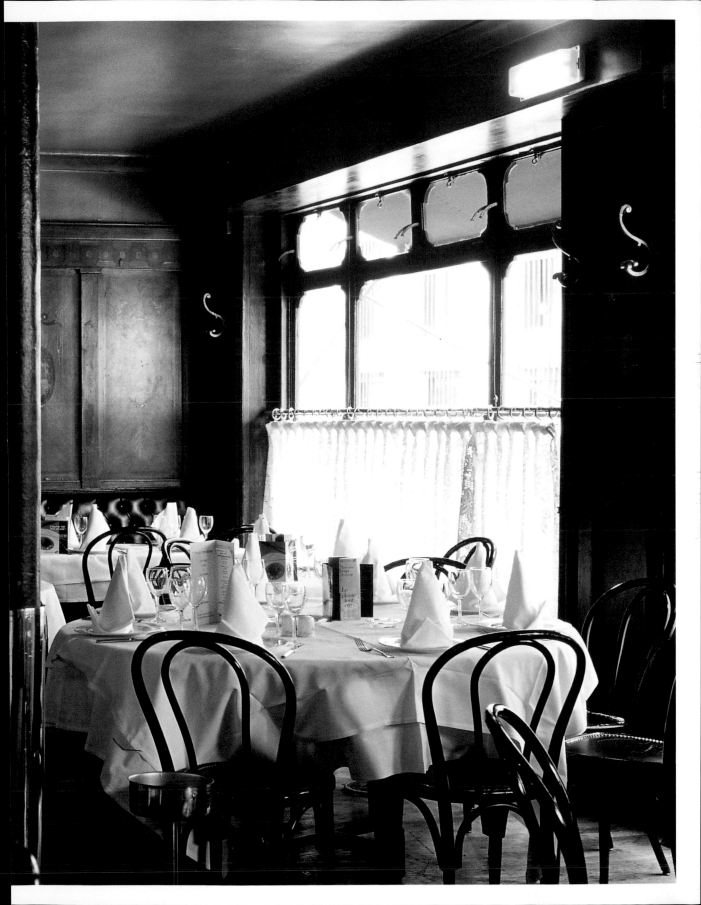

*Art almost as far as
the restrooms. Brasseries
do not do things by halves
when it comes to decor:
the public of the time
wanted their money's worth
(below and facing page).*

On the right bank of the Seine, near the Faubourg Saint-Antoine, Bofinger has, over its one-hundred-and-fifty-year life, embodied the spirit of the political left. This has always been a politically active part of Paris, ever since the storming of the Bastille on July 14, 1789. Today, place de la Bastille and rue de La Roquette, the area surrounding it, are among the more bohemian parts of Paris, inhabited by artists converting old furniture-makers' studios into loft apartments. Bofinger is one of their favorite meeting points; it owes much of its character to its local residents. One finds more true Parisians per table than tourists out on the town.

The reputation as a "left-wing" brasserie is largely due to the assiduous patronage of the famous French politician Édouard Herriot. This great figure was as well known in the Soviet Union as in the United States—he met both Stalin and Franklin D. Roosevelt in the 1930s. When staying in Paris, he loved to repair to this plebeian atmosphere, and hold political meetings there. Édouard Herriot formed the Cartel des Gauches, the progressive political coalition that governed France from 1924–27 and from 1932–36 in room no. 9 on the first floor of Bofinger. The place has hardly changed; one can easily imagine that meeting of goateed sages, shoveling down the sauerkraut and beer and shrewdly reshaping the world. A great deal of politics at that time was conducted at the café-bar of the National Assembly, but more still on the benches at Bofinger's. Later, in 1981, after the victory of the Union de la Gauche, François Mitterrand sat on the same benches with his minister of culture, Jack Lang, and, realizing that the interior was not officially protected, took the decision to have it listed as a *lieu de mémoire*—a place of memory.

In fact, Bofinger has been connected with politics since it started. It is situated—as are so many brasseries—not far from a train station, one that has now disappeared, the Gare de la Bastille. It is also not far from two other important termini, the Gare de Lyon and the Gare d'Austerlitz, which are in effect the gateways to the southwest and southeast of France. The parliamentary representatives and senators, coming up from their districts to attend the National Assembly, meet there almost as a matter of course. Especially since the modest premises at 5 rue de la Bastille, once distinguished only by the generosity of the beer pump, were enlarged in 1919. Frédéric Bofinger's successors, his son-in-law Albert Bruneau, and Louis Barraud, bought nos. 3 and 7 on either side and began the process of renovation and improvement. The decor we see today dates from this period. It embodies the spirit of the Parisian brasserie: a happy mix of bench seats in buttoned leather, as if from a gentleman's club, Thonet bentwood chairs, and paneled mirrors surrounded with delicate blind arcades. The retrospective style after

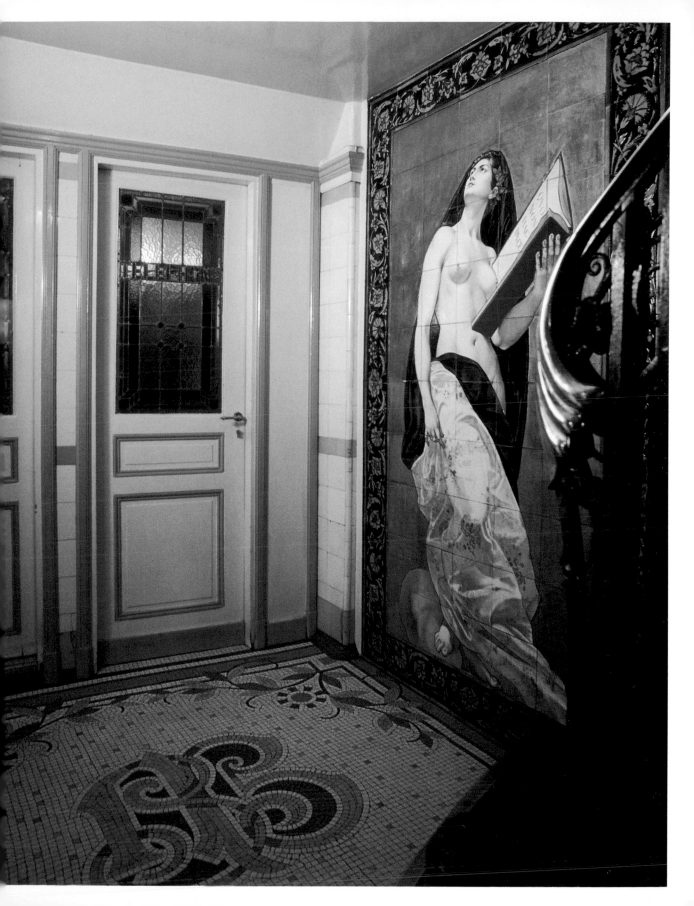

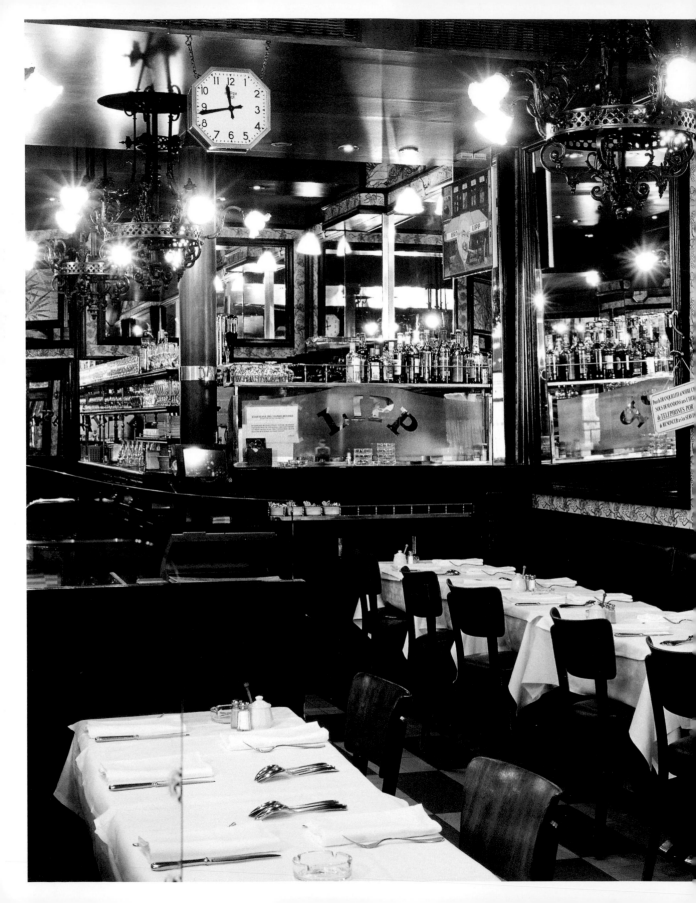

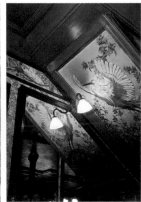
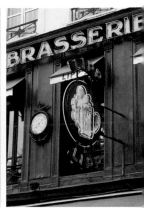

the disaster of World War I seems to want to merge art nouveau with the later Belle Époque. The cupola dominating the large main room is decorated with floral motifs, which combine with the greenery on the ceramic vases and the white napkins on the tables to give a pastoral look, almost as if one were eating at a large inn. The sign at the entrance, depicting two figures in Alsatian folk costume, and the decoration in the room above, are by the artist Hansi and date from 1930. In a naive and fresh style, they evoke the idealized picture of Alsace that Paris wanted to believe at the time.

Now under the ownership of the Groupe Flo, which controls the majority of Paris' brasseries, Bofinger is known and appreciated for its oyster display, its traditional choucroute (sauerkraut), and an atmosphere which owes a lot to the regular Parisian clientele who are attached to this legendary establishment.

It was in some ways inevitable that the brasserie started by another Alsatian, Léonard Lipp, in Saint-Germain-des-Prés in 1880, should become the intellectual heart of Paris. As the Brasserie des Bords du Rhin was starting up, the main publishers of contemporary French literature—Flammarion, Gallimard, Grasset, Le Mercure de France, and others—were moving into the same neighborhood. The proximity of the major publishing houses quickly made the Brasserie Lipp a meeting place for writers and, following close on their heels, politicians (who typically in France undergo a struggle at some point in their lives with a repressed desire to become authors). Paris is in the center of France, and the Paris literati tend to consider themselves to be the center of the city. Little wonder then that Léon-Paul Fargue summed up the function of Lipp over the twentieth century like this: "Lipp is without a doubt one of those places, perhaps the only place, where one can get, for the price of a glass of beer, a complete and accurate political or intellectual summary of the day." Fargue wrote these lines in *Le Piéton*

LIPP

Beneath the appearance of a simple brasserie, Lipp is a labyrinth of rank and reputation, where every table occupies a particular position in the hierarchy of the Parisian social elite (facing page). The beer glass on the shop front and the notice prohibiting the feeding of dogs are a reminder that Lipp, too, was once a working-class establishment (above).

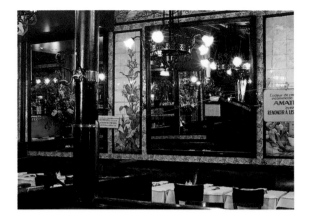

LIPP

*The "right side" of Lipp,
where one goes to be seen
(above). The waiters are
numbered in order of
seniority,* un *(one) being the
one who has been there
longest (facing page).*

de Paris in 1932, but they remained true for as long as Saint-Germain-des-Prés retained its monopoly over French publishing life. To list the figures who have been seen at Lipp at one time or another would be to recite the history of contemporary French literature.

The precise degree of celebrity of guests at Lipp could always be gauged by the rigorous seating customs. Marcellin Cazes, who took over the establishment in 1920, quickly understood the value of a ceremonious approach, as did his son Roger, who ran it until 1987. On December 26, 1926, at a reopening banquet after some renovation work, Marcellin Cazes first put into operation the unwritten rules that would regulate the Brasserie Lipp with the precision of the court of Louis XIV for the next sixty years. Following an unshakable hierarchy, he sent strangers, tourists, and run-of-the-mill diners up to the second floor. For other guests, their importance was directly proportional to the distance of their table from the terrace, and particularly from the front entrance. The B-list were herded into the second room, behind the cash desk, facing the vertiginous staircase that leads to the toilets. VIPs had the honor of being seated in the first room, which was decorated with ceramic panels by Léon Fargue (Léon-Paul Fargue's father) featuring designs of exotic plants and pretty friezes of macaws. The most important position, reserved for great stars and, when bestowed, worth a Prix Goncourt in its own way, was the table situated in the right angle just past the revolving door at the entrance, from where the lucky laureate could acknowledge those coming in, as might a host. The personalities of the affable yet inflexible Cazes contributed greatly to the renown of Lipp. They treated their role as chamberlains of the Paris smart set with the utmost seriousness; perhaps only those who have experienced at first hand negotiations for a table with these two potentates can realize just how important they judged their function to be.

The last twenty years have been less glorious for Lipp. Saint-Germain-des-Prés has had its literary day: several of the most important publishers have moved elsewhere, and the neighborhood has become distinctly gentrified. But loyal customers still come back to sample the unchanging classics on the menu: *bœuf gros sel*, poached haddock in *beurre blanc*, and a chateaubriand steak and fries which, for us, stands as the best in Paris—doubtless due to our childhood memories.

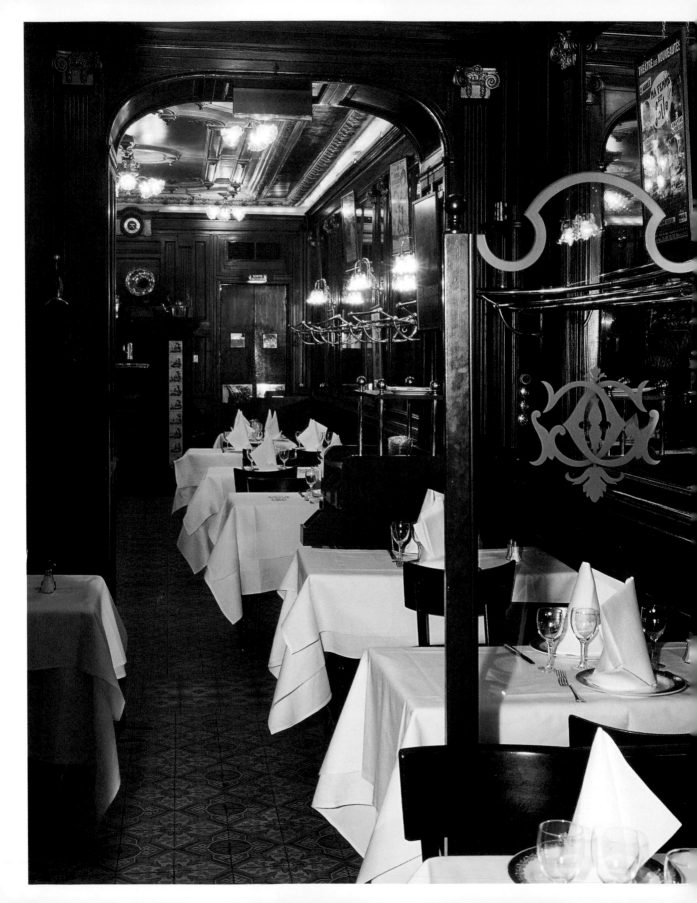

The Alsatians were not the only ones to inspire Parisian restaurant owners. The British and the Americans also influenced the Parisian scene. The English bar is a typically French concept. Parisian society has regularly been seized by Anglomania since the eighteenth century. In the 1880s, despite the colonial rivalry between the two powers, this feeling reached its height and was widely manifested in society, from elegant gentlemen's fashions to the adoption of "tea time." English bars flourished, and it was no accident that one of the first to open in Paris, in 1878, was located near the stock exchange, La Bourse. The top traders were quick to become regulars at Gallopin, and were followed there by aspiring brokers and dealers from the trading pit. English words etched on the front windows advertise "American Drinks" and a "Luncheon Bar." The gold letters running above proclaim, again in English, "Stock Exchange Luncheon Bar," leaving no doubt as to the establishment's intended function.

Gustave Gallopin married an English heiress, a member of the Wyborn family, who had made their fortune from grocery outlets. He started a fashion for cocktails, and served beer in small silver tankards (*gallopins*, named after himself) which are still in use today. For many years a large tin bath filled with water, ice, and bottles of champagne was kept at the ready to celebrate outstanding deals on the exchange. The current decor dates from 1886: the date is painted on the ceiling. The large bar and the Victorian-style paneling in all the rooms are made of Cuban mahogany and were supplied directly from London. The ceiling and wall lights, with their tulip-shaped glass shades, were worked out of copper by Parisian craftsmen, but seem to put the finishing touches to a very coherent look of Englishness. For the Exposition Universelle in 1900, Gustave Gallopin partitioned off the back room with a wall of opaline, decorated with art nouveau flowers and branches in translucent enamel. The design is reflected infinitely by a double-mirror effect. In the summertime, this glass partition slides back to reveal a small garden. Despite the many owners who have filed through one after the other over the decades, Gallopin has been preserved in its original state. The stock exchange has long since left the neighborhood, but regular business customers still appreciate the traditional menu—seafood dishes, *andouillette de Troyes* ("5A" grade, the best), or the chateaubriand with fresh green beans—and above all, the unchanging interior, a reminder for posterity of the financial trading quarter that Paris once had.

GALLOPIN

Dabblers in the stock exchange used to crowd into the English bar at Gallopin (facing page) to exchange hot tips.
It remained a rendezvous for investors until the 1980s, when the Paris Bourse went completely electronic.
The back room with its pretty 1900 glass partition (below).
The acid-etched windows bear the ornamented initials of the proprietor, and modish English slogans (following pages).

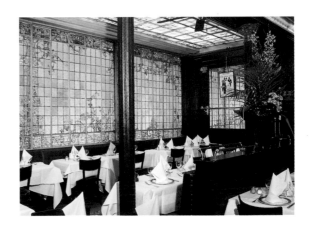

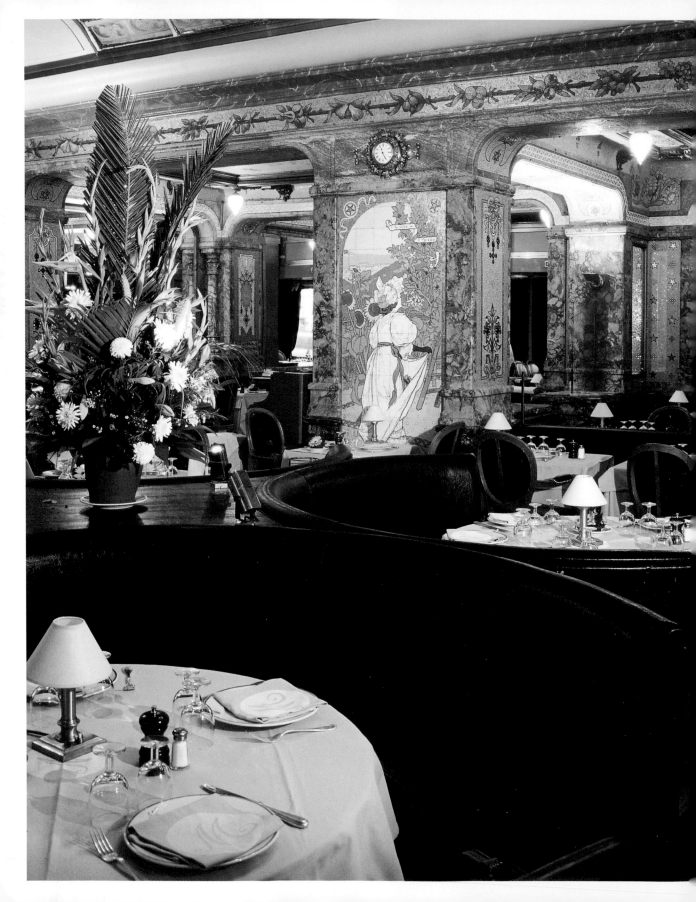

On the Right Bank, like Gallopin, and opposite the Gare Saint-Lazare, Brasserie Mollard has not had the glamorous history of Lipp, but it is worth a detour to see. First of all, it is one of the only large, historic brasseries in Paris not to be owned by the Groupe Flo. The pristine original interior makes it one of the most beautiful examples of the Parisian modern style. And it has, at least in part, preserved its original function: to refresh the hurried traveler before he embarks upon the formidable adventure of a railway journey.

Interestingly, the proprietors who first hung their sign here in 1865 were not from Alsace, but Savoie, a Monsieur and Madame Mollard. They were given a very cool reception by the Alsatian community in Paris. A contemporary competitor set up only two doors away, and is still there today: the Brasserie Jacqueminot Graff, better known as "Au Roi de la Bière." Here, everything—the gabled facade, with its alternating brick and half-timbers, the sculpted decoration of tankards on tables and a stork above its nest, and above all, at the center of the composition, the figure of Gambrinus, the folk hero of northern and eastern Europe (who is said to have invented beer after making a pact with the devil)—is supposed to suggest (in a rather kitsch way) a typical Alsace house, at least as it might be imagined by Parisians. By contrast, the Mollards renovated their premises in 1895, bringing the mosaic-setter Enrico Bichi over from Italy, and giving overall control of the work to Édouard Niermans, the art nouveau architect. Niermans' later work includes the Rumpelmeyer tearooms on rue de Rivoli (now Angelina) and the Hôtel Negresco in Nice. The ceramic panels, made at Sarreguemines in the east of France, depict towns reached from Saint-Lazare—Deauville, Saint-Germain-en-Laye, Ville d'Avray—as well as the station itself. And of course there is the obligatory allegory of France's lost provinces: Alsace and Lorraine. One other picture is worthy of note in passing: it represents an orgy. A reminder of how, although this was just a place of transit for many, the atmosphere could become steamy for the regulars. The original wall decorations were hidden behind paint and tall mirrors in 1920, and thus miraculously preserved. They only emerged again in 1965,

MOLLARD

The mosaics at Mollard give this brasserie the feel of a Byzantine basilica, dedicated to pleasure (facing page and above).

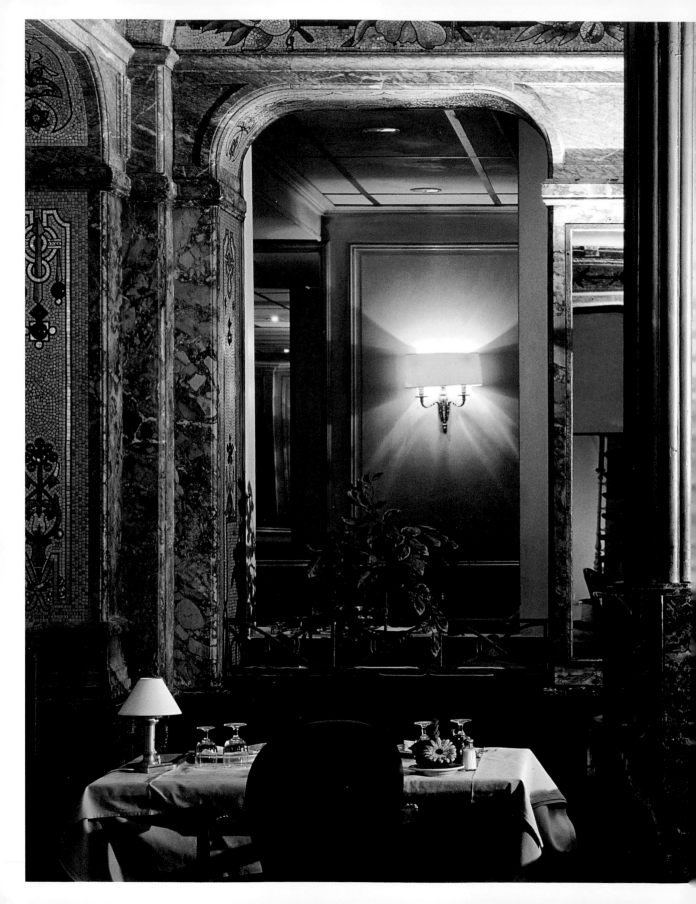

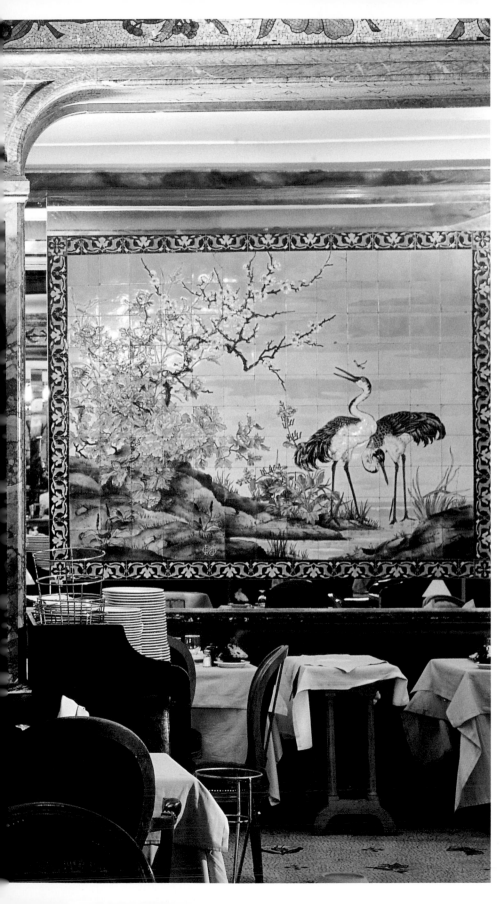

MOLLARD

*The stork fresco is less
"remember Alsace" than
"imagine Japan," very much
in the spirit of the 1900s.*

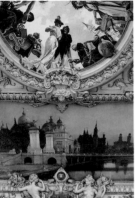
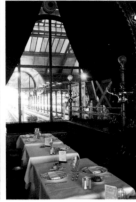
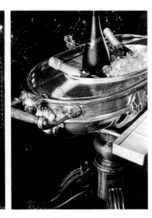

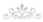

LE TRAIN BLEU

There was a time when restaurants were cathedrals. The station buffet at the Gare de Lyon looks, in its own way, like the sacristy of Saint Peter's in Rome: gilt, stucco work, huge paintings on the ceiling and walls. And the traveler is treated like a monsignor (above, facing and following pages).

at the behest of the new proprietors, giving the Brasserie Mollard a freshness that is a great part of its charm. It remains busy, especially at midday with office workers from the surrounding businesses. In the evenings, travelers still break their journey here, while other interested parties are drawn by the authenticity of the place. Mollard serves characteristic brasserie fare. The seafood platters are particularly impressive, the excellent quality due to ingredients picked directly from seawater tanks on the premises. The Brasserie Mollard has been a listed building since 1989.

Of course the rapid development of the brasserie in Paris is linked to the expansion of the railways. And from this point of view, the inauguration at the Gare de Lyon of Le Train Bleu on April 7, 1901, during the Exposition Universelle, marks a kind of apotheosis. Some distinguished artists were involved in its creation, but what really marks out Le Train Bleu is the sheer excess of decoration. The Paris–Lyon–Marseille railway company clearly intended to make this a modern cathedral, dedicated to the celebration of the most up-to-date means of transport of the time. Their success could not be more vividly apparent.

The first impression, on pushing through the revolving doors from the station, is one of drowning in the exuberance of the sculpted plasterwork gleaming from the walls and ceilings. Then one notices the proportions of the main room: 85 feet (26 meters) long, with a ceiling of almost 40 feet (11 meters), lit by two superb crystal chandeliers. Wide windows, centered in archways, look directly out onto the street. Finally the eye settles on the frescoes that occupy all the remaining space available: the ceilings, the walls, and the spandrels between the arches. They depict landscapes from the Alps, the south of France, Algeria, and Tunisia, as well as the three principal cities on the line, Paris, Lyon, and Marseille. To the right of this great room is another, the Salle Dorée, or Golden Room, almost as big and just as richly decorated. To the left are two more modestly proportioned dining areas that evoke Tunisia and Algeria

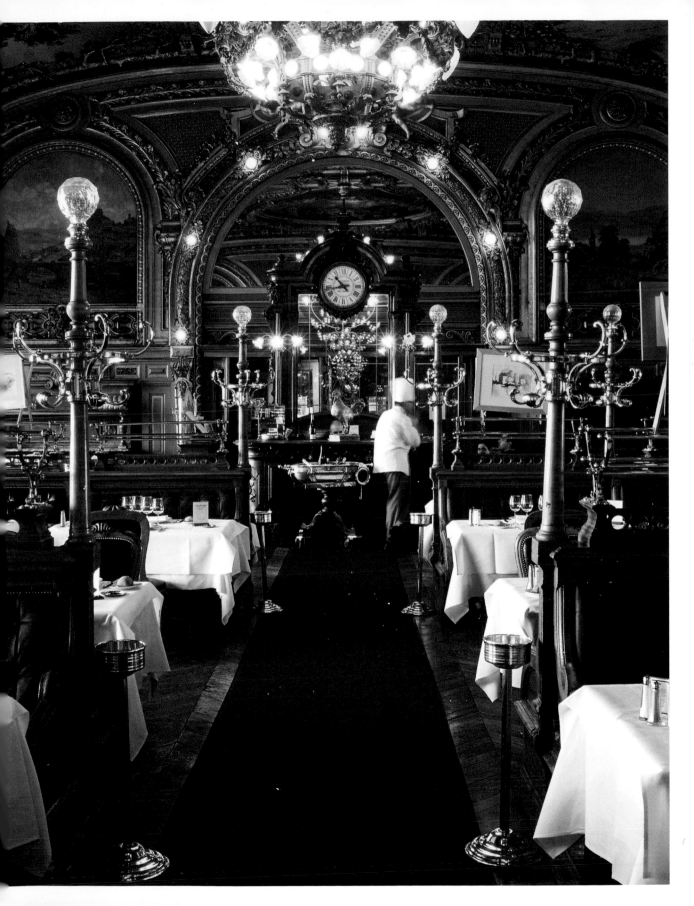

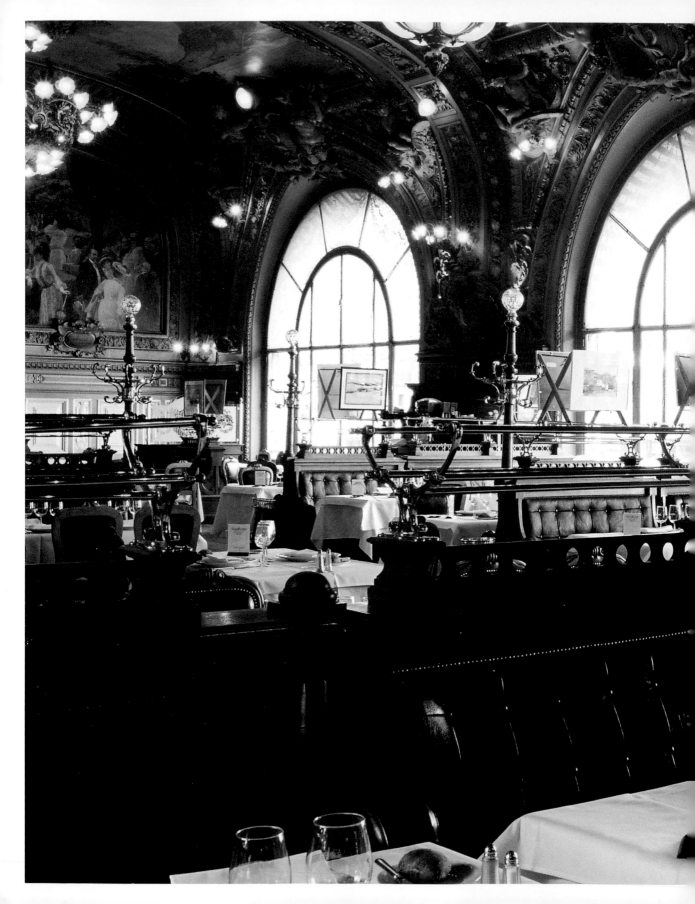

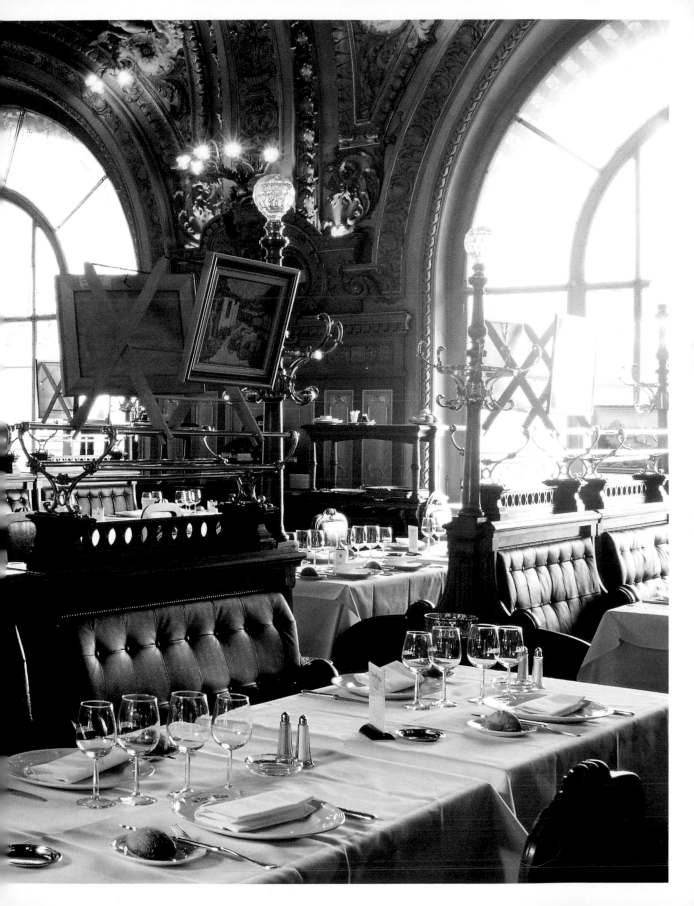

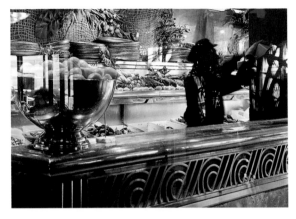

LA COUPOLE

*The oyster display (above).
At La Coupole, local artists
are still invited to submit
their works for temporary
exhibition in the explosive
hubbub of this immense
former warehouse
(facing page).*

respectively, the ceilings and walls ornamented with arabesques of a vaguely eastern style. Critics at the time made fun of this decorative profusion, dubbing it the "annual trade fair for landscape gardeners." But even if the undeniably pretentious style is not your cup of tea, you cannot but gasp at the pure indulgence of the site and the overall effect. Thirty painters took part in the collective composition, including Guillaume Dubuffe and Gaston Casimir Saint-Pierre, official celebrities of the École des Beaux-Arts at the time. Numerous sculptors, plasterers, and gilders also participated in what was intended as an innocent celebration of travel, infused with all the promotional optimism of the Belle Époque.

The kitchens, while not without merit, were never quite a match for the abundant decorative richness. But who really comes to Le Train Bleu for the food? The restaurant was threatened with demolition before being listed as a historic monument in 1972 by André Malraux, then minister of culture. The frescoes were restored and cleaned, to the delight of the prospective passengers.

When the managers of the Café Dôme, René Layon and Ernest Fraux, decided in 1927 to buy a large coal and wood depot opposite their establishment, the proximity of a station—the Gare Montparnasse—was once more a factor. This was no ordinary ambition: the partners aimed to use the 11,000 square feet (1,000 square meters) of space to create the largest brasserie in Paris: La Coupole. But a stronger motivation for such a large-scale project was the effervescence of the Montparnasse area itself. Over the 1920s, Rodin's enigmatic statue of Balzac on carrefour Vavin had watched a huge influx of artists and writers. The surrealists made it their headquarters, as did the Lost Generation of the first American exiles in the capital, from Ernest Hemingway and Ezra Pound to Anaïs Nin and Henry Miller. Pretty girls were in plentiful supply as models or muses: Kiki de Montparnasse, Youki Desnos, and Gala Éluard, who ended up with Dalí. The leading lights of avant-garde literature, Aragon, Antonin Artaud, André Breton, Jean Cocteau, and René Daumal, led their own perpetual *grand jeu*, making and breaking friendships with a vengeance. Montparnasse overflowed with energy and ebullience; La Coupole was to galvanize this vitality simply by offering it a space that was big enough to accommodate it.

The premises would effectively be both a brasserie and a café, and would also have a dance floor in the basement. When it opened, over four hundred staff were employed. The dimensions and the flexibility of La Coupole marked the beginning of a new era. By leaving behind the standard references to Alsace, beer, traveling and railways, the brasserie could become a truly Parisian concept. To support the immense dining area, thirty-two pillars were

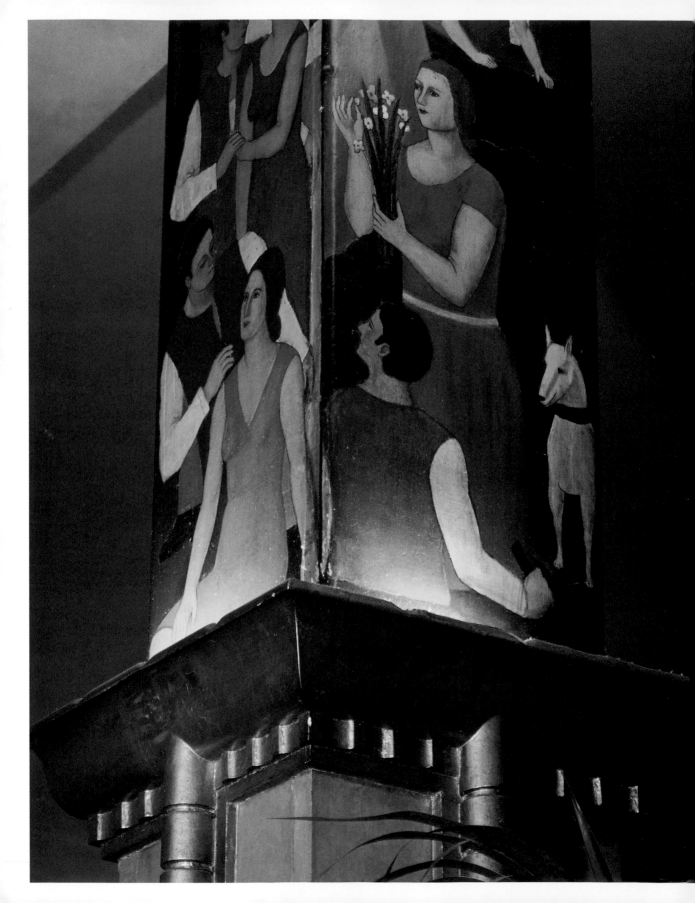

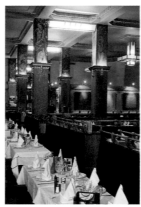
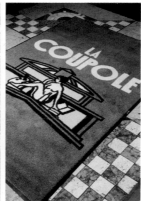

needed. The proprietors of La Coupole asked local painters to decorate them: some are the work of Fernand Léger, others are by Marie Vassilieff from the Russian Academy in Paris, or Moise Kisling, one of the most prominent representatives of the Parisian School of painting. Today it is difficult to tell which pillar belongs to which artist, but in the absence of any precise attribution, this aspect of the decoration of La Coupole stands as a unique expression of the party spirit that prevailed in Montparnasse at the time. And that spirit has survived: Montparnasse and La Coupole still attract intellectuals and artists. In the 1960s, a clique of young film actors and musicians formed the "bande de La Coupole," pioneers of the Parisian underground. In 2008, the frescoes on the establishment's dome, untouched until that point, were repainted by four internationally renowned contemporary artists: France's Carole Benzaken towards the north of the dome, Morocco's Fouad Bellamine towards the south, China's Xiao Fan towards the east, and Argentina's Ricardo Mosner towards the west. The work of the four artists deals with the dome's original themes of woman, nature, and celebration. La Coupole is so much a part of the mythology of Paris that, despite being taken over by Groupe Flo in 1988 and the food being standardized, the place remains a magnet for all those who love space, noise, and a party atmosphere. Today, the Dancing de la Coupole has reopened its doors to host the renowned *thés dansants*. A former temple of ballroom dancing, the Dancing sets out to bring back the spirit of the Roaring Twenties every Sunday afternoon.

LA COUPOLE

There is a Montparnasse variant of art deco style, of which La Coupole is the prime example, making this brasserie a sanctuary for the spirit of the 1920s (facing page and above).

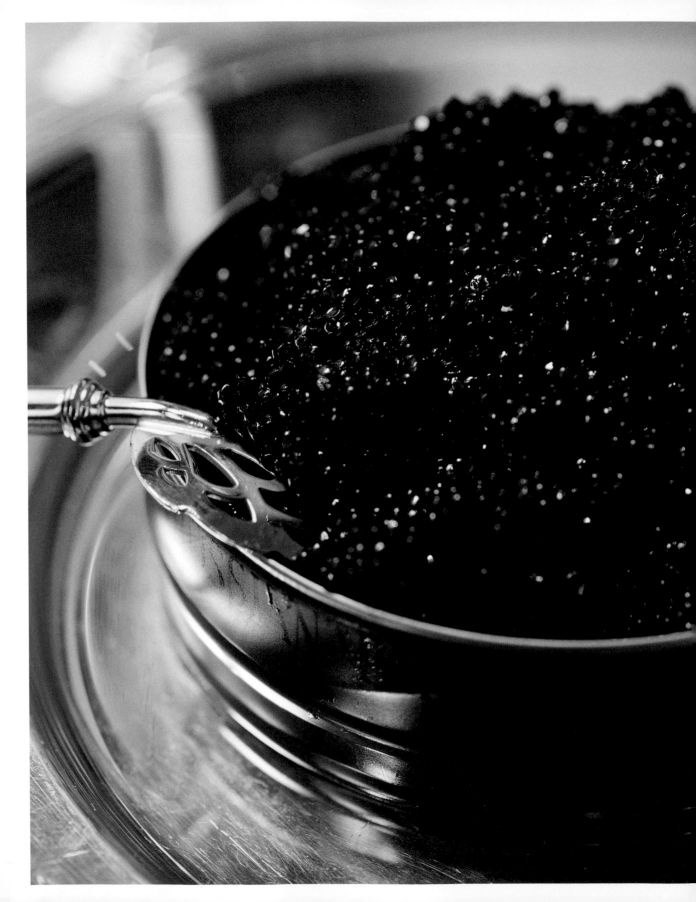

Exceptional products

PETROSSIAN

*There is no need to
introduce Petrossian, famous
worldwide for the caviar
it "invented" in the 1920s,
except to add that it also
offers a fabulous selection
of smoked wild salmon and
eel, salmon roe, foie gras,
and truffles. A paradise
for the fortunate . . .
and the fortuned.*

Can it be said that it was in Paris that caviar, a luxury product par excellence, obtained its title of nobility? For what is caviar, if not a *poutargue* from pressed, salted, and dried mullet roe? It took two Armenian brothers from Russia, Melkoum and Mouchegh Petrossian, to "invent" caviar in the 1920s. Their "invention" was not so much to export a previously unknown comestible but to refine it so that it was acceptable to the sophisticated palates of 1920s Paris society. Until they came along, the sturgeon's roe had been pressed regardless of the variety of fish from which it came. Recognizing that the roe from each species had its own specific taste and color, they distinguished between the different types of sturgeon—Beluga, Ossetra, and Sevruga—and convinced Parisians that caviar should be eaten in a festive atmosphere, preferably accompanied by champagne or vodka. Nowadays it is the Petrossians' nephew Armen who runs the business. His ambition is for caviar to enter the gastronomic pantheon in its own right, which is why in 1999 he opened a restaurant above the famous boutique on rue de la Tour Maubourg. He already had one in New York, but perhaps caviar marries more easily with the cuisine there. Yet the Paris smart set didn't waste time in falling for the dishes that Armen Petrossian and his chef Sebastien Faré, then Roujui Dia, had concocted for them: Petrossian soft-boiled eggs, crispy from their breadcrumb coating, are topped with a mound of caviar to look like a Fabergé egg; fine sturgeon "cigars" are stuffed with caviar to resemble a saltimbocca. Recipes such as these add new dimensions to caviar, and in doing so give a new lease on life to Petrossian's fabled commodity.

TERRES DE TRUFFES

Truffles of every sort and season—winter, summer, spring, and fall—can be found at Terre de Truffes. Parisians can rediscover the "black diamond" in all its guises at this boutique situated near the Madeleine (above and facing page).

Next comes an exceptional product about which Parisians once assumed they already knew all there is to know, but which took a two-man team moving to Paris from the south of France to reveal all of its nuances: the truffle. Clément Bruno and Dominique Saugnac have almost thirty years' experience as proprietor and chef, respectively, at Chez Bruno—a restaurant specializing in the "black diamond"—in Lorgues in the Var region. At the end of 2003 they opened their restaurant-cum-grocery Terre des Truffes on rue Vignon near the Madeleine where truffles are doled out according to the harvest and the seasons, because truffles are not just a winter food. True, the *tuber melanosporum* is the undisputed champion of the genre, rivaled only by its white cousin *tuber borchi*, also known as the *bianchetto d'Alba*. But Terre des Truffes has always been a keen champion of the rights of other truffles to stimulate our nostrils and make their way into the dishes we enjoy. *Tuber magnatum pico* from Piedmont; *tuber aestivum*, the summer truffle; *tuber uncinatum*, the Burgundy truffle; and the winter truffle *tuber mensentericum* prove that these fungi are a year-round phenomenon.

At Terre de Truffes you can buy your truffles fresh or preserved. Fresh truffles need to be brushed under cold water without soaking in it. They can be kept for around a week at the bottom of a refrigerator in a hermetically sealed container lined with a paper towel that should be changed every day. This method will prevent the truffle from oxidizing and losing its flavor. But of course, if there is the slightest doubt as to which you want, why not try some of the delicious dishes that are available either to take out or eat in, such as scrambled eggs with truffles, truffled Brie de Meaux, and even a series of deserts where the complex aroma of truffle is married to a blancmange with apricot jam or a runny chocolate cake.

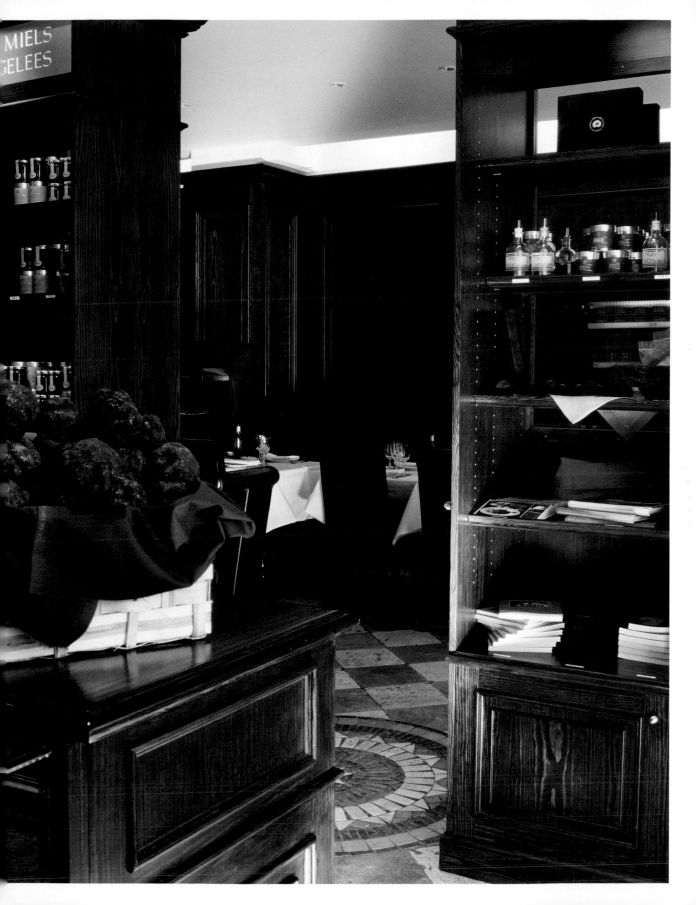

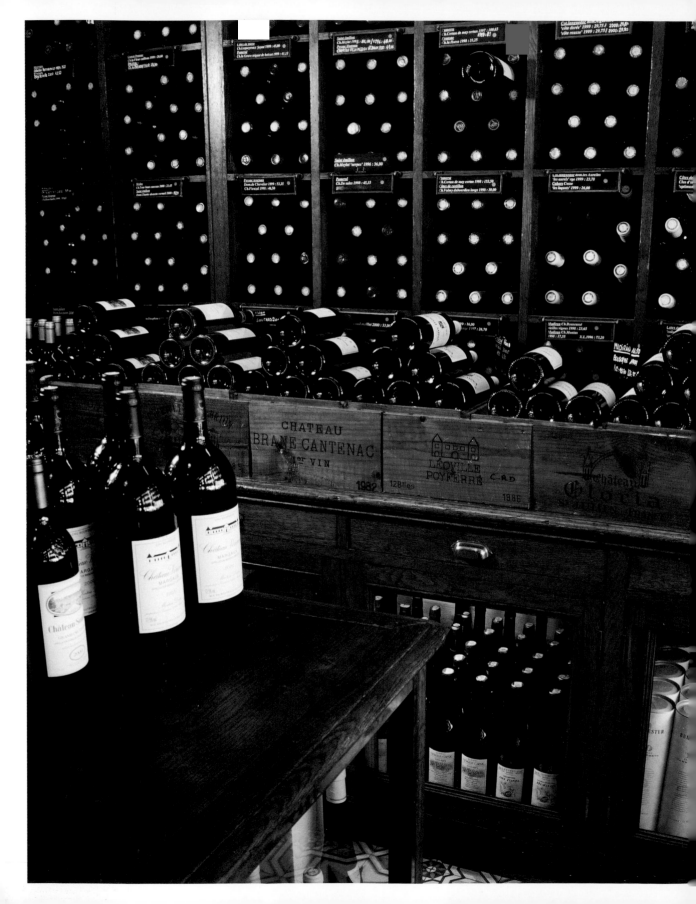

French soil has witnessed the births of the most reputed *grands crus*, and Paris has stepped in by collecting and making available these great wines. Les Caves Augé has been around since 1850. Located on boulevard Haussmann in the heart of bourgeois Paris, this establishment has never had difficulty in finding clients only looking for an excuse to part with money for wedding presents, first communion mementoes, or corporate gifts. One came to—and still comes to—Les Caves Augé for the very finest wines, the best vintages, the chateaus that defy all attempts at categorization, and they are all here: Latour, Haut Brion, Margaux, Romanée Conti, Yquem. With its solid brass ladder, enclosed cash desk, and dark wood shelves, Les Caves Augé resembles nothing more than one of the reading rooms at the National Library, the precious bottles lying in lieu of the weighty tomes that patiently await some erudite scholar to come and leaf through them. Even if Les Caves Augé were nothing other than a repository for these surefire wines, for many it would be worth a visit in its own right, but that alone is not enough to solicit the interest of the true amateurs who are motivated by a desire to share with others their passion for wine in the atmosphere that is so specific to Les Caves Augé. Their passion is not for the establishment wines but for the "dissident" wines, wines that are in some way different. Running Les Caves Augé since 1988, Marc Sibard is the Paris ambassador for these wines and the winemakers who produce them. He represents real winemakers who work their own vines without weeding everything around them, who only use the natural yeasts on the grapes for fermentation and let that fermentation occur naturally, without resorting to heating up the must so as to make it go faster; real winemakers who do not filter or remove the impurities artificially from their wine and use a minimum of sulfur, if they use it at all. And their wines have to be good, because Marc Sibard is unforgiving when it comes to taste. Ask him, and he is happy to give you his list of favorite winemakers, the ones who take risks, whose wines, as he puts it, are not afraid to reveal all: Thierry Cuzelet of Clos Tuboeuf in Cheverny, René Mosse in Anjou, Jérôme

Prévost at Gueux in Champagne, Romaneaux Destezet in Saint Joseph, Bruno Duchêne in Collioure. These producers are only known now to a small cohort interested in these matters, but they are destined to be the great names of tomorrow. In promoting them now, Marc Sibard is continuing a long-established tradition at Les Caves Augé, that of stocking only the very best, regardless of the label. In any case, Sibard believes that a label is only worth the value he puts on it, rather like the art critic who determines the worth of a particular artist. Induction into this inner circle of Les Caves Augé—the outer circle is composed of those who come only for what is on the label—is akin to being welcomed into a religion, and Les Caves Augé has attracted a

LES CAVES AUGÉ
Les Caves Augé on boulevard Haussman (facing page and below), not far from the church of Saint-Augustin, is like a cathedral to wine: the grand crus *are presented on the main altar, the lesser wines in the side chapels.*

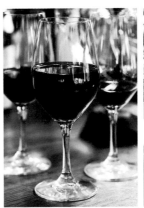

LES CAVES AUGÉ

The interior of Les Caves Augé hasn't changed since 1850. And it still has the same aim: to provide the very best of what France's wine producers have to offer (above and facing page).

following among amateurs looking to share in the discovery of these new growers that for them are the way, the truth, and the light when it comes to wine. Which is somewhat of a pity, because it would be nice if Les Caves Augé could serve as a sort of school for everyone who wants to use their senses of taste and smell to buy "good" wine rather than just wines that stand out by virtue of their label.

In the same way as there are certain bookshops specializing in rare books, lovers of vintage wines can often find what they are looking for by rummaging through the collections belonging to certain dealers in antique wines. De Vinis Illustribus was started in 1994 by Lionel Michelin, a telecoms expert with a passion for old wines. When he first started, the location was secret, accessible by appointment only. It quickly became a pivotal operation in this specialized sector of the wine trade. In his boutique situated behind the Panthéon, Michelin has gradually built up an impressive collection of wines; collectors from around the world call him in search of a Cheval Blanc 1903 or a Romanée Conti 1937. In 2004, he had the opportunity to reopen Les Caves Besse, which date back to the seventeenth century: beneath the spacious boutique lie two levels of magnificent wines cellars which can be booked for private lunches, dinners, and tastings. Lionel Michelin is also happy to supply amateur wine-tasting clubs, or provide a birthday gift for a loved one of a wine from the year they were born. Because there is no doubt that opening an old bottle of wine generates a very special set of emotions.

No introductions are required for Ladurée. Indeed, Ladurée transcends fashion. It has been on the same site on rue Royale since 1862, and Paris's gourmets could probably make their way there blindfolded. One word explains all this: macaroons. Perfected in the early twentieth century by Pierre Desfontaines, the grandson of the founder Ernest Ladurée, this little petit four, by turns moist and dry—two shells made of roughly ground almonds, icing sugar, and egg white held together by a flavorsome ganache—should really be called a

"Ladurée" in memory of its inventor, in the same way as the *madeleine* and the *tarte Tatin*. But there is no such thing as copyrighting a discovery in the world of pastry. Pierre Desfontaine's invention was to enrich a dry cake brought to France by Maria Medici and her Italian cooks, making it what the Americans call a "double-decker" and filling it with a delicious almond paste. It was a stroke of genius that transformed a simple "cookie" into a miniature delicacy as seductive as a Tanagra figurine. Because in a macaroon, everything contributes to the pleasure, starting with the curvaceous shape, both reassuring and tempting. Next, the color, originally subtle, has since taken on every hue of the spectrum in accordance with the flavors concocted by Ladurée's successors. And above all, its size, small, discreet, and yet so appetizing—without a moment's hesitation in one mouthful it is gone—makes it an innocent pleasure par excellence. Such is the secret of the macaroon's success, and the formula hasn't changed in over a century.

After the first store on rue Royale, Ladurée opened a second branch on the Champs-Élysées and a third on rue Bonaparte in the sixth arrondissement to cater to those diehards who couldn't live without their daily dose of macaroons. Over the years, the macaroon has evolved at Ladurée, with summer and winter collections and ever more fanciful, subtle, exotic, and surprising flavors: licorice, Amaretto-soaked cherry, basil and lime, aniseed, mint, Yunnan tea, and salted butter caramel. It was with the turn of the century that the house of Ladurée decided to treat itself to a new look, in the same way as great classics—a Chanel suit or a Vuitton bag—get a facelift from time to time. As a result, the eyes of a whole new generation turned to Ladurée, drawn by its macaroons. While traditionalists will be pleased to know that their old favorites—vanilla, coffee, and chocolate—are still available, unusual colors such as pale pink for the orange blossom macaroon, bright pink for the rose petal one, or black for the licorice flavor—which has now become a classic—are also on offer, while retaining the essence of what macaroons are all about. You may go to Ladurée first and foremost for its macaroons, but alongside this armada of colorful delicacies, it produces a full range of cakes and pastries, each more tantalizing than the next, which follow Ladurée's formula: take a classic that has proven itself over time, and reinvent it. For summer, the *religieuse* is given a coating of violet-blackcurrant, rose-raspberry, or cherry-pistachio. The *Saint-Honoré*, traditionally filled with vanilla pastry cream, also receives a violet-blackcurrant or cherry-pistachio treatment, though its classic crown of whipped cream remains untouched. And of course there are today's inventions, the ones that may or may not stand the test of time. For Valentine's Day, Ladurée concocted a sponge in the shape of a four-leaved clover, each leaf of which was filled with an enticingly

LADURÉE

At Ladurée, macaroons come in all flavors and colors and change with the seasons (facing page). They also sell beautifully packaged gift boxes of fruit jellies, violet-flavored marshmallow, and fine chocolates (below).

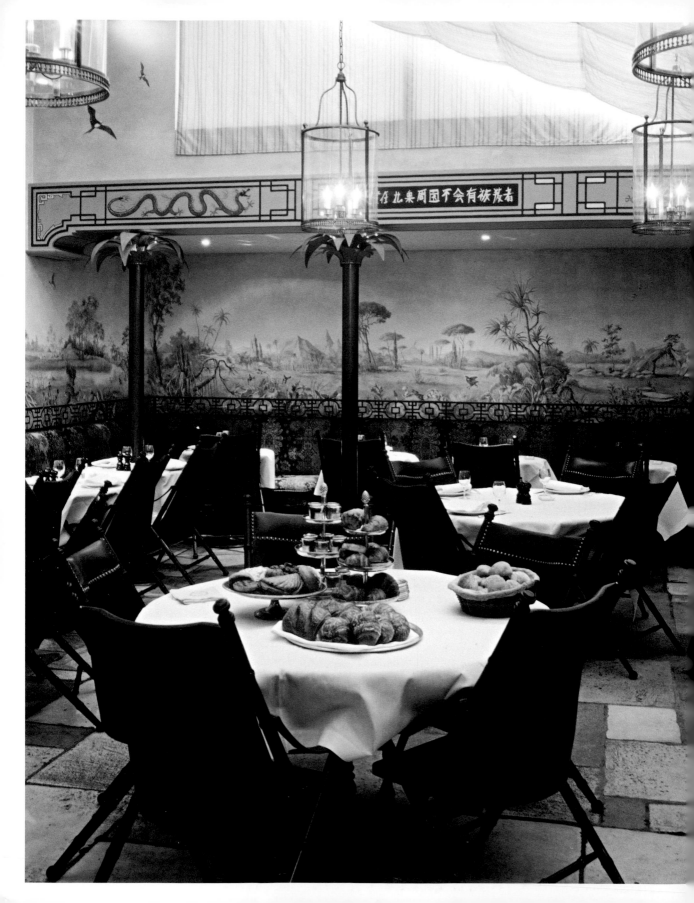

different combination: strawberry-poppy, chocolate-mint, rose-raspberry, and blackcurrant-violet. A reflection of the modern and daring couples who go to Ladurée these days. And to satisfy those diehards who absolutely have to have their chocolate cake, they neutralize the traditional sweetness by marrying chocolate cream with Sarawak pepper and lime zest, and coating it in a Java chocolate icing that highlights the bitterness and acidity so much in vogue these days among serious chocolate lovers. The most important thing is to give pleasure to the customers, and in so doing Ladurée remains faithful to the tradition on which it has built its reputation— always being perfectly in tune with the desires of Paris's most demanding food lovers.

We have mentioned Antonin Carême, who once famously said: "There are five branches of fine art: painting, sculpture, poetry, music, and architecture, whose principal branch is patisserie." This deserves to be taken more seriously than it usually is, because in France patisserie is taken very seriously indeed and the "Paris School," as we have seen, has brought a distinctly French touch to this art form, namely classicism and balance coupled with finesse and attention to detail.

For the Chinese, Japanese, English, Russians, and Arabs, tea has always been a national drink. But what about the French? The French—or rather the Parisian—*salon de thé*, or tearoom, is a bit of a misnomer. In reality it is a place to eat cake, and a visit was generally a pretext for satisfying one's hunger rather than one's thirst. Traditionally, the choice of tea was limited to the most basic Earl Grey, Darjeeling, or Ceylon varieties. But take a look around: scrumptious *babas*, cream puffs, and chocolate éclairs line the trolleys and windows. One is forced to conclude that Parisian tearooms are simply upscale patisseries. Or are they? Although the tradition endures at places such as Angelina on rue de Rivoli and Carette on place du Trocadéro, a new phenomenon has sprung up as Parisians have begun to take tea seriously and treat it in much the same way as they would fine wine. They are learning about the different plantations in Darjeeling, enthuse about green tea, and are fascinated by the complicated hierarchy attached to China tea. Unlike the Japanese, with their tea ceremony, Parisians are not interested in tea as some sort of metaphysical metaphor, nor do they associate it with a particular moment in the day, like the English with afternoon tea or the Russians with their samovars. Their approach—albeit in a more modest fashion—is more like that of the Chinese, anxious to recognize the source of a particular variety, to place it on a hierarchical scale, and to appreciate fully the specific characteristics of a particular tea or

LADURÉE

Ladurée on rue Jacob is the famous pastry shop that invented the macaroon. Whether for a business breakfast or a romantic afternoon snack, any excuse will do to enjoy a visit to this calmly luxurious tearoom (facing page). In the window of the delightful boutique, on the corner of rue Jacob and rue Bonaparte, macaroons are displayed on cubes (above).

a particular grower. Two coinciding phenomena explain this sudden growth of interest in tea. First, the emergence of a genuine French *art du thé*, despite the fact that not a leaf is grown in the country. Second, the emergence of Paris, or rather the choice of Paris by certain Asian tea experts, as the Western outpost for the trade in high-quality teas from the leading markets in Hong Kong, Singapore, and Taipei.

Is there a specifically French way of having tea? If there is, the credit must go to two foreigners, a Dutchman by the name of Richard Bueno, grandson of a plantation owner in Indonesia, and Kitti Cha Sangmanee, an aficionado of tea, as is common in his native Thailand. In the early 1980s, the two men discovered a wholesale tea merchant on rue du Cloître Saint-Merri by the name of Mariage Frères. The firm was run by Marthe Cottin, whose ancestor Henri Mariage had founded the business. Richard Bueno and Kitti Che Sangmanee were awed by the authentically timeless atmosphere of the strictly wholesale store—furniture impregnated with tea dust, old weighing scales, leather drawer pulls. They became friends with Marthe Cottin, who initiated them into the tea trade *à la française* and, considering them her true successors, subsequently sold them the business. Mariage Frères had been trading in teas from the finest gardens and blending them for the European market since the seventeenth century. The new owners kept the original wholesale store, but went one step further by opening a retail boutique on rue du Bourg Tibourg in the Marais neighborhood in 1985. They kept the furniture from the original premises that had so attracted them in the first place: wooden panels, tea chests, and memorabilia. For the first time, Paris had a wide selection of teas—some five hundred of them from thirty-six different countries. Because they knew their customers were likely to be largely ignorant of what they were buying, the partners paid particular attention to educating them, going so far as to produce a brewing chart giving the correct infusion times and temperatures for each variety. Parisians were bowled over by this. For the first time, somebody was talking about tea in a language they understood.

MARIAGE FRÈRES

Mariage Frères was the first Paris tea merchant to display its teas in boxes and give customers the chance to inhale the aromas of their chosen leaves before they make their purchases.

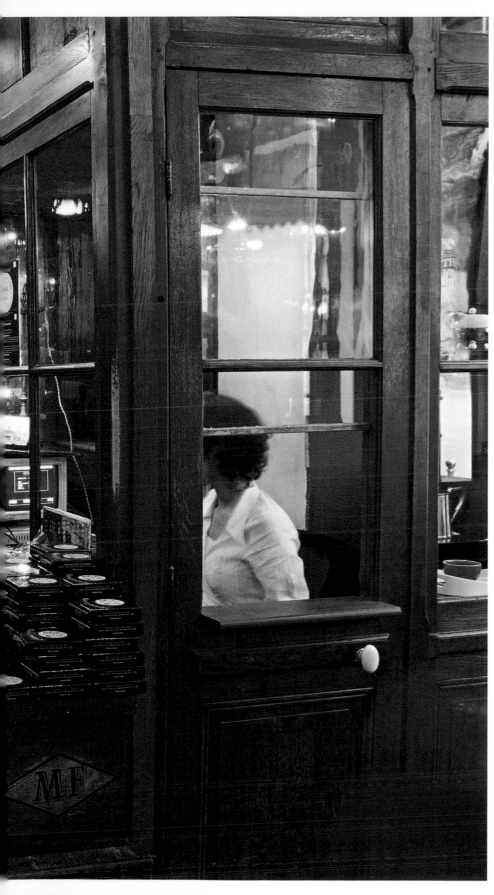

MARIAGE FRÈRES

The Mariage Frères boutique on rue du Bourg Tibourg in the Marais is modeled on the interior of a nineteenth-century tea merchant. Its colonial ambience and heady aromas are integral to the art of tea à la française.

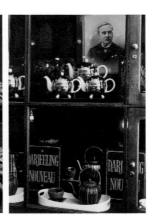

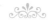

MARIAGE FRÈRES

*You can choose a tea here to
take home, or initiate yourself
into the mysteries of this
beverage in the tearoom
at the back, where all the
blends sold in the boutique
are available for tasting.*

Mariage Frères, guided by its new owners, offered something to a sophisticated clientele that no teabag could match. Mariage Frères classified its five hundred teas into the finest "first flushes," garden teas that come from a distinct region, blended teas that combine different types of tea, and aromatic teas that incorporate spices, flowers, fruits, or roots. In doing this, two distinct skills come into play. The first is akin to that of the vintner, who carefully selects and brings to fruition his wine; the second is that of a perfumer who combines flavors and aromas to produce an original result. The two partners were not content simply to create a pleasant environment around the old-fashioned countertops in their three boutiques. They were also the first to invite their customers to inhale the aroma of the tea directly from the tins in which it is stored, a gesture hitherto unknown in Paris.

As part of their gourmet approach, they have added a tearoom to their boutique on rue du Bourg Tibourg, not a patisserie, but a real dining area where one can eat and drink at any time of the day. In so doing, they have changed the way Paris drinks tea. At the same time they have created a particularly Parisian attitude as to how and where tea should be drunk. No longer is it limited to accompanying cakes and pastries; tea can be consumed with savory dishes as well. Tea has become a possible accompaniment to every meal, from breakfast to dinner, not only an alternative to morning coffee but also to wine. This is not to say that France is on the verge of abandoning wine for tea. Rather that those who appreciate tea now recognize that the same sort of matches can be made between food and a beverage that has a character as universal as wine. Mariage Frères has published a book that contains two hundred original recipes that go well with tea. For that reason alone, it is fair to assert that Mariage Frères invented the "French art of tea." Mariage Frères' unique "French art of tea" has achieved international recognition with the opening of a number of tearooms in Japan, namely in Tokyo, Kyoto, and Kobe.

Traditional Paris

Old-Fashioned Flavors and Atmospheres

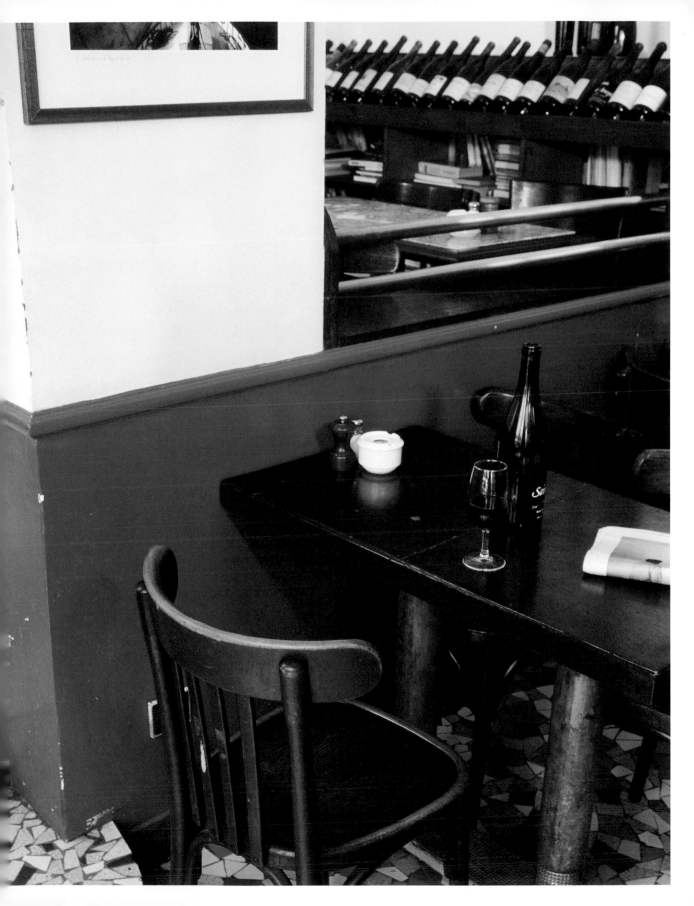

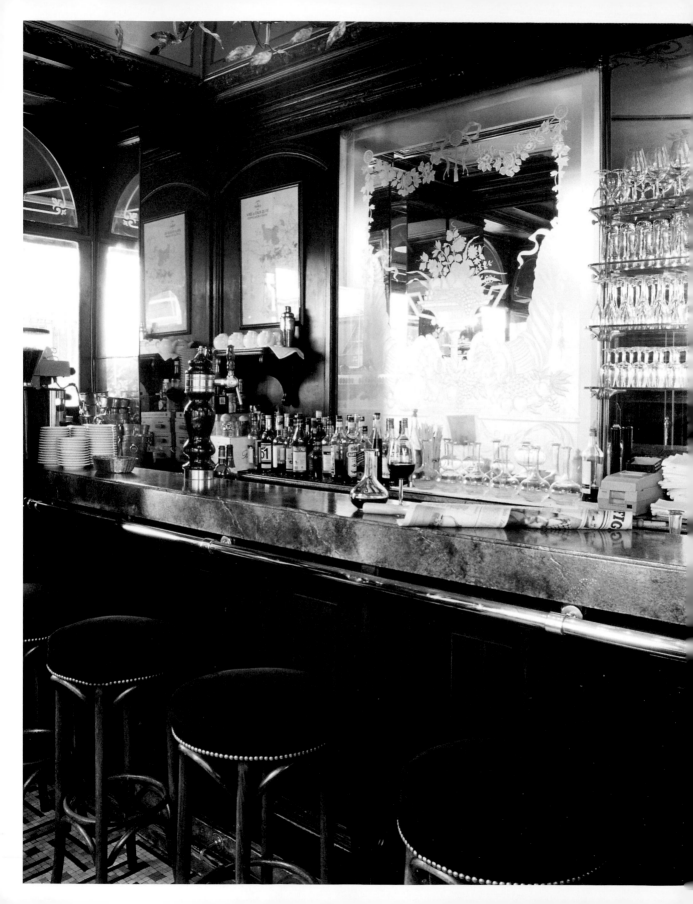

Bistros

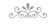

BARATIN

A table and chair that could be straight out of a Van Gogh painting in this working-class bistro in today's Belleville (page 103).

AU PETIT RICHE

Its entrance and bar have not changed since 1880, the period when Au Petit Riche, initially a restaurant for coachmen in the area around the Opéra, became a bourgeois, classier establishment (facing page).

Home cooking has always had its followers in Paris, for reasons of taste as well as economy. Even the most cultivated gastronomes are drawn to the more robust fare served in Paris's *bistrots*, *bouillons*, and *bistroquets*. Dishes concocted from rustic ingredients, such as the cheaper cuts of beef or a whole range of winter root vegetables—turnips, parsnips, rutabaga— offer the weary palate a substantial connection with the more basic raw materials. These are dishes with density, and, quite literally, bite. Menon, a head cook in the eighteenth century (about whom nothing else seems to be known), published in 1742 a manual of household management for housewives entitled *La Cuisinière Bourgeoise suivie de l'Office, À l'usage de tous ceux qui se mêlent de dépenses de Maisons*. This was the first real treatise on modern household gastronomy, and was updated and reprinted for a century. Bistros began to gain in popularity at the same time as restaurants—indeed they are a proletarian variant of the restaurant (although the customers have never been exclusively poor people; far from it). But they really flourished at the end of the nineteenth century, that overwhelmingly prosperous period for Parisian gastronomy.

The word *bistrot* itself was also coined around this time, and dating its appearance this late can set straight a popular belief about its etymology. Russian Cossacks occupying Paris in 1814 would hasten the innkeepers to serve them at saber-point, to quench their legendary thirst; the received wisdom is that the term was adapted from the Russian word *bystro*, meaning "quickly." Thanks to the work of the linguist Pierre Guiraud, we now know that the word *bistrot* is derived from the word *bistouille*, meaning a bad wine: by association, a bistro would (originally) have been a "place where one drinks bad wine." What is more, the term only started to be used in French to refer to a more upmarket establishment extremely recently, at the end of the 1980s, when home-style cooking came back into fashion.

When Au Petit Riche first started in 1854 near the Opéra, it was a typical example of the bistro. Haussmann's remodeling of Paris from top to bottom was just getting under way. Little by little, the opera house commissioned by Napoleon III and designed by Charles Garnier

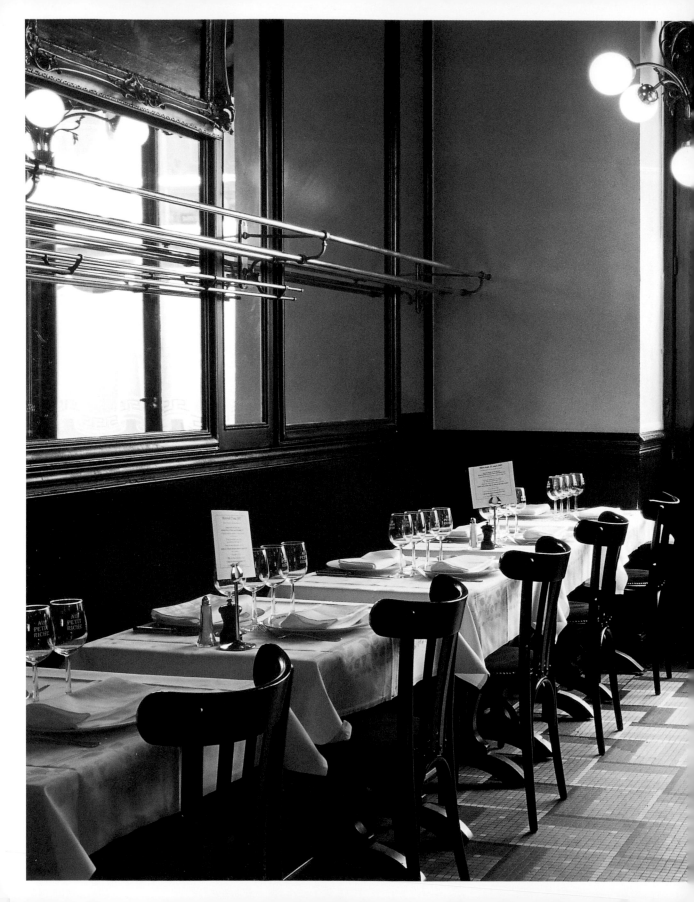

AU PETIT RICHE
*"Bistro" chairs, brass
coat racks, opaline globe
lamps, tiled floor: the
bourgeois bistro as it was
conceived in the early
twentieth century.*

L'ESCARGOT MONTORGUEIL

The gastropod is everywhere in this bistro on rue Montorgueil in Les Halles: from the reverse-painted glass in the window to the lace curtains (above and facing page). And, of course, on the plates. The spiral staircase of L'Escargot d'Or, the former name of this restaurant, also evokes the snail's form (following pages).

started to emerge above this vast building site, the embodiment of the grandeur of the new, wide boulevards. Both high society and the demimonde, politicians, journalists, and actors would crowd into the nearby Café Riche, the Maxim's of the period. But all the little people who formed their invisible escorts—the coachmen, scene-shifters, and theater employees—had nowhere to go and eat. The Petit Riche—an ironic twist on the name of its prestigious neighbor—offered them simple but hearty sustenance. The proprietor, a Monsieur Besnard from the Loire Valley, stocked his cellars with Vouvray and Bourgueil, and served typical regional dishes such as crispy pork greaves, green lentil salad, *filet de sandre* (pikeperch), and *géline de Touraine*, the local breed of chicken. These are specialties at the Petit Riche to this day.

A fire devastated rue Pelletier in 1873, destroying this unpretentious little restaurant, and paradoxically persuading Monsieur Besnard to make improvements that would turn the Petit Riche into a restaurant aimed at a much classier clientele. The 1880 decor is still visible in the first four dining rooms with their painted-wood ceilings bordered with a frieze of fruits and vegetables in rectangular cartouches, spanned with trompe l'œil flowers. Large mirrors on the walls are richly engraved with fruit bowls and horns of plenty. The Petit Riche draws in those attending auctions at the nearby Hôtel Drouot, and still retains its hold on some theater people, who have remained faithful to this antiquated but charming place.

L'Escargot Montorgueil is located a stone's throw from the old site of the market at Les Halles. The eating of snails, "which doe ruine to the buddes of vines" as it says in the sixteenth-century almanac *Le Compost des bergers*, has long been a tradition in Paris. The first medieval cookery book, the fourteenth-century *Le Ménagier de Paris* (brought to light in Paris by Jérome Pichon's edition of 1846), gives a vivid recipe where it is recommended to remove the tail: "et puis leur devez oster leur queue, qui est noire, car c'est leur merde" (and then you should remove their tails which are black because of their crap). Pliny the Elder advised the consumption

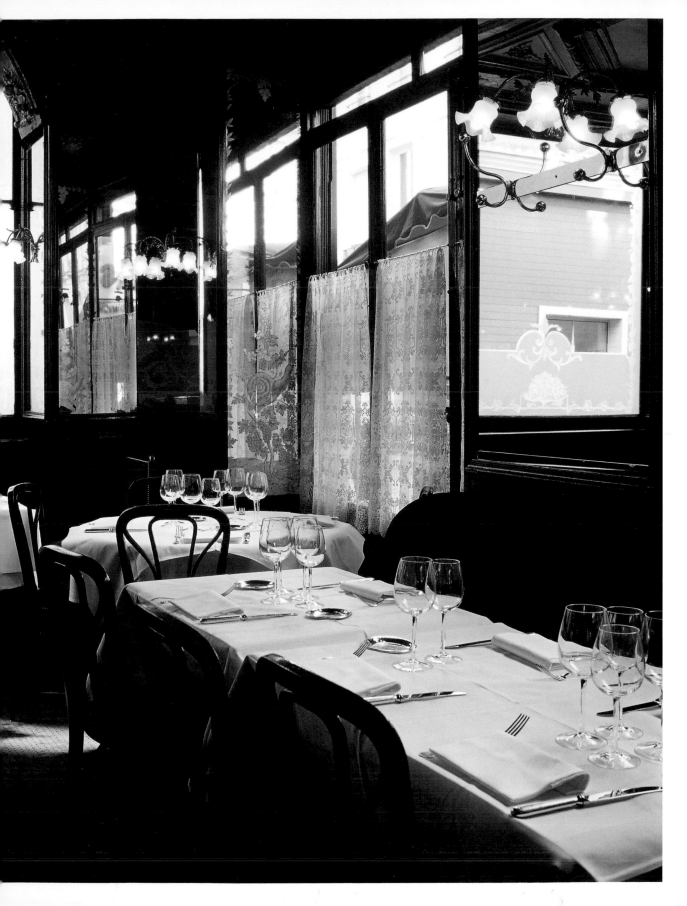

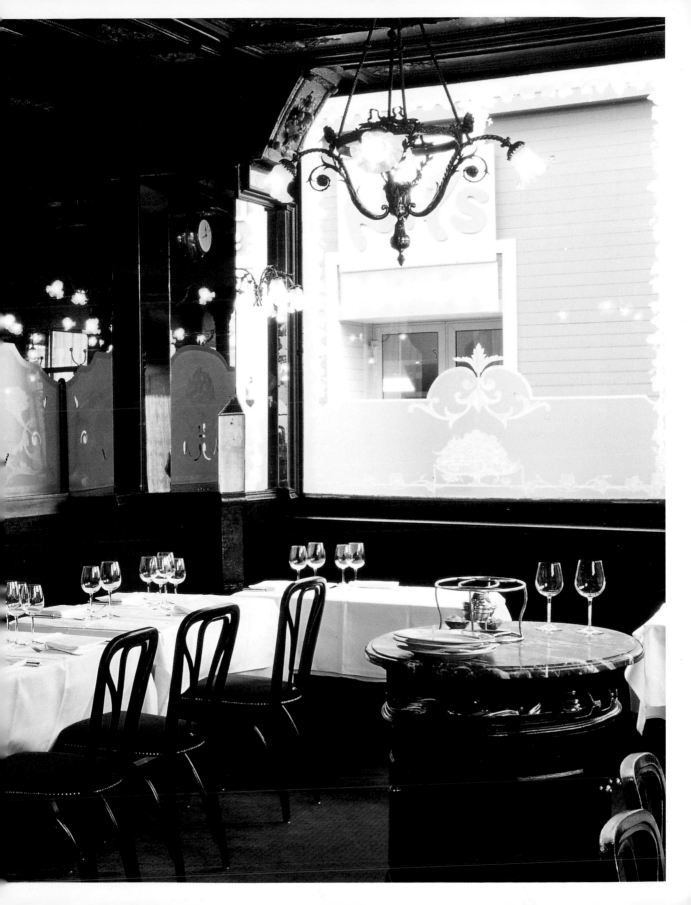

✤

CHARTIER

*The decor has not changed
at Chartier since 1898:
neither the checkered
tablecloths, nor the
appearance of the waiters.
And the clock on the mirror
reminds everyone that there
is only one hour to eat
(above and facing page).*

of snails for their benefits to the stomach, and all gourmets agree that the sauce is what makes them. The delicacy seems to have reached the height of its popularity in the nineteenth century, a fact borne out by the opening of the specialized establishment L'Escargot Montorgueil in 1875, under a sign proclaiming "Vins, escargots et restaurant." Rue Montorgueil used to be the home of the Paris oyster market, which prompted Jean-Claude Ribaut, restaurant critic for *Le Monde*, to comment in his *Guide sur les restaurants de Paris* that "the snail is the poor man's oyster." Voltaire even offers an explanation for this in his correspondence, when he praises the aphrodisiac qualities of the little hermaphrodite creature, noting that it is capable "of being in raptures for three or four hours on end."

Before the restaurant, the site had been occupied by L'Escargot d'Or since 1832, simply selling snails and plenty of wine (after all, the *persillade* sauce served with the snails is well known for making you thirsty). The original frontage in green wood with gilded geometric motifs probably dates from that previous incarnation. But the impressive pediment above the shop front only appeared when the premises were refitted in 1900. The façade is proudly topped by an enormous golden snail, with smaller cast-iron ones at its foot. A glass-fronted panel outside, showing medals won in Paris and Amsterdam, also dates from this renovation, as does the spiral staircase inside, and the glasses engraved with snail shells and horns of plenty full of oysters and crustaceans. In 1919, André Terrail from La Tour d'Argent acquired the business and set about transforming L'Escargot d'Or into a fashionable spot. There were celebrations there held after the signing of the Treaty of Versailles, and in 1925 a commemorative painting that had been in Sarah Bernhardt's dining room was mounted on the ceiling. Over the twentieth century, L'Escargot d'Or followed the ups and downs of this district of Paris as it was ravaged by idiotic town-planning policies. Today, as Les Halles is on the verge of rebirth, this old place continues to raise its proud horns above the pedestrian street, and be a meeting point for all those who are not frightened off by a cluster of warm snails in garlic sauce.

In 1870, on the eve of the Franco-Prussian War, a butcher named Duval hit upon the idea of the *bouillon*, a working-class restaurant serving only *pot au feu*, the thin beef and vegetable stew that was an economic way for him to use up the poorer cuts of meat. He met with success, and increased the number of outlets, creating a whole chain of *restaurants populaires*—in effect, soup kitchens. Guy de Maupassant's hero in *Bel-Ami*, Georges Duroy, eats there regularly when making his laborious start in journalism, when he has only "six francs fifty left in his pocket." The food was rudimentary, but not devoid of charm, as maintained by the minor dramatist Albert Glatigny in a poem addressed to his contemporary, the food critic Charles Monselet:

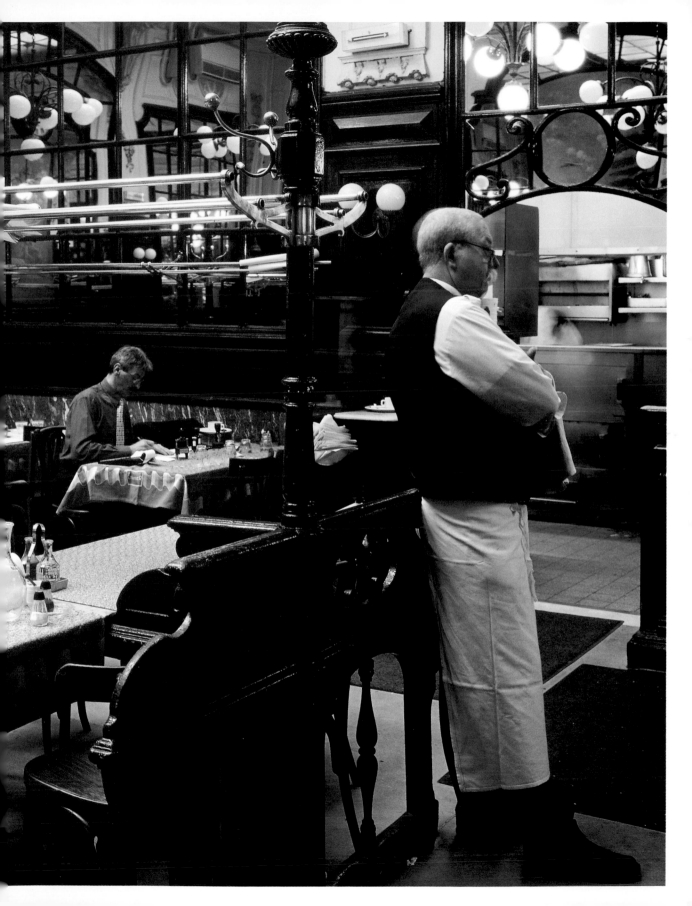

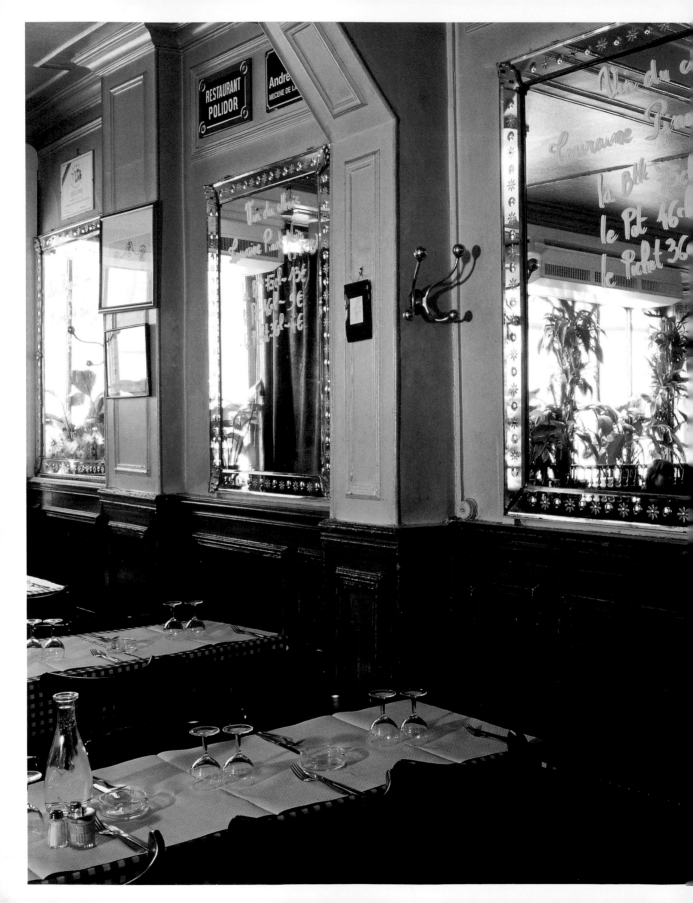

Tu te voudrais sans doute au fond de tes gargotes
Dans un Bouillon Duval près d'une portion
De lapin contestable ou de bœuf aux carottes.
[Perhaps you would rather be among the greasy spoons
Of a Duval Bouillon, tucking into a questionable portion
Of rabbit, or some beef and carrots.]

Just off place Clichy, in the unchanged premises now occupied by the Académie de Billard, one of these famous establishments offered quality meals at low prices to all those who needed them, until the 1930s. The Duval formula was quickly imitated, notably by Camille and Édouard Chartier. They stuck to the principle of *pot au feu* in its broth, but made a selling point out of upgrading the décor. Most of the finer *bouillons* that still exist in Paris, for example the Bouillon Racine in the Latin Quarter, the Bistrot de la Gare in Montparnasse, or Vagenende in Saint-Germain-des-Prés, were either created or bought up by the Chartier brothers. But the *bouillon* on the rue du Faubourg-Montmartre is perhaps their flagship. Opened in 1898, Chartier was aimed at artisans as well as workers, since there were so many in this area. There was clearly a body of very regular customers: after every meal, they would put away their napkins in little numbered wooden compartments. The second room is enormous, and is lit by a glass skylight that covers the entire ceiling. It is divided by two partitions, each marked out with five stout, fixed, coat racks. Mirrors mounted on the walls reflect the animated service. From the wall at the back, a large clock dominates the entire hall, reminding the diners that time is ticking by and they will soon have to go back to work. Over a century old, Chartier prides itself on having served around fifty-five million meals. Today it is as full as it ever was. The high level of noise is compensated by the low level of the prices: many of the main dishes can be had for under ten euros.

POLIDOR
The dishes are written up on the mirrors with a brush, the frontage bears the word crémerie *in golden letters, and the placemats are paper: Polidor is faithful to the tradition of the family-run bistro (facing page, below, and following pages).*

The Polidor belongs to a different category of *bouillon* from the late the nineteenth century, going by the name of *crémerie restaurant*. At first, milk, eggs, and cheese were sold to an early morning clientele, mostly of women, but gradually these businesses changed hands, broadened their outlook, and evolved into delicatessens. Still, for a long time the Polidor kept up a fine reputation for its egg-based dishes. In *Voyage de Sparte* (1883), the nationalist writer Maurice Barrès describes meeting the father of modern phonetics there, Louis Ménard, who recommends to him "the fried egg which one absorbs on the cheap." Jean Paris, in his biography of James Joyce, relates similar peregrinations on the part of the Irish writer, penetrating

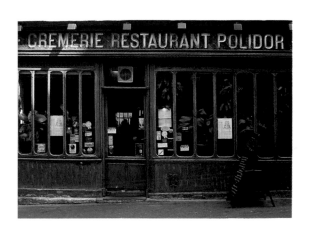

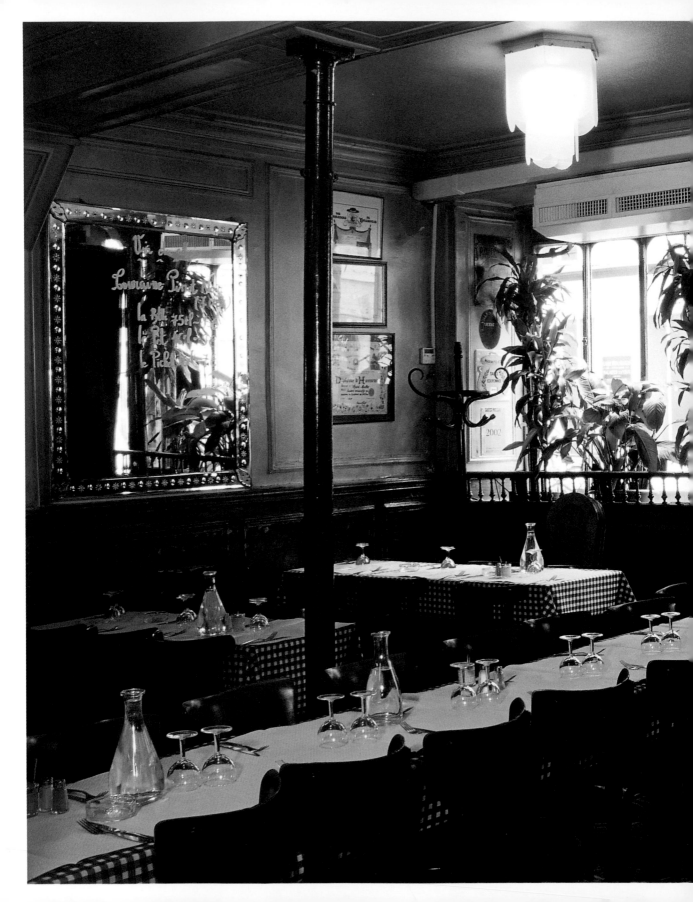

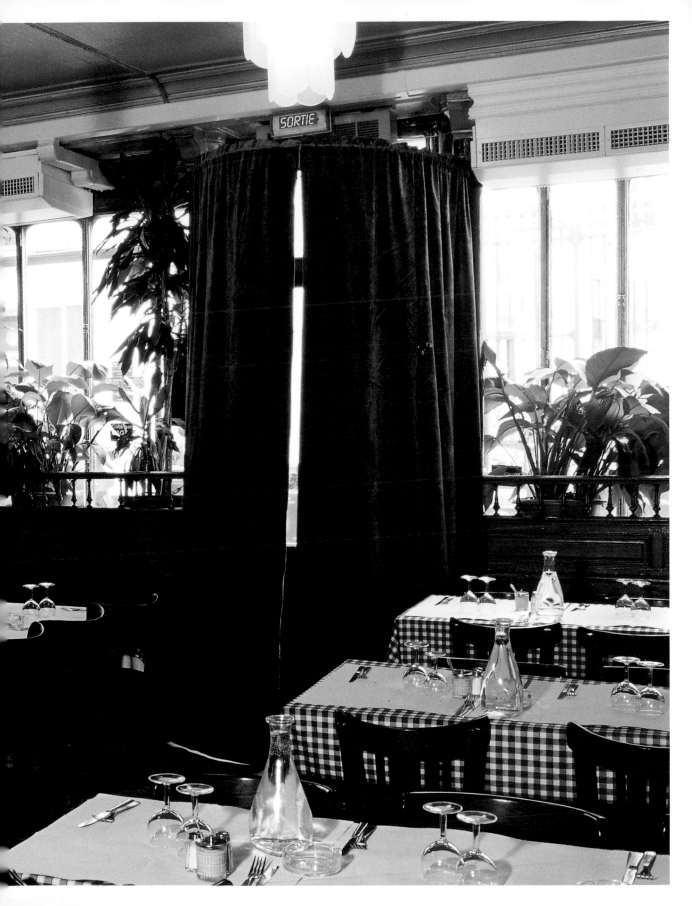

the Latin Quarter "in search of a Polidor omelette." Generation after generation of penniless writers from the Left Bank were drawn to this unpretentious place. The poet Germain Nouveau, a contemporary of the symbolist Stéphane Mallarmé, celebrates Polidor as a place where "one guzzles magnificently and cheap." Verlaine himself dined there in the company of a Spanish journalist, and Paul Léautaud made it his regular haunt during the dark times of the Occupation. In 1948, the restaurant became the headquarters of the "Collège de Pataphysique," one of the foundries of experimental postwar literature, involving

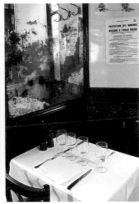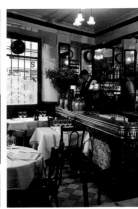

Raymond Queneau, Eugène Ionesco, Boris Vian, Jacques Prévert, and later, Julio Cortázar. The Collège still holds sessions there. One of the endearing things about Polidor is that, of all the bistros of the last century, it is the one that has best hung onto its original clientele: the real authors of our time are just as fond of it as their illustrious predecessors were. One still receives agreeably brusque treatment from the energetic and mothering waitresses; and one can still, for a few pennies, eat a substantial meal that is not without soul.

ALLARD
Nineteenth-century fare at this bourgeois and comfortable bistro, protected from the ravages of time by its eighteenth-century bars (facing page and above).

In contrast, Allard near place Saint-Michel is a place for powerful editors and powerful men; one of those restaurants where carnal natures seek potent, stimulating food. There are bars on the windows of this authentic eighteenth-century working-class dwelling: a reminder of the prince regent's edict in 1720 requiring wine merchants to safeguard their premises. But the bistro itself only dates from the beginning of the twentieth century. A man from Sancerre by the name of Vincent Candré opened La Halte de l'Éperon on rue de l'Éperon, and the metal sign is still in place today. Candré offered simple wines from his native region and rustic, country-style dishes, concocted by a professional woman chef, "Mère Josephine," one of Paris's first *mères* (literally "mothers," here denoting females running kitchens). He handed over to a couple from Burgundy, Marcel and Marthe Allard, who continued the custom introduced by the cook of a thoroughly regular menu: Monday, Toulouse *cassoulet*; Tuesday, veal *à la berrichonne*; Wednesday, *navarin* of lamb; Thursday, *petit salé* with lentils; Friday, braised beef and carrots; Saturday, *coq au vin*. The star dish for special occasions was duck with olives. This sequence is still available on the menu, or rather on the tables, since there are no individual portions at Allard: the casserole dish or terrine is placed directly on the tablecloth and everyone takes what they want. Ever since the restaurant was founded, the public entrance has been via the kitchen, which really epitomizes the spirit of the place. You come here to tie your napkin around your neck, and solemnly dig in to large amounts of substantial, filling food.

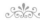

ALLARD
*Acid-etched windows
shield the solid appetites
feasting at Allard from
curious passersby.*

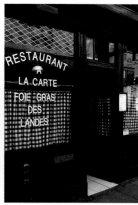

L'AMI LOUIS

*The stove (facing page)
inevitably evokes
the wartime period, as do
the checkered curtains
in the front window (one
almost expects Jean Gabin to
pop out from behind them).
The typically Parisian
vaulted cellars hold some
memorable bottles (above).*

The little bistro L'Ami Louis has been tucked away behind place de la République and its nearby boulevards since 1934, but it only really took off after World War II. Due to historical happenstance, and its own particular charm, it has become known as a rendezvous for Americans in Paris. The décor, it has to be said, does seems to be straight out of *An American in Paris* or *Gigi*. Baskets of fruit and vegetables are laid out at the back like in a market; the look is so quintessentially "French bistro" that it matches the Hollywood ideal of the capital. It is hardly surprising then that a club of American billionaires fly over every year in their jets for a private dinner in the restaurant. Bill Clinton and Jacques Chirac set the example in July 1999.

In fact, L'Ami Louis has been a landmark for Americans since 1944, when intelligence officers in the OSS—including Jack Warner, the youngest of the Warner Brothers—set up their headquarters there. Americans have remained loyal, and the place has become synonymous, in the United States, with the small Parisian bistro, picturesque and not too expensive. While the dollar was strong, that is: in local terms, the prices (like the portions) can reach Himalayan dimensions. You come here for the simple potluck style of the place, the gigantic ribs of beef and the mountains of matchstick potatoes, but you can expect to blow the limit on your American Express. It has become a trendy spot for the Parisian showbiz set as well. It suits the solid appetites of "outdoor writers" too: you might find Jim Harrison here after signing a profitable contract. All in all, L'Ami Louis is pure Hollywood, right down to the bill. Such is the price of success for this most American of Parisian bistros. For a finishing touch to the ambience and to preserve the spot's patina, the walls and ceilings were never repainted but layers of smoke—from the time when it was still possible to light up in restaurants—were simply covered over with varnish.

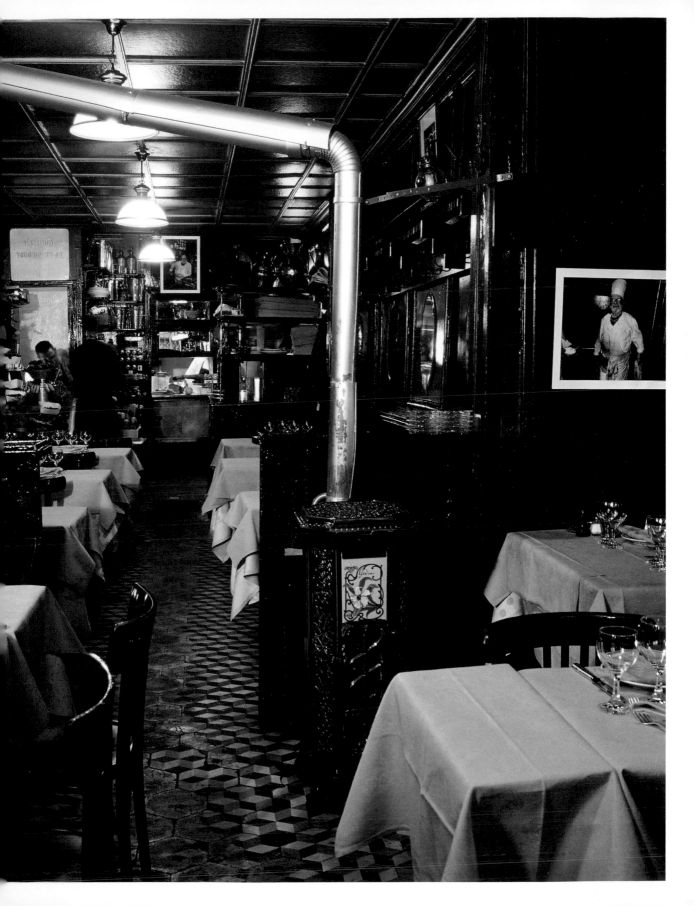

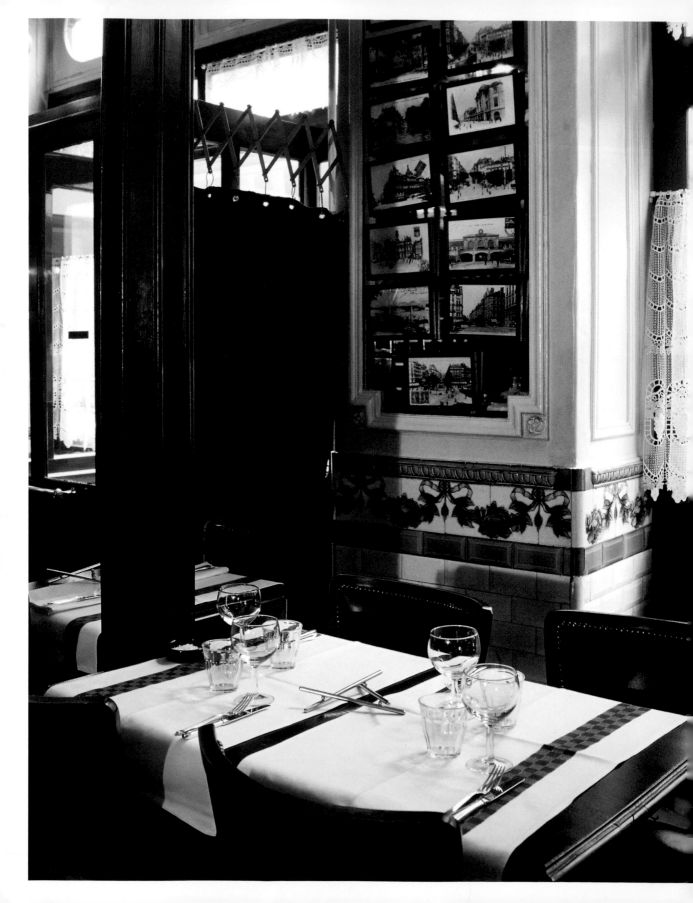

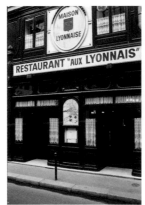

Since the 1980s, the bistro has made a strong comeback in Paris. A new generation of chefs left the big hotels and headed instead for the kitchens of minor sites on their periphery, where they could prove themselves. Yves Camdeborde was the first: he had been at Le Crillon when he opened the Régalade, near the Porte d'Orléans. His southwestern influences from Béarn and the Basque Country quickly drew in lovers of traditional *charcuterie*, *piperade* with fried Bayonne ham, and *hachis Parmentier* with *boudin noir* black sausage. Thierry Breton on the other hand, at Chez Michel behind the Gare du Nord, is dedicated to the flavors of the west. Thierry Faucher at L'Os à Mœlle in the distant fifteenth arrondissement, offers a simple *table d'hôte* where the *blanquette* has become legendary; Rodolphe Paquin is at Repaire de Cartouche, between Bastille and Nation, a Norman inn in the middle of bohemian Paris, where they serve freshly farm-killed pork. They have all adopted the same model: economical products, but good quality, prepared with all the attention to detail of high gastronomic style, coupled with cleverly selected wines from lesser-known regions. And the bill is as light as the preparations.

The emergence of these unconventional bistros made the Parisian gourmet scene suddenly much more lively. The Michelin-starred restaurateur Michel Rostang set the tone by developing his concept of *bistrots d'à côté*, or "next-door" bistros, and today he has two: Le Flaubert and La Boutarde in the west of Paris. Rostang's chefs train in his eponymous flagship restaurant, absorbing a generous style tinged with bourgeois manners. His interiors are brightened up by collections of old editions of the Michelin Guide, Parisian slipware figures, and antique stoves; reconditioned sites that are as successful as ever.

Alain Ducasse took over an old bistro in the centre of Paris in the year 2000, Aux Lyonnais, the once-favorite haunt for coachmen killing time waiting for shows to finish at the Opéra-Comique. He spruced up the décor, which is based around the same tilework as the Paris Metro, and rejuvenated the cuisine. The result is a Parisian version of a Lyon *bouchon* or tavern.

AUX LYONNAIS

Alain Ducasse has brought this Lyon-style mâchon *back to its former glory. The ceramic tiles are the same as those in the Paris Metro (facing page and above). The mahogany bar has not changed since coachmen used to come and lean on it (following pages).*

The pike quenelles are probably the lightest in Paris. In 2005, he extended his empire by taking over Benoît, a luxury bistro situated near the Hôtel de Ville, which has been part of the routine of city councilors since 1912.

In fact a turn towards a more domestic style of cooking has been seen right across the range of Parisian gastronomy, including the most upmarket tables. Here is Albert Glatigny again:

> Eh bien, oui ! j'aime un plat canaille
> Bien mieux que ces combinaisons
> Qu'un chef alambique et travaille.
> [Well, yes I do like a no-frills dish
> Much better than these combinations
> Made so much of by a chef.]

LE BARATIN
The ceremonious display of the wine list and, vitally, the plats du jour, *on a blackboard, is synonymous with the culture of the contemporary bistro (facing page). Raquel Carena, the owner-chef of this high-class tavern, writes them up herself, depending on the seasonal and daily availability of her ingredients (above).*

Women chefs were not far behind in becoming stars of the stoves again. Michelin-starred Hélène Darroze got her hands on a very trendy place in the sixth arrondissement, where the substantial dishes of her native southwest are not neglected. And Paris can be proud to continue the historic *mère* tradition of women chefs, after the Joséphines, Fernandes, and Adriennes of the past. Raquel Carena arrived from Argentina as a teenager. In 1987, she walked into a bistro in the multicultural Belleville area of Paris and took over a minuscule galley kitchen, from where she would conquer the city. Assisted out front by Philippe Pinoteau, she gave center stage to her ingredients, preparing them with a simplicity that won over the most blasé palates. Her vegetables come from the best truck farmer supplying the region of Rennes, Annie Bertin, and her meats from the cult butcher of the fifth arrondissement, Jean Marie Charcellay. The fish comes from the dockside market in Le Guilvinec in Brittany and from Saint Jean de Luz. Nice little table wines from great winemakers and coffee from Café Verlet round off a very astute and very tasty experience. An evening at Le Baratin is a dive into authentic Paris, where you sit elbow-to-elbow with writers, pretty girls, and local inhabitants, including the great photographer Willy Ronis (the walls bear a number of his prints of Paris, given by him in appreciation). The kitchen door is always open, and Raquel Carena looks out over the dining area, a little like an actor watching the reactions of the audience through a hole in the curtain. There is no menu: the dishes change every day depending on what the market inspires, and are written up on a black slate. Raquel Carena is the best embodiment of domestic-style *cuisine ménagère* in Paris today. Her bistro is always full: proof that the Parisians have not lost their taste for simple pleasures.

LE BARATIN

The walls of Le Baratin are hung with works by local artists from Belleville, which still has a village feel. The photographer Willy Ronis (back wall) often came here as a neighbor and friend.

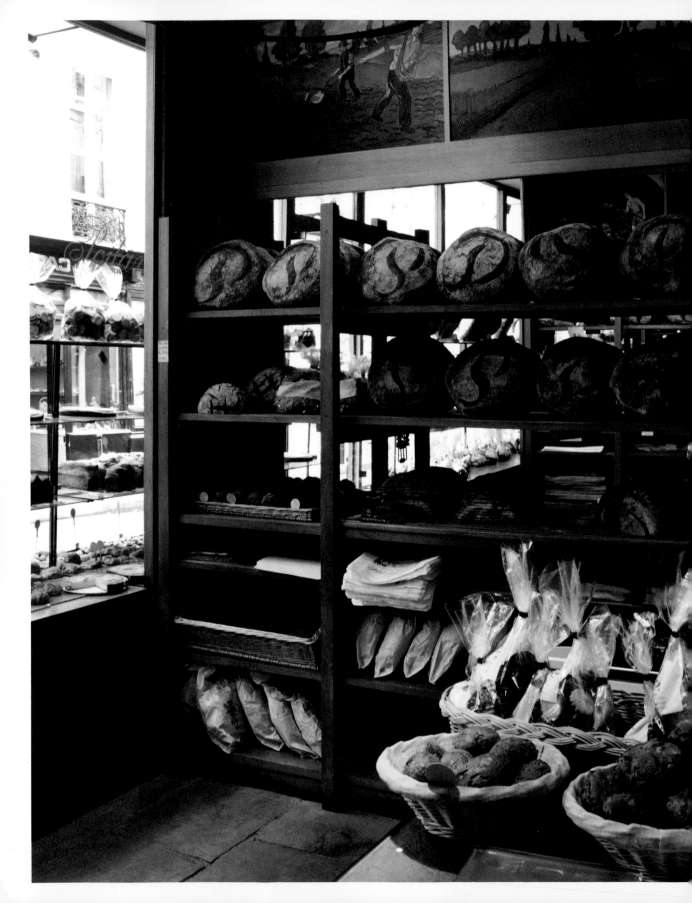

French culinary essentials

When the women of Paris set off to demonstrate at Versailles on October 5, 1789, thereby forcing Louis XVI, Marie-Antoinette, and the young heir to the throne to decamp to the Tuileries, their initial objective had been to return with "the baker, the baker's wife, and the apprentice." Such was the importance of bread at the time of the ancien régime. It has been said that the events of July 1789 started off as a bread riot and turned into a revolution, due to the dearth of food in the preceding period and the high price of bread, an essential part of the French diet in the eighteenth century. Today, food is no longer scarce and bread is plentiful, but Parisians continue to complain: bread no longer tastes like it used to. Good bread is impossible to find, they say. If that is true, it is not for want of trying on the part of the great and the good who came up with the annual "Best Baguette in Paris" prize.

Today, there are still more than 1,300 traditional *boulangeries-pâtisseries* in Paris, though ten years ago there were 6,000. Yet bread consumption has increased slightly over that period, from 150 grams per inhabitant per day to 163 nowadays. So should one believe Parisians when they complain about the state of bread? Yes, if what they are talking about is the industrial bread that is sold in supermarkets, which goes rubbery after a day on the shelf. But for genuine bread lovers—and there are many of them—a detour to another district, or even a trip to another part of the city, in search of a real baguette or an authentic loaf of bread is worth the trouble. And they are well rewarded for their efforts, because paradoxically, although the baking industry is undoubtedly in crisis, at the quality end of the market, bread has never been so good, whether you look at the variety on offer or the care that is paid to how it is made. While bread may not yet be a luxury, for many Parisians the address of a good bakery is, and one that they pass to one another by word of mouth, like a precious secret. The names of some of these elite bakers are as much a password to quality as those of any of the master chefs and patissiers.

This is unquestionably true of Poilâne. A food critic once wrote that Pierre Poilâne and his son Lionel were to baking what Gaston Lenôtre was to pastry and Paul Bocuse to restaurants. Following World War II, Parisians had had enough of black bread: it had been their staple during the Occupation and with liberation they longed for bread that was white, with a loose and springy

POILÂNE

Welcome to Pierre Poilâne's historic boutique on rue du Cherche-Midi, near the Saint-Germain area. For many years, Parisians have lined up to buy their bread here, not because there was any particular shortage, but because here they could be sure to find the very best quality.

POILÂNE

*Poilâne is also the place
to come for delicious little
butter cookies, whether for
a quick mid-morning bite
to stave off your hunger
until lunch, or with tea as
an afternoon snack (above).
While waiting, take a look
at the collection of bread
still lifes displayed on
the walls (facing page).*

crumb and a crust as golden as the future they were looking forward to. To satisfy them, many bakers produced a baguette that appeared perfect, but only on the outside. To give their bread an extra lift and make the crumb airy—which consumers took to be a sign of quality, so used had they been to the hard and compact bread of the war years—they added raising agents that resulted in a tasteless, neutral baguette lacking in aroma and a precursor of the industrial baguette to come. It was this baguette that became the norm and, like white bread had been in former times, was synonymous with the good life and a harbinger of better times to come.

In short, it was bread for the rich, bread to make you dream. At his bakery on rue du Cherche-Midi, which he opened in 1932, Pierre Poilâne took a different approach to bread making. For Pierre, bread had to be made with stone-ground flour that was blackish-brown in color and slightly oily from the crushed wheat germ; it needed to rise using a natural leavening agent and then be baked in a wood-fired oven. In keeping with tradition, he refused to make baguettes, preferring instead to produce a hefty round loaf that would keep in the larder for several days. The result is the spectacular round loaf that weighs in at 4.2 pounds (1.9 kilograms), big enough for a family, sitting in the shop window, glowing like the sun. First to be drawn to this sun were the artists who populated the area around Poilâne's *boulangerie* situated not far from the École des Beaux-Arts. The artists were usually poor, and Pierre Poilâne's bread consistently nutritious, so it was not long before he began exchanging his bread for paintings and over time he succeeded in amassing a collection that depicts bread in all its glory. The works are still on show in the back of the shop, and while not all masterpieces—far from it—their presence is testament to the strength of the link between Poilâne bread and art. Against the odds, the artists in Saint-Germain-des-Prés succeeded in making *pain Poilâne* fashionable. The apotheosis of this synergy between the arts and crafts is the furniture that Pierre's son Lionel made from bread under the supervision of Salvador Dalí. Lionel's bread chandelier is still hanging in the shop. Little by little, the Poilânes's reputation continued to grow. Besides the original bakery on rue du Cherche-Midi, a larger production facility was added in a converted farm in the suburb of Clamart. This supplied the numerous distributors of Poilâne bread in Paris. But the methods used to make the bread didn't change. Poilâne began to export their bread during the 1970s, and you can now find it in the United States, Japan, Hong Kong, and, of course, throughout Europe. *Pravda*, the official organ of the Soviet Communist Party, once published a report on the lines that formed outside the bakery on the rue du Cherche-Midi: a sign, it claimed, of the shortage of bread in the West. In 1982, having

LE MOULIN DE LA VIERGE

The façade of the Moulin de la Vierge, on avenue de Suffren near the École Militaire, dates from 1900 and illustrates the traditions associated with bread in France. The silhouette of the woman sowing evokes the much later image of Marianne, icon of the French Republic, a secular goddess who for years adorned the French franc (above). The bread from the Moulin de la Vierge is distinctly nutritious, as it is made using only organic flour (facing page).

been forced to leave Clamart, the Poilâne business—because at this stage it had gone from being a bakery to being a sizable business in its own right—built a brand new production facility in Bièvre, between Paris and the wheatfields of Beauce. While the architecture might be modern, the production area is fitted out exactly like an eighteenth-century bakery might have been: twenty-four wood-fired ovens and a similar number of preparation areas are organized along traditional lines. A crane located in the middle of the ovens rotates to distribute wood, and the flour that is stored in four huge silos arrives directly into each kneading trough by means of a pneumatic system. In an era where modern bakeries make soulless bread in increasingly large quantities, Lionel Poilâne succeeded in inventing a "retro" factory that manages to combine the best of modern technology with traditional bread-making methods. A visit to the rue du Cherche-Midi bakery is like a trip to a museum: the sales assistants are dressed in linen smocks and the pale-wood décor is permeated with the warm, slightly pungent aroma of the fresh bread that is produced here daily. The range of breads on sale has not changed since the 1970s: the round loaf that still carries the bakers' monogram, the walnut bread rolls, and the deliciously yellow sandwich bread (only on sale in this location because "it doesn't travel well") are all made from wheat flour, while the rye bread is particularly appreciated for its smoothness and the touch of sweetness that comes from a rye-based leaven that incorporates a tiny amount of wheat flour. By preserving traditional methods, Lionel and Pierre Poilâne revolutionized and transformed an entire profession. Following the tragic 2003 accident in which Lionel was killed, the task of continuing this tradition has passed to his daughter Apollonia.

Bread is intrinsically linked to social history, and that is particularly true of Paris. In its quest for modernization, Paris nearly lost its baking tradition. It called for a Pierre and Lionel Poilâne to preserve that tradition. As part of its reaction against the excesses of modern urbanization, the city has welcomed and encouraged those "bread makers" who

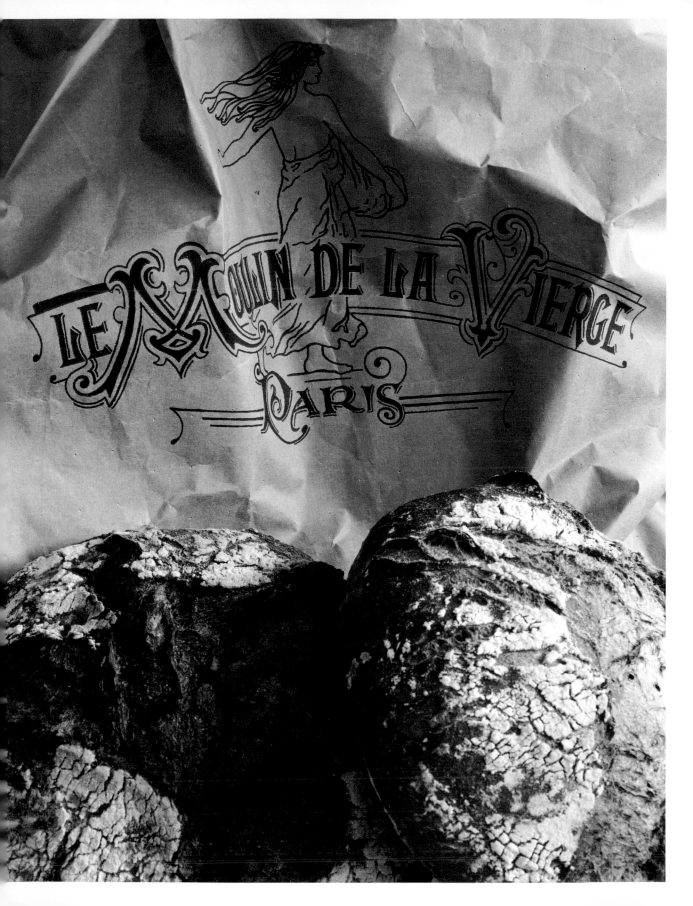

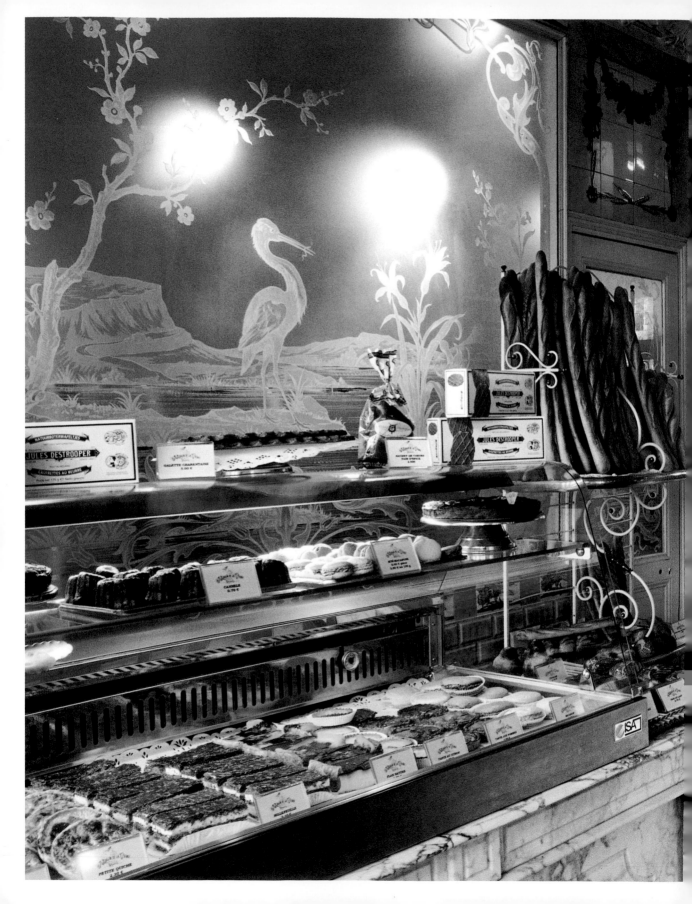

LE MOULIN DE LA VIERGE

The traditional interior has been preserved at the Moulin de la Vierge, on rue Vercingétorix, and in all the other outlets of this typically Parisian bakery.

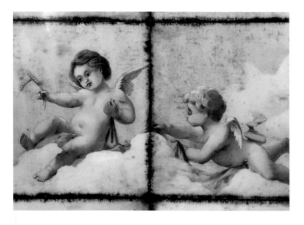

LE MOULIN DE LA VIERGE

*The panels that decorate
the walls and ceiling of
this bakery reflect how
for Parisians, bread and
love are inextricably
linked (above). In need
of a little tenderness?
The Moulin de la Vierge
has delicious* viennoiserie
*breakfast pastries to be
eaten alone or with the one
you love (facing page).*

strive to satisfy the demands of a population that is particularly attached to its lifestyle. The story of the Moulin de la Vierge, a bakery on rue Vercingétorix next to the railway tracks that lead to Montparnasse station, is a good example of this trend. Difficult as it is to imagine today, in the middle of the 1970s a posse of technocrats came up with a plan to run a series of highways through the center of Paris culminating in a central junction at Notre Dame. Skyscrapers would be dotted here and there, in case the highways did not succeed in making Paris—the City of Light after all— "modern" enough. In 1975, the area around this antique bakery was demolished in preparation for the massive public works to come. But like the Gaul village that held out against the Romans in the *Asterix* cartoons, this typical old boutique with its beautiful facade painted on glass was spared the wrecker's ball.

The culture minister, in a wise move, gave the building protected status, though no bread had been baked in its ovens for the previous five years. Basile Kamir was one of a handful of activists determined to prevent the bulldozers from doing their work. A childhood friend of the founder of the Virgin empire, Richard Branson, and a concert promoter in his own right, Basile Kamir decided to buy the historic monument. It was said that in the Middle Ages a flour mill had stood on the site, and that the Virgin Mary had freed the miller from a pact he had made with the devil. Basile Kamir used the shop to sell records, but locals who visited constantly complained of the disappearance of all of the area's bakeries, so he decided to start selling Poilâne bread alongside his records. The Moulin de la Vierge had begun a return to its roots. To get over the thorny issue of where to plant their highway, the planners proposed taking down the boutique and building it elsewhere. But a traditional wood-fired oven is not as easy to take down and reassemble as is a facade, and once in use its destruction is forbidden. To foil the planners' intentions once and for all, Basile Kamir ended up resuscitating the oven and making the store a bakery once again. He called on the services of Monsieur de Collogne, a master baker of the old school, to get things going again, and because Basile Kamir was an environmentalist, he made sure only to use organic flour in his breads. Many legal battles and one hunger strike later—ironic for a baker—Basile Kamir succeeded in saving the Moulin de la Vierge, and in the process saved Paris from the planned highways that would have disfigured the city irreparably. An incredible but true story with a satisfactory outcome and one that would have been impossible to make up. The concert promoter turned baker has spawned other outlets in the city all of which use the same techniques as Poilâne and organic ingredients that produce excellent bread. The activist has become a successful baker, and Parisians are undoubtedly better off as a result.

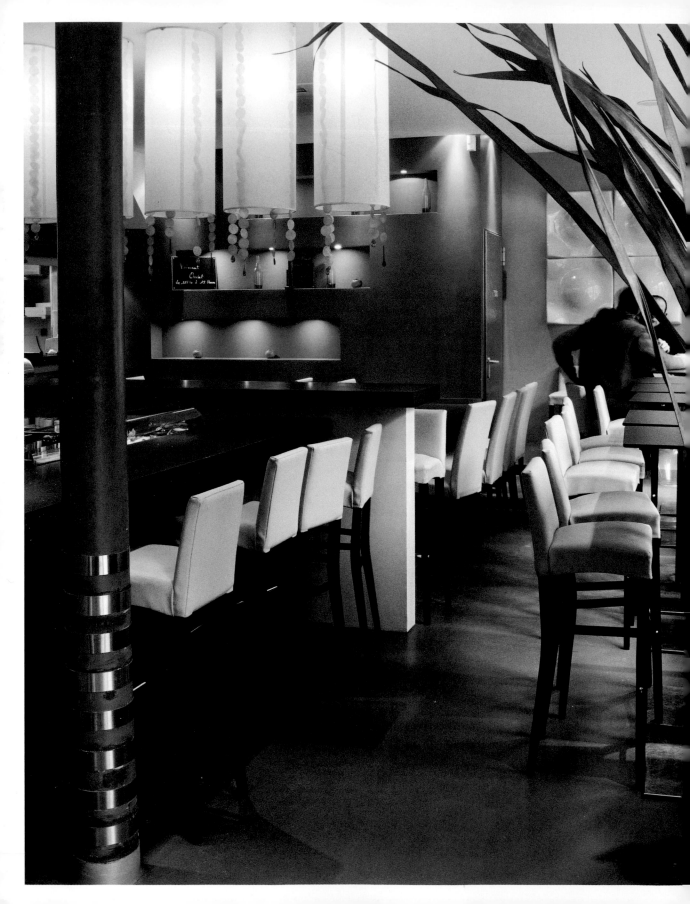

Quality baking is not necessarily synonymous with a rigid adherence to the past. Lionel Poilâne's production facility is evidence of that. Two other bakers, each in his own way, illustrate this: Éric Kayser and Francis Holder, founder of the Paul group. Éric Kayser incarnates a new breed of Paris baker. Parisians enjoy labeling as "new" anything that deviates from the ordinary, opens up new paths of discovery, or creates new sensations, even if genuine innovation is not always in evidence. But Éric Kayser's reputation—he is the first "star" baker since Lionel Poilâne—is founded on a genuine innovation and an approach that is truly revolutionary. Kayser's breads, despite the wide variety of flours used and varieties on offer, share a common consistent quality that is unaffected by weather conditions or the hand that makes them. This is not to say that his breads are uniformly the same. Rather, that whether it is a country loaf or one made of buckwheat, rye, or a combination of ten different grains, or even just a simple baguette, they all have the same qualities that, according to Kayser, are essential for good bread: an appetizing color both in the crust and the crumb, a crusty outside and soft inside, and above all the irregularly shaped air pockets that are the sign of handmade bread. How does he achieve this "handmade" quality while ensuring that each loaf is consistently perfect? By carefully introducing technology into the process at the right moment. Éric Kayser grew up in a family bakery in Lure, in the east of France. As part of his training he undertook an age-old system of apprenticeship—the *compagnons de devoir*—that took him to work with the best bakers in France until he graduated under the soubriquet "Francomtois le Décidé," a reference to this Franche-Comté native's determination. Very early in his career he discovered a vocation as a teacher and from Mexico to Dubai, from Stockholm to Toronto, he has taught bread making while continually observing and learning everywhere he goes. With his vast experience and from his contacts in the food industry—in particular with Patrick Castagna, an engineer specialized in bread making—he came up with the idea of a machine that would automate the most delicate part of the bread-making process: controlling

ÉRIC KAYSER

The bread at Éric Kayser's is a paradox: each loaf is different but each the same. The secret of how to achieve this uniform individuality lies in a special machine, the fermentolevain, *which controls the release of the acids in the yeast leaven. The rows of chairs in the boulevard Malesherbes branch invite the shopper to stop for a little treat (facing page).*

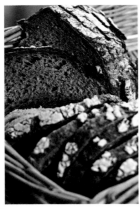

ÉRIC KAYSER

Éric Kayser's bakeries double as tearooms. Come and enjoy a sandwich or a pastry. The financiers, *small almond sponge cakes, are a hit (facing page).*

the fermentation of the leaven. Why do bakers not sleep at night? The main reason why their hours are so out of synch is that they are obliged to watch over how the leaven ferments and ensure it does not over ferment or become too "thin," releasing unpleasant acetic acids that would result in a vinegar-like taste in the bread. The aim is to have a leaven with just the right balance of acids that complement each other, resulting in a pleasant combination of aromas and tastes ranging from acidic to lactic to honey that are the hallmark of good bread. Éric Kayser invented the machine and had it made industrially. In 1994, his *fermentolevain* machine was put on sale to the general consternation of his professional brethren who attached an almost mystical quality to this aspect of their art and for whom no machine could possibly replace the baker's own senses of smell, taste, touch, and sight. In order to convince them, Éric Kayser became his own first customer. Thanks to his artistry, and because he knew how to set up his *fermentolevain* to get optimal results— at this stage nothing can replace the baker's eye, nose, hand, and palate—he started producing bread that became the talk of the town.

In his first boutique on rue Monge in the Latin Quarter, Éric Kayser also had the idea to let his customers see the production process from beginning to end from the store floor. Behind the counter, a window looks onto the preparation and baking area, where bakers slide the loaves and baguettes into and out of the hot oven. A front-row seat at the birth of the bread one is about to buy. Not content to innovate only in the technical aspects of bread making, Éric Kayser was also supremely creative in the range of breads that he came up with. Varieties such as turmeric and hazelnuts, poppy seeds, olives, Beaujolais and cheese, seaweed, prune and bacon have made their way from the tables of the great Paris restaurants into people's homes and bread is now eaten as a gastronomic delicacy in its own right.

For Francis Holder also, it was important that his customers could see the bread coming out of the oven. Originally from Lille, he has built up the largest chain of bread shops in France, with over sixty in the Paris region alone. The Paul chain of bakeries are recognizable by their distinctive black and gold storefronts, their well-stocked window displays that are changed four times daily, the friendly atmosphere that reigns and the staff dressed like baker's apprentices of old, topped off with the traditional *faluche* hat. They have become an integral part of the urban landscape, and one could be forgiven for thinking they had been there forever. In actual fact they first appeared during the early 1990s. Holder comes from a family of bakers with roots in the north going back four generations to 1889. The Paul bakery in Lille was renowned for its Viennese-style breads. In 1958, when Holder took over from his father, France was on the brink of a revolution in how it was to do its shopping with the imminent arrival

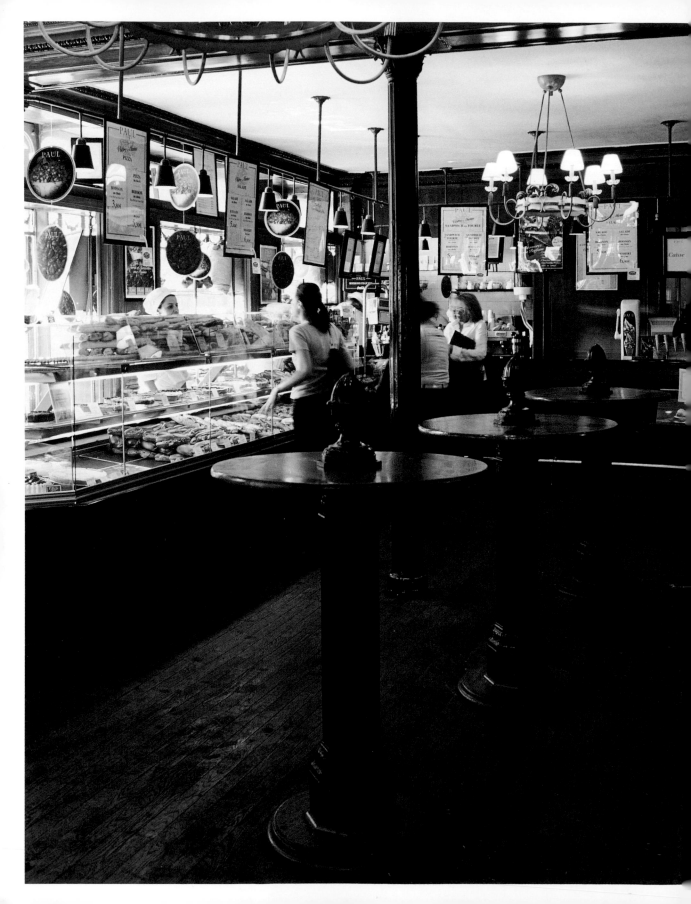

of the supermarket. Bakers were faced with a dilemma: either they went the way of other small businesses and let themselves be absorbed by the new giants with the risk that their bread would become just another industrial product, or they could follow the French in their exodus to the new shopping centers and continue to provide the traditional bread that their customers still craved. Holder chose to develop genuine bakeries in areas with close proximity to the supermarkets that surround France's cities and to combine a strong brand identity with a guarantee of first-rate quality. They are like oases of authenticity in a desert of mass-produced uniformity. Paul bakeries and outlets are now to be found in train stations and airports as well as shopping centers, and while Paul may have taken on the attributes of a brand name, it has nonetheless succeeded in retaining the traditional working methods that make French bread unique. The number of Paul bakeries in Paris is more a sign of how a traditional bakery has successfully adapted to modern conventions than the triumph of a carefully constructed marketing concept. And Parisians are delighted with the result, something which would not have been possible had the bread not been up to scratch. In this respect, Holder never neglected what was always the strong point of his shops. His intention has always been to give to his customers what they really want. Which is why he places so much emphasis on ingredients, in particular the flour: he uses a rustic winter variety of wheat, grown according to sound farming principles, that has no additives or preserving agents, is rich in wheat germ, and is spread out and left to mature for thirty days before being milled. It takes seven hours to make a loaf of Paul bread, the same time it took Francis Holder's ancestors all those years ago. The difference is that in order to keep up with the cravings of his Parisian clientele he has 142 varieties of bread on offer, starting with the classic Paul loaf made of Camp Rémy flour. This is then "rolled out" into loaves with names like Pistolet, Paulette, Faluche, Ficelle, Flûte, Chapata, Épi, Couronne, and Polka that are flavored with sesame or poppy seeds, bacon, onion, olives, and walnuts, making forty-two varieties of bread from a single basic dough. Then there is the Benoîton, a whole-wheat roll perfect for a little snack or a romantic dinner and available in several varieties: apricot, date, fig and raisin, raisin, hazelnut and cinnamon, olive oil, green olive, and black olive. Finally, there is the organic bread that uses only a natural leaven made from stone-ground flour containing coarse sea salt from Guérande and no pesticides. Francis Holder has made the best of good French bread available to Parisians and they are grateful to him for it.

PAUL

Aux Tortues on boulevard Haussmann is the flagship for Paul's operations in Paris (below). The window display changes four times a day: breads and breakfast pastries in the morning, sandwiches and hot dishes at lunchtime, pastries and cakes in the afternoon, and finally, more breads in the evening (following pages).

BARTHÉLEMY

The boutique on rue de Grenelle doesn't look like anything special from the outside, but step inside and you enter one of the doyens of the capital's cheese shops. Follow the advice of Nicole Barthélémy and you will only buy what is in season. Facing page: Delicious little goat cheeses on sticks.

Where there is bread, there has to be cheese, said writer Colette, quoted by the no less great cheese merchant Pierre Androuët. In one of his many books on cheese he wrote, "Paris has all the cheeses, the soft, the bitter, the tangy, the strongly fermented, the ones that age in the cellars of France and the ones that come from afar. None lack customers. What is missing are the women, the people who know something about cheese. Women are fond of cheese but they have fallen prey to an obsession with slimness." Is this sad state of affairs still true? In the French capital—and by extension the cheese capital—the number of cheese merchants and shops selling dairy produce (known as BOFs for *beurre*, *œufs*, *fromage*—butter, eggs, and cheese) has fallen drastically, and it is true that women continue to be obsessed with their weight, but cheese lovers can gather some reassurance from the fact that the fat content of cheese is not nearly so high as they once might have thought. Measurement of the fat content of cheese was once taken from a dry extract, in other words, the residue after all the water has been removed. Yet this meant that a *fromage blanc* cream cheese actually composed of only 8 percent fat had to be labeled as being made up of 40 percent fat content, while a camembert containing 25 percent would be labeled as containing 45 percent in fat. To better inform consumers, France introduced a new labeling system for cheeses in 2007 and labels can now indicate the product's actual fat content. This new approach is no doubt encouraging women to reintegrate cheese into their diets, and as those "who know something about cheese," they are likely to be seeking quality products from unpasteurized milk, perhaps bearing *appellation d'origine contrôlée* labels guaranteeing their contents.

Pierre Androuët, who in the early 1970s had trouble in convincing people of the superiority of these "country" cheeses, would be pleased to note that he has won the battle for public opinion and that authentic, unpasteurized, strong-tasting cheese has become the benchmark for quality in the eyes and mouths of Parisiennes and French women in general. This "ideological" battle was won by a few elite cheese merchants, among them Androuët, whom we have already mentioned, Marie-Anne Cantin, Marie Quatrehomme, and Roland Barthélémy. Barthélémy has led what amounts to a crusade to rehabilitate the profession of cheese merchant and have it recognized through a special "Meilleur Ouvrier de France" (literally, best craftsman in France) competition for the profession. In 1997, he achieved his goal, and in 2000 the first four candidates received this prestigious, state-recognized award, with a deserving few added to their ranks every year since, a sign of the importance of emulating one's peers in a profession such as this. But what can one expect of a "Meilleur Ouvrier de France" cheese merchant? Roland Barthélémy describes as follows the ambition that must

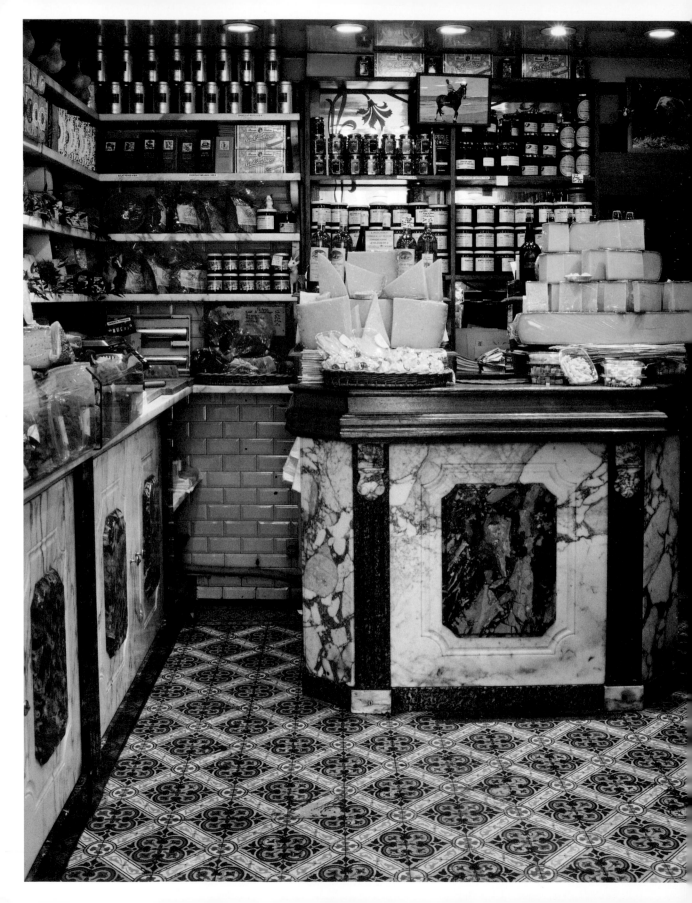

drive a hopeful candidate: "He has to make the role of the cheese merchant intrinsic to gastronomy as a whole." As for what the jury looks for: "A "Meilleur Ouvrier de France" cheese merchant should be capable of suggesting combinations of cheese with various dishes and wines, without trespassing on what is ultimately the preserve of the chef, and also propose subtle marriages of tastes, like for example Roquefort with gingerbread or fruit. He should be able to create flavored goat cheeses or blend radically different cheeses like a Coulommiers that has a bloomy rind, with a creamy truffled Mascarpone." In short, they are looking for creativity. Barthélémy himself is a keen promoter of this sort of creativity. Since 1971, cheese lovers have been making the pilgrimage to this shop—now

BARTHÉLÉMY

Lose your heart to a delicious Brie (above). Anyone who is anyone comes to this little old-fashioned cheese shop that also sells every possible cheese accessory you can imagine (facing page).

run by Nicole Barthélémy—on the corner of rue de Grenelle and boulevard Raspail in the heart of what used be known as the Faubourg Saint-Germain. As you squeeze into this tiny 150-square-foot (40-square-meter) boutique where only cheeses in season are on display, it is hard to imagine that the cellar extends to three times that surface area and contains up to three hundred varieties of cheese at different stages of maturity. And of course throughout France—in Bauges, Salers, Roquefort, Fort des Rousses, or Doubs—cheese is waiting in various stages of development in dairies and caves before being shipped here. The creations are reason alone for a visit, like the little terrine of fresh goat cheese with its alternating layers of cheese and fresh tomato that are doused in a coulis of fresh tomato, basil, and *tapenade* (black olive paste). Then there is the fabulous Mont d'Or trussed up in a spruce-wood corset to prevent the cheese from oozing out; Barthélémy removes the rind from on top so that all you have to do is plunge a spoon into the creamy mass inside. And advice is always on hand to help you get away from the time-honored cheeseboard and move on to something more gastronomically exciting, like mixing little balls of Bleu d'Auvergne with walnuts, Chaource with yellow plums, or Ossau-Iraty with cherries.

On the far side of the Champs de Mars is Marie Anne Cantin, another high priestess of Paris cheese. Together with her husband Antoine Dias, this passionate and vivacious woman has become an ambassador for French cheese throughout the world and for cheeses from the rest of the world in Paris. In Japan, she has outlets in Tokyo and Kyoto, and from her cellars in the seventh arrondissement over 450 pounds (200 kilos) of cheese are sent each week to the Land of the Rising Sun. As supplier for twelve years to the presidential palace, the National Assembly, and the Senate, she has also been responsible for generating awareness of French cheese among visiting dignitaries. Alongside the traditional Brie, Comté, and Roquefort you might expect, she is happy to display English Stilton, Cabrales from Asturias, real Greek Feta,

MARIE ANNE CANTIN

*At Marie Anne Cantin's,
behind the Champ de Mars,
you will find tiny fresh goat
cheeses, perfect for a little
snack, or Camembert, that
she ripens herself, made from
unpasteurized milk.*

and Queijo Serra da Estrella from Portugal. Cantin is delighted to introduce Parisians to cheeses from what she calls "our European cousins." Her boutique has become an obligatory staging post for tourists to Paris and is present in every guide book to the city. There isn't a moment in the day when an American or Japanese tourist cannot be found admiring the huge choice of cheeses that fill the shelves of her boutique. Cantin welcomes everyone, tourist and loyal customer alike, with the same smile and is happy to explain why France has the best cheese in the world: the diversity of its countryside and climate, its mountains and the seasonality of its cheese that depends on the three best periods in the year for milk—the sprouting of the grass (the germination), the first flowering of the pastures, and the second growth of grass. But she is not afraid to gently rebuke her customers when they don't include in their selection one of the European cheeses of which she is such a champion. The mayor of Paris, Bertrand Delanoë, has been spied enjoying a two-year-old Comté in her cellar. Hardly surprising, when, according to Cantin, this is the ideal age for this hard cheese. The privilege of visiting the immaculately maintained cellar—strictly in keeping with the latest hygiene regulations—is reserved for the lucky few, but as soon as you open the door of one of the four cold rooms that she uses to ripen her cheeses, your senses are flooded with the aromas that burst forth from within. As a gastronome herself, Cantin is happy to dispense useful advice to those who buy her products and to suggest delicious recipes that will add a new dimension to your enjoyment of cheese. In winter, she suggests soup of milk and Roquefort; in spring, canapés of goat cheese with paprika, cumin, and mixed herbs (tarragon, chives, chervil); in summer, Fontainebleau with strawberries and lavender flowers; or in fall, hare with Comté. All are testament to the abiding creativity and intelligence of this woman who has devoted herself to a fundamental component of fine French cuisine. Even if one may deplore the fact that good bakeries and cheese shops are no longer to be found at every street corner in Paris today, the continuation of these traditional stores where the alliance of breed and cheese is celebrated is tantamount to an oath for the future, a promise that these key products remain in the hearts of Parisians.

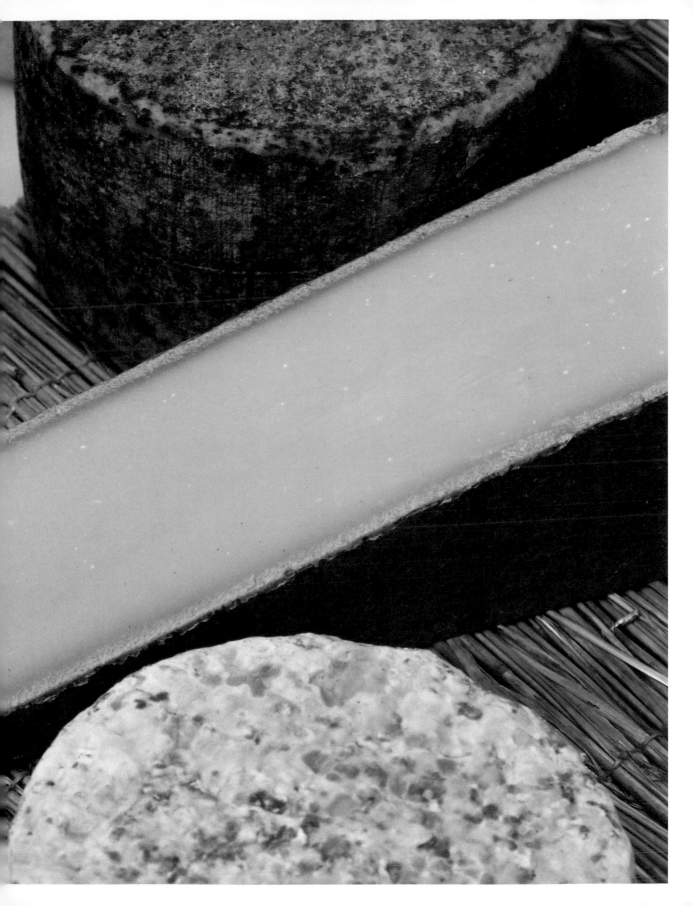

Another natural partner to cheese is wine, and Paris's love affair with wine goes back a long way. We know from the correspondence of the Emperor Julian—who made the city his capital—that the Romans were the first to plant vineyards in Paris, or Lutetia as it was then known, on the slopes of Suresnes, and on the hill of Montmartre. In October each year, the grape harvest is still the occasion for a party. In a fable from the Middle Ages, "The Battle of the Wines," the best wines from Paris—those from Montmorency, Mantes, Meulan, Pierrefitte and Argenteuil—hold their own against the finest growths from Champagne and Burgundy. Meudon, Sèvres, Issy, and Auteuil, suburbs of the city, were as renowned for their wines as Ay and Chablis. And while everyone knows that Paris is surrounded by five rivers, the Seine, the Aisne, the Marne, the Oise, and the Yonne, it can be said that a sixth river—of wine—has served the city since time immemorial, when wine from every region in France would flow into the capital to be stored in wooden barrels, first at place de Grève, now known as place de l'Hôtel de Ville, and later in vast warehouses further downstream at Bercy. The city became France's most important center for trade in wine, in particular because it was home to the wine merchants who "followed the court," twelve suppliers granted the right to supply the king with wine. But the populace also had a healthy, not to say insatiable, appetite for wine, albeit of a lesser quality than that drunk at court. In suburbs such as Belleville, Auteuil, and Suresnes, wine was sold at half the price as that in the capital because it was not subject to the tariff imposed inside the city limits. As a result, *guinguettes*—out-of-town taverns—like the Ramponneau flourished. White wine (*la blonde*) and red wine—the darker the better—(*la négresse*) flowed freely, and while the quality may have left much to be desired, all that was asked of it was that it produce the required inebriation among its consumers.

For a long time wine was just another part of the Parisian diet; serious appreciation was reserved for an elite of connoisseurs. Parisians thought they knew all there was to know about wine because they drank so much of it. In fact they drank far too much of it: at the bistro, during meals, and between meals too, to help them work better they claimed. Whether it was the physical exertions of a stonemason or the mental efforts of a writer, wine was the essential lubricant. And, of course, they drank it whenever they had a party. Suffice it to say that Parisians were not always the most discerning of wine drinkers. Indeed, up to thirty or so years ago, wine was still often bought in bulk and bottled at home, and since cellars in Paris apartment buildings are often small and not especially safe, it was best to drink it up quickly. Wine as an essential part of the art of living was only for the cosmopolitan privileged classes. While Paris might have been the wine capital of the world when measured by volume, its great rival London drank less, but what it drank was of better quality. This was the ultimate paradox: a city that was the capital of a country with the finest wines in the world was itself not particularly concerned about the quality of what it drank. Without generalizing too much—the city's great restaurants were always well stocked with a plentiful supply of *grands crus*, and the gourmets that frequented these establishments knew how to marry a particular dish with just the right wine—most of the wine to be found in the city was of pretty poor quality.

LA DERNIÈRE GOUTTE
At La Dernière Goutte, Parisians are introduced to little-known wines from around France by an American! (facing page).

LA DERNIÈRE GOUTTE
*Wine lovers gather
to worship at La Dernière
Goutte, in a cellar just a few
yards from place
Furstemberg, behind
the church at Saint-
Germain-des-Prés.*

But over time, with the rise in living standards and the move away from manual labor, new consumption patterns emerged. Wine ceased to be an essential component of every meal and became instead something to be relished and enjoyed with reference to its regional origins, indeed it came to be seen as the expression of a culture if not an entire civilization. Parisians began to take a greater interest in their national beverage. In their quest for greater knowledge of their country's traditions they were to be guided not by their fellow Frenchmen but by foreigners such as George Bardawil, an Englishman who in the early 1980s introduced Paris to the wine bar when he opened L'Écluse, the first of what was to become a chain. Anglo-Saxons have played a significant role in introducing Parisians to the discoveries they have made throughout France's regions, in the same way as they have been responsible for drawing the Parisians' attention to every last vine of the Bordeaux and Champagne regions. Their own islands being devoid of any sort of vineyard, these eminent wine connoisseurs came in search of approbation. Or was it just that they wanted the approval and recognition of the French and Parisians in particular? For Michael Broadbent this was indeed the case: he was the first wine expert to organize an auction of fine wines at Sotheby's, and in 1971 the French government awarded him the Agricultural Order of Merit.

With this in mind, it is fitting that we begin our wine tour of Paris with another foreigner, Juan Sanchez. Cuban-American in origin and hailing from Miami, he originally came to Paris to study cookery at the École Ferrandi that has trained many of France's top chefs. Naturally, his interest in food led him to wine, and in 1993 he opened Les Béoux in the heart of Saint-Germain-des-Prés. He moved premises, remaining in the same area, but changed the name to La Dernière Goutte. The new boutique is distinctly specialized and holds minimal stock, because with the sort of pragmatism for which Americans are renowned, Juan Sanchez only sells the very best wines, though at reasonable prices, in the process earning the ultimate Parisian accolade—usually bestowed excitedly—of "excellent value for money." Many have tried the same formula, but few have succeeded as well as La Dernière Goutte. Because he was not born with the genetic tendency to vacillate only between Bordeaux and Burgundy that affects so many Parisians, Juan Sanchez chose to promote lesser-known wines that were beginning to make rapid advances in quality but were as yet unknown outside their regions: Corbières, Faugères, Coteaux du Roussillon, and Languedoc are all from the far south and their reputation in the capital had been marked by a quality in the past that was not always what it should have been, but Parisians have since come to love these wines for their intensity. As he continued his journey up the Rhone, Sanchez came across some of the better-known wines but continued to find here and there, in Savoy and Jura—as well as already established regions such

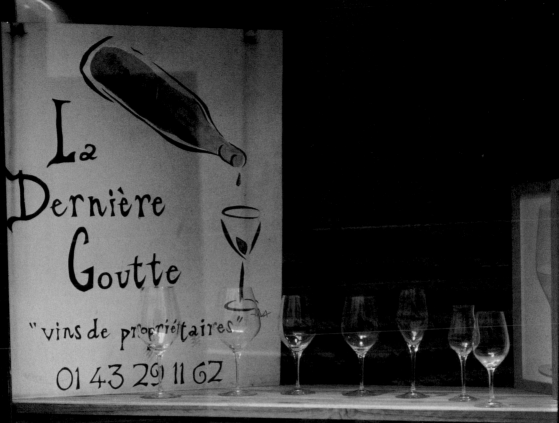

LEGRAND

Weekly tasting sessions
are organized around
the U-shaped bar at
Legrand (facing page).

as Beaujolais, Alsace, and Champagne—winemakers producing the sort of wine he liked. Marcel Lapierre, André Osterag, and Anselme Selosse were not the stars they have since become when they first brought their wines to La Dernière Goutte for the tasting sessions that were organized there. This astute American has discovered a rich stream of wine for his local clientele, and it took an outsider, passionate about his latest discoveries to forge a lasting link between a highly demanding public and the avant-garde of French wine. After World War II, Saint-Germain-des-Prés became known for its basements where one danced existentialist be-bop. Nowadays, it is wine that provides the atmosphere in those same cellars.

Paris is filled with local wine shops where buying wine remains a personal affair and the wine merchant if not a personal friend, is at least a willing accomplice. Les Caves Legrand is a good example of the sort of place where Parisians—who for the most part do not have their own cellars—nonetheless have the impression that their own personal reserve of fine wine is ageing nicely in the boutique's cellar. Since 1880 this venerable, not to say patrician, institution situated between the Galerie Vivienne and rue de la Banque has been to Paris what Berry Bros. & Rudd is to London: the arbiter of good taste when it comes to wine. Generations of Parisians have shopped here, not just for wine but also for fine foods and sweets. The boutique has retained the aura of an Ali Baba's cave about it, with its jars of hard candy, boxes of tea, and baskets of duck sausage. But above all one comes here for the wine. Legrand has always known how to change with the times. Until the end of the 1990s it was still being run by descendents of the founders, first by Lucien Legrand and then by his daughter Francine. Lucien Legrand was one of the first Paris wine merchants to hunt down the "little" winemakers who made and bottled their own wine, something which was not as common forty years ago as it is now. Parisians can thank him for the discovery of vineyards that were relatively unknown at the time but that have since entered the pantheon, such as Zind Humbrecht in Alsace and La Grange des Pères in Languedoc. Despite being bought out by a wine dealer, the current team has maintained this tradition and come up with its own discoveries: Domaine Bizot in Vosne Romanée and the Rectorie in the Roussillon are just two of them. Legrand has also known how to adapt to the changing tastes of its Parisian clientele: on the Galerie Vivienne side, a tasting area complete with a U-shaped bar and a *table d'hôte* menu, is the perfect setting to explore this newfound attitude to all things related to wine. Merchant banks are delighted to invite their clients for tastings of the most prestigious wines here, private individuals to celebrate a birthday or wedding with friends. Every Tuesday, wine experts and sommeliers host tastings for the uninitiated, and beneath the gallery, where thirty thousand bottles of France's finest wines are stocked (though this is only a fraction

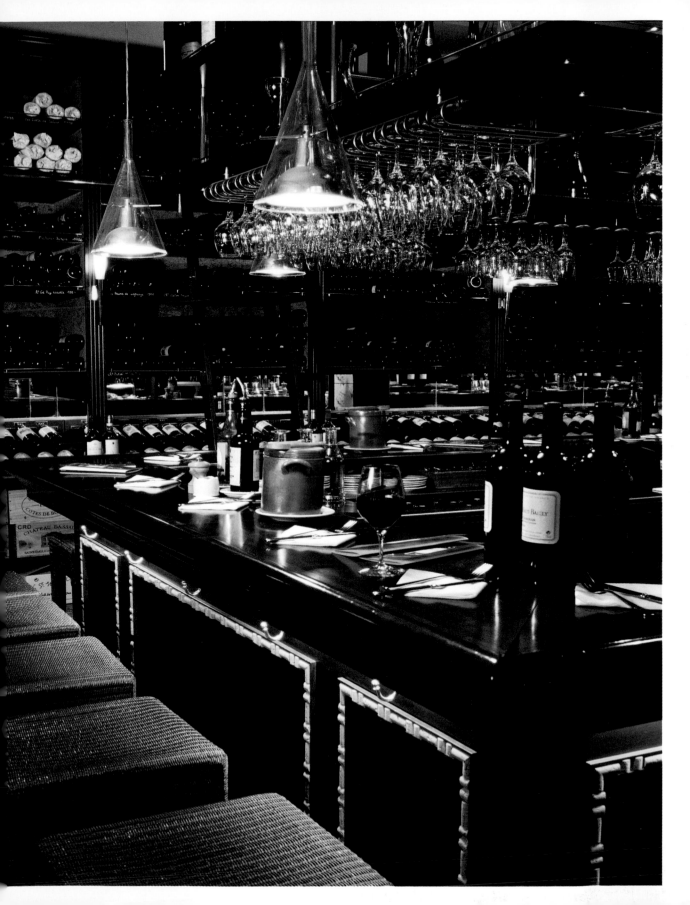

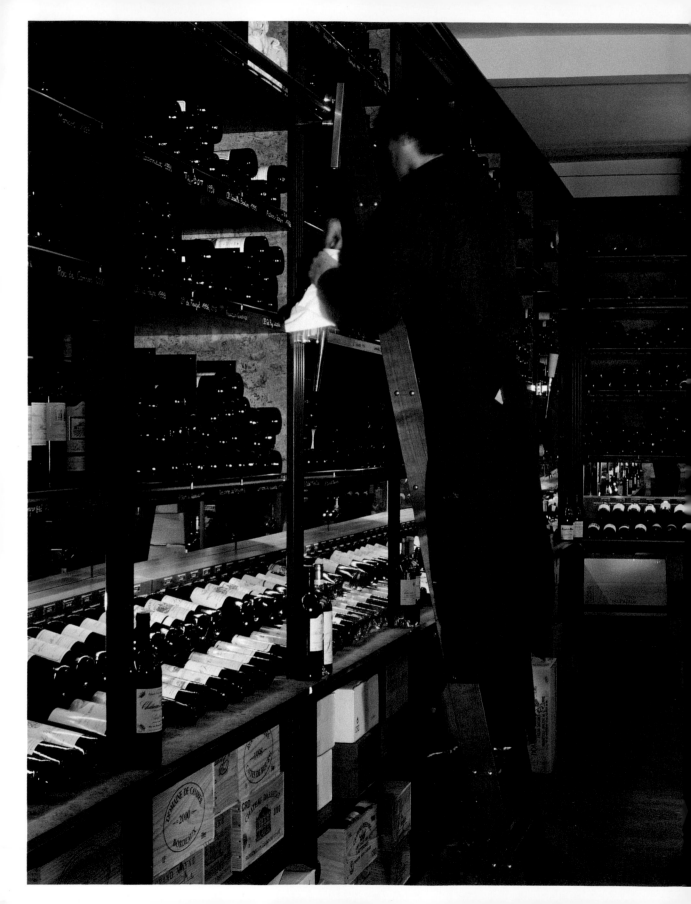

of the hundred thousand or so bottles that constitute Legrand's war chest), the boutique offers an original wine stocking service.

The wine trade is particularly keen on inner circles and brotherhoods. The history of Le Repaire de Bacchus is a case in point. Its founder, Dominique Fenouil, started life as a middle manager with Philips, and in 1983 his employer gave him the not unpleasant task of buying five thousand cases of wine falling within the "Grands Crus Classés" classification to use as rewards in an incentive campaign for the sales force of one of its subsidiaries. The club that he created as part of this operation gave rise to the first Paris outlet of Le Repaire de Bacchus on rue des Acacias in the seventeenth arrondissement. For the first time in Paris, free

LEGRAND

Legrand, close to place des Victoires, offers an astonishing selection of grands crus *and table wines.*

tastings were on offer, some of which have gone down in the club's annals: such as the assortment of Petrus '78, Romanée Conti '84, and Yquem '81 offered for tasting in 1987 or the tasting of five vintages from Mouton Rothschild in 1988 and the same again, only this time with Latour, in 1990. Since then, the number of outlets has grown exponentially. There are numerous shops now in Paris and its environs, a good many of which continue the club's tasting sessions. Le Repaire de Bacchus's strength lies in the loyalty it has succeeded in generating among a predominantly well-off clientele that is happy to trust it and go along with its recommendations. Now with several thousand members, the club can no longer afford to be as generous with the wines it offers for tasting as it was in the 1980s. The selection of wines has broadened, and nowadays it is the discoveries and personal favorites that Dominique Fenouil and his team come up with that draw the crowds: the Château Beaucastel from the Frères Perrin in Chateauneuf du Pape, the Château Le Thil from Jean de Laitre in Pessac Léognan, the Domaine Sarda Malet by Jérôme Malet on the Côtes du Roussillon, and the Château Hostens Picant from Sainte-Foy de Bordeaux. Le Repaire de Bacchus has also used the goodwill associated with its name to launch a range of spirits that have not been colored, caramelized, or otherwise adulterated, which it sells under the brand-name "Natural Color." Five types of spirits—armagnac, calvados, cognac, rum, and whiskey—are rolled out in thirty-three separate products, all contained in clear glass bottles so as best to display the lightness of the alcohol inside. Dominique Fenouil's revolution in this regard is all the more remarkable when one considers that—with the exception of J&B and Cutty Sark—practically all whiskey is artificially "darkened" and then bottled in opaque bottles so as to boost our impression of the spirit's strength. Interestingly, Paris has become the European test market for single malt whiskeys with distillers launching there for the first time specialties like vintage malts, whiskey that has been aged in oak barrels previously used for *grand cru* wines, and even whiskey straight from the barrel before it has had time to reduce. Boutiques like La Maison du Whisky now specialize in these limited-edition whiskeys.

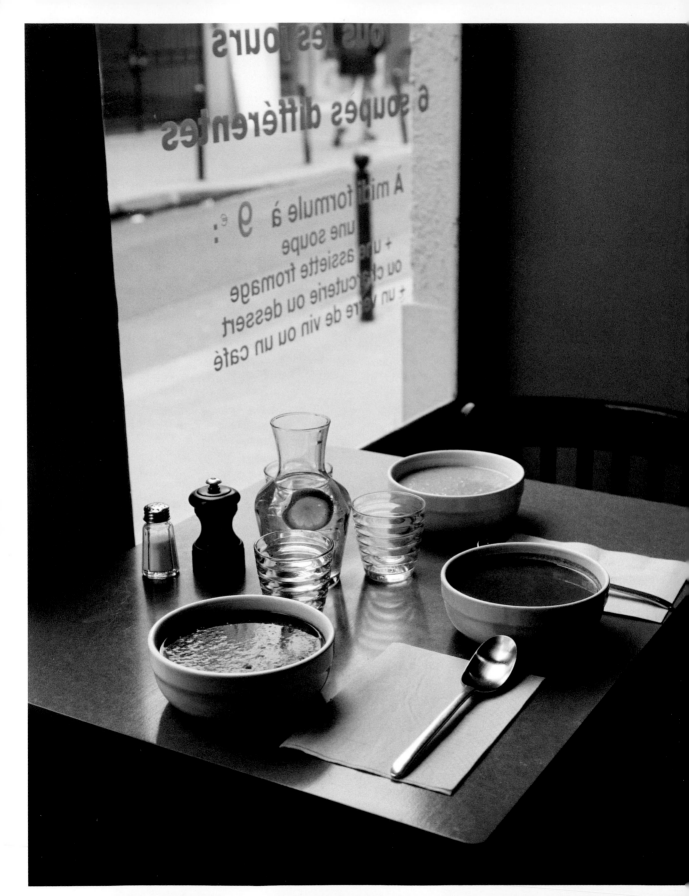

The word "restaurant" was first used in 1765 to designate a tavern where "restorative" soups were sold. Over the entrance of a certain Monsieur Boulanger's café on rue des Poulies was the Latin inscription, "Venite ad me omnes qui stomacho laboratis, et ego restaurabo vos," which literally translates as "Come unto me all ye whose stomachs labor, and I will restore you"—a parody of the Gospels. As the Enlightenment was well under way by then, Boulanger managed to avoid attracting the wrath of the Church, but he did upset the caterers' guild which contested his right to sell food. When he eventually won his case before parliament, he opened the very first restaurant, which proved to be the forerunner of today's soup bars. Others followed, including the renowned chief caterer to the Count of Provence, Antoine Beauvilliers, who founded the first upscale restaurant, La Grande Taverne de Londres, in 1784. But let us return to the "soup bars" that became hugely popular in Paris during the nineteenth century, when they were known as *bouillons*—in honor of the bouillon, or stock, that provides the main ingredient in any good soup—and that remained popular until after World War II because of their reasonable prices. Establishments like Chartier and Café du Commerce catered to thousands of workers every day. At the time, soup was a dish for the poor. With the advent of self-service restaurants and office cafeterias, the *bouillons* gradually disappeared. Like traditional restaurants, "soup bars" were a Parisian invention. But while the former thrived and went on to become a worldwide phenomenon, the latter owe their resurgence to influences from outside France and in particular to a phenomenon that originated in the United States. During the 1980s, soup—despite its rural connotations—began to crop up on the menus of U.S. city restaurants. The combination of good old-fashioned soup with the convenience of fast food owes its success primarily to women. In Paris, the first new-style "soup bar" opened in 2000, fueled by the success of the concept from the other side of the Atlantic. But in reality, owner Anne-Catherine Bley is perpetuating a time-honored Paris tradition in her premises, whose façade is New York cab yellow, on rue de Charonne just two minutes from the Bastille.

A former music industry marketing executive, she used none of her training when it came to launching her Bar à Soupes—she did it completely on instinct, and out of frustration at not being able to get a healthy, tasty, and natural meal next to where she worked. And what could be healthier, tastier, or more natural than soup? But unlike her counterparts in New York or Boston, she has opted for a huge choice of soups—over eighty in all—and the charm of her little establishment lies in the wide variety on offer. Of course, gazpacho makes its appearance in summer and vegetable soup in winter, but the winter menu also features— just to cite a few examples—split-pea soup with bacon, and tomato and apple soup with ricotta, while the summer menu includes carrot soup with coconut milk and meatball soup flavored with cumin seed.

LE BAR À SOUPES
Red (gazpacho), yellow (pumpkin), or green (watercress)—the choice of soups at Le Bar à Soupes on rue de Charonne near the Bastille is as colorful and varied as an artist's palette (facing page).

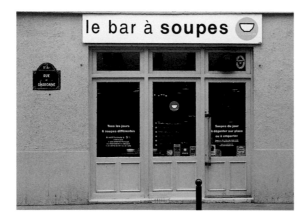

Bley has refrained from opening other outlets and personally supervises the output of her chef Fritz Talvin, a former pastry chef also responsible for the traditional deserts that round out the menu, including homemade *clafoutis* and French-style crumble. The welcome is distinctly personal with Bley behind the cash register playing the role of big sister to her customers, never afraid to hand out advice ("That's enough protein"), encouragement for those on a diet ("You've lost weight since the last time you were here"), or just a warm word ("Enjoy today's selection of colors and flavors"). She even has something to say to the Japanese who have flocked to the Bar à Soupes ever since she appeared on Japanese public television channel NHK: "Arigato!" The soup bar on rue de Charonne has become something of an institution, a slice of gastronomic life as it were in one of Paris's hippest neighborhoods, where Bley, far from trying to start a franchise empire, is quietly working away at her own version of a restaurant where everything is "handmade" and the soups are haute cuisine.

At the same time Anne-Catherine Bley was launching her operation near the Bastille, Giraudet, which for over a hundred years has been producing and distributing traditional soups, was looking to capitalize on its experience by opening its first retail outlet. Since 2002, the designer Bar à Soupes et Quenelles has been doing just that a few yards from the Marché Saint-Germain. It is a roaring success with the publishers and bourgeois bohemians who populate Paris's sixth arrondissement—it would be all the more surprising if Bley hadn't already demonstrated that soup has come a long way from its populist roots to become one of the favorite dishes of a certain elite. Even more unusual is how the same people have taken to the traditional quenelle from the Bresse region, simply poached and served as an

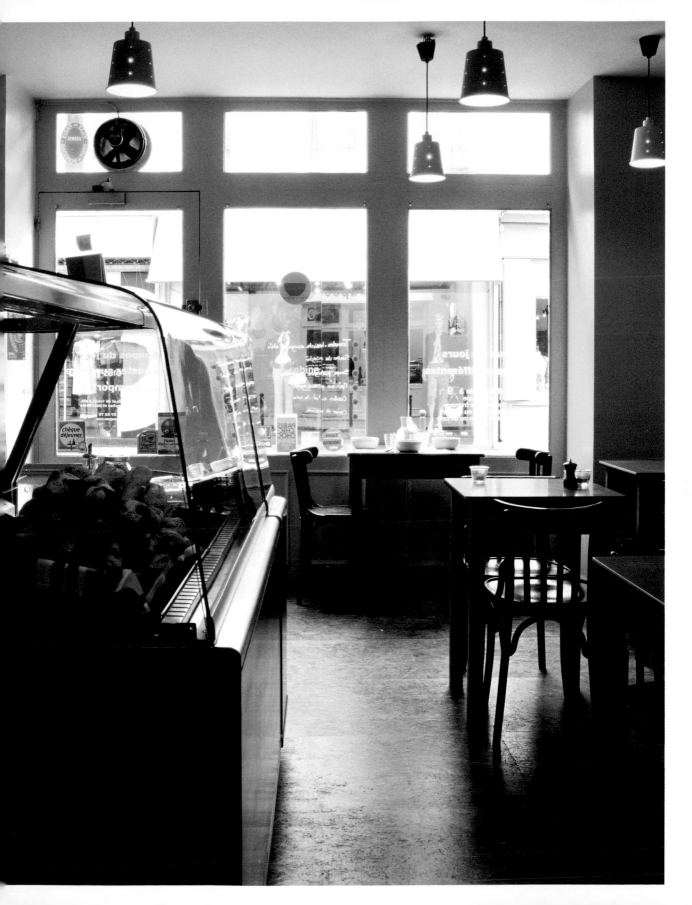

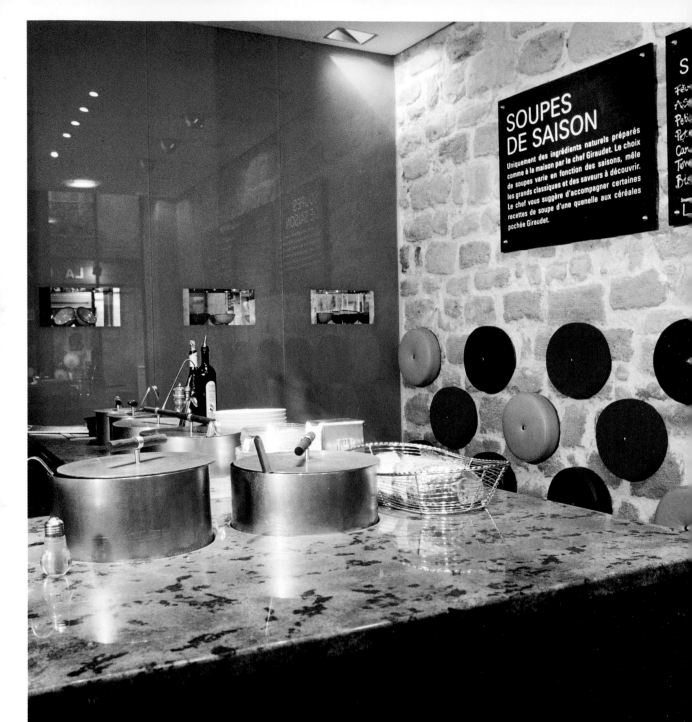

**SOUPES
DE SAISON**

Uniquement des ingrédients naturels préparés
comme à la maison par le chef Giraudet. Le choix
de soupes varie en fonction des saisons, mêle
les grands classiques et des saveurs à découvrir.
Le chef vous suggère d'accompagner certaines
recettes de soupe d'une quenelle aux céréales
pochée Giraudet.

accompaniment to soup or as part of a series of tapas *à la bressane*—evidence of a return to the gastronomic values of a past century. The quenelle has long been a staple of Lyonnais cooking. It was considered the ultimate delicacy, whether made from pike, chicken, or crayfish. Giraudet's Michel Porfiro prefers to use semolina or rye instead of flour or breadcrumbs in his quenelles to keep them as light as possible. A few yards from the restaurant, on rue Mabillon, Giraudet has opened a boutique where the full range of Porifiro's specialties is on sale. Nowhere else in Paris can you find such a selection of miniature culinary masterpieces— quenelles of pike or crayfish, with morels or porcini, with rye and hazelnut oil, or simply plain with sesame oil—as well as an organic range. Handmade quenelles line the immaculate store window like so many jewels waiting to be chosen by discerning gourmets.

BAR À SOUPES ET QUENELLES

The design of the Bar à Soupes et Quenelles, near the Marché Saint-Germain, is resolutely modern and it attracts a loyal following at lunchtime from the artists, publishers, and journalists that populate the neighborhood (facing page). Favorite soups can also be taken out in bottles (above).

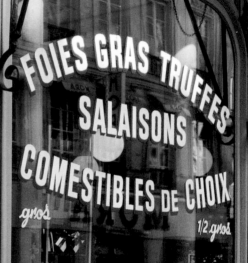

Gourmet food stores
and coffee merchants

**LE COMPTOIR
DE LA GASTRONOMIE**

*In the heart of Les Halles,
Le Comptoir de la Gastronomie
maintains the tradition
of fine food in this district,
which the writer Émile Zola
described in the nineteenth
century as "the belly of Paris."*

It would seem as though all of Paris's fine food stores have given in to the craze of letting their customers eat on site. While the privileges accorded to innkeepers may have disappeared with the French Revolution—and even before with the encroachment of the café owners—no law today prevents a delicatessen from setting up a few tables and offering its wares for the gratification of its customers. In this manner you can enjoy a slice of cloth-cooked foie gras at the Comptoir de la Gastronomie, one of the last gastronomic outposts remaining in the old market district of Paris or take a trip to Provence at the Pipalottes Gourmandes on rue Rochechouart on the way to Montmartre, where you can nibble on an open sandwich of sun-dried tomatoes and thyme drizzled with olive oil or knock back a mussel stuffed with pesto.

While Paris is increasingly taken with a simpler and faster approach to food, there is still a preoccupation with quality, tradition, and authenticity. All three are in evidence at La Crémerie, also known as the Caves Miard, just a few yards from Odéon. The old-fashioned interior of this tiny space has been preserved, including a beautiful ceiling under glass dating from 1880. Here, the authentic original furnishings stand, such as the refrigerator and ice chests once used to store dairy products. But instead of cheeses and cream from Normandy, La Crémerie offers a selection of the finest Spanish cold cuts and has a cellar with some magnificent French wines. Although owner Serge Mathieu may not be officially affiliated with the Slow Food association that works to protect culinary traditions, he adheres resolutely to its spirit. One comes to La Crémerie to enjoy the exceptional *burrata* cheese from the village of Corato at the heart of the Puglia region, the traditionally-made Prince de Paris ham free

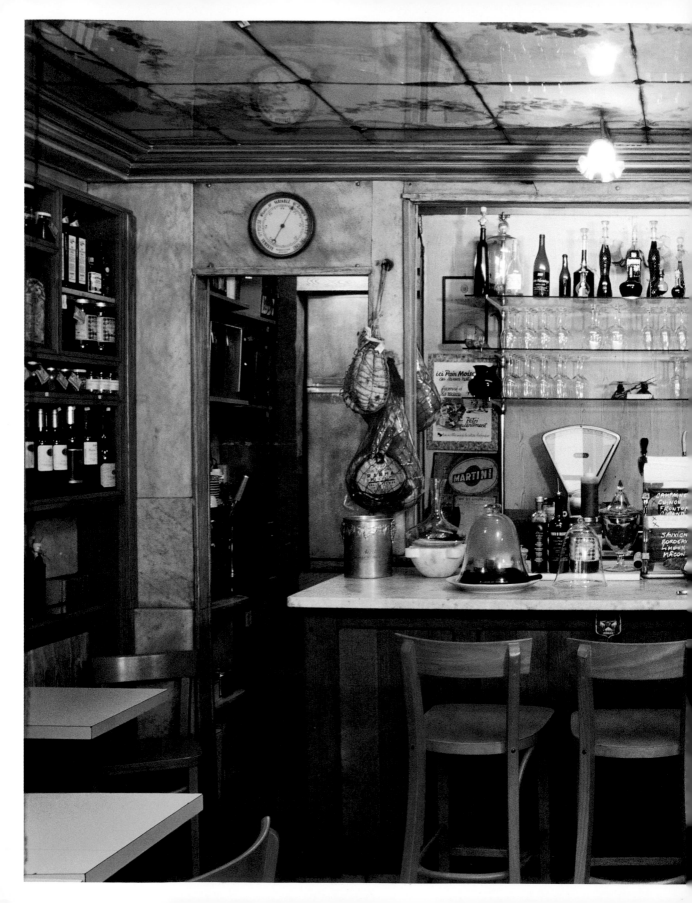

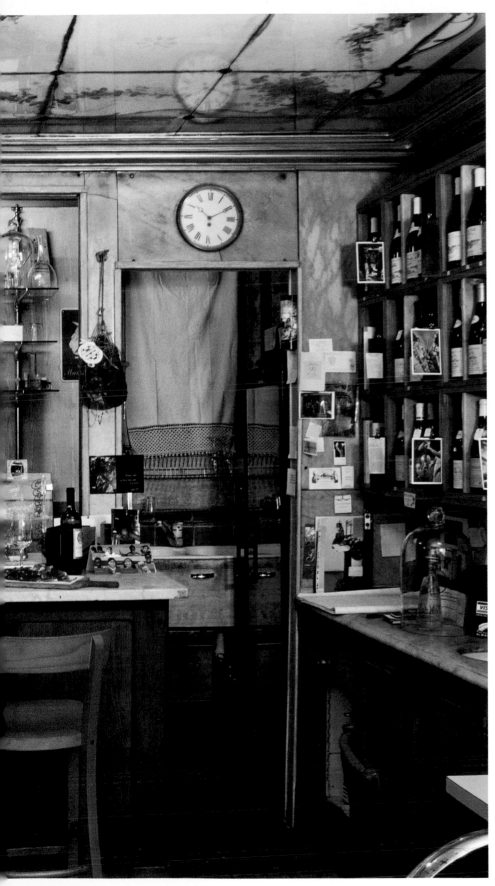

LA CRÉMERIE

*With a bar and twelve seats—
don't hesitate to book!—La
Crémerie has a wealth of
surprises to discover, including
Spanish cured meats, organic
wines carefully selected by the
owner, and delicious* mostarda
di frutta *from Cremona.*

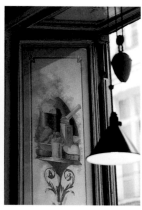

from additives and conservatives, or the tasty Parmesan. In the middle of La Crémerie lies the Rolls Royce of slicers, a 1930s Berkel that has been lovingly restored by Italian craftsmen. The Dutch firm Berkel stopped producing this type of machine in the 1950s, but the Italians have continued to maintain their fleet. La Crémerie also stocks a wide selection of Italian delicacies that are very difficult to find in France: *mostarda di frutta*, a condiment based on candied fruit and a mustard syrup, from Cremona; balsamic vinegar from Reggio and Cremona, and its byproduct, *fragolaceto* jam made from whole strawberries marinated in the vinegar; and, of course, olive oils from Tuscany and Sicily. Everything is available either to eat in the store or take home. Chances are that once you have done the former, you will want to do the latter. And, if you wish to take an "Italian" tour of Paris, Serge Mathieu is your man: he willingly shares his list of favorite Italian trattorias in the city. And if Mathieu sends you, red carpets will unroll to welcome you. La Crémerie may be small, but it is certainly perfectly formed.

LA CRÉMERIE
In the Odéon district, La Crémerie has succeeded in combining the dual role of first-class charcuterie and wine bar, and also manages to be one of the most charming spots in the area (above and facing page). The Berkel slicing machine purrs quietly while customers drink in a delightful turn-of-the-century interior.

Paris has begun to show an interest in all oils that were common to rural society in the period preceding the agricultural revolution of the twentieth century. Before it became available on every supermarket shelf, oil was a rare—if indispensable—commodity that was used not just in preparing food, but also in lubricating machinery. Every region produced its own oil from whatever was grown locally: olives, if that was what was available, but also almonds, argan, canola, hazelnut, walnut, pine-nut, pistachio, and sesame. Some of these oils—argan, for example—are of North African origin. Others have been pressed in France since time immemorial.

Anne Leblanc is from a long line of oil millers. For four generations—since 1878 to be precise—the Leblanc family have owned an oil mill in the Saône-et-Loire region where the local farmers could bring their walnuts and colza to be pressed. At that time, such mills were common in France. Now only a few remain, and the Leblanc family's mill is one of those to have maintained the traditional working methods. While production methods may not have changed much, distribution has changed considerably. The renewed interest in oil as an ingredient in serious cooking has opened up new perspectives for those craftsmen concerned with quality. While Anne Leblanc's brothers Jean-Charles and Jean-Michel have continued to press their oil in the old-fashioned way, their sister sells it in a tiny boutique on rue Jacob, between the École des Beaux-Arts and the rue de Buci market, where connoisseurs can procure those oils which they would be forgiven for thinking had disappeared. The oils served up here are pure extracts of the original fruit, because the oils at Leblanc are simply decanted directly into the bottle,

never filtered. The flavor is all the more intense for doing so. And in the same way as Oliviers & Co. set the scene for Paris's claim to olive oil capital of the world, who knows but that in time Leblanc, from its postage-stamp size boutique might well do the same for canola, hazelnut, or walnut oil.

Paris is also the coffee capital of the world. No matter what time of the day or night, coffee is a fundamental part of Paris life whether drunk standing at the bar or sitting on a terrace watching the beautiful people go by. London has its pubs, with their beers and spirits; Rome its bars where you can drink coffee, but there you always knock it back quickly. Paris has cafés, and it is no coincidence that although these institutions also sell alcohol and soda, they bear the name of their most popular beverage. But Parisians increasingly complain about the quality of their preferred stimulant. While not striving to imitate the Italian *ristretto*, which they think is too strong and bitter, and rejecting what the Americans call coffee, which they consider too bland to be the real thing, they nonetheless recognize—not without a certain nostalgia—that their own coffee is no longer what it used to be. A few decades ago, the old *cona* machine, a paraffin-heated contraption where the coffee brewed in the upper part before dripping into the jug below, still reigned supreme in the former coal merchant cafés. This has been replaced by the infernal espresso machine, which overly concentrates the taste of the coffee, making it difficult to appreciate, and couples this with a noise like that of a steam engine. The *cona*, on the other hand, allows the full aroma of the coffee to be released, and nothing is better for those roasted mocha or Arabica beans than long, slow infusion far from contact with metal. Real coffee lovers have taken refuge in their own kitchens where they perpetuate the Parisian coffee tradition, and in doing so are helping to maintain an equally important Parisian custom that is inextricably linked with coffee, the art of conversation. In former times, at literary salons, whether at court or in town, a sharp wit was often looked down upon and Parisians were considered superficial. The eighteenth-century statesman and diplomat Talleyrand noted as an excuse for this national propensity to "speak without saying anything," that "the power of speech was given to man to hide his true thoughts." But he was quick to attribute to coffee all the virtues he most admired: "Black as the devil, as hot as hell, as pure as an angel, and as sweet as love."

For perfect coffee, look no further than Café Verlet, situated not far from the Palais-Royal on rue Saint-Honoré. Here, we see that Paris's coffee merchants have nonetheless managed to uphold their traditions. Or rather, that they have managed to rediscover their traditions, because it was only in 1965 that Pierre Verlet started selling a range of the finest Arabica coffees to restaurateurs, and subsequently to the general public. Thus, from October to

LEBLANC

In their earthenware pots, the oils pressed by Leblanc and sold in the boutique Tomat's Épicerie on rue Jacob in Saint-Germain-des-Prés are a reminder of times when oil served many purposes, not just for cooking but also for oiling machinery and lighting. Nowadays, however, their oils from a wide variety of fruits and plants serve only one purpose: to please the palate.

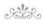
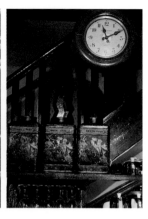

✻

CAFÉ VERLET

*At the Café Verlet, next
to the Palais-Royal,
an old-fashioned
percolator is still used
to brew the coffee, while
the original clock keeps
ticking in a timeless setting
(above and facing page).*

January, they travel the world—from Cameroon to Laos, from Mexico to Panama—armed with a miniature coffee roaster and coffee maker so as to judge for themselves the quality of that year's crop. That was how the Thong Set farm on the Bolovens Plateau in Laos was found. In the Americas, they buy from the Torcaza farm in Panama, run by planters of Swedish descent who maintain the traditions of Scandinavian social democracy: a dispensary for the farm workers, schools for their children, recycling of the water that is used for washing the beans, and, of course, meticulous, not to say clinical, attention to detail when it comes to caring for the coffee bushes, be they of the Bourbon, Tipica, Catuia, or Caturra varieties. But Café Verlet's work is not limited to choosing the finest beans. The beans have to be roasted, and they only reveal their true qualities after they have undergone this subtle process. Each roaster has his trade secrets, and each type of coffee needs roasting to a different point. For Café Verlet, "You have to adapt the roasting of each type of coffee to the final taste that it will have." Only through experience and innumerable experiments can you tell. To avoid such mistakes as too fast a roasting, which results in an acidic taste, it is best to roast slowly. Similarly, too high a heat will result in a "burnt" taste, which is known as the "Italian taste" because of the Italian penchant for very strong, almost bitter coffee. Yet the so-called German or American roasting methods that are supposed to reduce bitterness have a tendency to exacerbate it because the bean is only browned on the outside and the acidity remains inside. Café Verlet's roasting technique aims to achieve a perfect balance between acidity and bitterness and in doing so to release the essential oils that lie dormant in coffee beans so as to reveal the full range of aromas and taste sensations they contain.

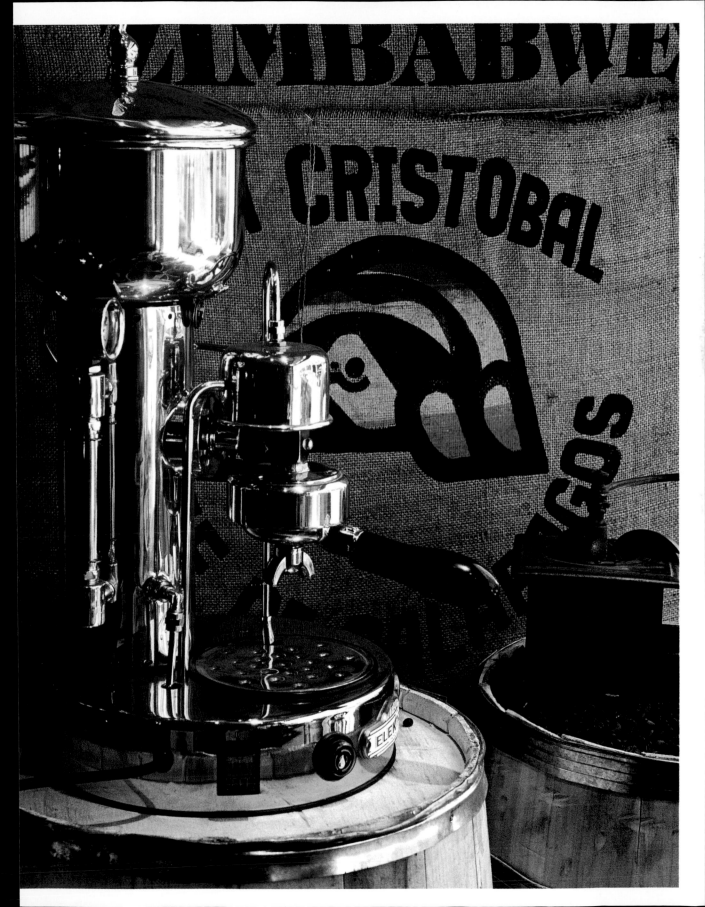

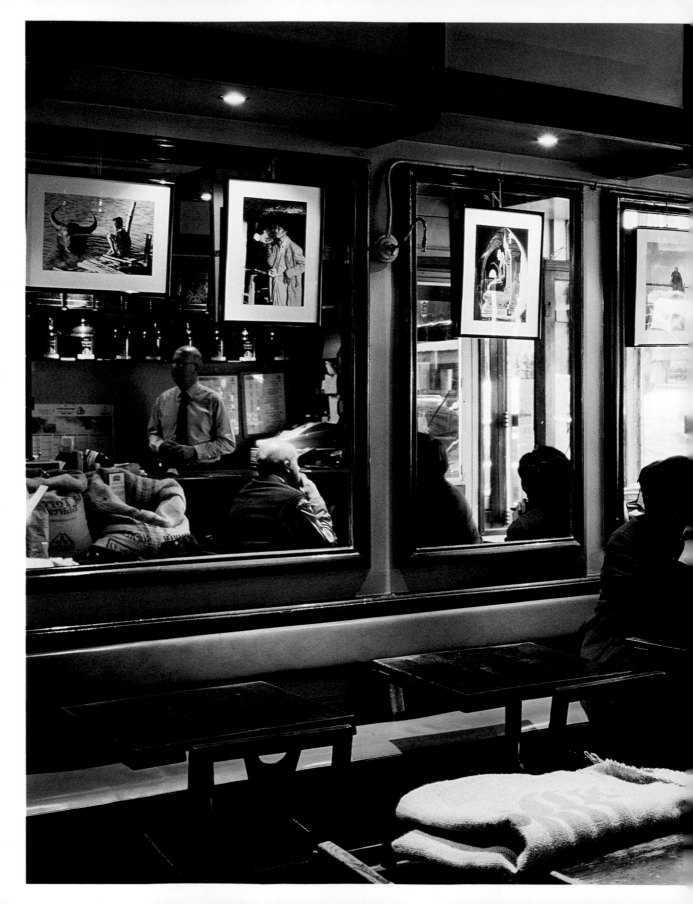

CAFÉ VERLET

Where better to practice the art of conversation than in an old-fashioned coffeehouse where they roast the coffee on site? At the Café Verlet, wit and intelligence fill the air.

Childhood treats

Spain maintains that it was the first to introduce chocolate to Europe, and England that it was the first to eat solid chocolate—in a famous incarnation known as the "Spanish pudding." Honors also go to Switzerland for inventing the technique that gave us bars of chocolate, to Holland for cocoa powder, to Austria for the Sacher torte, to Italy for chocolate truffles, and again to Switzerland for milk chocolate. We owe the mass production of chocolate bars to the United States, and are indebted to Belgium for coming up with the first solid chocolate shells that are now used as receptacles for praline, toffee, or cream. Although France was already host to many chocolate aficionados in the sixteenth century, it cannot be said that French confectioners played a pivotal role in the slow evolution of the delicacy that has since become indispensable to our palates. And yet, would it really be presumptuous to consider Paris one of the world's chocolate capitals today?

"You are a wizard with ganache," declared Jean-Paul Aron—philosopher and author of *Le Mangeur du XIXe siècle*—of Robert Linxe. In 1987, Linxe opened his second Maison du Chocolat in Paris on rue François 1er. Since then, dozens of other branches have sprung up, not only in the French capital, but spreading to Cannes, London, New York, Tokyo, and Hong Kong. Furthermore, La Maison du Chocolat has joined the Comité Colbert, the exclusive reserve of France's leading luxury goods firms. While chocolate may have brought Linxe a long way from his Basque origins, it is worth remembering just how audacious he was in being the first to open a store devoted entirely to chocolate. But then again his chocolates, which he has been selling since 1977, were not like any chocolates available then. He set out to reinvent chocolate and knew exactly how to go about it: by creating an aesthetic emotion around it. He knew that he wanted the experience of tasting each mouthful of chocolate to be comparable to that of tasting a wonderful dish or of contemplating a great work of art, and that to achieve this he would need to attain "excellence, savoir-faire, and good taste." These became his watchwords and governed his whole approach. Robert Linxe ensured that only the very finest chocolate from Valrhona—maker of the best chocolate for use by patissiers—made its way

LA MAISON DU CHOCOLAT

A basket of La Maison du Chocolat's famous praline chocolate eggs (facing page).

**LA MAISON
DU CHOCOLAT**

*Prunes with chocolate;
chocolate, coffee, and caramel
éclairs; and the mousse of
marrons glacés in dark or
milk chocolate (above from
left to right). Close-up
of the seductively shaped
rum-flavored chocolate
truffle (facing page).
La Maison du Chocolat's
delicious chocolate éclairs
(following pages).*

into his products and closely followed the development of the cocoa used. Linxe's good taste was confirmed by the rapturous reception that Paris's gourmets gave to the characteristics of his chocolate—a casing that is super-fine, crunchy, and, above all, neutral so as to highlight the flavors of each ganache; associating different types of chocolate to achieve the perfect balance between the responses of the various senses and the flavors of the filling; and the variety of innovative flavorings that never distract from the taste of the chocolate. Take, for example, the Andalousie, one of La Maison du Chocolat's most popular creations. Inside a casing that is lower in cocoa content so as not to interfere with the taste and texture of the filling, a delicate assembly of strong chocolate from Trinidad, offset by a milder one from Ghana, gives way to a zing of lemon zest that has been lightly infused in cream. The result is both delicious and eminently satisfying. In the Zagora, on the other hand, the strength of the fresh mint infusion is heightened by the chocolate from Trinidad, and the outcome is distinctly refreshing. For the Garrigue, Robert Linxe has combined a small proportion of flowery Madagascar chocolate with a much more assertive chocolate from Ecuador. This combination enhances the flavor of a fennel infusion which is in turn accentuated with a little star aniseed that underlines the unexpected licorice taste. In each of these chocolates, as in everything that La Maison du Chocolat does, the hallmarks are a light filling, and clear and precise aromas. Truly, these are chocolates to make your mouth water.

Paris is also the capital of French chocolate made by smaller regional confectioners, of which there are many. Just beside the Moulin Rouge is the L'Étoile d'Or, run by Denise Acabo, an obligatory stop for all those who—unlike Acabo—don't have the time to visit the many excellent chocolate makers outside Paris. With her braids and tartan dresses, some might consider Acabo eccentric, but if she is, it is in a way that makes her passionate about

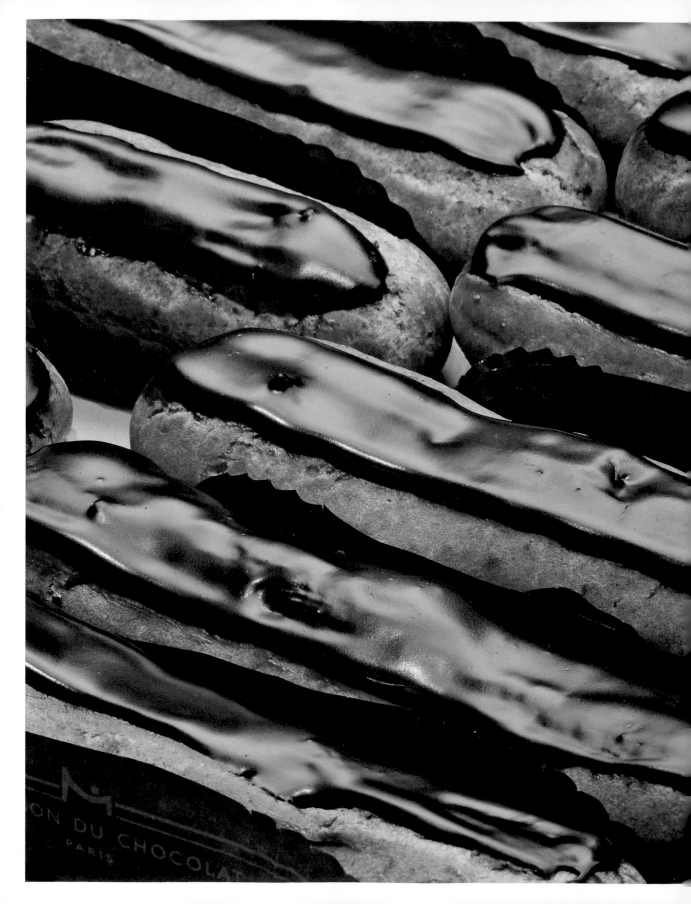

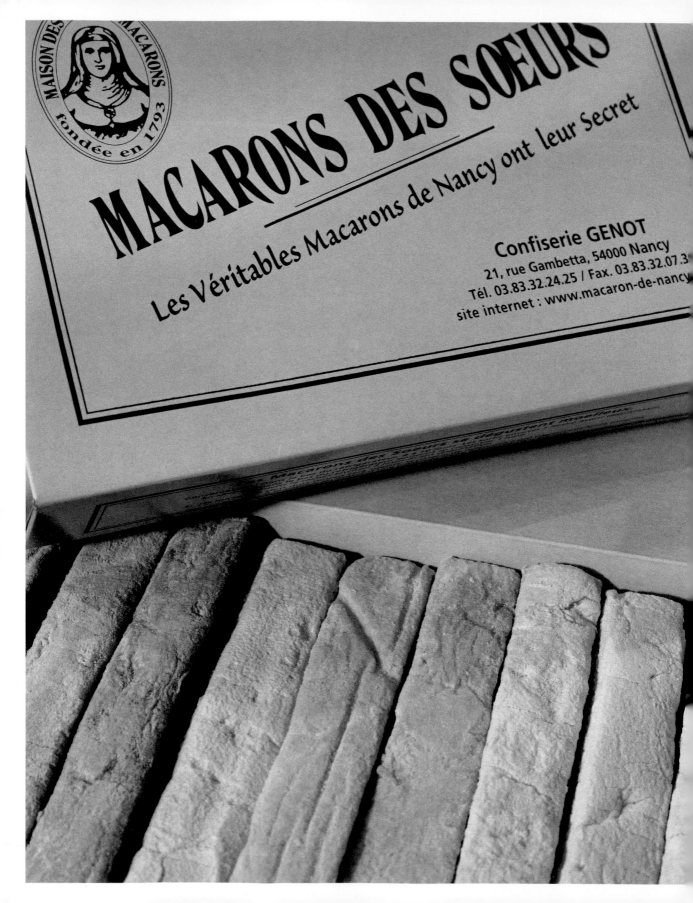

her subject and impervious to fashions or the passage of time. What is her specialty? Chocolate, of course, but also confectionery in general. Her little boutique welcomes the foreign tourists who seem to come straight from the buses that deposit them on boulevard Rochechouart. They come for Acabo, her impeccable palate, and her forthright views. For those chocolate makers who don't have a store of their own in Paris, to be selected by Acabo is equivalent to a national badge of honor. Mind you, she will only accept the very best and even from them she chooses their best items—the crème de la crème—for her boutique.

A visit to Acabo's boutique is like a crash course in the best that French chocolate making has to offer. Start with the world-famous chocolate master from the Rhone Valley, Maurice Bernachon. The son Jean-Jacques upholds the family tradition by making his own *couverture* and roasting beans that come from only the finest sources: Puerto Cabello, Guayaquil, Santa Fe, San Antonio, Madagascar, Jamaica, and Bahia. In the finest tradition, these are combined with the best ingredients—butter from Échiré, cream from Isigny, and the choicest vanilla pods—to produce truly luxurious chocolates that are renowned for their richness and finesse. A visit to the shop is proof of Bernachon's international success with visitors from as far as Tokyo and New York. Denise Acabo carries the full range of Bernachon chocolate in Paris, and is the only boutique to do so. Particularly noteworthy are Bernachon's Palet d'Or, made from *crème fraîche*, dark chocolate, and decorated with gold leaf, and his Aveline, with praline made from genuine Piedmont hazelnuts and wrapped in the finest chocolate. Don't miss his extraordinary range of chocolate bars, particularly the fruit-and-nut and nougatine varieties.

The goods of other French regional chocolate makers are on display in the delightfully old-fashioned shelves and windows of L'Étoile d'Or: look out for Bernard Dufoux from La Clayette in Burgundy. His dark chocolate with figs and prunes, and the aphrodisiac minilog filled with ginger are especially noteworthy. Delicia—little more than a gram of pure cocoa each—are made by Palomas in Lyon, as are Fourvières, small, cocoa-wrapped pralines covered in coffee-flavored meringue. Stéphane Bonnat from Voiron is represented by the Krugette, a strip of candied orange peel dipped in chocolate fondant, and the Sicilian, a honey and rum fondant encased in chocolate fondant. Acabo selects each item with one key stipulation: she must have the exclusive distribution rights in Paris because, as she says, "I am very selective, and I want to be the only one to stock them." And she doesn't confine herself to chocolate. Her boutique is like a merry-go-round where each ride ends with a treat, the stuff of children's dreams. From the Basque country in southwestern France come the black cherries produced by Goizetik; from Corsica, organic jams and chestnut purée made by Marie-Claude Scarbonichi; Fouque's nougat from Signes in

L'ÉTOILE D'OR

Just a stone's throw from Pigalle is the nearest thing there is to a living museum of French confectionery. And make no mistake, Denise Acabo has personally tasted and selected all of the specialties she has on display. Marshmallows and a vintage box of Nancy macaroons (facing page). Hard candy, caramels, and bonbons (below).

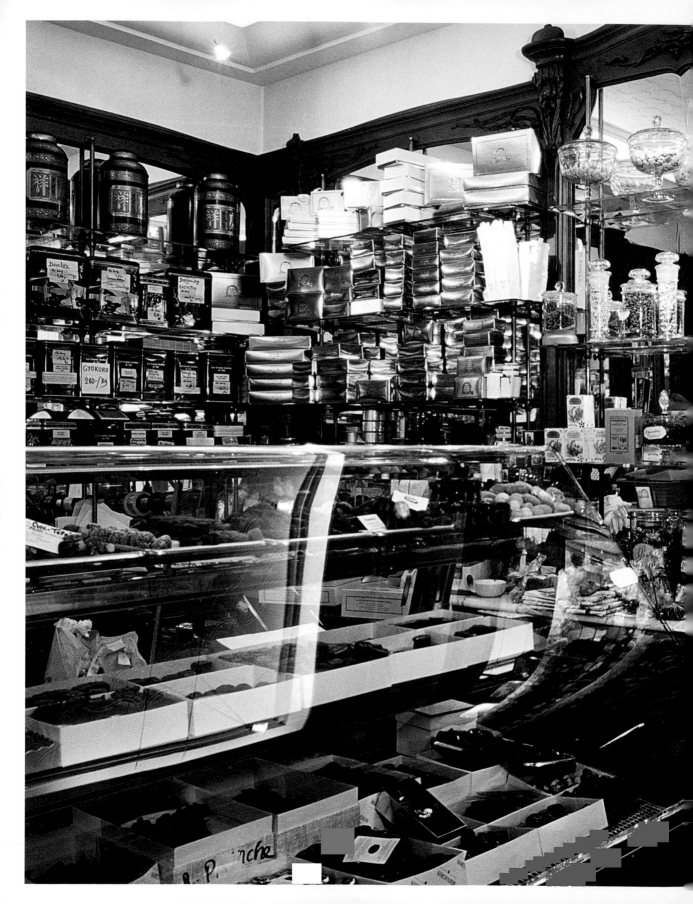

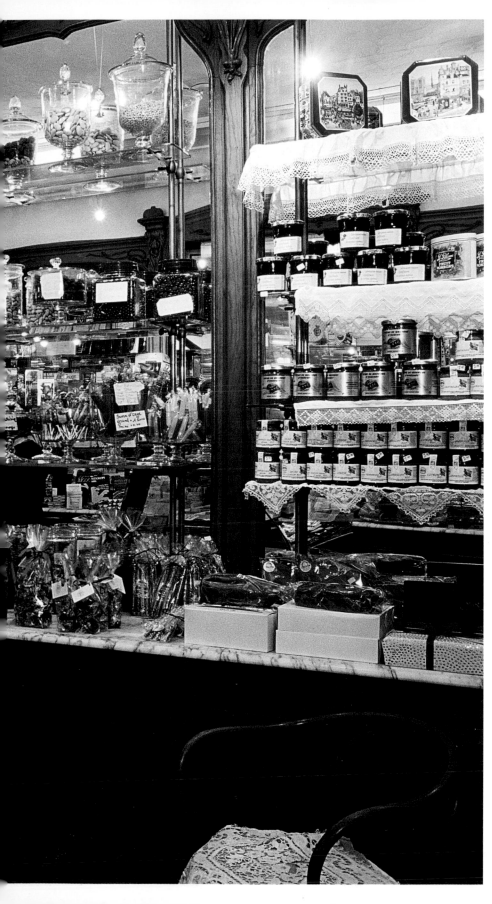

L'ÉTOILE D'OR

A tiny boutique packed with boxes and jars, dominated by a large window display full of chocolates. L'Étoile d'Or is like a chocolate antique dealer where you come to hunt down some forgotten treasure.

À LA MÈRE DE FAMILLE

À la Mère de Famille on rue du Faubourg Montmartre has been for many years the place where well-behaved children come to be rewarded. Hard candy, frimousse *lollipops, and mouthwatering fruit candies (above). Display cases, which have remained unchanged since the nineteenth century, filled with treasures, and crystallized rose petals—the sight alone delights old and young alike (following pages).*

Provence is guaranteed to be 100 percent honey and almonds; the toffees from Quiberon are from Henri Le Roux. Acabo has them all there, unexpected delights that are the best in French confectionery. One might have thought this world lost, were it not for Denise Acabo's Noah's ark of a boutique that proves its existence.

À la Mère de Famille is yet another treasure trove that looks like something out of a short story by Guy de Maupassant. The store's name is appropriate since elegant mothers still congregate here—with or without their offspring. The window is always beautifully decorated for the main holidays, particularly Easter when the eggs are exuberantly decorated. The boutique owns a workshop in Saint-Avertin, outside Tours, where it makes its own chocolate, and sells a chocolate cake kit that includes the necessary dark chocolate and ground almonds—as well as the recipe, of course. À la Mère de Famille specialties include plain ganaches flavored with alcohol, puff pastries that melt in the mouth, and the Mokaresse, a walnut kernel wrapped in a coffee-flavored ganache set on a slice of nougatine. Customers seem to come to À la Mère de Famille first and foremost to treat themselves, beginning with a feast for the eyes. The boutique's "interior" looks the same as it did in the late nineteenth century, when it first opened. The same jars are still used to store the candied fruits, angelica, orange and lemon peel, and glacé cherries that decorate the cakes, and the same windows display the multiple pastel shades of the mouthwatering almond delicacies—*calissons* and *amandins* flavored with orange vodka, prunes in Armagnac, and walnuts in kirsch—as well as tempting *grignotines*, or nibbles, made from chocolate and orange. The fruit jellies are handmade in the Auvergne region, the candied chestnuts come from the Ardèche region—as they should—the multicolored hard candies come in flavors such as violet-poppy and caramel, and the pralines come from Montargis in central France. The cash register, in copper and wood, is taller than a confessional; the assistants still serve as in times past, dressed in white

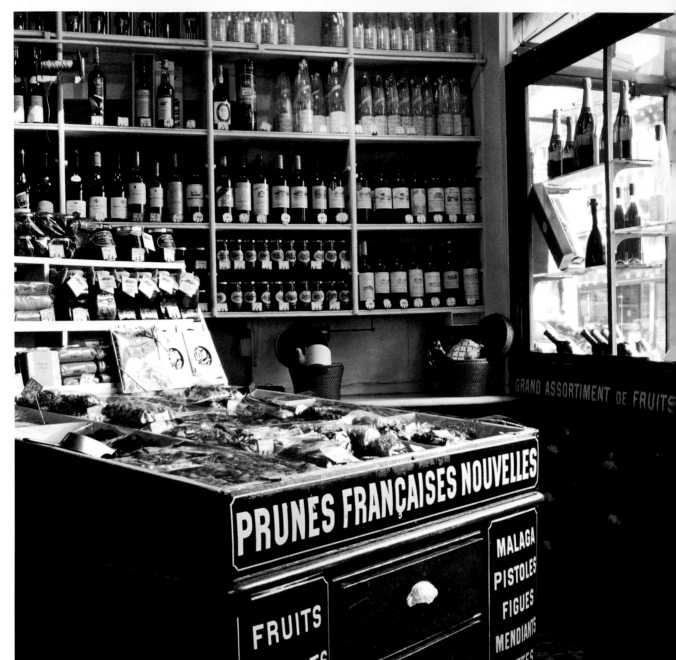

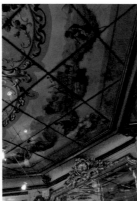

DU PAIN ET DES IDÉES

From its apple turnover, filled not with apple sauce but with half a fresh apple (above, left), to its pistachio rolls (above, right) and its pains au chocolat *(pages 198–99), all the products at Du Pain et des Idées are baked with the highest quality ingredients, making it hard to choose.*

aprons and gloves; and as you leave, they might suggest you buy a "little face" lollipop. Try as one might, it is impossible to resist the old-fashioned charm of À la Mère de Famille, a charm that is guaranteed to send you back to your childhood.

Although the cake may come at the end of the meal, the true Parisian gourmet always leaves room for dessert. The habit goes back to childhood. On Sundays, only the sight of cakes on the family dining table was consolation for an otherwise interminably dull day. Any Parisian worth his salt will regale you with stories about his neighborhood patisserie, but is still capable of going from one end of the city to the other (and beyond if necessary) to taste an *opéra* here, a *mille-feuille* there, or a *baba* just about anywhere.

For a long time, tearooms were simply an excuse for indulging in cakes and pastries under the pretext that one was just having tea with one's friends. And for a long time, the patisserie was an appendage to the bakery where, while choosing a baguette or *pain de campagne*, one could commit the venal sin of looking in the window where the *vacherins* and charlottes lay dormant, and on special occasions—at Christmas, or for a birthday—yield to temptation and splurge. Sunday was the day when cakes were always permitted. Sunday in Paris was dull beyond belief and only distinguished from fast days by the brightly colored ribbons wrapping the inevitable cake box that lit up the eyes of expectant children.

Just a stone's throw from the Canal Saint Martin in the tenth arrondissement is one of the most delightful—and one of the best—bakeries in Paris: Du Pain et des Idées. With its old-fashioned decor and its bountiful displays, featuring large pottery dishes piled high with specialties that are refilled several times a day (and are always empty by closing time), this boutique attracts fans and faithful clients from all over the capital.

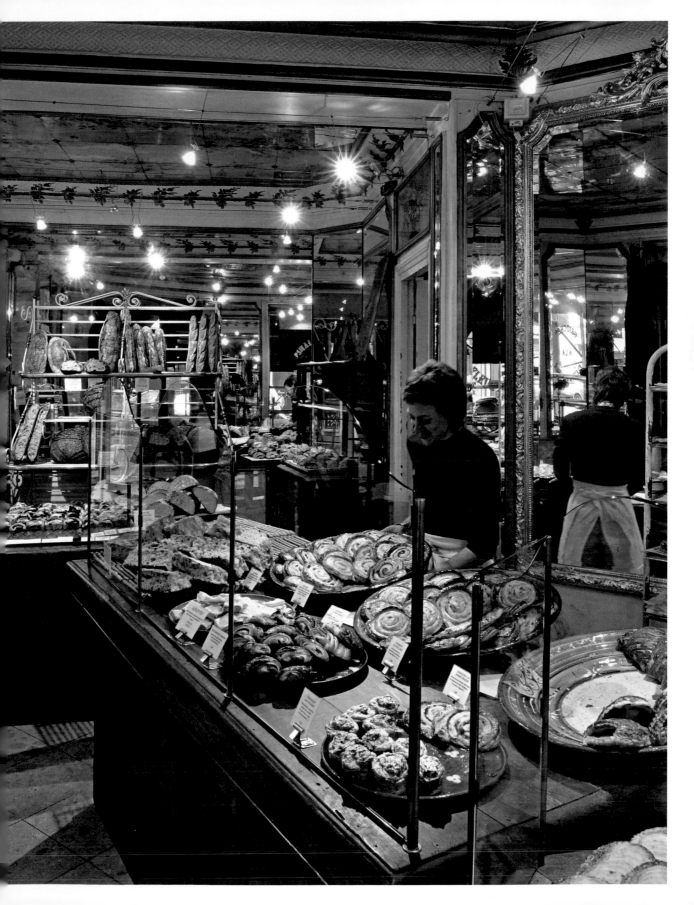

Contemporary Paris

Design and Creativity

The future perfect

GEORGES

GEORGES

The restaurant of the Centre Georges Pompidou is a contemporary art installation, playing on the themes of inside and outside, organic and metallic, transparent and opaque (page 201).

LE CARRÉ DES FEUILLANTS

The entrance area of Alain Dutournier's restaurant near place Vendôme, with a bronze sculpture by Alberto Bali in the foreground, and a painting by Bengt Lindström from his Cobra period in the background (facing page).

Then came nouvelle cuisine. And with it, the whole question of the relationship between the creative act that is gastronomy and contemporary art. The young chefs of the 1960s who wanted to find a space for themselves that broke with tradition were thinking in exactly the same avant-garde way as contemporary artists. Presentation on the plate is an aesthetic matter requiring careful thought; references were sought and found in abstract painting. From there, it was a small step to extend these considerations to the objects surrounding the plate, and the wider setting within which the ceremony of a gastronomic meal takes place. A number of chefs of this generation have continued to collaborate with famous artists and interior designers to create a coherent environment. In 2000, Guy Savoy asked Jean-Michel Wilmotte (who had redesigned the street furniture on the Champs-Élysées) to invent a new interior for his restaurant on rue Troyon. In 2003, Alain Dutournier commissioned the Argentinian painter Alberto Bali to work on his Carré des Feuillants. In both cases, the use of contemporary works and primitive pieces highlights the common ground between the intentionally innovative gastronomic offering, and the abstract forms so characteristic of modern art. This trend was started in Paris by a great chef who is rather less talked about today, Claude Peyrot. His restaurant Le Vivarois opened in 1966 on avenue Victor-Hugo in the sixteenth arrondissement. It was wall-to-wall Knoll International: Saarinen chairs, with walls covered in beige silk and peppered with framed prints. The design provoked sarcastic comments at the time, and subsequently was paradoxically criticized for being "dated." It would probably be back in fashion now, as would Peyrot's cuisine, with its warm oysters and curry, snails with a leek *persillade*, and chocolate *tarte fondante*.

Slightly later examples of this style, characterized by refined elegance without ostentation, are still to be found in Paris. The Flora Danica and the Copenhague, the two restaurants owned by the Danish cultural center, the Maison du Danemark, on the Champs-Élysées, were first opened in 1955. When they were completely redecorated in 1973, the work followed strict

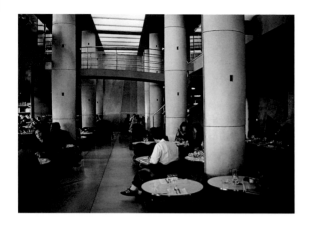

Scandinavian creative criteria, and included the famous purple eggshell-shaped armchairs by Arne Jacobsen. Though refurbished in 2002, the decor in both restaurants remains distinctly 1970s. In Flora Danica the tables and chairs are in light wood, and the fixed bench seats and cardboard lampshades are orange. The Copenhague has very contemporary armchairs in bright red leather, set around strictly white tables. The uncluttered decor harmonizes with precepts of Scandinavian cuisine.

To understand what a clean break the designs of Le Vivarois and the Danish restaurants represented, one has to place oneself in the historical context. A particular sort of restaurant had flourished during the 1950s, a sort of neo-roadside-inn to be found up and down the country as well as in Paris. The walls would be lined with rows of copper saucepans and hunting trophies, the chairs were upright Louis XIII style, upholstered in Genoa velvet, and the tables were solid oak. These establishments, dripping in "early Merovingian" historicism, perpetuated the myth of a rural France that was fast disappearing. This was a period when food critics with questionable political pasts would intone reverently about country cooking, à la Curnonsky, the famous French gastronome whose favored cooking style, rich in sauces and flavors, had dominated restaurants of the interwar period. The whole country was engaged in a backward-looking fervor in which *coq au vin*, *crêpes Suzette*, and *quenelle de brochet* were glorified in a Lewis Carroll-style jumbled celebration. The serving staff still played a vital role in the ceremony of a restaurant meal: carving and flambéing at a side table were de rigueur, as were the convoys of cheese and dessert trolleys. As a result, the restaurant manager or head waiter normally held a much more prominent position than the chef. Then the shock of nouvelle cuisine came and wiped all this solemn formality away. Chefs were allowed space to develop in the foreground. Plates would arrive as finished presentations, rather than being constructed at the table. The physical theater of the waiter metamorphosed into a more serious dramatic style, where manual dexterity was less important than a smooth patter to sell you the chef's culinary breakthroughs and distract you from the price of the wine. Some great Parisian restaurants have stuck to the old tradition. La Tour d'Argent of course, but Lasserre even more so, where the surprisingly eclectic decor embodies both the personality of its illustrious founder, Roger Lasserre, and the spirit of those quiet times in the 1950s when pleasantness and luxurious comfort were more important than stylistic coherence.

Whereas the staunch would-be classicism of the 1950s ended up becoming slightly pompous, the two following decades in Paris were marked by a cheerful recycling of styles, as if the city intended to use its restaurant interiors to flaunt its own historical diversity. One name embodies this enthusiastic (if not entirely rigorous) hodgepodge, more than any other: the iconoclastic Bill Slavik. He first stood out for his surrealist staging of the Drugstore

CAFÉ BEAUBOURG

With its exposed concrete columns, polished concrete floor, and functional walkways and furniture, this café-restaurant designed by Christian de Portzamparc for the Costes brothers in the early 1980s remains one of the most significant creations of the talented partnership (above).

GUY SAVOY

Jean-Michel Wilmotte's design for Guy Savoy's flagship restaurant highlights noble materials and tribal art. Here in the smaller dining area, a partition in wenge wood and an African sculpture (facing page).

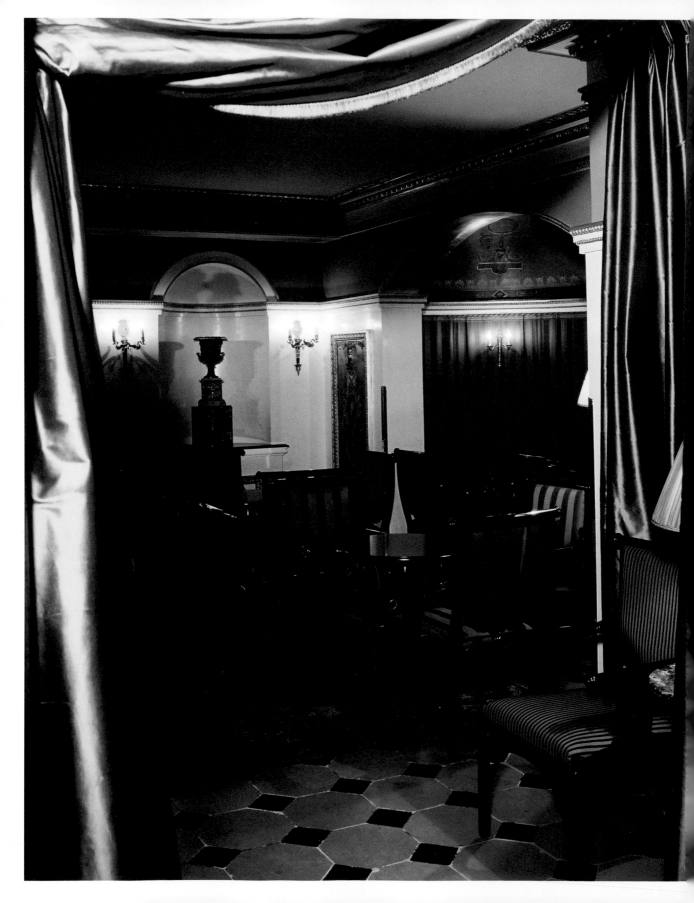

Saint-Germain, on the corner of boulevard Saint-Germain and rue de Rennes. Parisians remember this place as revolutionary in its time, where you could get something to eat until two in the morning, and buy records, newspapers, books, and cigarettes. On the awnings, Slavik had put casts of the hands and lips of film stars, loaded with an erotic charge that bewitched the imagination of the young people hanging around there looking for adventure. Slavik became *the* restaurant designer in Paris in the late 1960s, trotting out variations on ultra-kitsch settings.

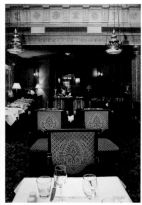

We sometimes forget that the Renaissance owed as much to Lorenzo de' Medici, arts sponsor, as to Leonardo da Vinci. Two brothers from Aveyron in the south of France, Gilbert and Jean-Louis Costes, were to become today's equivalent, gathering and commissioning talent to create a fabulous design empire. At the beginning of the 1980s, the Costes brothers started to change from small-time café owners into patrons of the arts; they decisively launched artists, architects, and interior designers into restaurant work, nurturing talent that would go on to define the two following decades. Some of the names alone indicate the influence of their patronage: Philippe Starck, Christian de Portzamparc, and Jacques Garcia. Starck was an unknown when Jean-Louis Costes asked him to design the interior of Café Costes in 1983. Portzamparc had won the competition for the Cité de la Musique at La Villette, but his reputation had not extended beyond a specialist inner circle when he was given the contract for the Café Beaubourg in 1986. Jacques Garcia was well known to the rich private clients whose interiors he worked on, but his contribution to Hôtel Costes in 1996 signaled the emergence of a neo-Rococo style, which projected the global supremacy of Parisian gastronomy via the art of interior design. The developer as patron made a fundamental contribution in each case, requiring not only complicity of taste with the artist, but more importantly, a fully professional conception of the evolving restaurant, predating the artist's involvement.

The Hôtel Costes is probably their most significant contribution to the revival of the Parisian restaurant scene. A network of rooms is arranged around a patio with ocher-painted façades, like a Roman villa; the decoration vaguely borrows from a Napoleon III theme, reworked by the eclectic mind of Jacques Garcia. The result is a labyrinthine place that has become one of the secret centers of today's Parisian elite.

It is interesting to compare this interior with that of Le Restaurant on rue de Beaux-Arts, which was also designed by Jacques Garcia, in the 1990s. It is a simpler space, naturally lit from a veranda and a small courtyard with a fountain, and by an overhead opening veiled by an ivory canvas awning. At night the light comes from old copper lanterns suspended from the ceiling.

BON
Details from Philippe Starck's resolutely eclectic interior, perhaps a modern take on the Napoleon III style of the mid-nineteenth century, with its button-tufted walls, stuffed rhinoceros head, and mock African art. (pages 206–207).

LE RESTAURANT
Jacques Garcia is all about dramatizing an atmosphere, with drapes, silk-lined walls, sconces, added marble columns, and a whole series of design accessories that together give the impression of always having been there, as shown here in the restaurant of the Hôtel des Beaux-Arts (facing page and above).

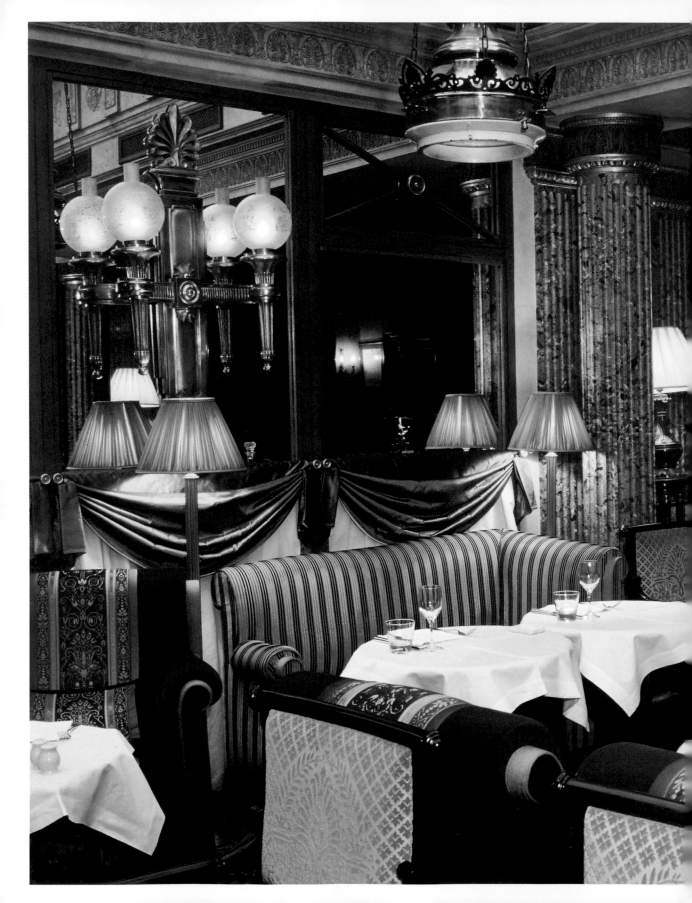

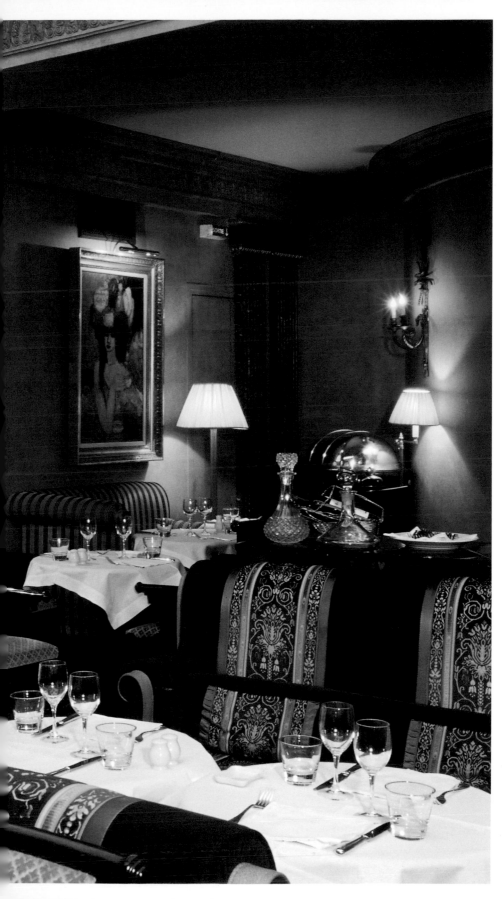

LE RESTAURANT

*Jacques Garcia works
like a cinematographer,
developing illusions to give
an impression of reality.*

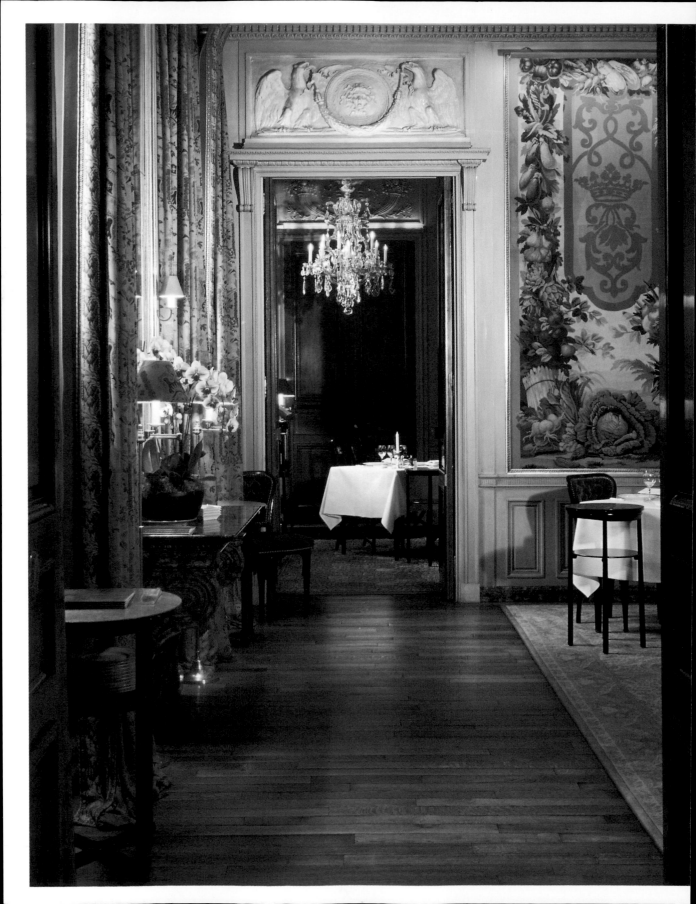

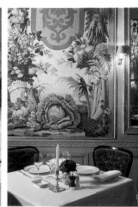

The inspiration is Empire style: upright armchairs, chaise longues, carpets with scrolling foliage, drapery, and those columns he likes so much. There is a pervading atmosphere of gold and green, in keeping with the spirit of the chosen period. How is it then that this design, in all its profusion, is less than convincing? The restaurant owner, rather than trying to manipulate the traditional restaurant space, has relinquished it to the sumptuous and kitsch devices of the designer. What we have here is unfortunately a rather ordinary dining room, which feels stuck on, rather than truly inspired. The food at this privately owned hotel once betrayed the same lack of decisiveness with a fairly classic menu, but since April 2011 a new wind has swept through the kitchen with the arrival of the young chef Julien Monbabut. His classic French cuisine focusing on products and seasons with a touch of modernity has scored him a Michelin star.

Another refreshing breeze, three times "starred" in this case, is also blowing on L'Ambroisie, Bernard Pacaud's restaurant. Here there is a perfect balance between cuisine and décor: the former, perfectionist and untouchable in its classicism; the latter, seemingly straight out of a private mansion in the Marais. The same meticulousness that governs Bernard Pacaud's culinary artistry—he is the spiritual heir of the famous Mère Brazier—is to be found in the details of the furniture and fittings. Some are accumulated antiques, some elements are reconstructions by François-Joseph Graf. Nothing is from one period, yet everything is authentic; the trompe l'oeil succeeds perfectly. The stucco cornices supported by their marble consoles, the chandeliers, and the gold-leaf mirrors all seem to have been there forever. This is an illusion: everything in this part of the building on place des Vosges has been remodeled, starting with the volume of the three rooms, which had the floors lowered and the ceilings raised. In a major piece of work, François-Joseph Graf has managed to bring harmony to a heterogeneous ensemble of elements. So even if the Köln chairs from

L'AMBROISIE

Bernard Pacaud's famous restaurant on place des Vosges gives the illusion of coming straight out of the seventeenth century. François-Joseph Graf, with exquisite attention to the smallest details, has created the perfect trompe l'oeil, combining authentic elements—the Beauvais tapestries or the Köln chairs from the Vienna Opera—with expertly reconstituted features (facing page, above, and following pages).

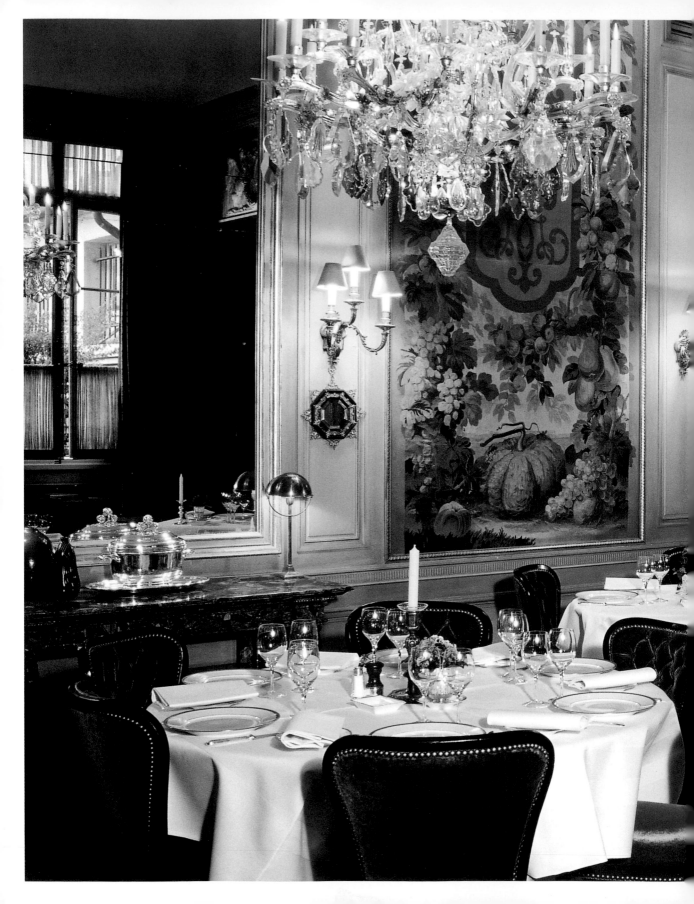

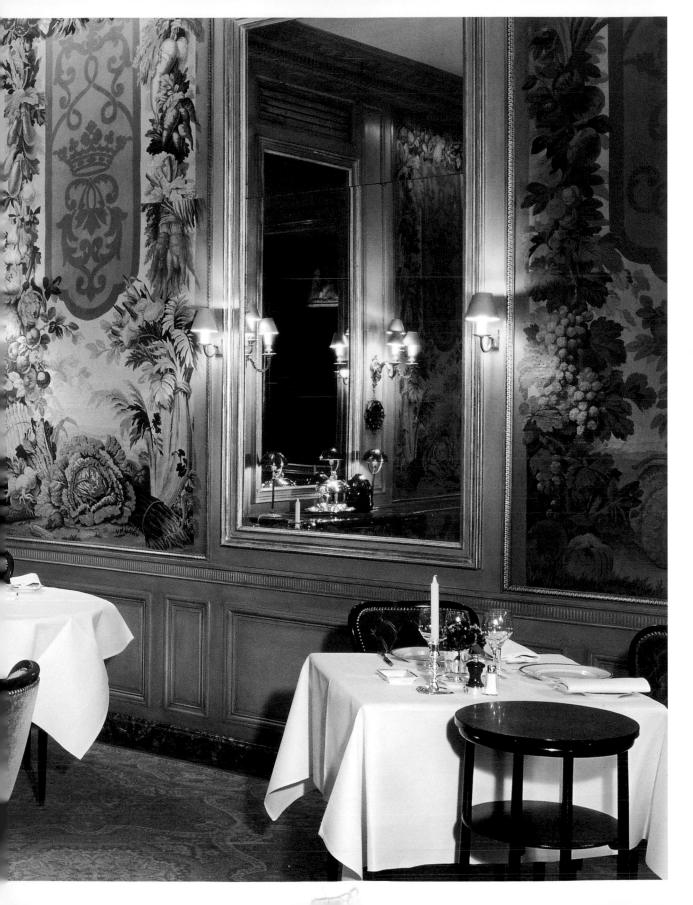

**L'ATELIER "SAINT-GERMAIN"
DE JOËL ROBUCHON**

*The culinary space of the Hôtel
Pont-Royal has something
of a contemporary museum
feeling (below and facing page).
Ingredients and finished dishes
alike seem to be behind glass,
although the proximity of guests
to the kitchen is supposed
to abolish this distance.
Elsewhere, shared tables look
out onto the street, keeping
the bar-top concept Robuchon
likes (following pages).*

the Vienna Opera are typical of 1900, and the Beauvais tapestries on the wall date from
the end of the Enlightenment, and the French crystal chandeliers hanging from the ceiling
exude an essence of the seventeenth-century, L'Ambroisie is bathed in a sort of sovereign
timelessness that places it beyond, and even above, specific fashions. The same is true of
Bernard Pacaud's deceptively simple preparations. Pacaud and his son Mathieu are heirs to
a modest but vital tradition in great French cookery, whose gastronomy stayed as close to its
ingredients as possible. This leading chef shows perfect technique and faultless integrity: no
show-off dishes, just flawless interpretation of the great gastronomic classics, in keeping with
a place that glows with a patina of good taste.

We have seen how the restaurant chef gradually gained control and supplanted the maitre
d'. Sooner or later, this change in the balance of power was bound to show in the architecture
of restaurants themselves. Joël Robuchon, one of the best-known international restaurateurs,
deliberately and very publicly went into retirement at the turn of the millennium. Then in 2003
he returned to the restaurant scene with a new concept: the open kitchen, immediately
arousing lively controversy. But the idea caught the imagination of the Parisian public, who
were, at least to begin with, charmed by the prospect of a gastronomic snack-bar, L'Atelier
de Joël Robuchon. At Robuchon's request, designer Pierre-Yves Rochon placed thirty-eight
stools backed in red leather around a rosewood bar looking directly onto the assembly area
of the kitchen. The kitchen staff, all dressed in the same colors, busy themselves before
your eyes. Spanish hams stand ready on their *jamoneros*; glass bowls filled with blocks of
ice are imperiously topped by pyramids of langoustine; glass and steel shelves show bottle-
ends off to good effect. The staging aims to be sober yet functional, reflecting a style of
cooking that makes many references to the Japanese art of food preparation and
presentation. There is an imposed economy of taste that borders on self-denial; a "this is

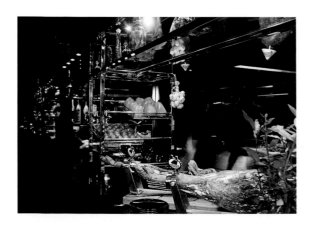

the way things are" attitude that aims to break the culinary
ritual out of its supposedly starchy formality. Yet a human
element has been removed: the service is made less
personal and one feels a distance where there could be
human contact with a maitre d' or wine waiter. As those in
the line outdoors envy each occupied stool and wait for
one to be free, those indoors remain on the outside of an
experience which, after all, is not very participative. The
open kitchen cannot rid itself of an aquarium feel, and the
absence of any intermediary has a disorienting effect. The
result is proof that a desire to "open out" is not enough:
communication is also essential, of emotions, or at least
aromas and voices, which, in this strange, insulated place,
seem peculiarly stifled.

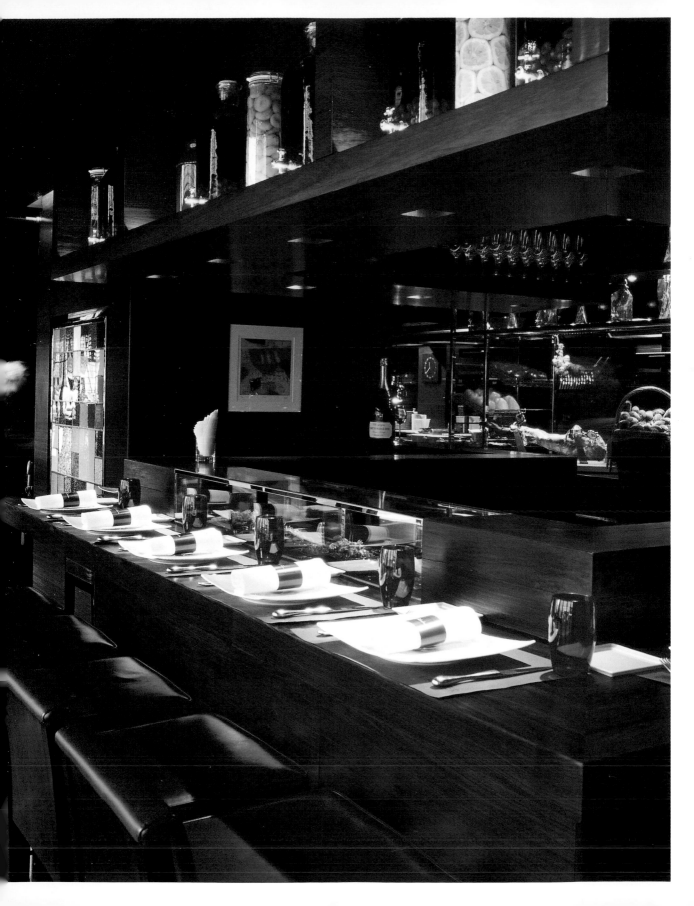

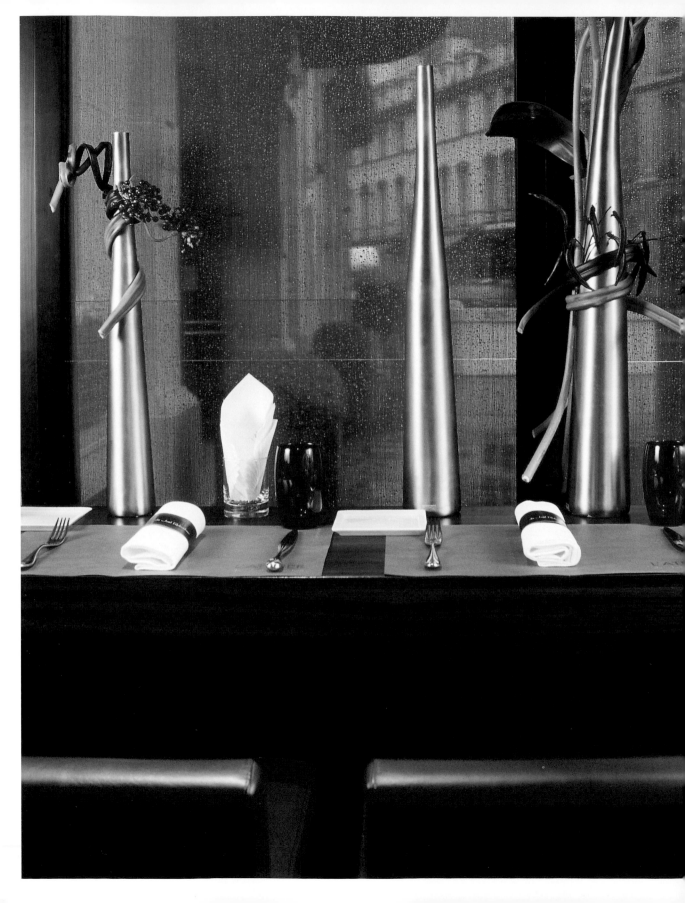

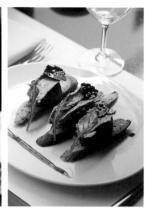

PINXO

*Just near rue Saint-Honoré,
Pinxo draws you into a
friendly shared experience
with its dishes* à partager
*with your companions
(above), closely spaced tables
(facing page), and plating
kitchen open to the dining
area (following pages).*

Curiously enough, with a similar concept and the same designer, Alain Dutournier's Pinxo at the Plaza Paris Vendôme hotel manages to be a perfectly convivial place. Presumably this is because the restaurateur gives proper emphasis to human contact. Visual access to the kitchen is reserved here for a dozen aficionados at a black granite bar, who follow the final phase of the preparation of dishes with interest, the kitchen as such being situated in the basement. The rest of the diners occupy the main room, which is bathed in natural light. Beige blinds filter the light from outside to soothing effect. The materials used are simple: wood and granite for the tables, black leather for the chairs, whitewashed walls. This discreet and elegant design does not get between the guest and the food, which combines playful fusion with a respect for country produce. Inspired by the culture of Spanish tapas—*pintxos* in Basque— Alain Dutournier has instituted a "sharing" concept: each dish is served in mini-portions so that everybody around the table can dip in as they wish and enjoy the meal in its entirety. From chilled *piperade*, poached eggs, and pan-fried shavings of matured ham, to *tataki* of salmon, or Granny Smith apple with horseradish and sweet and sour ginger, the menu proposes a respectful journey among the flavors of the ingredients, without anything jerky or aggressive. Pinxo is a civilized place, built around contemporary fashion, but most importantly it favors the ideas of pleasure and comfort. The public in this area—the highly trendy Saint-Honoré district— know a good thing when they see one, and they have chosen Pinxo as their regular canteen, which is a much more difficult distinction to obtain than a star in the Michelin Guide. The talented Dutournier has caught the attention of the fickle world of Parisian fashion, and has managed to get them in, keep them in, and keep them coming back.

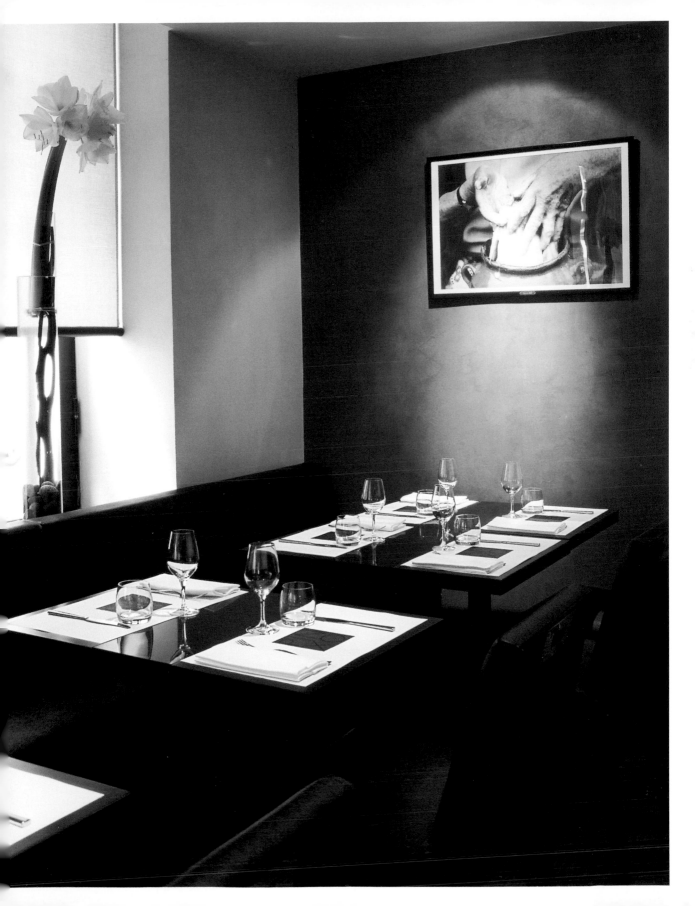

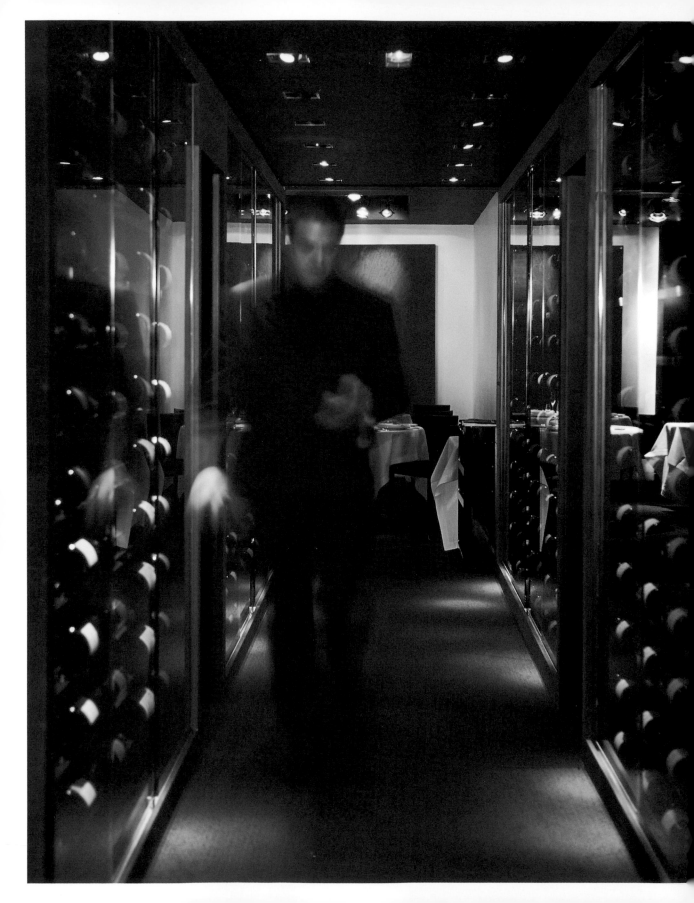

The same regard for conviviality is evident at Le Chiberta, an old Parisian establishment just off the Champs-Élysées, taken over by Guy Savoy in August 2004. The interior was redesigned by Jean-Michel Wilmotte along resolutely contemporary lines. The leading architect's objective was to have different categories of diners come together in a relatively homogeneous space: business-people negotiating a contract, couples dining tête-à-tête, families or groups of friends gathered around a good meal. In Guy Savoy's mind, the one common element to these different worlds is wine, because of its implication of sharing, and he wanted it to be brought into the foreground. Wilmotte obliged with a *cave de jour* where you can see the bottles arranged horizontally behind temperature-controlled

glass, sporting their multicolored labels. This functional design is visible from the entrance area, and is repeated in the secluded dining room where it takes up an entire wall. At the other end of the restaurant, socializing is encouraged at a square bar with about twenty places; cleaved slate blocks surround the top edge and proffer a surface of off-white Corian, a high-tech material combining natural minerals and pure acrylic polymers. One can sit at the bar and grab a bite in a *table d'hôte* atmosphere, which is once again becoming more fashionable in Paris. A few artworks punctuate the black walls: a digital reproduction on canvas of a detail from a street scene by Bertrand Lavier, and three large, colored flats with shimmering back tones by Gérard Traquandi, which are both abstract and sensual.

Guy Savoy's generous cuisine aims first of all to promote the intrinsic quality of the products he gets from his suppliers, among the best in France. The associations he makes are never fussy; they are limited to two or three flavors, combined in such a way that each enhances the other. Roasted langoustine with herb fritters is a harmony of sea and garden; the smooth texture of barely seared tuna is led by a rocket-oil dressing into the contrasting crunch of grilled beans. Another example is the alliance of roast, braised, or pan-fried meats with fruits and condiments: braised veal shank with peaches, pigeon and Espelette pepper, or shoulder of lamb and lemon confit. Within its first year, this place had become an essential address on the gourmet map, combining as it does a youthful attitude to gastronomy, a respect for produce, and a relaxing environment: a real contrast with the constrained ceremony of the grand, traditional French restaurant.

LE CHIBERTA

Wine is omnipresent at Le Chiberta, bringing warmth to Jean-Michel Wilmotte's dimly lit, meeting-friendly interior (facing page and above).

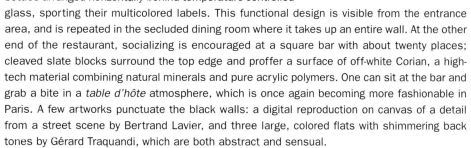

LE CHIBERTA
*Another way
of enjoying a meal:
eating around
the bar, elbow-to-elbow
with other guests.*

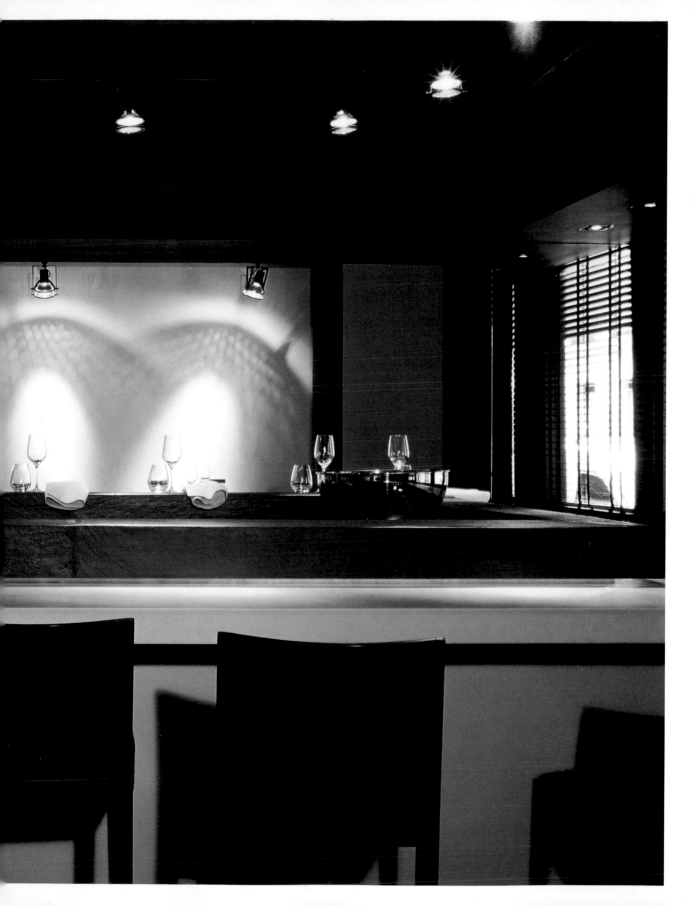

L'ALCAZAR

*At L'Alcazar, behind
Saint-Germain-des-Prés, there
is always a direction to gaze
in: into the kitchens, up to
the mezzanine, or down onto
the open and spacious main
room, an authentic latter-
day brasserie (above and
facing page). The bar on the
mezzanine has fat cushions,
bluish lighting overhead,
and chairs that are very
Terence Conran. The salt
and pepper holders, ashtrays,
and vases were, of course,
designed by the English master
(following pages).*

A breeze from across the Channel has brought success to L'Alcazar, the contemporary
brasserie created by Sir Terence Conran in 1998. This followed his success with Bluebird,
which opened in London the previous year, but Terence Conran has been in love with
continental food culture for a long time. As an unknown designer in 1953 he opened the Soup
Kitchen in London, which bore the distinction of being the first place in the capital to offer
decent espresso. Many restaurants followed in Great Britain, but also in New York, Stockholm,
and, of course, Paris. Over forty restaurants all over the world now operate under the banner
of Conran Restaurants. L'Alcazar, near the École des Beaux-Arts and Saint-Germain-des-Prés,
was originally a court where *le jeu de paume*, the French precursor of tennis, was played.
Then it was a printer's, before becoming the home of Jean-Marie Rivière's orchestral cabaret.
The large, airy space, lit by a glass roof, was ideal for the creation of a sort of loft on two
floors, with the restaurant dining area on the ground floor and a trendy bar above. Eight red
columns structure the large lower room, which is glazed on one side to allow diners to watch
the activity in the kitchens. Bench seats in burgundy velvet occupy the centre of the atrium,
while the wall opposite the kitchen has angled mirrors above the tables, encouraging sneaky
glances at surrounding tables.

Upstairs, the bar is arranged as a mezzanine around the room below, offering views of
the restaurant from all angles. Fun cushions are scattered on the seats, providing patches of
pure color here and there, and stylized low armchairs in white wicker reinforce the impression
of being in a children's playground. And since the guests are forced to talk louder and higher
than the delightfully bracing techno music, this impression tends to get stronger throughout
the evening. L'Alcazar is clearly a Parisian prototype of the trendy hangout, and Sir Terence
Conran has hit on a formula that successfully draws a young crowd into his restaurant.
The food has simple and unsophisticated aims, in line with the tastes of an age range that is
not quite out of its gastronomic childhood: seafood platters, fish and chips for a bit of London

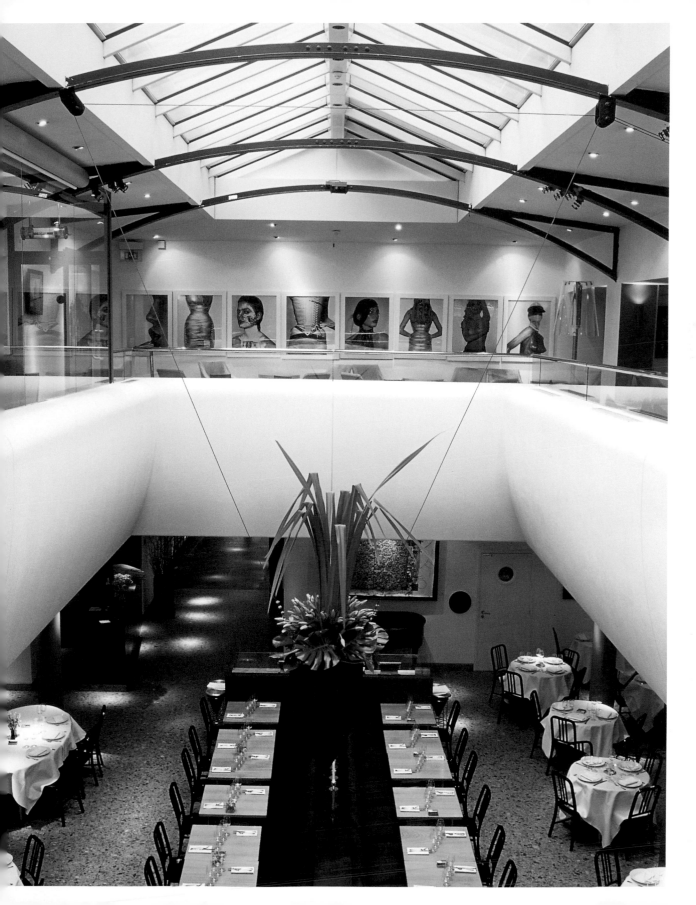

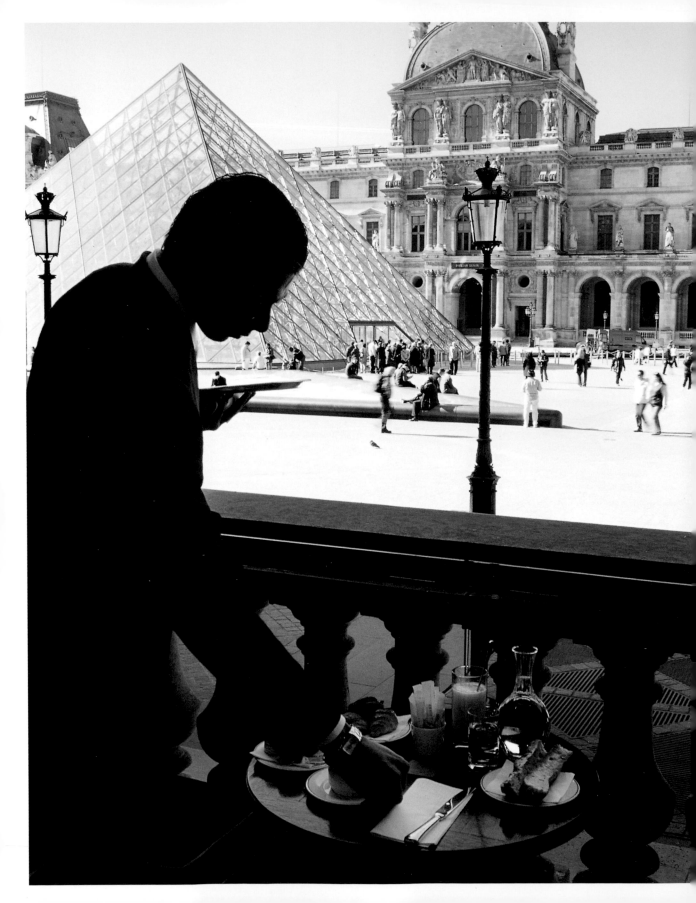

color, and a whole variety of basic country dishes, from *boudin noir* with chestnuts and apple, to Landes farm chicken stuffed with foie gras, Grenaille potatoes with a jus, and shoulder of lamb confit with thyme.

On the other side of the Seine, near the Italianate arches on rue de Rivoli, can be found the work of a Parisian designer with strong influences from Ettore Sottsass in Milan. Olivier Gagnère has given a neoclassical slant to the historic Marly wing of the Louvre. The site, obtained by the Costes brothers in 1994, overlooks the Ieoh Ming Pei pyramid, posing delicate problems of integration for a café-restaurant. Olivier Gagnère is used to working with traditional luxury artisans, such as Murano glassware and Bernardaud porcelain. He responded elegantly to the challenge of Le Café Marly, without renouncing any of his sense of new lines. The furniture and lighting schemes fit well into three rooms painted in warm colors: burgundy red for the large one, and cashmere gray for the two little annexes that look onto rue de Rivoli. At the centre of each inner wall, Gagnère has traced a square in gold leaf, a stylized reminder of the period when the nobility of France filled these halls. Although the chairs are modern, their shape echoes Empire furniture, and each one bears a gold ring on its back, the designer's signature mark. On the ceiling is an admirable crystal chandelier designed by Gagnère and made by Murano in Venice, which stretches out and unfurls like the snake Moses threw at Pharaoh's feet. Other lamps in black metal stand on the ground like totems, with a vaguely African air about them. The diners in this unusual place are a curious mixture of regulars, slightly lost-looking tourists, art lovers, young women pausing for a breather from shopping, and businessmen relaxing off the clock. Le Café Marly lends itself to long meditations after lunch, or idle afternoon trysts spent tackling the meaning of life. A reasonable and basic menu in the contemporary bistro spirit of the Costes brothers completes this welcome halt in the great urban confusion that surrounds it.

LE CAFÉ MARLY

The terrace of Le Café Marly looks onto the Louvre pyramid (facing page). Tourists and all sorts of Parisians relax there in the summer months, while the three rooms inside, dressed by Olivier Gagnère, look as if they belong in a very elite club (below). The chairs with brass rings and feet and the Murano chandelier are signature elements of Gagnère's design (following pages).

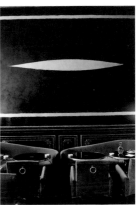

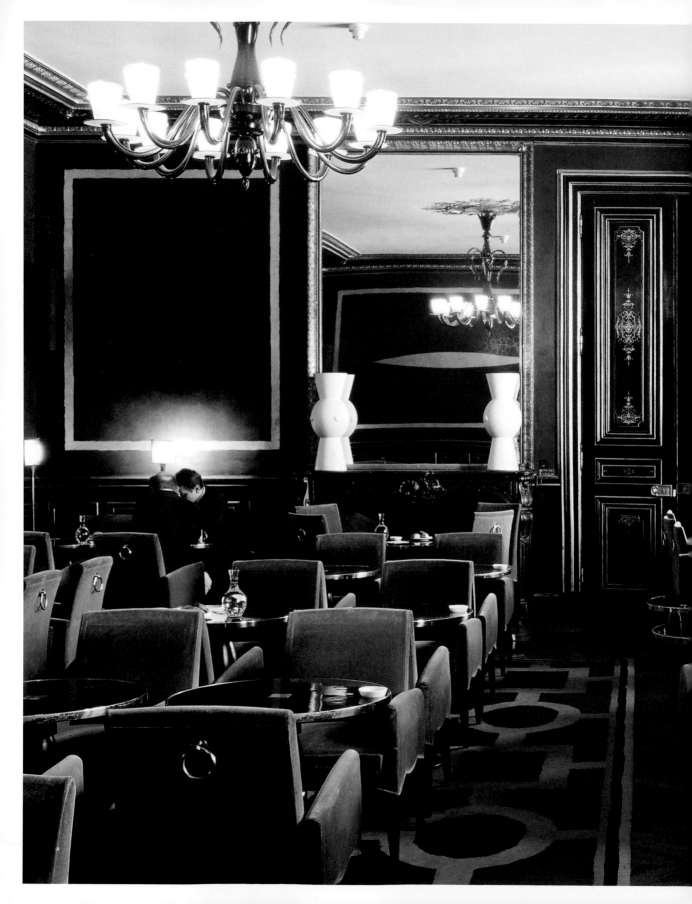

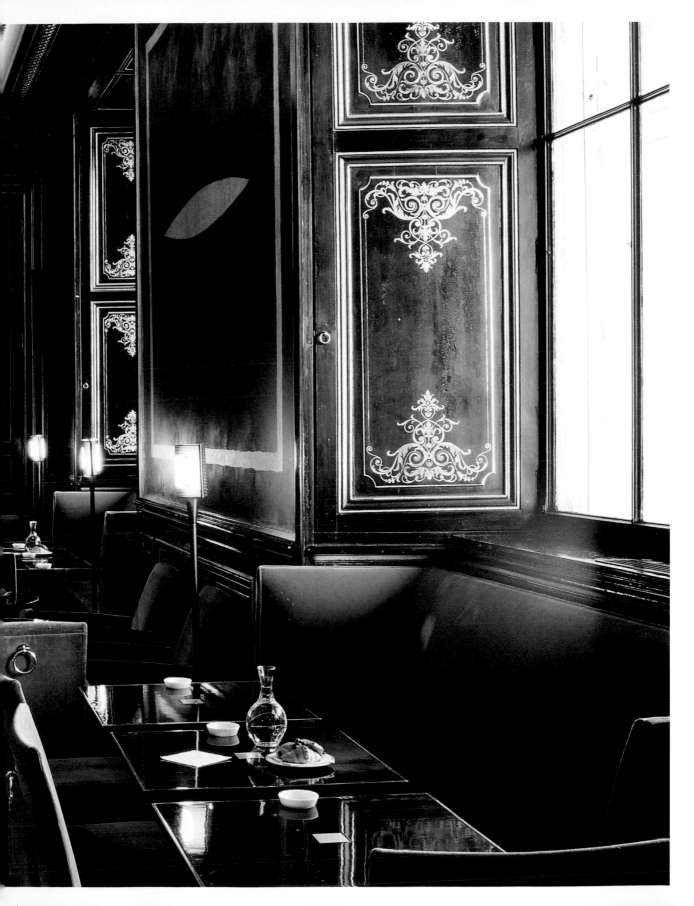

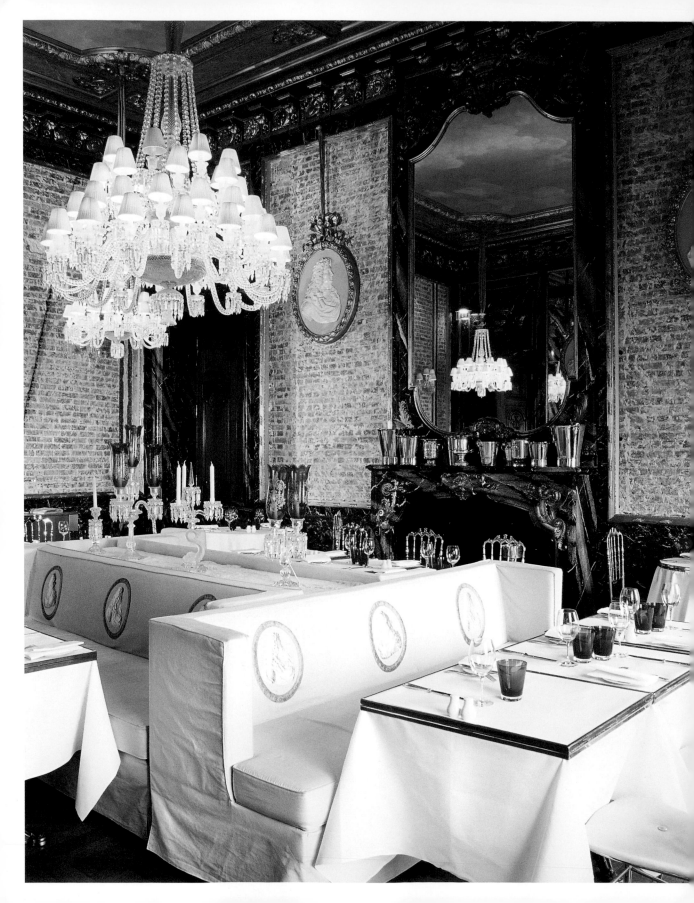

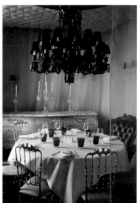

One step further beyond the real world takes us into the new Maison Baccarat on place des États-Unis, the former residence of Marie-Laure de Noailles, the muse of Jean Cocteau, Salvador Dalí, Luis Buñuel, and Man Ray. From the 1920s to the 1950s this Haussmann mansion hosted some of the most surreal parties in Paris, from the Bal des Matières in 1929 to the Bal de la Lune sur Mer in 1951, before the doors closed on this epoch of hyper-creativity (never to reopen, unfortunately). But the famous crystal manufacturing firm Baccarat, in choosing this building in 2003 to house their management offices and museum, saw an opportunity to prove themselves equal to the place and its legend. The designer in charge of recreating the interior was Philippe Starck, well known for his whimsical and expressionistic style, and for revolutionizing all the objects and spaces he touches (and he touches everything). Starck—also discovered by the Costes brothers—designed the first modern café in Paris at the end of the 1970s, Café Costes, which today has disappeared. There, he did away with the archetypal leatherette and vinyl decor, and replaced it with raw materials and a rock 'n' roll atmosphere. Since then he has been transforming atmospheres all over the world, from Hong Kong to Mexico, via London and Miami, with an acute sense of personal metamorphosis, whether it be in hotels, restaurants, or showrooms. Not to mention the innumerable everyday objects, furniture, and household appliances whose shapes he has remodeled.

It is clear, even from the outside of this private building near place de l'Étoile, that Starck has made Baccarat into a baroque fairyland. Crystal is of course the favored material, and its juxtaposition with white stone reveals secret hues within, hidden until now. The severe Parisian classicism is thus suddenly rejuvenated, as if a once polychromatic Gothic cathedral were restored in all its color. The monumental hall contains a chandelier held by a hand, mounted on a large mirror, and drapes supported by fine crystal columns: a reference to the castle in Cocteau's film *Beauty and the Beast*. On either side of the entrance, two Baccarat vases that belonged to the emperor of Ethiopia miraculously start to talk. A projection makes two faces appear on their fusible surface, like Gorgon's heads bathed in a milky substance, and they deliver measured words about the crystal makers' ancestral craft. On the ground, an illuminated carpet indicates the mysterious path to follow. At the foot of the stairs, a candelabra made for Czar Nicolas II looks over an enormous chair and a footstool to match, threatening to send the visitor who dares to confront them back to the world of *Alice in Wonderland*. As you climb the stairs to the Cristal Room restaurant, a chandelier with 157 lights turns slowly above your head. You eventually enter the large salon. In a space dedicated

CRYSTAL ROOM DE BACCARAT
Walls stripped back to the brick and a profusion of crystal: Philippe Starck plays brutally with contrasts in this fantastical palace, seemingly dreamed up rather than designed, transforming the former private residence of Marie-Laure de Noailles (facing page and above).

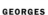

to transparency, Philippe Starck has had the inspired idea of stripping sections of wall completely, contrasting the bare original brick with the brilliance of the crystal, the silkiness of the sofas, and the metallic reflections of the furniture. Four large pink-and-white cameos of Louis XIV and members of his court frame the room. Parisians obviously come here for the décor: it is a feast for the eyes. But thanks to the chef, the Michelin-starred Guy Martin, seconded by David Angelot, it is a feast for the taste buds, too. Here, seasonal cuisine promotes the quality of the ingredients, accompanied by a wine list with *grands crus* to do justice to the majesty of this Grand Siècle dining room.

Thierry Costes, the son of Gilbert Costes, has followed in the family footsteps of breathing new life into the restaurant business. For Georges, the restaurant on the sixth floor of the Centre Georges Pompidou, he called on two young talents of contemporary architecture, the Frenchman Dominique Jakob and the New Zealander Brendan MacFarlane, to work together. Into the measured dimensions of Richard Rogers and Renzo Piano's cubic structure—left untouched down to the smallest aeration duct—they have introduced opaque aluminum "volumes" colored red, yellow, and blue. A new space is defined by these forms, which seem to emerge from the ground like outgrowths, spreading out in lava flows like the sculptor César's foam *Expansions*. This opposition of organic forms with the glass and steel structure of the museum is echoed by the presence on each table of a single rose, raising its head with fragile pride above the steel tables and white leather chairs; a virtual garden that strikes the eye when you enter each area. Jakob and MacFarlane started their career with private commissions, notably the acclaimed Maison T in La Garenne-Colombes to the northwest of Paris, where their capacity to adopt organic forms was already in evidence. Georges has very quickly become one of the trendiest tables in the capital, a blend of showbiz people, movie people, and contemporary art people with their groupies, models and fashion

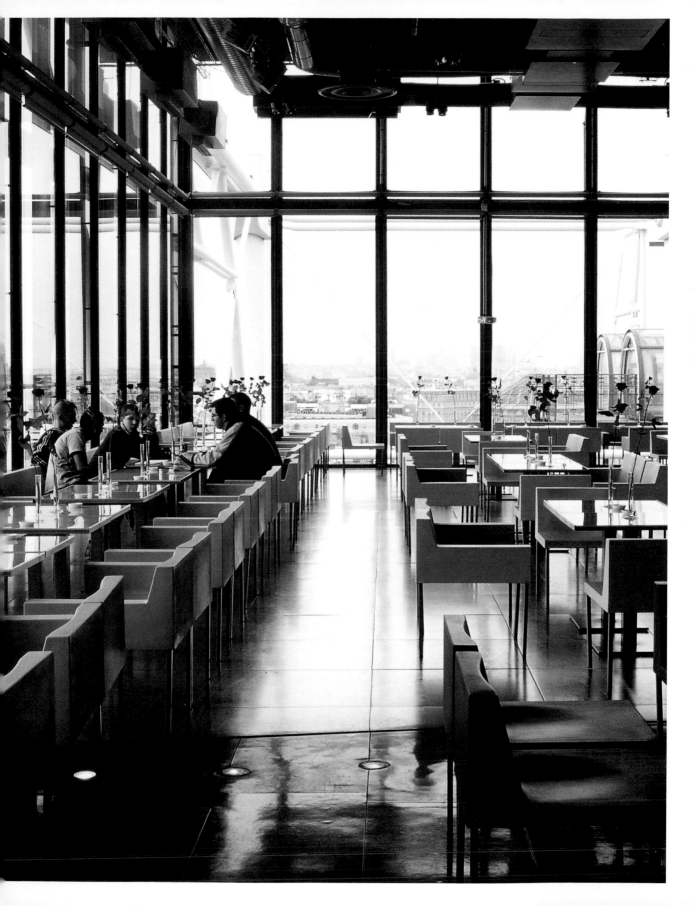

designers, all mixed with tourists attracted by the exceptional view the restaurant offers over Paris. Inevitably, arguments arise over seating, with the strategic spots near the picture windows, or the red "volume" for VIPs, being the most sought-after. The waiting staff (composed principally of young women with interminable legs and catalog smiles) struggle to arbitrate over these disputes. The cuisine rides the crest of an overtly fusion wave—prawn ravioli with hoisin sauce, Peking duck with caramel, tuna or salmon tartar—before gliding in to a "diet" version of chocolate fondant, invented by Michel Bras and now cropping up in all the fashionable restaurants. It should be noted however that Georges is the only place in Paris where one can find

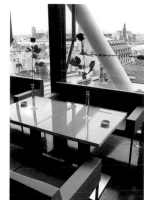

Pacific black cod, as fatty and melt-in-the-mouth as you could wish. For that, Paris's true gastronomes also come here, and they don't care where they sit. In 2006, Jakob and MacFarlane created a small bar in this restaurant. The result was the Pink Bar, a vodka and cocktail bar tucked away at the end of an alcove. With a multifaceted metallic bar that gives this small space a festive disco feel, the Pink Bar is a place for the restaurant's fashionable clients to stretch out their evenings.

This brief look at some of Paris's finest contemporary interiors makes it clear that the definition of "capital of the nineteenth century" does not go far enough. A real spirit of competition between restaurateurs has allowed a revival, not only of the food, but of the setting in which the culinary ceremony takes place. That is where this true capital of gastronomy excels, making lunch or dinner in Paris a celebration for all the senses.

GEORGES

An avenue of roses under the mouth of a volcano? An airport lounge? A funeral parlor? Panoramic viewpoint, or entrance to the catacombs? Georges offers all these possibilities, a work open to a multitude of interpretations (facing page and above).

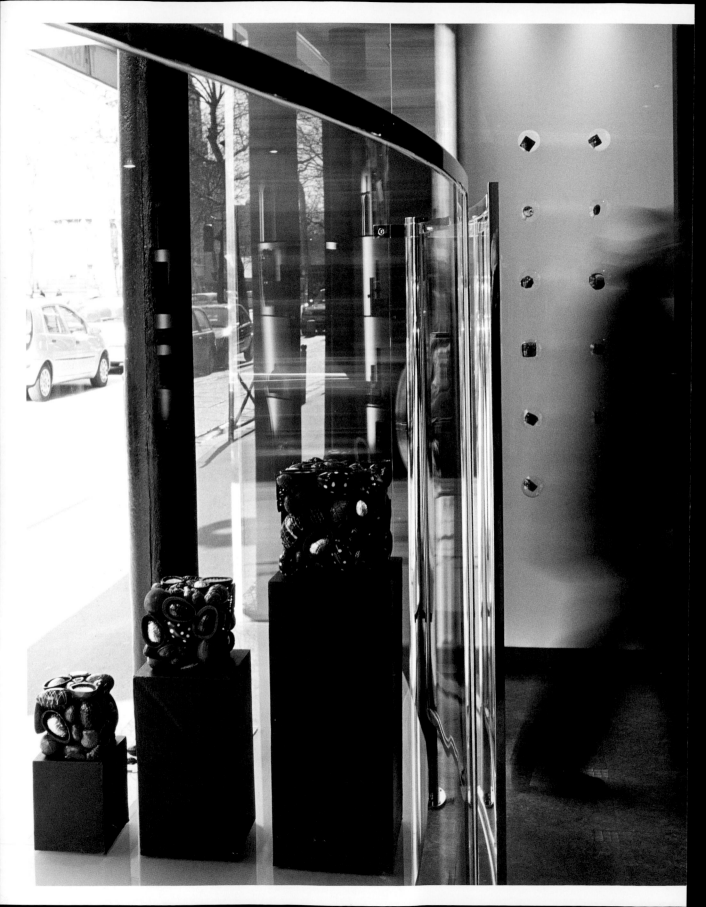

Tradition revisited

In the twenty-first century, the eyes of the world's chocolate lovers are increasingly turning to Paris. This is not because the city's confectioners have come up with some new method of processing the cocoa bean. It is due to the way they have refined traditional presentation to the point that, in Paris, chocolate has gone beyond its original role as a mere delicacy to become a gastronomic food in its own right. And what was once relegated to the fields of craftsmanship or industry has since been raised to the level of art. Parisian chocolate makers, or those who have set up in Paris, cannot be content simply to reproduce recipes from the repertory that have proved their worth in the past. Faced with an educated and demanding public that is quick to compare chocolate not with goods from other chocolate makers but rather with the very best that Paris's rich gastronomic landscape has to offer, chocolate makers need constantly to refine their art to make their mark. In the land of the "must-have," the chocolate maker is expected to surpass himself in his quest to attain the summit of refinement.

Jean-Paul Hévin embodies this ambition. Honored with the title of "Meilleur Ouvrier de France" for his pastry in 1986, he first worked with Joël Robuchon at the Hôtel Nikko before running the Peltier chocolate store in Tokyo and then opening his first store in Paris on avenue de la Motte-Picquet. Hévin calls himself a "chocolate artist" and his creations "signature chocolates" in direct reference to the "signatures" found on haute couture labels. What is so special about his "signature"? First, there is the attention he pays to the quality of his raw

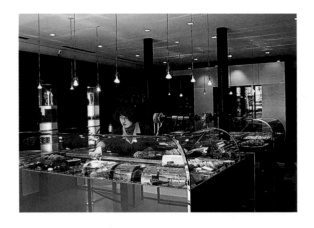

materials. "I never delegate the task of tasting to anyone," he says, and his exceptional palate can detect what he calls the "different levels of taste" in the various cocoa beans he uses, mainly from Venezuela, Ecuador, Colombia, and Madagascar. As a chocolate maker, Hévin is primarily a first-class taster of chocolate whose aim is not to alter the flavors he detects, but to enhance them through combinations that are both surprising and delicious. This has led him to invent so-called "dynamic chocolates" filled with preserved ginger and mixed with spices like cola nuts and *bois bandé*, and "chocolate-cheese aperitifs" flavored with cheeses, such as Époisses, Pont l'Évêque, goat cheese, and Roquefort, and best savored with a *vin jaune* from the Jura region. But Hévin's style can also be seen in his approach to the classics. The finesse of a plain ganache filling comes from the perfect proportion of cocoa; a spiced version uses cinnamon, ginger, coffee, or honey; fruit flavors incorporate lime, grape, orange, raspberry, or blackcurrant; praline variations use the best hazelnuts, almonds, or nougatine; and the milk chocolates come in plain, caramel, truffle, and gianduja varieties. All burst with heady aromas, while the fine chocolate that surrounds them melts on the tongue before revealing the subtle flavors contained within.

"Chocolate is like wine," says Hévin. "From a single ingredient you can make a wide variety of products, and without variety there is no pleasure." What is his definition of pleasure? "I want to make chocolates that are full of flavor and fresh tasting, which generate well-being, tenderness, and even poetry in those who taste them. In short, I want to provide a moment of happiness." Happiness through chocolate—now there is something that Parisian chocolate makers can be proud to claim as their contribution to the history of the cocoa bean.

Pierre Marcolini is Parisian by adoption but Belgian by birth. Already well known both in his native land and internationally, he came to Paris looking for further recognition and respect. And he deserves it, because he is one of the few remaining European chocolate makers who still make their own *couverture*. To the uninitiated this may not seem radical, but it is a genuine declaration of independence, because Marcolini makes his own chocolate from raw cocoa beans—like nineteenth-century confectioners did—and he wants everyone to know. And for that Paris, world capital of all things gastronomic, is the best place to be. "Making chocolate from scratch means you get to know your material better," he explains. "Making it yourself also means you use only what you know to be the very best ingredients."

❧

MARCOLINI
*In his rue Bonaparte
boutique, Pierre Marcolini
exhibits his chocolates
the way a museum would
its greatest treasures
(facing page). His obsession
with the fine coating
of his chocolates makes
these square and heart-
shaped creations utterly
irresistible (below).*

His vanilla comes from Tahiti, and he incorporates violets or cinnamon at the early stages of the process instead of adding extracts at the end as a shortcut. Having chosen to manufacture his own chocolate has changed the way he exercises his chosen profession in other ways, too. Marcolini spends a significant part of each year visiting cocoa-producing regions so that he can choose his own beans. This has resulted in personal relationships with certain growers, large shares of whose crops he purchases—at fair-trade prices, of course. That is how, for the last few years, he has bought the entire crop produced by a Mexican grower, Clara Echevaria, who has been fighting to save her exceptional variety of 100 percent *criollo* cocoa bean, the *porcelana*, with its aromas of rose and jasmine. And Parisians, ever conscious of the importance of the region of production, can now buy the first bar of chocolate made entirely from the *porcelana* bean. Given its extraordinary "mouth feel," and magnificent aroma, tasting it is akin to drinking the finest of wines.

In order to make his own *couverture*, Marcolini had to find both the machines and the techniques that were used in the past and had been forgotten due to industrialization. He gave the machines he managed to find in flea markets across Europe to retired Belgian confectioners, who were the only ones left who knew how to use them. From them he learned how to crush the bean, remove the skin, and transform it into a smooth paste, which is then kneaded with sugar and vanilla. He brought back the old technique of heating the paste to release the good lactic acids, while simultaneously driving off the bad ones. In short, he took control of the cocoa's fermentation process. By making his own *couverture*, Marcolini is also free to flavor it as he wishes by introducing coffee, cardamom, or ginger at the roasting stage. But whether they are round or square, all of Pierre Marcolini's chocolates are remarkable for their crunchiness due to the thickness of the chocolate casing that makes up at least 40 percent of the total weight of each chocolate. This detracts in no way from their subtlety or finesse, but instead gives them a distinct personality, and one that is bound to seduce those ardent cocoa lovers who recognize chocolate for what it really is—a genuine luxury item that is really quite rare.

MARCOLINI

*Pierre Marcolini's
boutique, designed
by Yan Pennor—
one of the rising stars
of French design—
with its exotic woods
and immaculate window
displays is a veritable
shrine to chocolate.*

When it comes to wine, modernity also means new ways of offering this beverage: firstly by opening up to wines other than French ones, then by making them accessible to all and not just the elite. Doubtless because he was aware of the closed nature of wine circles, Marc Sibard agreed to become involved in opening Lavinia in Paris. Lavinia is somewhat of a UFO in the rarefied world of Paris wine merchants. Just a few paces from the Madeleine, its 16,000 square feet (1,500 square meters) spread over three floors is kept at a constant 66°F (19°C) and 70 percent humidity.

Thierry Servant, former head of L'Oréal in Spain, and his business associate Pascal Chevrot, businessmen and wine lovers both, had first tested the

concept of a supermarket devoted to wine in Barcelona, but to do the same in the heart of conservative Paris was to gamble for even greater stakes. Not only were they launching the largest wine shop in Paris, but of the 6,500 different references they had in stock, 2,000 were from outside France, a death-defying risk in a city not noted for its tolerance of non-native wines. The whole of the ground floor is devoted to them: Château Musar from Lebanon, Sassicaïa from Chianti, "little" wines from Chile, and even rare sparkling Chardonnays from England.

True wine lovers will be drawn to the basement, where most of the French and rare wines are to be found. In a cellar maintained at a constant 57°F (14°C), bottles of every vintage of Chateau Latour, Jaboulet Hermitage, and Amarone Bertoni are lined up imposingly. But there are also the wines made with little or no sulfur so dear to Marc Sibard, and that are made available here to the 8,500 members of the club that is the backbone of Lavinia's clientele. The ritual surrounding wine that is such an important—and imposing—aspect of Les Caves Augé is absent in this modern and functional space where the connoisseur and the debutant are put on an equal footing. Fact sheets, special signs denoting "Wines for under 10 euros," "Sommelier's Choice," and "Organic Wines" make buying wine less of a ritual and opens it up, if not to all comers, at least to all those who are interested. Paradoxically though, it is the connoisseurs who are likely to be most ecstatic about what they find here. Many years ago, the French chain Fnac was the first to sell books and music in the same way as others sold clothes; Lavinia hopes to do the same for Parisians when it comes to wine.

LAVINIA

At the Lavinia restaurant the wine is the same price as in the boutique. Choose your bottle off the shelf and drink it with your meal. Lavinia has democratized how wine is sold and drunk in Paris, and clients enjoy this practical approach.

CHAMPAGNE

FRAGILE

LAVINIA

Just around the corner from the Madeleine and spread over three floors, Lavinia has over six thousand different wines on offer from all over the world. In the basement you can hunt down the finest vintages of the greatest wines in a temperature-controlled environment, and also find a wide selection of untreated wines.

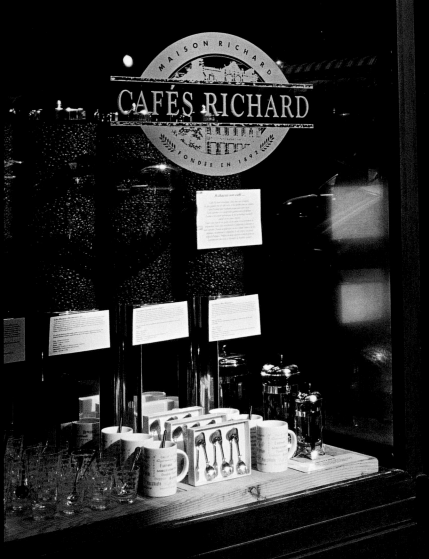

Matching quality with modernity was also the ambition of Les Comptoirs Richard. This century-old establishment was founded in Paris in 1892. First making a name for itself in wholesale trading of wines and spirits, this family business went on to adapt its knowhow to coffee, and at the start of the 1950s, it began to specialize in the art of coffee roasting. Nowadays, Les Comptoirs Richard has many points of sale in Paris. The contemporary-looking one on rue du Cherche-Midi has an area for tasting before you buy. A strong smell of roasting coffee greets you as you enter. Attentive and well-trained staff is there to serve you from a large selection of guaranteed "pure" Arabica coffee from around the world: *maragogype* from Mexico, known as Liquidambar; huge beans with citrus overtones, which are surprisingly mild in flavor; Blue Mountain from Jamaica that is velvety and chocolaty to the taste; and mocha from Ethiopia with its complex aromas. Les Comptoirs Richard is also the source of blends such as Perle Noire, which contains Arabica beans from several sources, a blend that is now available on the terraces of many cafés throughout the city and which, in its own way, has helped to reconcile Parisians to both their city and their favorite drink. For while Les Comptoirs Richard still offers *grands crus*—unroasted coffees from the five continents that it has selected, then roasted in its own workshops—its savoir-faire is also evident in the creation of quality blends. Fruit of a tradition that has ripened, Les Comptoirs Richard reflects a long history and a deep passion. Dedicated to the universe of coffee, tea, chocolate, and infusions, its stores hold the "basics" for them to be prepared and tasted. The next stage is for you to take home the coffee of your choice in the form of beans, grounds or pods, along with the most appropriate coffee maker.

COMPTOIRS RICHARD

Les Comptoirs Richard has helped to rekindle interest in traditional coffee roasting thanks to its contemporary decor and a range of products that includes not just coffee, but also coffeepots, specialty sugars, and chocolates (facing page and above, right).
Here, the origins of the coffees are clearly marked, and with grands crus *and interesting blends lying side by side, buying coffee has never been such a pleasure. The purchaser is spoiled for choice: Guatemalan, Jamaican, Ethiopian, Costa Rican, to name but a few (above, left).*

British by birth but French by adoption, the humble sandwich has long been a staple of the traditional French brasserie. Whether made from a crusty baguette or—a more recent trend—from whole-wheat bread, it is under assault from Italian *panini*, American hamburgers, Japanese sushi, and Chinese dim sum. The brunt of this assault is borne by café owners whose quick and simple dishes, such as the *croque monsieur*, fed generations of workers anxious to grab a quick bite during their lunch break. Mass-produced sandwiches sought to fill a gap in the market, but they suffer from the same deficiencies as the "foreign" competition, namely ingredients that are not of the best quality, a tendency to aim for the lowest common denominator, and a combination of quantity with

COJEAN

If you are wondering where to go for a quick, healthy meal in the busy heart of the Madeleine, try Cojean. This boutique dedicated to snacking has seduced many a Parisienne: fresh produce, speedy service, and a stylish decor (facing page, above, and following pages).

speed rather than speed with quality. So when Alain Cojean and Fréderic Maquair offered both speed and quality at the first Cojean restaurant, which opened near the Madeleine in 2001, heads began to turn. They had a simple objective: feed as many people as possible, in as short a space of time as feasible, with dishes that could be eaten on the premises or brought back to the office. So far, normal. Where their concept differs is their insistence on the quality of the raw materials and the importance of genuinely fresh-tasting food, in contrast to previous approaches that involved using frozen foods and a "dumbing down" of flavors. And it is not just Cojean's predominantly blue decor that contributes to the sense of freshness. The cellophane-wrapped sandwiches are made fresh each morning; the fruit juice is squeezed on the premises; the wraps and daily specials are made fresh in the on-site kitchen. A delicious herb salad combines cilantro, chervil, chives, basil, arugula, Webb lettuce, and spinach, while the "self-tanning" salad combines freshly grated carrot with orange juice and cinnamon. Both are evidence of the obsession with freshness. Cojean and Maquair chose Bermudes, reputed to be the finest purveyor of fresh herbs at the Rungis market south of Paris, to supply them with vegetables. Standards are equally high in other areas with suppliers delivering fresh produce direct from Rungis to the different outlets each morning, perpetuating a time-honored tradition, albeit in a resolutely modern surrounding. And what is the secret of its success? There is no secret! Everything is right there to be seen on the plate in front of you: hard work, imagination, and a thorough respect for the customer explain why Cojean is the most talked about fast-food concept in Paris at the moment.

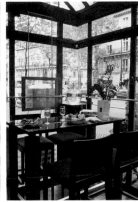

No survey of the "best and freshest" would be complete without mentioning Pomze, the first boutique devoted entirely to apples and their by-products. Apples, along with grapes, are the most universal food there is, being both food and drink. At Pomze, you can be sure to find your favorite fruit in all its forms. Throughout the year, there are some sixty varieties of apple from around the world as well as a similar range of single-variety apple juices, thirty or so unpasteurized farmhouse ciders, and a selection of the finest Calvados and *pommeau* (an apple-based aperitif) together with some excellent perry. Pomze was launched by Daniel and Emmanuel Dayan, two globetrotters who cut their teeth with the Flo catering group in Tokyo. This highly original and utterly charming store doubles as a restaurant where apples make their appearance both as a garnish and as a dessert. Genuine *tartes Tatin*; macaroons with Manzana Verde, an alcohol spirit flavored with apples from the Basque region; or *cannelés* (little cakes that are a specialty of Bordeaux) doused in Calvados are all guaranteed to raise your spirits without raising your cholesterol level. They also do lunch, and why not finish up with a delicious *pomme d'amour* (candy apple) with white chocolate, wrapped in a dark chocolate coating? Apples are used in multifarious ways, so you could also try them in *verrines*, little glasses filled with *panna cotta* and green Manzana apple, or in the "Tours d'Ivoire" (literally, ivory towers), a white chocolate cake filled with stewed apple and orange.

POMZE

At Pomze on boulevard Haussmann, you can find fresh apples at any time of the year. If necessary, they are imported from southern Africa, Australia, or New Zealand (facing page and above).

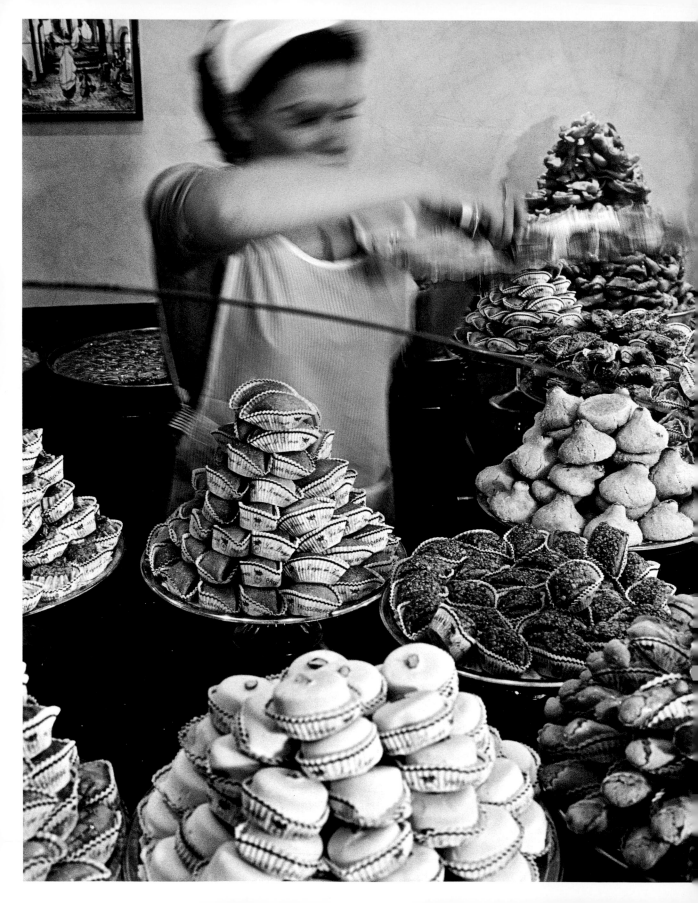

Exotic Flavors

Samira Fahim likes to be precise: her patisserie has its origins in Algiers. In 1996, the dynamic Fahim opened a boutique on rue Saint-Maur to the delight of the "bourgeois bohemians" who populate the rue Oberkampf neighborhood. Behind the store windows, pyramids of golden cakes are piled high, catching the eye and making the mouth water. In this store straight out of *The Thousand and One Nights*, everything is abundant: towers of baklava, mountains of *makrouts*, and swathes of *cornes de gazelles* fill the space. Fahim may admit that her pastries have vaguely Turkish origins from the time that Algiers was ruled by a bey, but she still sticks to her guns. So while the walnut baklava may come from Constantine, she prefers the almond version from Algiers, although both are available. And that is La Bague de Kenza's secret. It sees itself as a little outpost of Bab-el-Oued in Paris, which guarantees its authenticity. Everything else is just a question of taste, and Fahim is generous enough to offer specialties from the other regions of Algeria. What is striking about her pastries—all fairly traditional—is their lightness. The lightness that is found in pastry made using a minimum of shortening—margarine or sunflower oil—and in the hand that sprinkles the sugar or pours the honey. It makes you want to come back all the more often. When she crossed the Mediterranean, Fahim knew how to adapt delicious traditional Algerian pastries to European tastes, without for a moment sacrificing the intensity of flavor and aromas that characterize them. The result is a patisserie that is at the same time typically Algerian and firmly Parisian. La Bague de Kenza is now an established part of Paris's gourmet landscape and has not lost anything of its authentic roots.

The East is also to be found in the grocery store Izraël on rue François Miron in the Marais, where randomly displayed products bring to mind the convivial chaos of a souk. While you might come here in search of some cassia, ginger or lime, you are likely to leave bearing a bag of red lentils or chickpea flour. Izraël is where Parisians come to find everything, from donuts just like you get in New York to the rhododendron-flavored honey typical of the Aosta region. It has to be pointed out that a trip to Izraël is like no other. With its thousands of articles literally crammed into every corner of the store and spilling off the shelves, it requires an initiation

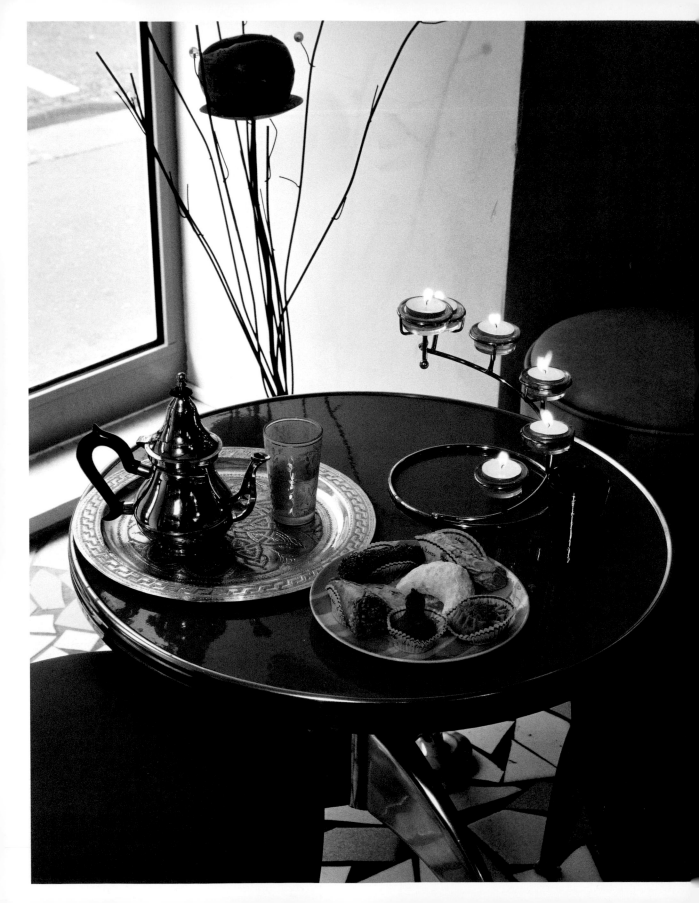

IZRAËL

You can find absolutely anything at Izraël in the Marais district: that is, anything edible, drinkable, or to spice, garnish, and boost flavors in your dishes— on the condition that you do the searching yourself and know what you are looking for.

ceremony to understand it fully. If you are in search of a pleasant gastronomic diversion then this is not the place for you: Izraël is for specialists only. Do not expect to receive advice—only those able to identify what is on offer and who know what certain products are used for can really benefit from what is not so much a store as a treasure trove of food.

Because of Paris's geographic location, butter has traditionally been the substance of choice for cooking, though lard occasionally makes an appearance. "Cooked with butter" is synonymous with good cooking, matched only for true gourmets by "cooked with cream." Neutrality has always been favored when it comes to cooking oil, which is why peanut oil is mixed with vinegar to form vinaigrette or as a substitute for animal or dairy fat when cooking. Olive oil used only to be of marginal importance in Paris kitchens, perhaps used on a tomato salad as a reminder of a past Mediterranean holiday or to evoke thoughts of a forthcoming trip to the Côte d'Azur. What is more, it had a reputation for being heavy and not standing up well to cooking, in short, being difficult to digest. Added to that was the catastrophic frost in the winter of 1956 that killed almost two-thirds of all the olive trees in Provence. So there was no objective reason why Paris should play a central role in any renewed interest in the so-called "Mediterranean diet" and in olive oil in particular. Yet it was from Paris that olive oil launched its onslaught and achieved its ultimate victory in the culinary world. Several factors were at work in making this happen. One was the role of chefs like Alain Ducasse who had achieved success on the Côte d'Azur and then came to Paris looking for further glory. The role of nouvelle cuisine in general was also important, with its emphasis on simply prepared ingredients and the use of the right olive oil as an accompaniment to certain dishes, particularly fish. But nothing would have happened were it not for the initiative of a certain number of individuals whose pioneering spirit helped olive oil achieve the status it now holds in Parisian homes and restaurants.

First to come to mind is Olivier Baussan, founder of Oliviers & Co. Before him, Paris had no boutiques specializing in olive oil, with the exception of L'Olivier on rue de Rivoli, that was more like an embassy of southern France in Paris than a shop, and which rather than setting out to educate the locals, was a Parisian outpost for those expatriates from the south of France who remained not a little suspicious of the dietary habits prevalent in their newly adopted city. Baussan's target was the native Parisian, and he set about educating his audience about a product which, until his arrival, had been relatively unknown in Paris. At the start of the 1990s this connoisseur of the Mediterranean (he also developed the concept behind the Occitane chain of stores) started choosing his suppliers based on the criteria that he wanted his new stores to promote: an identifiable region of production that had a reputation for the quality of their oils; olives were to be harvested by hand, no case could exceed 20 kilograms (44 pounds), and the journey from olive grove to where the oil would be extracted was not to be more than

OLIVIERS & CO.
What would Parisians do for olive oil were it not for Oliviers & Co.? Until this store arrived, really good olive oil was a little-known commodity in Paris. But it is more than a question of attractive packaging: rigorous selection at source and detailed information have helped turn Parisians into discerning consumers of this Mediterranean product.

LA MAISON DE L'OLIVE

This boutique on rue Ampère offers personalized advice and a vast selection of olive oils from growers and producers (above). Pata negra, *or "the art of ham," from the Iberian Peninsula can be found at Bellota Bellota (facing page).*

one or two hours; finally, pressing was to take place at specified times either in the owners' own mill or using traditional small stone mills, and the resulting oil was to be stored in a container appropriate to such a carefully made product. His conditions were draconian. Of the three hundred oils that he tastes each year he selects only thirty or so for sale.

Baussan first started looking for oils in Italy, then moved on to Spain and Provence. Today, Oliviers & Co. offers oils from Greece, Lebanon, and Portugal—where Baussan has bought his own olive grove in order to apply to himself the conditions he imposes on others. But the undoubted strength of all of the Oliviers & Co. boutiques is the quality of the information they dispense on the products they sell. Olivier Baussan has noticed how tastes have changed over time with a trend away from the fruity and more mature oils to more delicate, lighter oils with complex, subtle aromas. Informative labels on the bottles and cans tell the consumer not just about the nutritional value of the oil and where it comes from, but also the variety of olive used and the date it was harvested. Tasting notes accompany each product on sale. The result is that a product Parisians knew hardly anything a decade or so ago, has become a fixture at any festive occasion and the favorite oil of any self-respecting gourmet.

Other boutiques specialized in olive oil have opened in Paris as a result: La Maison de l'Olive on rue Ampère in Marcel Proust's Paris. These stores specialize in olive oil from individual growers or small-scale producers and have given Parisians the possibility of discovering ever more esoteric oils and delving further into regional tastes and flavors.

Another typically local product from the Mediterranean that is in the process of receiving a gastronomic benediction in Paris is the *jamón ibérico*, known more generally as *jabugo*, *pata negra*, and *bellota*. This raw ham is produced from the Iberian pig, a descendant of the wild boar that is reared in the oak forests of Estremadura and more generally all across the southwestern Iberian Peninsula. The black-legged creature has the distinction of storing the oil secreted by acorns directly in its muscles, resulting in a highly distinctive taste. For obscure reasons linked to health and hygiene, this type of ham was banned in France until ten years ago. It is left to dry for anything between 24 and 48 months, the quality of the drying process being a gauge of the quality of the finished product. Since making its first appearance in Paris, it has become the latest fad and is credited with every possible virtue under the sun. While

BELLOTA BELLOTA

In a quiet backstreet off the Champs de Mars, an impressive range of Spanish cured hams catches the eye. Bellota Bellota recognized the gastronomic possibilities of these hams, and the menu here will initiate you into the mysteries of the various types of pata negra, *which differ in taste according to origin and length of curing time.*

DA ROSA

"Da Rosa-Épicier" is what this institution on rue de Buci likes to call itself and in so doing renews a tradition where "grocers" sold only the very best of everything.

it is reckoned to have the same cardiovascular benefits as olive oil, the main reason for its popularity lies in its appeal to all the senses: a puzzling aroma that on closer inspection reveals acorn oil, and a deep, intense flavor marked by a suaveness on the tongue and just a hint of saltiness. The fine-foods stores that brought this delicacy to Paris understood that if they were to interest people in it they would need to give them the opportunity to taste it, and in realizing this they launched—or rather, relaunched—a fashion, that of proposing a menu using the products on sale in the store.

Bellota Bellota near the Champs du Mars has opened a restaurant where you can taste a variety of hams on the same plate; on the terrace of Da Rosa, close to the rue de Buci market, you can sample Martin Raventos' Unico, which is to ham what Romanée Conti is to the Côte de Nuits in Burgundy. You will also find Spanish hams from the village of Guijuelo in the south of the province of Salamanca and a selection of mustards. And if proof were needed that the vogue for *jamón ibérico* has taken hold among a much larger audience, look no further than the *coin gourmand* delicatessen counter of Lafayette Maison which offers its own selection of hams from a refrigerated cellar in the basement. With this interest have come prices to match, though despite the levels they can sometimes reach, these do not yet seem to have inhibited the true amateur.

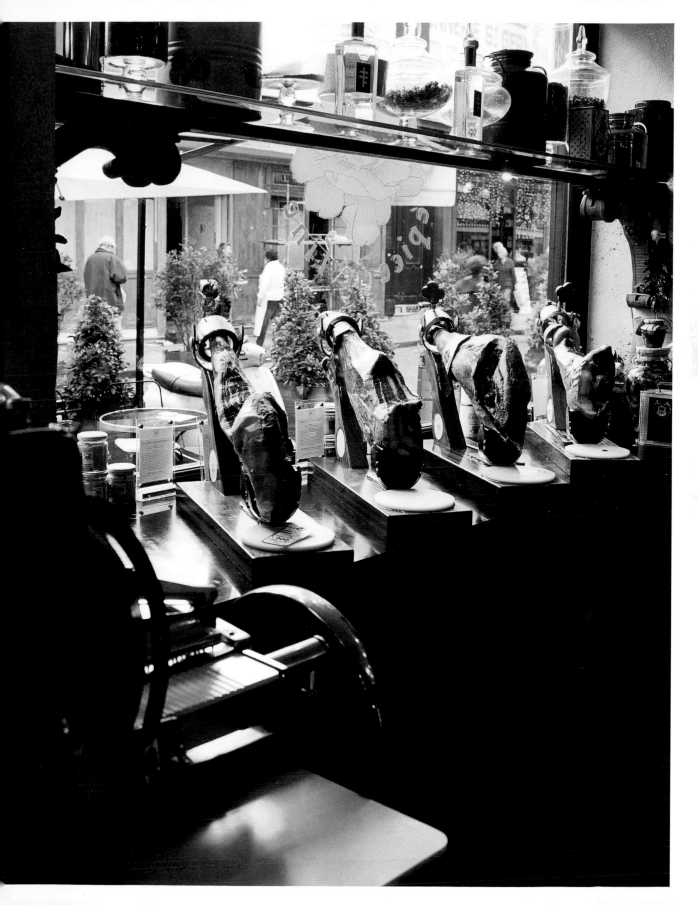

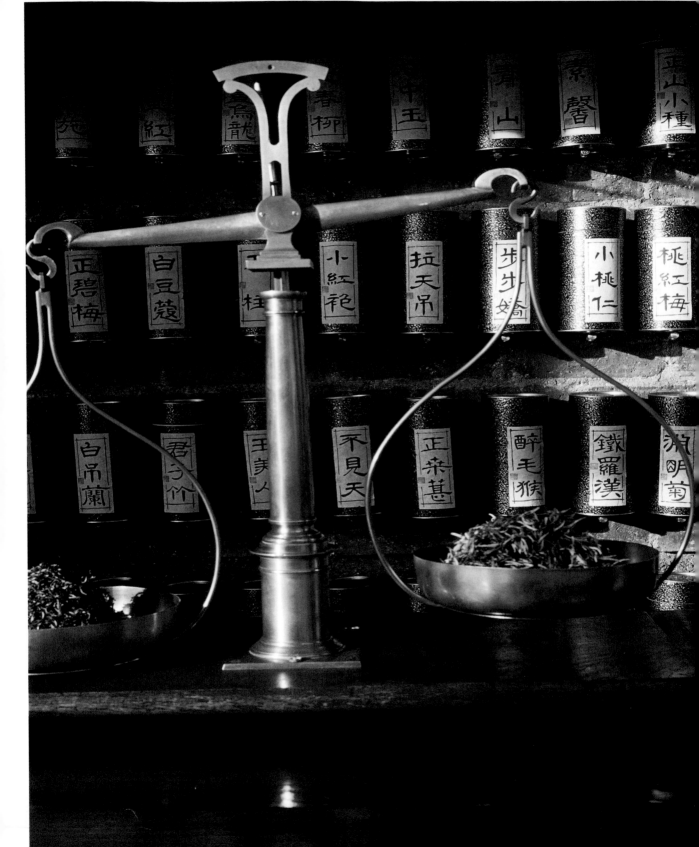

A further sign of external influences flowing into Paris is the opening of a store specializing in rare and precious teas on rue Gracieuse behind the Panthéon, La Maison des Trois Thés. A plain storefront, a bell at the entrance, a subdued Ming-like décor, and a few tables is all there is on the ground floor. The real business is downstairs in the basement where seventeen tons of tea is stored in strictly controlled conditions. This is an important center in the international tea trade, and although private individuals are welcome, the majority of its customers are professionals and collectors from around the world. If further proof were needed of Paris's significance in the tea trade, Madame Tseng Yu Hui, originally from China and one of the world's leading tea

experts, has chosen Paris as her base. The role of the tea expert is important because unlike with wine, there is no *appellation contrôlée*. The reputation of a particular tea plantation—and the price of certain prestigious teas—depends in large part on the opinions of these experts who co-opt their members from a restricted circle of growers, traders, and recognized connoisseurs. Tseng Yu Hui belongs to all three of these circles. On her mother's side, she comes from a family of tea planters in Fujian where Oolong tea—a semi-fermented variety—is traditionally produced. Two hundred years ago, her ancestors were among the first to bring tea to Taiwan. Her family still owns a plantation producing one of the best Wulongs, Dong Ding. It was in this atmosphere that Tseng Yu Hui grew up. In keeping with the family tradition, and in order to ensure an exclusive supply of the best teas, she has plantations in Taiwan and mainland China. Paradoxically, her experience as a trader began in Europe during the early 1990s, because nowhere could she find—particularly in Paris— the teas she had enjoyed during her youth. Five or six times a year, she goes to China and Taiwan where she chooses teas at their source. But she also deals in vintage teas, the famous *pu-erhs*, or oxidized teas, that age as well as—if not better than—the best Bordeaux wines. In Taiwan, Tseng Yu Hui has a list of some five hundred teas, and in Paris she offers teas that date to the early twentieth century. Prices for these teas can reach astronomical levels, often in the region of tens of thousands of dollars per kilo. But to appreciate them you need to be a genuine connoisseur, and it is here that one is drawn to the very Asian rituals of initiation, and not just initiation to tea. Early on, Tseng Yu Hui's instructors recognized her vocation. Apart from teaching her everything there was to know about tea,

LA MAISON DES TROIS THÉS

At La Maison des Trois Thés, Madame Tseng (above), an undisputed tea expert, holds court. The tea is prepared according to traditional Chinese methods and weighed on antique scales, the boxes marked only with ideograms (facing page).

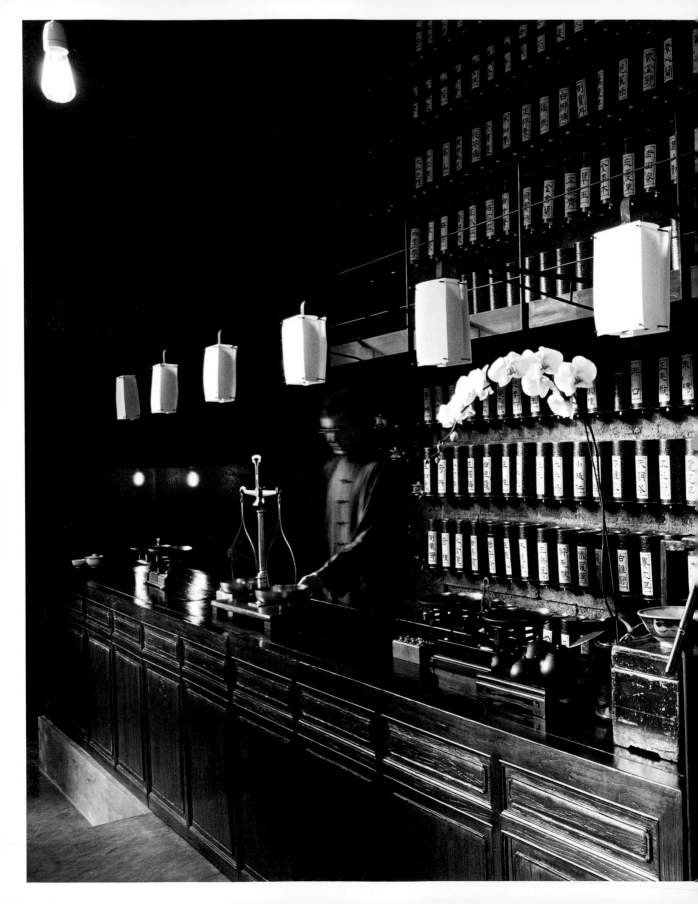

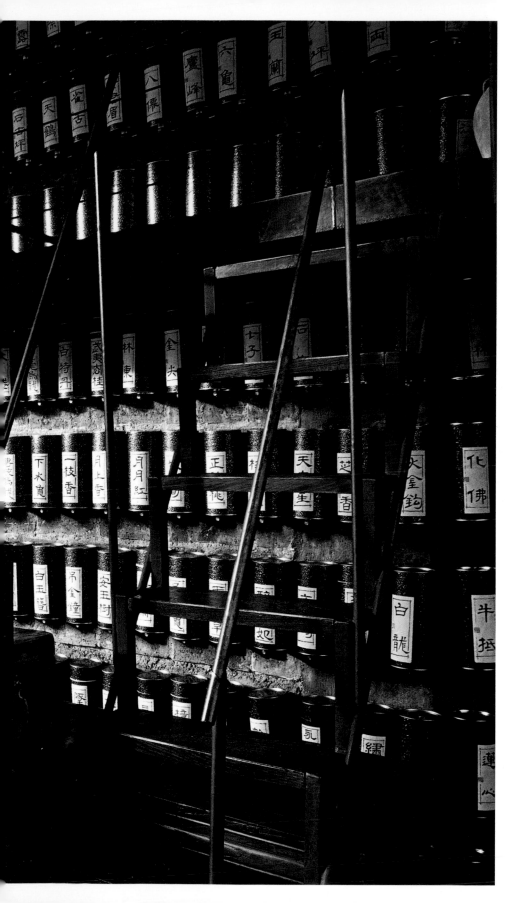

**LA MAISON
DES TROIS THÉS**

*Beijing? Shanghai? Taipei?
No, the extraordinary
La Maison des Trois
Thés on rue Gracieuse
at the foot of Montagne
Sainte-Geneviève
has made Paris a
vital center in the
international tea trade.*

her family was told to develop her sensibilities and to this end she was trained in very specific domains, first in the traditional areas of Chinese medicine and calligraphy. Her artistic side was also pursued. In Tseng Yu Hui's case, this involved music—she became a solo clarinetist on the concert circuit. Her career brought her to Paris, where she discovered a world-class cultural capital and a society where the art of food was primordial. She recognized that from Paris she could orchestrate the revival of the ancient Chinese tea tradition, which had been sacrificed to the demands of the Communist revolution. By doing so, she would also raise the profile of tea in the West. La Maison des Trois Thés is her way of fulfilling both ambitions. Only time will tell if she has succeeded in making Paris the Western tea capital she envisages, but in the interim, make the most of this renaissance and let a thousand tea plants bloom.

LA MAISON DES TROIS THÉS

With its terra-cotta teapots, great range of tea, and porcelain cups and bowls, traditional Chinese tea institutions have been transplanted to the banks of the Seine, much to the delight of Paris's tea lovers.

Today's Parisian fully owns up to his liking for sweet things by selecting a few choice places that are not ashamed of being temples to cake. He goes there regularly, at any time of the year and without feeling the need to justify himself. Cake has become an obsession, and in truth only attention to his figure and diet prevent him going to the patisserie more often. And even that is changing. Because those clever patissiers have reduced the amount of sugar, flour, and eggs they use to the strict minimum. In order to seduce their clients, the thick, heavy creams of the past have been replaced by smooth, airy mousses; the choux and puff pastries are made ever lighter; and the range of fillings—in ever increasing varieties—change every season, much like the collections of fashion designers. So the once humble patisserie has become a boutique, as fashionable and elegant as a fashion store, where the environment—fun and gourmet at the same time—sets out to feed the eye in preparation for the gastronomic feast to come. Even their interiors borrow heavily from that of fashion. It is as if today's pastry chefs, with a nod to the great nineteenth-century chef Antonin Carême's statement that pastry is "the principal branch of architecture," see themselves as interior designers as much as purveyors of gourmet pleasure—perhaps to compensate for what cakes have lost in scale and grandeur since Carême's time.

Sadaharu Aoki has done things his way. The Japanese pastry chef has quickly become a part of Paris's culinary landscape thanks to his training by a series of master chefs. After having initially apprenticed in the legendary Lucien Peltier patisserie on rue de Sèvres

PÂTISSERIE AOKI

Behind the minimalist façade of his boutique on rue de Vaugirard lie Sadaharu Aoki's exotically flavored creations. But Aoki is classically trained, and his mille-feuilles, éclairs, *chocolate croissants, and Danish pastries adhere to the strictest traditions of the French pastry chef's art.*

(ironically, a branch now exists in Tokyo), Aoki went on to work at La Méditerranée restaurant on place de l'Odéon before taking up a post with Freddy Girardet at his Michelin three-star restaurant in Crissier, outside Lausanne. Aoki returned to Paris to work at one of the bastions of traditional pastry, Couderc on boulevard Voltaire. During his training, his hard work was rewarded with a string of prizes: finalist in the Mandarin Napoléon competition, second place in the Charles Proust prize three times, Peltier Trophy in Arpajon, and winner of the Jean-Louis Berthelot Trophy in Romorantin. With such an exemplary track record, the Japanese apprentice can now proudly call himself a great French patissier. When Aoki decided to open his own boutique at the end of 2001, he had a clear idea of what he wanted, based on his intimate knowledge of Western and Eastern culture. "In Paris, there are plenty of good pastry chefs, but not as many beautiful patisseries; whereas in Japan, the reverse is true," he said in an interview with the trade paper *Le Journal du Pâtissier*. He aimed to create a synthesis of the two approaches.

When you step inside his store on rue de Vaugirard, you are struck by the clinical sterility of the place and the almost glacial interior, which might be off-putting were it not for the cakes, perfectly lined up in the window like so many sparkling jewels. And at this level of perfection, the nearest comparison is indeed jewelry. Aoki has brought traditional pastry to the highest level possible in a way that only a pupil who has gone beyond the level of his teachers can do. What strikes one most at a tasting is not so much the exotically flavored pastry creams (including green tea) that he uses to fill his *mille-feuilles* and éclairs; rather, it is the near perfection of the cakes themselves. "I always use the best ingredients," he points out, whether it is butter from the Charente region, wheat flour for choux pastry, seasonal fruits for his fillings, or the eggs and ground almonds that go into his sponges. Everything else comes down to impeccable technique. The base of his éclair, for example, is as round and crusty as a baguette. To achieve this effect, Aoki uses three baking trays instead of the usual one and bakes the

éclairs in a moderately hot oven—300°F (150°C)—for thirty or forty minutes instead of the usual fifteen to twenty minutes. As a result, the pastry base doesn't go soggy when the filling is introduced, and produces a delicious contrast of textures. Like the chefs who spend their energies on reworking one recipe with maniacal attention to detail until they achieve perfect harmony rather than inventing something new, Aoki can have a limited selection of cakes on offer. This Japanese-Parisian chef is a worthy representative of the best in traditional craftsmanship. While you may first be drawn into his boutique by the steel-and-glass Bauhaus-style window, you will come back for his unforgettable cakes that are like so many intangible reminders of the greatness of French patisserie.

Gourmet Notebook

The addresses we have chosen to include in this volume for sweet and savory lovers alike—fine food stores, confectioners, wine cellars, restaurants, bistros, brasseries—are those for which the setting, culinary quality, and products on offer are well worth the trip. There are literally thousands of exciting culinary spots in Paris, and it is not possible to list all of them here. The authors have made a personal selection of their favorite locations, and this list is far from exhaustive; it is simply a snapshot of a gastronomic landscape in a constant state of evolution. Of course, while these addresses are all in Paris, many are also happy to deliver orders abroad.

DECADENT PARIS
Historic and Prestigious Settings

MUSEUMS OF GASTRONOMY

ALAIN DUCASSE
Hôtel Plaza Athénée
25, avenue Montaigne, 75008
Tel: +33 (0)1 53 67 65 00
www.plaza-athenee-paris.com
It was with this historic Belle Époque hotel that Alain Ducasse sparked the renaissance of great gastronomy in the grand hotels of Paris, as Auguste Escoffier had practiced it before him. The decor by Patrick Jouin has been improved by the addition of a magnificent contemporary chandelier with its cloud of pendant glass drops. But the best reason for coming here is the top-notch cuisine, expressed by one of the most highly skilled teams in the Parisian culinary scene.
(See photographs p. 35.)

LES AMBASSADEURS
Hôtel de Crillon
10, place de la Concorde, 75008
Tel: +33 (0)1 44 71 16 16
www.crillon.com
A truly historic interior like that at the Hôtel de Crillon is a perfect match for its equally splendid cuisine.
(See photographs pp. 40–43.)

ANGÉLINA
226, rue de Rivoli, 75001
Tel: +33 (0)1 42 60 82 00
www.angelina-paris.fr
A very pretty tearoom and patisserie with an interior which is listed as historically important. The Mont Blanc made from whipped cream and chestnut purée should not be missed.

LE BRISTOL–ÉPICURE
112, rue du Faubourg-Saint-Honoré, 75008
Tel: +33 (0)1 53 43 43 40
www.lebristolparis.com
In a perfectly preserved Regency dining room, once the private theater of Jules de Castellane when this was a private residence, looking out onto an immense private garden which used to house a cloister, Eric Fréchon's cuisine is among the tastiest and most refined in the capital.

LE CINQ
George V
31, avenue George V, 75008
Tel: +33 (0)1 49 52 71 54
www.fourseasons.com/fr/paris
The food and the service are both so naturally subtle that you could almost forget the extravagance of the decor. The restaurant was decorated, along with the rest of this luxury hotel, by Pierre-Yves Rochon, in a spirit that combines its 1900 past with more modern ideas of comfort.

LE GRAND VÉFOUR
17, rue de Beaujolais, 75001
Tel: +33 (0)1 42 96 56 27
www.grand-vefour.com
Perhaps the most beautiful historic restaurant in Paris, with a decor that is difficult to date, but is from somewhere between the Directoire and Restoration periods. Guy Martin's cuisine is up-to-the-minute, but still satisfies those who are nostalgic for the classics.
(See photographs pp. 22–29.)

LA GRANDE CASCADE
Allée de Longchamp
Bois de Boulogne, 75016
Tel: +33 (0)1 45 27 33 51
www.lagrandecascade.fr
Napoleon III's private pavilion at the heart of the Bois de Boulogne, enhanced during the 1900 Exposition Universelle by the addition of a superb glass canopy. A reasonable and regular venue appreciated by Parisians in need of fresh air.

LAPÉROUSE
51, quai des Grands-Augustins, 75006
Tel: +33 (0)1 43 26 68 04
www.laperouse.com
Worth a visit for its private dining rooms and the unique Belle Époque atmosphere, even if the great Topolinski, the high priest of the Parisian night out, has never been replaced.
(See photographs pp. 30–35.)

LASSERRE
17, avenue Franklin-Roosevelt, 75008
Tel: +33 (0)1 43 59 02 13
www.restaurant-lasserre.com
With its opening roof and a typically 1950s atmosphere,

which enchanted Salvador Dalí, Lasserre was both the first of the great contemporary designs and the ultimate manifestation of the classic French restaurant. Today it offers the quiet charm of old-fashioned service and contemporary cuisine.

LAURENT
41, avenue Gabriel, 75008
Tel: +33 (0)1 42 25 00 39
www.le-laurent.com
A pavilion built by Jacques-Ignace Hittorff in 1844 on the Champs-Élysées, this restaurant is one of the high altars of Parisian gastronomy. The chef Alain Pégouret brilliantly interprets a menu devised by Joël Robuchon. Don't miss the fabulous art pompier paintings collected by the previous owner, the press tycoon Jimmy Goldsmith.

MAXIM'S
3, rue Royale, 75008
Tel: +33 (0)1 42 65 27 94
www.maxims-de-paris.com
Pierre Cardin has turned Maxim's into an international brand name, but a visit to the place where it all started is worth it: nothing has really changed here since 1900 (except the public, perhaps, which is less and less Parisian.) The classic example of the restaurant-museum. (See photographs pp. 44–47.)

LA MÉDITERRANÉE
2, place de l'Odéon, 75006
Tel: +33 (0)1 43 26 02 30
www.la-mediterranee.com

This fish restaurant first opening in 1944 is decorated with frescoes by Christian Bérard and Marcel Vertès, and boasts menus designed by Cocteau. A splendid terrace looks onto the Théâtre de l'Odéon.

LE MEURICE
228, rue de Rivoli, 75001
Tel: +33 (0)1 44 58 10 55
www.meuricehotel.fr
Yannick Alléno has turned this from a rather dozy place into one of the most dynamic restaurants in Paris. An exciting contrast between rigorous, inventive cuisine, and Louis XV decor as recreated by artisans at the beginning of the twentieth century. (See photographs pp. 38–39.)

LE PRÉ CATELAN
Bois de Boulogne
Route de Suresnes, 75016
Tel: +33 (0)1 44 14 41 14
www.precatelanparis.com
Flagship of the Lenôtre catering group of boutiques, cafés, and restaurants. An eighteenth-century folly built in 1905 in the heart of the Bois de Boulogne. Beneath the gold and stucco, Frédéric Anton, one of the masters of current gastronomy, offers precise and up-to-the-minute cuisine.

LE PROCOPE
13, rue de l'Ancienne-Comédie, 75006
Tel: +33 (0)1 40 46 79 00
www.procope.com

The oldest café-restaurant in Paris bears the marks of so many successive modifications that, apart from the facade, the only truly historic thing about this brasserie is its name. (See photographs pp. 18–21.)

PRUNIER
16, avenue Victor-Hugo, 75016
Tel: +33 (0)1 44 17 35 85
www.prunier.com
A classic 1920s art deco monument, entirely dedicated to caviar and seafood. A true landmark, this "sleeping beauty" is in the process of winning back its place as a restaurant for the Parisian smart set. (See photographs pp. 17, 54–57.)

LE RELAIS PLAZA
Hôtel Plaza Athénée
21, avenue Montaigne, 75008
Tel: +33 (0)1 53 67 64 00
www.plaza-athenee-paris.fr/le-relaisplaza
Decor from the 1930s inspired by the ocean liner Le Normandie, and contemporary chic brasserie cuisine devised by Alain Ducasse. (See photograph p. 37.)

SENDERENS–LUCAS CARTON
9, place de la Madeleine, 75008
Tel: +33 (0)1 42 65 22 90
www.senderens.fr
The brilliantly simple art nouveau decor has successfully come through a major facelift. Alain Senderens, in giving back his three stars to Michelin, has indicated

that he wants to turn the page on classicism and embrace modernity. (See photographs pp. 48–53.)

TAILLEVENT
15, rue Lamennais, 75008
Tel: +33 (0)1 44 95 15 01
www.taillevent.com
In the former residence of the Duc de Morny, the Vrinat family maintains the tradition of pageantry where the service and the cuisine are combined in a concerto of refinement.

LEGENDARY BRASSERIES

BALZAR
49, rue des Écoles, 75005
Tel: +33 (0)1 43 54 13 67
www.brasseriebalzar.com
A meeting place for academics at the Collège de France and the Sorbonne since the late nineteenth century. Entirely renovated in 1931 by Marcellin Cazes, the proprietor of Lipp. The authentic spirit has been preserved, perhaps more than in any other brasserie, largely thanks to the solid conservatism and corporate solidarity of the regular customers.

AU BOEUF COURONNÉ
188, boulevard Jean-Jaurès, 75019
Tel: +33 (0)1 42 39 44 44
www.boeuf-couronne.com
Facing the old abattoirs at La Villette, this meeting point for wholesale butchers and livestock

merchants has remained one of the best meat restaurants in the capital, and has kept its typically 1950s decor.

BOFINGER
5–7, rue de la Bastille, 75004
Tel: +33 (0)1 42 72 87 82
www.bofingerparis.com
Authentic art deco interiors and Alsace brasserie cuisine unchanged for a century. Bofinger has maintained its tradition with a fresh public from the nearby Opéra Bastille. (See photographs pp. 8, 60 –63.)

BOUILLON RACINE
3, rue Racine, 75003
Tel: +33 (0)1 44 32 15 60
www.bouillon-racine.com
Beveled mirrors, stained glass and opaline, carved wood paneling and marble mosaics, letters ornamented in gold leaf. Here, art nouveau expresses itself with baroque profusion. Restored in 1996 and listed as a historic monument, this former Chartier bouillon still provides popular fare, bringing tourists and students together around its tables.

LE CAFÉ DU COMMERCE
51, rue du Commerce, 75015
Tel: +33 (0)1 45 75 03 27
www.lecafeducommerce.com
This former canteen for car workers, now run by Marie and Étienne Guerraud, was completely renovated in 1988. The only restaurant in Paris apart from Lasserre (see this entry) with a roof that opens. Notable for the quality of its

meats, and one of the hotspots of the fifteenth arrondissement.

**CHARLOT–ROI
DES COQUILLAGES**
12, place Clichy, 75009
Tel: +33 (0)1 53 20 48 00
www.charlot-paris.com
Furnishings from 1925, engraved glass partitions, and seascape frescoes: the art deco at Charlot is exuberant and full of detail, hand in hand with the most extensive trays of seafood in Paris.

LA CLOSERIE DES LILAS
171, boulevard du Montparnasse, 75006
Tel: +33 (0)1 40 51 34 50
www.lacloseriedeslilas.fr
Once a skating rink, then a dance hall, then a bar, La Closerie, in becoming an American-style bar (and incidentally a restaurant), set itself up as a meeting place for writers, whose names are carved on the tables they were supposed to occupy. For those curious to know what La Closerie looked like in the nineteenth century, there is a very fine picture in one of the dining rooms at the restaurant Laurent (see entry p. 289).

LA COUPOLE
102, boulevard du Montparnasse, 75014
Tel: +33 (0)1 43 20 14 20
www.lacoupole-paris.com
The largest brasserie of the 1920s, still as vibrant and animated as ever, with its pillars decorated by the artists of the time, its grid of tables

and seats, its bar, its terrace and even its dance floor, still in use today. (See photographs pp. 80–83.)

FERMETTE MARBEUF 1900
5, rue Marbeuf, 75008
Tel: +33 (0)1 53 23 08 00
www.fermettemarbeuf.com
An interior from 1900, rediscovered and patiently restored between 1978 and 1982, then listed as a historic monument in 1983. This glazed pavilion situated in the courtyard of a private house is the last specimen of a much-appreciated specialty of the late nineteenth century, the "winter garden" restaurant. This one was transformed into a brasserie by the Blanc brothers.

GALLOPIN
40, rue Notre-Dame-des-Victoires, 75002
Tel: +33 (0)1 42 36 45 38
www.brasseriegallopin.com
The first English bar in Paris, with dark wood paneling and copper everywhere. Gallopin is still a popular meeting place in the business quarter of La Bourse. (See photographs pp. 68–71.)

LE GRAND COLBERT
2, rue Vivienne, 75002
Tel: +33 (0)1 42 86 87 88
www.legrandcolbert.fr
This brasserie opposite the Galerie Colbert has a spectacular reconstruction of a mid-nineteenth-century interior, better than the real thing.

JULIEN
16, rue du Faubourg-Saint-Denis, 75010
Tel: +33 (0)1 47 70 12 06
www.julienparis.com
One of the most sumptuous art nouveau bouillons. Boasts a mahogany bar attributed to Louis Majorelle, and on the walls, four Louis Trezel inlay works on glass with stud and pearl relief, depicting Byzantine beauties, in beautifully rich stucco frames.

LIPP
151, boulevard Saint-Germain, 75006
Tel: +33 (0)1 45 48 72 91
A political and intellectual meeting place of long standing, which is still a stronghold of Saint-Germain-des-Prés nostalgia. The protocol is as unyielding as the court of Louis XIV. (See photographs pp. 58, 64–67.)

MOLLARD
115, rue Saint-Lazare, 75008
Tel: +33 (0)1 43 87 50 22
www.mollard.fr
A beautiful station brasserie with an eclectic decor of murals and paintings dated 1880, Mollard has won back its rank with a traditional menu and a great range of seafood. (See photographs pp. 72–75.)

MONTPARNASSE 1900
59, boulevard du Montparnasse, 75006
Tel: +33 (0)1 45 49 19 00
www.montparnasse-1900.com

A true bouillon, *revamped in 1977 by Slavik who made it shine like new (perhaps a bit too much).*

TERMINUS NORD
23, rue de Dunkerque, 75010
Tel: +33 (0)1 42 85 05 15
www.terminusnord.com
This 1925 brasserie— as indicated by the sign above the outside menu—has kept its authenticity and its customer base of train lovers.

LE TRAIN BLEU
Gare de Lyon, 75012
Tel: +33 (0)1 43 43 09 06
www.le-train-bleu.com
The most beautiful station buffet in the world. Le Train Bleu is to art pompier *what the Sainte Chapelle is to Gothic architecture.*
(See photographs pp. 2–3, 76–79.)

VAGENENDE
142, boulevard Saint-Germain, 75006
Tel: +33 (0)1 43 26 68 18
www.vagenende.fr
This carefully maintained and listed art nouveau Chartier bouillon has a classier atmosphere than those on the Right Bank, and really deserves a more inspired approach to the food.

LE ZÉPHYR
1, rue du Jourdain, 75020
Tel: +33 (0)1 46 36 65 81
www.lezephyrcafe.com
Between Belleville and the Buttes-Chaumont, the interior is pure art deco in this

beautiful brasserie dated 1929.
Such style is unexpected in this part of town.
Traditional brasserie fare.

EXCEPTIONAL PRODUCTS

AUGÉ
116, boulevard Haussmann, 75008
Tel: +33 (0)1 45 22 16 97
www.cavesauge.com
This is an absolute must, as much for the great names in wine, as for the "natural" wines and the superb advice that is dispensed in an interior that has remained unchanged since the Second Empire, all of which has made it a veritable temple for genuine wine lovers.
(See photographs pp. 88–91.)

DALLOYAU
101, rue du Faubourg Saint-Honoré, 75008
Tel: +33 (0)1 42 99 90 00
2, place Edmond Rostand, 75006 Paris
Tel: +33 (0)1 43 29 31 10
5, boulevard Beaumarchais, 75004
Tel: +33 (0)1 48 87 89 88
For other addresses see: www.dalloyau.fr
A delicatessen with a history that stretches back in time, much to the delight of those lucky enough to live close by.

FAUCHON
(Boutique) 24–26, place de la Madeleine, 75008
Tel: +33 (0)1 70 39 38 00

("Le Café") 30, place de la Madeleine
Tel: +33 (0)1 70 39 38 39
www.fauchon.fr
The grand old lady of place Madeleine, the favorite fine food store of Paris's upper crust is also a patisserie and delicatessen, and offers snacks and packed lunches produced by the Flo group. They offer shipping worldwide.

LA GRANDE ÉPICERIE DU BON MARCHÉ
26–38, rue de Sèvres, 75007
Tel: +33 (0)1 44 39 81 00
www.lagrandeepiceriedeparis.fr
A huge choice of confectionery and cookies from around the world, together with wines, meat, fish, sandwiches, and salads are on offer here.
A wide selection of foods that you can take home or eat in the store are on display next to a delicatessen counter that includes light and tasty daily specials.

HÉDIARD
21, place de la Madeleine, 75008
Tel: +33 (0)1 43 12 88 88
For other addresses see: www.hediard.fr
A fine food store where everything is fabulous.

LADURÉE
21, rue Bonaparte, 75006
Tel: +33 (0)1 44 07 64 87
16, rue Royale, 75008
Tel: +33 (0)1 42 60 21 79
75, avenue des Champs-Élysées, 75008
Tel: +33 (0)1 40 75 08 75
www.laduree.fr

Three temples to the art of the macaroon, each with a nineteenth-century interior. Classics like raspberry, coffee, and rose are complemented by new inventions such as licorice and mint, with a new "collection" almost every season and a superb pastry shop with candy and choco- lates of the highest quality that make excellent gifts.
(See photographs pp. 92–95.)

LENÔTRE
44, rue d'Auteuil, 75016
Tel: +33 (0)1 45 24 52 52
For other addresses see: www.lenotre.fr
Gourmets remember with nostalgia Gaston Lenôtre's unforgettable cakes when he first set up shop in Paris. While Lenôtre may since have opened new outlets, the quality has remained as high.

MARIAGE FRÈRES
(Boutiques and tearooms)
30–32–35, rue du Bourg Tibourg, 75004
Tel: +33 (0)1 42 72 28 11
13, rue des Grands-Augustins, 75006
Tel: +33 (0)1 40 51 82 50;
For other addresses see: www.mariagefreres.com
With its miniature tea museum, boutique, and tearoom, a visit to Mariage Frères is a real treat. Be sure to book for Sunday brunch, which is extremely popular.
(See photographs pp. 96–101.)

PETROSSIAN
(Boutique and restaurant)
18, boulevard de la Tour
Maubourg, 75007
Tel: +33 (0)1 44 11 32 22
www.petrossian.com
*No surprise that you can find
the very best caviar here (the
Imperial is our favorite), as well
as smoked wild salmon, cod
with dill, or à la caucasienne,
Pacific salmon roe as well as
a variety of smoked fish such
as sturgeon, eel, and herring.
But Petrossian also has
a range of fine foods like
borscht, or chocolate drops
with vodka and a small dining
area where you can have
a plate of smoked fish
accompanied by a glass
of wine or vodka (plain, cherry,
or herb flavored), or a crab or
salmon sandwich to take out.
They offer shipping worldwide.
(See photograph p. 84.)*

PIERRE HERMÉ
72, rue Bonaparte, 75006
Tel: +33 (0)1 43 54 47 77
185, rue de Vaugirard, 75015
Tel: 01.47.83.89.96
4, rue de Cambon, 75001
Tel: 01.58.62.43.17
(Only macaroons and chocolates)
www.pierreherme.com
*No guide to gourmet Paris can
ignore this famous pastry chef.*

TERRES DE TRUFFES
(Restaurant and boutique)
21, rue Vignon, 75008
Tel: +33 (0)1 53 43 80 44
www.terresdetruffes.com
*Next to the Madeleine,
this attractive boutique was
opened by a chef originally*

*from the South of France,
Bruno de Lorgues. Truffles are
the stars of course, but their
derivatives play a strong
supporting role—truffled
cheese and truffled ice cream
to name but two. The
minimalist dining room is
perfect for tasting the wares
on display, but you can also
order dishes to take out or
buy some tortellini with
truffles to cook at home.
(See photographs pp. 86–87.)*

DE VINIS ILLUSTRIBUS
48, rue de la Montagne-Sainte-
Geneviève, 75005
Tel: +33 (0)1 43 36 12 12
www.devinis.fr
*Over a century of old vintages,
rare wines, great classics,
special occasion wines, and
favorites from all regions,
offering value for money to
boot. This specialist offers
tasting evenings in the cellar
and dispatches orders around
France and abroad.*

TRADITIONAL PARIS
Old-Fashioned Flavors
and Atmospheres

BISTROS

ALLARD
1, rue de l'Éperon, 75006
Tel: +33 (0)1 43 26 48 23
*A comfortable and upmarket
bistro where diners enjoy
copious amounts without
a thought for cholesterol.*

*(See photographs pp. 118–
121.)*

L'AMI LOUIS
32, rue Vertbois, 75003
Tel: +33 (0)1 48 87 77 48
*The Americans' favorite
Parisian bistro, with an interior
unchanged since the 1930s.
(See photographs pp. 122–123.)*

AU PETIT RICHE
25, rue Le Peletier, 75009
Tel: +33 (0)1 47 70 68 68
www.restaurant-aupetitriche.com
*An opulent 1880 interior
and traditional specialties
from the Val de Loire.
(See photographs pp. 104–107.)*

AUX LYONNAIS
32, rue Saint-Marc, 75002
Tel: +33 (0)1 42 96 65 04
www.auxlyonnais.com
*Typical 1900 decor with
tiles that come straight
from the Paris Metro.
Alain Ducasse has taken
over the menu, putting a
fresh spin on the traditionnal
Lyonnais restaurant.
(See photographs pp. 124–
127.)*

LE BARATIN
3, rue Jouye-Rouve, 75020
Tel: +33 (0)1 43 49 39 70
*An unpretentious interior,
but Raquel Carena's
cooking definitely makes
it worth a visit.
(See photographs pp. 101,
128–131.)*

BENOÎT
20, rue Saint-Martin, 75004
Tel: +33 (0)1 42 72 25 76

www.benoit-paris.com
*This plush bistro has long
been the haunt of councilors
at the nearby Hôtel de Ville.
Characterized by satirical
posters from the 1930s
and an ambience that has
not changed since 1904.
Taken over by Alain Ducasse
in 2005, this luxury bistro
has been rejuvenated.*

**LE BISTROT D'À CÔTÉ –
FLAUBERT**
10, rue Gustave-Flaubert, 75017
Tel: +33 (0)1 42 67 05 81
www.bistrotflaubert.com
*A lovely collection of Parisian
slipware figures and old
Michelin Guides adorns this
annex to Michel Rostang's
main restaurant. It offers
accessibly priced, tasty food,
notably delicious stuffed
vegetables in season.*

BISTROT PAUL BERT
18, rue Paul-Bert, 75011
Tel: +33 (0)1 43 72 24 01
*A French version of the wine
bar, where you keep a tab
running for the evening, and
what you eat is as important
as what you drink. Over
one hundred wines are
accompanied by solid offerings
like velouté of lentils with foie
gras, crunchy pig snout, or
smoked andouillette cassoulet.*

CHARDENOUX
1, rue Jules-Vallès, 75011
Tel: +33 (0)1 43 71 49 52
www.restaurantlechardenoux.com
*An authentic workers' canteen,
with a protected 1904 interior
that has not changed a bit in*

appearance though its cooking has been updated and refined thanks to chef Cyril Lignac.

CHARTIER
7, rue du Faubourg-Montmartre, 75009
Tel: +33 (0)1 47 70 86 29
www.bouillon-chartier.com
The quintessential Parisian bouillon with simple, functional food and an interior to match. (See photographs pp. 112–113.)

CHEZ MICHEL
10, rue de Belzunce, 75010
Tel: +33 (0)1 44 53 06 20
Thierry Breton opened his bistro Chez Michel in 1995, just after Yves Camdeborde opened his, La Régalade (see entry). The unpretentious decor dates back to 1939, but expect to be impressed: Breton did his apprenticeship at the Ritz, before working at top restaurants and hotels all over France. Sophisticated food based on authentic produce.

CHEZ PAUL
13, rue de Charonne, 75011
Tel: +33 (0)1 47 00 34 57
www.chezpaul.com
The typical Parisian local bistro: checkered tablecloths, local customers, and your bill marked down on a slate as you go along.

LE CLOWN BAR
114, rue Amelot, 75011
Tel: +33 (0)1 43 55 87 35
This wine bar is right next to the Cirque d'Hiver, and used to be part of the wings.

Worth a visit for a frieze dated 1910 made by the tileworks at Sarreguemines representing a clown parade.

LE COMPTOIR
9, carrefour de l'Odéon, 75006
Tel: +33 (0)1 44 27 07 97
Just around the corner from the Odéon, a new place for the founder of La Régalade (see entry). Yves Camdeborde sticks to the classics that made his reputation, like trotters off the bone or black pudding pâté.

L'ESCARGOT MONTORGUEIL
38, rue Montorgueil, 75001
Tel: +33 (0)1 42 36 83 51
A celebration of the snail since at least 1880. The stairs and shop front are original and the back room ceiling came from Sarah Bernhardt's private apartments. (See photographs pp. 108–111.)

L'OS À MOELLE
3, rue Vasco de Gama, 75015
Tel: +33 (0)1 45 57 27 27
www.paris-restaurant-osamoelle.com
Bistro food with a touch of haute cuisine where presentation counts and the best is brought out of simplicity. No actual decor as such, more of an ambience: that of a truly contemporary Parisian bistro. Good wine list.

LE POLIDOR
41, rue Monsieur-le-Prince, 75006
Tel: +33 (0)1 43 26 95 34

An old dairy shop turned into a student restaurant at the heart of the Latin Quarter where typically French cuisine can be had at reasonable prices. (See photographs pp. 114–117.)

LA RÉGALADE
49, avenue Jean-Moulin, 75014
Tel: +33 (0)1 45 45 68 58
This is where the bistro revolution started in 1991. Yves Camdeborde bet on his native Béarn produce and brought a taste for simple and affordable food back to Paris. He has handed over to Bruno Doucet now, but the place is still a must, and it's still just as hard to get a table.

LE REPAIRE DE CARTOUCHE
8, boulevard des Filles-du-Calvaire
99, rue Amelot, 75011
Tel: +33 (0)1 47 00 25 86
The yellow wash and wood panels date from 1900. Modern bistro cuisine, delightfully served by Rodolphe Paquin from Normandy, one of four disciples expertly trained by Christian Constant at the Crillon.

LE SQUARE TROUSSEAU
1, rue Antoine-Vollon, 75012
www.squaretrousseau.com
Tel: +33 (0)1 43 43 06 00
This 1900 popular restaurant has been partly restored and has kept its original spirit of a brasserie for local artisans. (See photograph p. 4.)

FRENCH CULINARY ESSENTIALS

Bread

L'AUTRE BOULANGE
43, rue de Montreuil, 75011
Tel: +33 (0)1 43 72 86 04
12, place de la Nation, 75012
Tel: +33 (0)1 43 43 41 30
Traditional and specialist breads as well as fougasses are on offer in this excellent address on the east side of Paris.

BOULANGERIE KAYSER
85, boulevard Malesherbes, 75017
Tel: +33 (0)1 45 22 70 30
8, rue Monge, 75005
Tel: +33 (0)1 44 07 01 42
For other addresses see:
www.maison-kayser.com
This is the most fashionable Parisian bakery of the moment with a huge selection of breads and four "collections" a year (one per season). The bread is always perfectly made thanks to the fermentolevain machine Éric Kayser invented so that every loaf has a fine crust and an impeccably formed crumb. Most stores also have a few tables for grabbing a quick snack. (See photographs pp. 142–145.)

BREAD & ROSES
7, rue de Fleurus, 75006
Tel: +33 (0)1 42 22 06 06
25, rue Boissy d'Anglas, 75008
Tel: +33 (0)1 47 42 40 00
www.breadandroses.fr

This new bakery next to the Luxembourg gardens has everything you need from hefty country loaves to organic bread with dried fruits and spelt bread as well as English brown bread, scones, muffins, a delicatessen counter, and a few tables for a quick snack.

À LA FLÛTE GANA
226, rue des Pyrénées, 75020
Tel: +33 (0)1 43 58 42 62
www.gana.fr
Isabelle and Valérie Ganachaud are two of the best-known women bakers in France and their reputation has spread far beyond their Belleville neighborhood.

MOISAN
4, avenue du Général Leclerc, 75014
Tel: +33 (0)1 43 22 34 13
57, rue Fondary, 75015
Tel: +33 (0)1 45 75 34 85
www.painmoisan.fr
The best in organic bread. Pastries based on ingredients originating from organic agriculture can also be found.

LE MOULIN DE LA VIERGE
166, avenue de Suffren, 75015
Tel: +33 (0)1 47 83 45 55
105, rue Vercingétorix, 75014
Tel: +33 (0)1 45 43 09 84
6, rue de Lévis, 75017
Tel: +33 (0)1 43 87 42 42
64, rue de St Dominique, 75007
Tel: +33 (0)1 47 05 98 50
www.lemoulindelavierge.com
Breads here are made with organic flour, baked in the old-fashioned way, and sold in old-fashioned authentic bakeries for local residents.
(See photographs pp. 136–141.)

PAUL
33, rue Tronchet, 75008
(Listed facade)
Tel: +33 (0)1 40 17 99 54
For other addresses see:
www.paul.fr
The marketing here is not overdone, and efforts are made to preserve traditional methods.
(See photographs pp. 14, 146–149.)

POILÂNE
8, rue Cherche-Midi, 75006
Tel: +33 (0)1 45 48 42 59
49, boulevard de Grenelle, 75015
Tel: +33 (0)1 45 79 11 49
39, rue Debelleyme, 73003
Tel: +33 (0)1 44 61 83 39
www.poilane.fr
No need to introduce Poilâne's bread, but the bakery on rue du Cherche-Midi is also a bread museum that includes an extraordinary collection of still lifes with bread as their theme. You can visit all areas, from the shop itself to the baking area.
(See photographs pp. 132–135.)

Cheese

ANDROUËT
37, rue de Verneuil, 75007
Tel: +33 (0)1 42 61 97 55
134, rue Mouffetard, 75005
Tel: +33 (0)1 45 87 85 05
97, rue de Cambronne, 75015
Tel: +33 (0)1 47 83 32 05
For other addresses see:
www.androuet.com
Pierre Androuët was the first Paris cheese merchant to have given cheese its rightful place in the gastronomic landscape.

BARTHÉLEMY
51, rue de Grenelle, 75007
Tel: +33 (0)1 42 22 82 24
The cheese merchant that supplies the Faubourg Saint-Germain has a comprehensive choice of cheeses ripened to perfection by Madame Nicole Barthélemy.
(See photographs pp. 150–153.)

MARIE ANNE CANTIN
12, rue du Champs de Mars, 75007
Tel: +33 (0)1 45 50 43 94
www.cantin.fr
In a profession dominated by men, Marie-Anne Cantin stands out as a master cheese merchant. With her innate sense of hospitality she is a key player on the Paris food scene.
(See photographs pp. 154–155.)

Wine

LE BARON ROUGE
1, rue Théophile Roussel, 75012
Tel: +33 (0)1 43 43 14 32
The patrons of this wine shop near the Aligre market are so numerous they end up spilling onto the sidewalk.

CAVES TAILLEVENT
199, rue du Faubourg Saint-Honoré, 75008
Tel: +33 (0)1 45 61 14 09
www.cavestaillevent.com
The Michelin three-star restaurant's boutique has one of the best selections of Burgundies in Paris.

LA DERNIÈRE GOUTTE
(Cellar, restaurant-wine bar)
6, rue Bourbon-le-Château, 75006
Tel: +33 (0)1 43 29 11 62
www.ladernieregoutte.net
This wine shop is run by a young American wine lover who is particularly keen on wines from the Languedoc and has made it his business to introduce them to Paris.
(See photographs pp. 13, 156–159.)

L'ÉCLUSE
(Boutique)
1, rue d'Amaillé, 75017
Tel: +33 (0)1 46 33 58 74
(Restaurant-wine bar)
15, quai des Grands-Augustins, 75006
Tel: +33 (0)1 46 33 58 74
For other addresses see:
www.lecluse-restaurant-paris.fr
A concentration of Bordeaux wines and a few regional dishes or a foie gras with a glass of Sauternes and a legendary chocolate cake make up the menu and give a homey touch to what was one of the first wine bars in Paris.

IDEA VINO
88, avenue Parmentier, 75011
Tel: +33 (0)1 43 57 10 34
www.idea-vino.fr
Supplier to all the best Italian restaurants. Its Barolos and Chiantis are particularly noteworthy as is the Modena mustard and the organic risotto made with squid ink or cèpe mushrooms.

LEGRAND FILLES ET FILS
1, rue de la Banque, 75002
Tel: +33 (0)1 42 60 07 12
www.caves-legrand.com
A stone's throw from place des Victoires, with a magnificent old-fashioned interior that leads to the Galerie Vivienne, Legrand is famous for its wine but also offers a selection of confectionery and traditional sweets.
(See photographs pp. 160–163.)

LE REPAIRE DE BACCHUS
88, rue de Montorgueil, 75002
Tel/Fax: +33 (0)1 72 63 68 48
For other addresses see:
www.lerepairedebacchus.com
A good selection of wines and spirits and a particularly interesting range of spirits sold under the name "Natural Color" that includes Armagnac, cognac, and whisky that have been aged naturally and without added color.

Soup

LE BAR À SOUPES
33, rue de Charonne, 75011
Tel: +33 (0)1 43 57 53 79
www.lebarasoupes.com

Anne-Catherine Bley's little yellow boutique is just next to the Bastille, and she has written a book of soup recipes. Every day there is a soup of the day and a choice of five other seasonal soups. Our favorites are pea and mint, nettle, and pumpkin with cinnamon. You can take out or eat in.
(See photographs pp. 164–167.)

BAR À SOUPES ET QUENELLES
5, rue Princesse, 75006
Tel: +33 (0)1 43 25 44 44
16, rue Mabillon, 75006
Tel: +33 (0)1 43 25 53 00
www.giraudet.fr
Soups here come in little bottles that are perfect for two people, or if you prefer you can have a bowl on the premises. In winter, our favorite is chestnut and lentil, and in spring it is a toss up between asparagus, pea, or broad bean. Giraudet, the originator of these creations, also specializes in quenelles.
(See photographs pp. 168–169.)

GOURMET FOOD STORES AND COFFEE MERCHANTS

L'AVANT-GOÛT CÔTÉ CELLIER
37, rue Bobillot, 75013
Tel: +33 (0)1 45 81 14 06
www.lavantgout.com
This tiny fine-food store belongs to the talented chef from the Avant-Goût restaurant opposite. As well as a range of foods and wine, dishes

from the restaurant can be ordered to take out.

CAFÉ VERLET
256, rue Saint-Honoré, 75001
Tel: +33 (0)1 42 60 67 39
www.cafesverlet.com
Annual trips to the key coffee-producing regions of the world by this traditional coffee roaster ensure a stock of the very finest coffees. You can also order a cup while inhaling the aromas of the coffee being roasted on the premises.
(See photographs pp. 178–181.)

LE COMPTOIR DE LA GASTRONOMIE
34, rue Montmartre, 75001
Tel: +33 (0)1 42 33 31 32
www.comptoir-gastronomie.com
Situated in Les Halles, this boutique opens from 6 a.m. to 7 p.m. as it might have done when this area was the former market district of Paris. Foie gras, salmon, wines, spirits, and a delicious chocolate cake are on offer behind a beautiful facade dating from the nineteenth century. At lunchtime a few tables are available.
(See photograph p. 170.)

LA CRÉMERIE
9, rue des Quatre-Vents, 75006
Tel: +33 (0)1 43 54 99 30
An address for Spanish cured meats as well as a very fine selection of Italian products such as the exceptional burrata

from the Puglia region.
(See photographs pp. 172–175.)

DUBERNET
2, rue Augereau, 75007
Tel: +33 (0)1 45 55 50 71
www.maisondubernet.surinternet.com
Everything you could want from southwestern France: foie gras, preserved foods, pâtés, and hams along with vacuum-packed cooked dishes like veal stew and boiled bacon.

GOUMANYAT
3, rue Charles-François Dupuis, 75003
Tel: +33 (0)1 44 78 96 74
www.goumanyat.com
A secret gourmet food address without which any guide on gourmet Paris would be incomplete.

GRANTERROIRS
30, rue Miromesnil, 75008
Tel: +33 (0)1 47 42 18 18
www.granterroirs.com
Delicacies from Provence and all over the Mediterranean are the specialty here. You can taste everything beforehand at one of the tables in the restaurant.

LAFAYETTE GOURMET
40, boulevard Haussmann, 75009
Tel: +33 (0)1 40 23 52 67
www.galerieslafayette.com
A huge food hall with a selection of goods from around the world and including a Bellota Bellota stand with Spanish hams.

LEBLANC
(At Tomat's Épicerie Fine)
12, rue Jacob (far side of
the courtyard), 75006
Tel: +33 (0)1 44 07 36 58
www.huile-leblanc.com
 "Fruit" oils (walnut, hazelnut,
pine-nut, sesame, and canola)
are the specialty at this Paris
outlet of France's leading
traditional oil mill.
(See photographs pp. 176–177.)

AUX PIPALLOTTES
GOURMANDES
49, rue Rochechouart, 75009
Tel: +33 (0)1 44 53 04 53
www.auxpapillotesgourmandes.
com
The few brightly colored tables
at this delicatessen on the way
to Montmartre are besieged
at lunchtime. Open every day,
it offers a selection of the
most exciting foods on sale
in the store (chutneys, pâtés,
preserved foods), and biscuits,
cakes, pastries (such as
"grandmother's" chocolate
cake) and desserts like
the chocolate crème brulée,
and teas from Mariage Frères.
It also has a range of fruit-
and vegetable-based cosmetics
like cucumber cold cream and
peach body scrub.

**CAKES, CANDY,
CHOCOLATE,
AND TEAROOMS**

BERTHILLON
(Ice cream maker and tearoom)
29-31, rue Saint-Louis-en-l'Île,
75004

Tel: +33 (0)1 43 54 31 61
www.berthillon.fr
Berthillon has been around for
three generations and is world
famous for its sorbets and ice
creams. Do not be put off by
the line outside the little
boutique on rue Saint-Louis,
the wait is worth it. Ice cream
comes in a huge choice
of flavors—coffee, whisky,
fresh mint, caramel with ginger,
and pine nut praline—but
the macaroons filled with ice
cream are doubly delicious.

BOISSIER CHOCOLATIER
(Boutique and tearoom)
184, avenue Victor Hugo, 75016
Tel: +33 (0)1 45 03 50 77
www.maison-boissier.com
The fruit balls here are
famous, but the chocolates
and tearoom are also
worth the trip.

LES BONBONS
6, rue Bréa, 75006
Tel: +33 (0)1 43 26 21 15
This minuscule boutique
in Montparnasse is well
known for its huge choice
of confectionery from all
over France.

DEBAUVE ET GALLAIS
30, rue des Saints-Pères, 75007
Tel: +33 (0)1 45 48 54 67
33, rue Vivienne, 75002
Tel: +33 (0)1 40 39 05 50
www.debauve-et-gallais.com
This beautiful boutique
in Saint-Germain-des-
Prés has lots of original
ideas like the pistoles
de Marie-Antoinette
and Arabica coffee

beans coated in chocolate
(keep a stock handy,
just in case).

DU PAIN ET DES IDÉES
34, rue Yves Toudic, 75010
Tel: +33 (0)1 42 40 44 52
www.dupainetdesidees.com
Near the Canal Saint-Martin,
this magnificent bakery has
a listed decor dating from
1889. Owner Christophe
Vasseur worked in fashion
before deciding to learn the
baker's trade. He was named
Paris's top baker in 2008 by
the Gault et Millau guide. Here,
you will find pastries that exist
nowhere else, namely the fresh
apple chausson, where
traditional puff pastry is filled
not with compote, but half
an apple cooked with a hint
of sugar.
(See photographs pp. 196–199.)

À L'ÉTOILE D'OR
30, rue Fontaine, 75009
Tel: +33 (0)1 48 74 59 55
A visit to this little boutique
on place Pigalle is quite
an experience. Denise Acabo
will enchant you with her
knowledge of France's
confectionery. And only
in her shop can you find
such a selection of specialties
from the country's best
craftsmen, with chocolates
from Bernachon in Lyon,
Dufoux in Burgundy, and
marshmallows from Nancy.
(See photographs pp. 188–191.)

FOUQUET
(Chocolate, confectionary,
and fine foods)

22, rue François Ier, 75008
Tel: +33 (0)1 47 23 30 36
36, rue Laffitte, 75009
Tel: +33 (0)1 47 70 85 00
42, rue du Marché Saint-Honoré,
75001
Tel: +33 (0)1 47 03 90 07
www.fouquet.fr
This superb store has an
excellent choice of confectionery,
including fondants that are not
so easy to find. They offer
shipping worldwide.

GÉRARD MULOT
76, rue de Seine, 75006
Tel: +33 (0)1 43 26 85 77
93, rue de la Glacière, 75013
Tel: +33 (0)1 43 81 39 09
6, rue du Pas-de-la-Mule, 75003
Tel: +33 (0)1 42 78 52 17
www.gerard-mulot.fr
Excellent cakes that include
a cherry pie (pick the plain
version instead of the pistachio
variety) and orange tart as well
as first-class sandwiches and
a wide choice of rich and
wholesome savory tarts, with
salmon or vegetables, etc.

LAURENT DUCHÊNE
2, rue Wurtz, 75013
Tel: +33 (0)1 45 65 00 77
www.laurent-duchene.com
In the heart of the thirteenth
arrondissement this pastry
shop is really worth a trip:
delicious little almond cakes
known as financiers, and a
host of other mouthwateringly
moist teatime cakes. The mini
chocolate cakes that melt
in the middle are a specialty.
Incidentally, he is also one
of the best bread bakers
in Paris.

LA MAISON DU CHOCOLAT
225, rue du Faubourg-Saint-
Honoré, 75008
Tel: +33 (0)1 42 27 39 44
19, rue de Sèvres, 75006
Tel: +33 (0)1 45 44 20 40
52, rue François Ier, 75008
(Tearoom)
Tel: +33 (0)1 47 23 38 25
For other addresses see:
www.lamaisonduchocolat.com
*La Maison du Chocolat never
ceases to amaze with its
creations. Do not attempt
to resist the Marroni with
its unsweetened mousse
of marrons glacés, or the
Rigoletto—a light truffle mix
combined with caramelized
butter—the Zagora with fresh
mint, the lemon-flavored
Andalousie, or the chocolate
prunes, not to mention his
divine éclairs flavored with
chocolate, coffee, or caramel.*
(See photographs pp. 182–
187.)

À LA MÈRE DE FAMILLE
35, rue du Faubourg
Montmartre, 75009
Tel: +33 (0)1 47 70 83 69
82, rue de Montorgueil,
75002
Tel: +33 (0)1 53 40 82 78
For other addresses see:
www.lameredefamille.com
*A beautiful old setting—
among the most famous
in Paris—for this paradise
on earth where chocolates
from all over France will
lead you into temptation.
The problem is deciding
what to choose.*
(See photographs pp. 192–
195.)

CONTEMPORARY PARIS
Design and Creativity

THE FUTURE PERFECT

L'ALCAZAR
62, rue Mazarine, 75006
Tel: +33 (0)1 53 10 19 99
www.alcazar.fr/siteft_us
*It's Conran down to the
smallest details, a trendy
brasserie where the food
is carefully prepared,
the atmosphere young
but not exclusively so,
and the bill steep but
not outrageous.*
(See photographs pp. 228–
231.)

L'AMBROISIE
9, place des Vosges, 75004
Tel: +33 (0)1 42 78 51 45
www.ambroisie-paris.com
*In a setting that reproduces
a private house of the
seventeenth century, splendidly
recreated by François-Joseph
Graf, a meal at L'Ambroisie is
one of the great gastronomic
experiences Paris has to offer.
As its name suggests, it is
the food of the gods.*
(See photographs pp. 212–
215.)

L'APICIUS
20, rue d'Artois, 75008
Tel: +33 (0)1 43 80 19 66
www.restaurant-apicius.com
*Don't be overwhelmed by
the grand nineteenth-century
building off the Champs-
Élysées, or its princely garden.*

*Jean-Pierre Vigato has changed
none of his culinary practices
and still makes the best calf's
head in Paris. Regulars
from his "bistro" on avenue
de Villiers have followed him
here: such sublime dishes
are not easy to find
in the west of Paris.*

L'ARPÈGE
84, rue de Varenne, 75007
Tel: +33 (0)1 47 05 09 06
www.alain-passard.com
*The very sober decoration—
Arman sculpture, Lalique
glass, and a portrait of Alain
Passard's grandmother on
the wall—allows the culinary
creations to stand out. Passard
is one of the most original
chefs in Paris. He has imposed
an almost minimalist
gastronomy by rediscovering
vegetables and putting them
at the center of his menus.
But he is also a master at
cooking meats to perfection;
his dishes have something
almost musical about them,
both enigmatic and obvious.*

L'ASTRANCE
4, rue Beethoven, 75016
Tel: +33 (0)1 40 50 84 40
*Five years at L'Arpège
(see entry) set free
Pascal Barbot's taste for
invention and creativity.
His restaurant, with its
modern but discreet interior
has become a hot spot of
Parisian gastronomy.*

L'ATELIER DE JOËL ROBUCHON
L'Atelier St-Germain
Hôtel Pont-Royal

5, rue Montalembert, 75007
Tel: +33 (0)1 42 22 56 56
L'Atelier Étoile
133, avenue des Champs-
Élysées, 75008
Tel: +33 (0)1 47 23 75 75
www.joelrobuchon.net
*L'Atelier de Joël Robuchon
caused quite a stir when
L'Atelier St-Germain
opened, aiming for
a new way of thinking
about restaurants,
by opening up the kitchen
onto the client space and
putting that client space
around a bar. The concept
and precise food by Robuchon
were so successful
that a second Atelier
has opened in Paris.*
(See photographs pp. 216–
219.)

L'ATELIER MAÎTRE ALBERT
1, rue Maître Albert, 75005
Tel: +33 (0)1 56 81 30 01
www.ateliermaitrealbert.com
*A menu reworked by Guy Savoy
and an elegant and calm
interior by Jean-Michel
Wilmotte at this truly
contemporary rotisserie:
"How Paris reinvented the inn
in the twenty-first century."*

BON
25, rue de la Pompe, 75016
Tel: +33 (0)1 40 72 70 00
www.restaurantbon.fr
*Satin-lined walls, candles,
a fireplace, and a lovers'
dining room: chef Bruno
Brangea, former sous-chef at
Flora Danica (see La Maison
du Danemark entry), has his
work cut out to make us forget*

Philippe Starck's omnipresent baroque interior.
(See photographs pp. 206–207.)

BUDDHA BAR
8, rue Boissy D'Anglas, 75008
Tel: +33 (0)1 53 05 90 00
www.buddha-bar.com
More staggeringly kitsch than a Hollywood spectacular, this place is only incidentally about food. The design is a real eyeful, and the music an earful of remixes of remixes of remixes.

LE CABARET
2, place du Palais-Royal, 75001
Tel: +33 (0)1 58 62 56 25
www.cabaret.fr
With Franco-fusion food, and an interior by Ora Ito, this very trendy club is obviously still looking for its identity. Or perhaps it is happy to float aimlessly on the waves of fashion for a while longer.

CAFÉ BEAUBOURG
100, rue Saint-Martin, 75004
Tel: +33 (0)1 48 87 63 96
www.maisonthierrycostes.com
Less interesting for the basic contemporary brasserie food than for Christian de Portzamparc's design. Severe but coherent, promoting aesthetic polished concrete, and featuring a spectacular staircase up to the mezzanine.
(See photograph p. 204.)

LE CAFÉ MARLY
Le Louvre, Cour Napoléon
93, rue de Rivoli, 75001
Tel: +33 (0)1 49 26 06 60

Olivier Gagnère has successfully brought a touch of class to this space within the Louvre by furnishing it and dressing its walls with a discreet theatricality, avoiding showiness and incongruous effects.
(See photographs pp. 232–235.)

LE CARRÉ DES FEUILLANTS
14, rue de Castiglione, 75001
Tel: +33 (0)1 42 86 82 82
www.carredesfeuillants.fr
In a restaurant where the design extols the beauty of raw materials and raw art, Alain Dutournier brings together the gastronomic traditions of the southwestern Landes, the technique of haute cuisine, and an acute sense of innovation, to offer food which is both original and solidly anchored in regional produce, both refined and authentic.
(See photograph p. 202.)

LE CHIBERTA
3, rue Arsène Houssaye, 75008
Tel: +33 (0)1 53 53 42 00
www.lechiberta.com
Now in the capable hands of Guy Savoy, with an interior designed by Jean-Michel Wilmotte and based around wine. A fun place where you can make an accessible journey in the culinary world of this great chef.
(See photographs pp. 224–227.)

COLETTE
213, rue Saint-Honoré, 75001
Tel: +33 (0)1 55 35 33 90
www.colette.fr

Choose a glass of water from the dozens on offer to accompany a quick snack at the bar or at one of the tables in the basement.

CRISTAL ROOM DE BACCARAT
11, place des États-Unis, 75016
Tel: +33 (0)1 40 22 11 10
www.baccarat.fr
Philippe Starck let himself go as never before at the Baccarat Cristal Room: chandeliers, seats, bare walls, and marble pillars, all reminiscent of a Dalí painting.
(See photographs pp. 236–237.)

LA CUISINE
Hôtel Royal Monceau
37, avenue Hoche, 75008
Tel: +33 (0)1 42 99 98 70
www.leroyalmonceau.com
This restaurant designed by Philippe Starck is a large cathedral in which convivial spaces have been created, such as the dining room with its open kitchen. Light and fragrant cuisine. Desserts conceived by Pierre Hermé.

EMPORIO ARMANI CAFFE
149, boulevard Saint-Germain, 75006
Tel: +33 (0)1 45 48 62 15
Designed by Armani and situated at the heart of the Armani store in Saint-Germain-des-Prés. The Italian cuisine based on seasonal produce is really very good, the service is masterfully managed by the charming and diligent Massimo Mori, and you can eat there

quickly at any time, even on the terrace, weather permitting. A must for fashion victims.

GEORGES
Centre Georges Pompidou, 7th floor
19, rue Beaubourg, 75004
Tel: +33 (0)1 44 78 47 99
www.centrepompidou.fr
A very space-age design by a team of young avant-garde visual artists. Georges has one of the loveliest views of Paris from the top floor of the Centre Pompidou, and serves fusion food that is constantly improving.
(See photographs pp. 201, 238–241.)

LA GRANDE ARMÉE
3, avenue de la Grande-Armée, 75016
Tel: +33 (0)1 45 00 24 77
One of the oldest addresses of the Costes group.

GUY SAVOY
18, rue Troyon, 75017
Tel: +33 (0)1 43 80 40 61
www.guysavoy.com
Guy Savoy has had a leading place in the Parisian restaurant scene for several years now. His gastronomy is both sophisticated and native, profoundly rooted as it is in the terroirs, assuring him a longstanding international reputation even before being awarded a third Michelin star. For many visiting from abroad, his restaurant is the first port of call, after which they can say that they have at last arrived in France. The design

by Jean-Michel Wilmotte features primitive African and Asian statues and paintings by the Cobra group, reflecting Savoy's exacting and lyrical cuisine. (See photograph p. 205.)

HÔTEL COSTES
239, rue Saint-Honoré, 75001
Tel: +33 (0)1 42 44 50 00
www.hotelcostes.com
A fine Napoleonic maze designed by Jacques Garcia, and one of his indisputable successes.

LE JULES VERNE
Tour Eiffel, Champ-de-Mars, 75007
Tel: +33 (0)1 45 55 61 44
www.lejulesverne-paris.com
Alain Ducasse wanted this restaurant to be the most beautiful spot in Paris for savoring excellent and fairly affordable French cuisine. An unbeatable view of the whole of the city.

MAISON BLANCHE
Théâtre des Champs-Élysées
15, avenue Montaigne, 75008
Tel: +33 (0)1 47 23 55 99
www.maison-blanche.fr
Jacques and Laurent Pourcel, the twin brothers from Montpellier, have their Paris annex on the terrace of the Théâtre des Champs-Élysées. The building, by the great architect Auguste Perret, dates from 1913 and is an architectural tour de force in its own right. The modern structure stands clear of the historic monument by means of

independent posts, supported like a suspension bridge. The Window Room gives a dizzying vertical feel, its single glass wall overhanging the west of Paris. The Mezzanine on the upper level opens onto wider views of the landscape and reveals a gorgeous surprise: the terrace, an islet of greenery within the city, generally open from the month of April until the cold weather arrives.

**LA MAISON DU DANEMARK–
FLORA DANICA / COPENHAGUE**
142, avenue des Champs-Élysées, 75008
Tel: +33 (0)1 44 13 86 26
www.floradanica-paris.com
The two restaurants of the Danish cultural center, the Flora Danica and the Copenhague, were refurbished in 2002, but still have a very 1970s look about them. This is where you can find saumon à l'unilatérale or dishes from the Scandinavian tradition.

MARKET
15, avenue Matignon, 75008
Tel: +33 (0)1 56 43 40 90
The partnership of two stars: Vongerichten (Jean-Georges to his friends) devising the food and Christian Liaigre designing the interior, both names in their own right in New York. Jean-Georges is fast becoming the most high-profile French restaurateur in the United States with his (slightly) fusion approach, and Liaigre has remodeled the Mercer Hotel in

New York's SoHo. Here he has chosen to create a warm room where primitive art statues in stone, wood, and glass stare each other down. The menu includes tuna and wasabi, lobster and radish, and satay chicken, which do not easily convince certain Parisian palates.

MICHEL ROSTANG
20, rue Rennequin, 75017
Tel: +33 (0)1 47 63 40 77
www.michelrostang.com
Michel Rostang is at home in his restaurant with a cozy English club feel, delighting diners with what he does best: solid but refined cuisine bourgeoise such as veal shank, fattened Bresse chicken, whole veal sweetbread. The produce is not dressed up or disguised, just brought to its point of perfection by precise cooking and a strict art of preparation.

LE MURAT
1, boulevard Murat, 75016
Tel: +33 (0)1 46 51 33 17
One of Jacques Garcia's most successful interiors, on the theme of the Grande Armée of the Napoleonic Wars: grenadiers' shakos, plum-colored chairs and sofas, violet and almond-green silk curtains hiding one or two alcoves, and the walls and ceiling covered with silver birch trunks. Wow.

PERSHING HALL
49, rue Pierre Charron, 75008
Tel: +33 (0)1 58 36 58 36
www.pershing-hall.com

A very "designed" place, where plays on light evolving from day to night contrast with the impressive vertical garden by Patrick Blanc. The cuisine wears its fusion tendencies on its sleeve. Modernity on display, for all to see and eat.

PINXO
9, rue d'Alger, 75001
Tel: +33 (0)1 40 20 72 00
www.pinxo.fr
A modern but unaggressive setting, which encourages a convivial atmosphere. Pinxo is a paradigm for the bistro of tomorrow. (See photographs pp. 220–223.)

LE RESTAURANT
13, rue des Beaux-Arts, 75006
Tel: +33 (0)1 44 41 99 01
http://fr.l-hotel.com
Situated in a hotel, this restaurant features decor designed by Jacques Garcia in his inimitable and distinctive style, combining First and Second Empire, Belle Époque, and baroque elements. (See photographs pp. 208–211.)

RESTAURANT 1728
8, rue d'Anjou, 75008
Tel: +33 (0)1 40 17 04 77
www.restaurant-1728.com
This restaurant, occupying the restored salons of the Hôtel d'Anjou where Lafayette lived, offers fusion cuisine in an eighteenth-century setting: talk about a contrast!

**RESTAURANT
PIERRE GAGNAIRE**
6, rue Balzac, 75008
Tel: +33 (0)1 58 36 12 50
www.pierre-gagnaire.com/anglais
*Pierre Gagnaire is carrying out
one of the most unusual
experiments in the history
of French cooking. With the
help of the chemist Hervé This,
he has perfected a "molecular
gastronomy" that seeks
the true nature of ingredients
at the level of the chemical
processes at work in different
types of cooking. This provides
a natural impetus to creativity,
not just for making new dishes
but also for finding completely
new ways of cooking: chantilly
butter, chantilly cheese, warm
aspic, or flank steak in soup.
The decor of his restaurant is
sober to the point of austerity.*

SPOON
12, rue de Marignan, 75008
Tel: +33 (0)1 40 76 34 44
www.spoon.tm.fr
(Reopening planned for 2012)
*If there had to be just one
"fusion" restaurant in the
world, this would be it,
set up by Alain Ducasse
at the beginning of the new
millennium. Rather than an
assortment of flavors, this
is cuisine built on the mastery
of the most diverse
techniques: modern ones, like
induction, steam, and vacuum;
exotic ones like plancha and
wok; and traditional ones like
pressure-cooking, grilling, and
rotisserie. All for the benefit
of a completely flexible meal,
where everybody, from Asia*

*to America and from France
to Africa, can compose their
own gastronomic itinerary
without risking getting it wrong.
A bare but elegant light-gray
interior gives the place
a refreshing serenity.*

TERRASSE MIRABEAU
5, place de Barcelone, 75016
Tel: +33 (0)1 42 24 41 51
www.terrasse-mirabeau.com
*Pierre Negrevergne, previously
with Michel Rostang (see entry),
is just as capable of dashing
off dishes in the bistro style as
devising more sophisticated
preparations. His simple,
modern-looking neo-bistro is
one of the better addresses in
this well-to-do neighborhood.*

TOKYO EAT
Palais de Tokyo
13, avenue du Président Wilson,
75016
Tel: +33 (0)1 47 20 00 29
*The space alone is worth
a visit. The room within the
Palais de Tokyo, shared with
the Musée d'Art Moderne de
la Ville de Paris, looks more
like an aircraft hangar than
a restaurant. Thierry Bassard,
chef and manager of Tokyo Eat
have festooned it with large
pink flying saucers that honk
out brisk techno music.
Something is out there—
and it's the fusion food, which
is way out there. Welcome
to the hyper-trendy world of
what the French call fooding.
Despite this, the prices
are reasonable, the service
comes with a smile, and the
customers are a mixed bunch.*

ZE KITCHEN GALERIE
4, rue des Grands-Augustins,
75006
Tel: +33 (0)1 44 32 00 32
www.zekitchengalerie.fr
*William Ledeuil, who used
to work with Guy Savoy at
Les Bouquinistes, opened this
handsome space in 2001.
The decor is postmodern
and the place is just a little
too noisy. The menu is entirely
dedicated to fusion—Guy Savoy
being one of the Parisian
masters. As a devotee of Thai
cooking, he has developed
a technique for using Asian
roots and herbs in the
French culinary tradition.
His authentic source for
ingredients is Paris's
Chinatown in the thirteenth
arrondissement, but he
visits the floating market in
Bangkok several times a year,
and imports from as far away
as Japan.*

TRADITION REVISITED

BE
73, boulevard de Courcelles,
75008
Tel: +33 (0)1 46 22 20 20
*The partnership between Alain
Ducasse and Eric Kayser has
produced this combination of
breads, sandwiches, soups,
and salads (from the baker)
and fine foods (from Ducasse)
like tins of first-class tuna
straight from Bilbao, Italian
olive oil, wonderful antico
balsamic vinegar, as well as
risottos and handmade pasta.*

LE CARRÉ DES SIMPLES
22, rue Tronchet, 75008
Tel: +33 (0)1 44 56 05 34
www.lecarredessimples.com
*A pretty and modern boutique
in the department store
district with a selection of
teas, essential oils, and a
choice of originally flavored
herbal teas that include
a children's brew and
Lebanese white coffee.*

CHRISTIAN CONSTANT
(Boutiques and tearooms)
37, rue d'Assas, 75006
18, rue de Fleurus, 75006
Tel: +33 (0)1 53 63 15 15
www.christianconstant.fr
*This chocolate maker is one
of the capital's true masters:
try his orangettes made from
Sicilian mandarins or his
truffles and chocolate creams.*

COJEAN
3, place du Louvre, 75001
Tel: +33 (0)1 40 13 06 80
For other addresses see:
www.cojean.fr
*Delicious soups and super-
fresh salads in ultramodern
American style. Sandwiches
to take out, smartly offered
in mini-versions, filled with
crab, herbs, curry. Hot dishes
include quiches and vegetable
crumbles as well as a selection
of tasty desserts: compotes
(rhubarb, strawberry), carrot
cake, cherry cake, crumbles,
tarts, and tiny pasteis de nata
(Portuguese custard tarts).
All types of freshly squeezed
fruit and vegetable juices.
(See photographs pp. 258–
261.)*

COMPTOIRS RICHARD
48, rue du Cherche-Midi,
75006
Tel: +33 (0)1 42 22 45 93
145, rue Saint-Dominique,
75007
Tel: +33 (0)1 53 59 99 18
For other addresses see:
www.comptoirsrichard.fr
*While coffee is the main
attraction in these pretty
boutiques, chocolates,
cookies, teas, and herbal
teas are also on offer.
(See photographs pp. 256–257.)*

LA FERME
55, rue Saint-Roch, 75001
Tel: +33 (0)1 40 20 12 12
*Rustic-style decor for organic
products, to eat in or to take
out. Delicious little Portuguese
pasteis de nata and Martine
Lambert ice creams from
Deauville.*

JEAN-PAUL HÉVIN
(Boutique and tearoom)
231, rue Saint-Honoré, 75001
Tel: +33 (0)1 55 35 35 96
3, rue Vavin, 75006
Tel: +33 (0)1 43 54 09 85
23 bis, avenue de la Motte-
Picquet, 75007
Tel: +33 (0)1 45 51 77 48
www.jphevin.com
*Chocolates with cheese
(Roquefort is our favorite)
but also more traditional
chocolates like the best-selling
Carupana that mixes a ganache
with three types of honey,
miniature Florentine cookies,
Paladins with pecan nuts, and
candied chestnuts that are
less sweet than the traditional
marron glacé. In the cake line*

*there is the Turin made from
a mousse of candied
chestnuts, the Safi flavored
with orange, and the Guayaquil
with either bitter chocolate
or a combination of raspberry
and chocolate. Also a range of
dream gifts like the chocolate
heart that resembles the finest
lace, and the Kheops
chocolates with marzipan
and pistachio.
(See photographs pp. 242–247.)*

LAVINIA
3–5, boulevard de
la Madeleine, 75001
Tel: +33 (0)1 42 97 20 27
www.lavinia.fr
*This is not a supermarket,
more like a wine department
store with seven thousand
types and the widest choice
of foreign wines in Paris.
(See photographs pp. 252–255.)*

LINA'S
50, rue Étienne-Marcel, 75002
Tel: +33 (0)1 47 31 37 37
For other addresses see:
www.linasparis.com
*A quality sandwich chain
where soups, salads, and
desserts are also available,
to eat in or take out. An
American-style atmosphere
and newspapers so you can
linger over lunch.*

PIERRE MARCOLINI
89, rue de Seine, 75006
Tel: +33 (0)1 44 07 39 07
3, rue Scribe, 75009
Tel: +33 (0)1 44 71 03 74
www.marcolini.be
*In this ultramodern setting,
the chocolate maker from*

*Brussels has set Paris on fire
with his "chocolate squares"
and tea-flavored ganaches that
include Earl Grey, jasmine,
milk, and lemon varieties.
(See photographs pp. 12,
248–251.)*

POMZE
109, boulevard Haussmann,
75009
Tel: +33 (0)1 42 65 65 83
www.pomze.com
*Here, you can drink freshly
squeezed apple juice, ciders,
Calvados, in a boutique
devoted to the apple.
A very pleasant restaurant
on the first floor offers
dishes featuring this fruit.
(See photographs pp. 262–263.)*

EXOTIC FLAVORS

LA BAGUE DE KENZA
106, rue Saint-Maur, 75011
Tel: +33 (0)1 43 14 93 15
70, rue Turbigo, 75003
Tel: +33 (0)1 44 61 06 36
For other addresses see:
www.labaguedekenza.com
*The Algerian pastries that
are piled high here are given
a French touch that keeps
them light and smooth.
(See photographs pp. 264–267.)*

BELLOTA BELLOTA
18, rue Jean Nicot, 75007
Tel: +33 (0)1 53 59 96 96
Byzance Champs-Élysées
11, rue Clément Marot,
75008
Tel: +33 (0)1 47 20 03 13
www.bellota-bellota.com

*Specialists in Spanish
cured hams—jamón ibérico.
Each variety is displayed
on plates with details of
its origin and curing time
along with a range of
Spanish wines carefully
selected by these experts
in Spanish gastronomy.
(See photographs pp. 273–275.)*

BYZANCE
27, rue Yves-Kermen,
92100 Boulogne
Tel: +33 (0)1 46 09 02 28
*The other main supplier of
caviar in the capital, Byzance
has recently added Spanish
hams and wines to its range.
Twice a year they organize
tastings and the chance
to discover new products.*

COMPTOIR DU SAUMON & CIE
(Restaurants and fine foods)
60, rue François Miron, 75004
Tel: +33 (0)1 42 77 23 08
116, rue de la Convention,
75015
Tel: +33 (0)1 45 54 31 16
www.autourdusaumon.eu
*With their Nordic atmosphere,
these boutiques are
popping up all over Paris
and around France.
Salmon from the Baltic,
Ireland, and Norway lies
alongside smoked shark,
eel, tuna, and herring,
as well as the vodka and
aquavit which are essential
accompaniments!*

DA ROSA
62, rue de Seine, 75006
Tel: +33 (0)1 40 51 00 09
www.darosa.fr

A wonderful fine food store that also has a few tables where you can taste the products on display, in particular real ibérico ham. A selection of specialty sweets completes the choice on offer—the raisins soaked in Sauternes and dipped in chocolate are a perfect accompaniment to coffee and absolutely irresistible.
(See photographs pp. 276–277.)

DAVOLI
34, rue Cler, 75007
Tel: +33 (0)1 45 51 23 41
www.davoli.fr
The best Italian delicatessen in the chic seventh arrondissement has a choice of wines, charcuterie and take-out dishes: your guests will love the vitello tonnato.

ITALIA
9, rue de Lévis, 75017
Tel: +33 (0)1 43 87 01 00
The best Italian delicatessen on this street devoted to the pleasures of food. Pastas, of course, but also wines and deserts. The miniature babas and the limoncello are unforgettable.

IZRAËL
30, rue François Miron, 75004
Tel: +33 (0)1 42 72 66 23
You could be forgiven for thinking you were in a bazaar in Morocco or Istanbul when you step into this boutique in the Marais.
(See photographs pp. 268–269.)

LA MAISON DE L'OLIVE
3, rue Ampère, 75017
Tel: +33 (0)1 47 66 55 13
www.lamaisondelolive.fr
Specialists in genuine olive oil from small producers.
(See photographs p. 272.)

LA MAISON DES TROIS THÉS
33, rue Gracieuse, 75005
Tel: +33 (0)1 43 36 93 84
www.troisthes.com
Possibly Paris's most mysterious shop. In a quiet back street behind the Panthéon is the world's largest tea shop. In an extraordinary design by the architect/designer François Muracciole there are no less than a thousand teas from Taiwan and China and vintage teas dating back to 1890.
(See photographs pp. 278–283.)

LA MAISON DU DANEMARK
LA BUTIK
(Boutique of the Restaurant Flora Danica)
142, avenue des Champs-Élysées, 75008
Tel: +33 (0)1 44 13 86 26
www.floradanica-paris.com
A Nordic-flavored boutique with a wide selection of pickled herrings and salmon, along with aquavit to wash them down. Sandwiches to take out, salads on the terrace with an unbeatable view of the Arc de Triomphe, dishes from the deli section for a Scandinavian feast to take out or have delivered to your home.

LA MAISON DU WHISKY
20, rue d'Anjou, 75008
Tel: +33 (0)1 42 65 03 16
6, carrefour de l'Odéon, 75006
Tel: +33 (0)1 72 63 68 48
www.whisky.fr
This is a temple in honor of whisky: with its single malts, "limited editions," undiluted whisky "straight from the cask," and other "collector's items," it is full of whiskys that are hard to find, even in Scotland.

MAVROMMATIS
47, rue Censier, 75005
Tel: +33 (0)1 45 35 64 95
18, rue Duphot, 75001
Tel: +33 (0)1 42 97 53 04
www.mavrommatis.fr
The best Greek delicatessen in Paris is to be found at the bottom of rue Mouffetard. The city's Greek population comes here for its retsina, taramasalata, and tzatziki.

À L'OLIVIER
23, rue de Rivoli, 75004
Tel: +33 (0)1 48 04 86 59
www.alolivier.com
For many years Paris's only specialist in quality olive and other oils and their by-products.

OLIVIERS & CO.
36, rue des Francs-Bourgeois, 75003
Tel: +33 (0)1 42 74 38 40
128, rue Mouffetard, 75005
Tel: +33 (0)1 43 37 04 38
For other addresses see:
www.oliviers-co.com
A chain of stores primarily dedicated to olive oil: a wide selection and a constant attention to quality and information on the oils on display. Oliviers and Co. boutiques are found in all the best gourmet shopping streets in Paris including rue de Buci, rue Mouffetard, and cour St Émilion.
(See photograph p. 270.)

LE PALAIS DES THÉS
61, rue du Cherche-Midi, 75006
Tel: +33 (0)1 42 22 03 98
64, rue Vieille du Temple, 75003
Tel: +33 (0)1 48 87 80 60
For other addresses see:
www.palaisdesthes.com
A huge choice of teas, samovars, teapots, and a comprehensive library that is certain to satisfy any genuine tea lover.

PÂTISSERIE VIENNOISE
8, rue de l'École de Médecine, 75006
Tel: +33 (0)1 43 26 60 48
Since 1928 this miniscule patisserie in the heart of the Latin Quarter has been a haunt for students, who come for its strudel, poppy-seed cakes, chocolates, and Viennese coffee.

AU RÉGAL
4, rue Nicolo, 75016
Tel: +33 (0)1 42 88 49 15
www.auregal.fr
Russian specialties at this superb 1930s store include salmon and smoked sturgeon, pierogi (little pastry appetizers), and—with advance notice—the best koulibiac in Paris.